LEONARDO DA VINCI

V. P. ZUBOV

Leonardo da Vinci

Translated from the Russian by
DAVID H. KRAUS

HARVARD UNIVERSITY PRESS
CAMBRIDGE · MASSACHUSETTS

1968

Distributed in Great Britain by Oxford University Press, London

A translation of Leonardo da Vinchi, 1452–1519, published in 1962
by Izdatel'stvo Akademii Nauk SSSR, Moscow and Leningrad

Library of Congress Catalog Card Number 67-27096

Printed in the United States of America

FOREWORD

JACOB BURCKHARDT'S *The Civilization of the Renaissance in Italy,* first published in 1860, created the concept of the Italian Renaissance as a period in which many of the characteristic institutions and modes of thought of modern western civilization had their origin. Burckhardt's generalizations are founded on the careful study of the work of individuals, popes and princes, merchants and bankers, humanists, poets, philosophers, and artists. He has himself recorded that he was inspired to undertake this work by reading Vespasiano's *Lives of Illustrious Men.*

In spite of his preoccupation with creative individuals who were in his view in some sense "representative" of their times as well as "forerunners" of a later age, Burckhardt devotes singularly little space to Leonardo da Vinci. In the section on "Personality" in the chapter entitled "The Development of the Individual," Leon Battista Alberti is presented as the archetype of "uomo universale" whose motto is, "Men can do all things if they will." This is followed by the few short lines on Leonardo: "And Leonardo da Vinci was to Alberti as the finisher to the beginner, as the master to the dilettante. Would only that Vasari's work were supplemented by a description like that of Alberti! The colossal outlines of Leonardo's nature can never be more than dimly and distantly conceived."

At the time when Burckhardt wrote, very little had been published from Leonardo's scattered Notebooks, but, beginning in 1883, a series of editions made these difficult texts available in the original Italian and in translation. Based on these sources a great deal of scholarly effort has been expended in bringing into sharper focus what had appeared in the middle of the nineteenth century as the dim outlines of an enigmatic figure. Historians of both art and science have examined and re-examined all that remains of Leonardo's literary and artistic production. Biographies—scholarly or popular—and special monographs have appeared in many different languages, bearing witness to the continuing appeal of the problem of understanding this great genius. On the whole, the result of these reinterpretations has been much more substantial agreement on Leonardo's achievement as an artist than on his place in the evolution of the history of science.

When in 1883 J. P. Richter brought out two volumes of selected ex-

FOREWORD

cerpts from Leonardo's Notebooks, he emphasized in his commentary the extent to which Leonardo anticipated the outlook of "modern" science, especially in his dependence on observation and experimentation. Even today the popular image of Leonardo is that of a lonely figure, transcending the prejudices of his time, and pointing the way toward many of the dramatic discoveries of the nineteenth and twentieth centuries.

More recent scholarship, especially the work of Pierre Duhem, George Sarton, and Lynn Thorndike, has presented a different Leonardo, a man who belonged much more to the medieval world, who accepted uncritically many statements of ancient and medieval authorities, and whose "scientific discoveries" were in fact limited to his anatomical and mechanical drawings. A Leonardo has emerged who is much nearer the modern inventor than the modern scientist, more akin in mental outlook to Thomas Edison than to Albert Einstein except that unlike Edison's all of Leonardo's inventions and gadgets remained on paper, buried in the pages of the complicated and disorganized Notebooks. Only in the twentieth century have working models of many of these inventions been realized. It is recognized that the Notebooks reveal an omniverous curiosity and a remarkable capacity for observation and accurate description, but it is said that they show no interest in the formulation of systematic law, by which the great advances of modern science have been made possible.

In the present work, translated from the Russian first edition of 1962, Professor V. P. Zubov presents an interpretative biography in which he seeks to describe more precisely the characteristics of Leonardo's scientific and philosophical ideas. As he says in his preface, he hoped to avoid either archaizing or modernizing Leonardo, thus correcting some of the errors of perspective in the work of his predecessors. He came to this task prepared by a lifetime of studies dedicated to problems of ancient, medieval, and renaissance science. He was the translator and editor of a Russian edition of the *De re aedificatoria* of Leon Battista Alberti. His greatest work, a history of atomism, was posthumously published by the Soviet Academy in 1965.

Professor Zubov has organized his interpretation of Leonardo's thought under five comprehensive headings. In the chapter entitled "Science" he analyzes Leonardo's ideas on the relation between theory and practice, and on experimentation, generalization, and the verifica-

FOREWORD

tion of hypotheses based on analogies. He finds many examples of individual observations generalized into a formula, and these examples make very clear the way in which Leonardo's mind worked as he moved from the general thesis to the illustration and back again.

The succeeding chapter is dedicated to perception, "The Eye, Sovereign of the Senses." Here are suggestively brought together the many observations on the perception of objects, perspective, and the anatomy of sight. These problems, especially the consideration of the "geometry of painting," lead logically to the next rubric, namely, Leonardo's views on the nature and importance of mathematics. Under the heading "The Paradise of the Mathematical Sciences" Zubov examines what he calls "the mechanization of the world of man," with many examples of Leonardo's theoretical and applied mechanics. This is followed by the chapter on time, in which particular attention is devoted to Leonardo's speculations on geological and paleontological time.

In a final chapter Zubov analyzes the meaning of the concept of creativity in Leonardo's philosophy. He repudiates the view that Leonardo was essentially a glorified failure because his interests were so diverse and unconcentrated and because he was never able to finish anything. On the contrary, Zubov believes that Leonardo should be compared to the hero of an ancient tragedy, affirming the power of man to create things that are not in nature, pictures, statues, machines, not by repudiating or transcending the natural world but by penetrating deeply into the understanding of it through patient observation. In this sense Leonardo the artist and Leonardo the scientist are one. The rules laid down for the painter's art are formed on the same principles as the observations on water, weather, bridges, war machines.

Professor Zubov's closely reasoned pages are filled with quotations from Leonardo's manuscripts. One of the great merits of this book is that Leonardo is thus made to speak for himself. The result is that the reader has before him all the evidence which has led Zubov to conclude that the permanent historical significance of Leonardo is that he remained apart from the sixteenth century trend to resort to books in order to learn.

MYRON P. GILMORE

TRANSLATOR'S PREFACE

IN TRANSLATING PROFESSOR ZUBOV'S BIOGRAPHY of Leonardo da Vinci, I made some minor adjustments in the format for the sake of clarity and continuity of the narrative. This included moving a number of footnotes into the text and a few sentences of the text into the footnotes. Informative notes are given as starred footnotes, while bibliographic references are cited as endnotes, arranged by chapter. The appendices of the original have been rearranged slightly, for purposes of logical sequence, but their content has been left intact. I have deleted nothing from the text except references intended for the Russian reader that are of no consequence or sense to the English reader. All comments by the translator are so marked, and information supplied by me is enclosed in brackets.

In support of his interpretation of Leonardo da Vinci, Professor Zubov employed a large number of quotations from the Leonardo notebooks and from contemporary sources, in excess of 1000 quotations varying in length from a word to lengthy paragraphs. To avoid the dangers inherent in translating into English a Russian translation of Renaissance Italian, I have drawn on standard English translations of the Italian. In each case I have chosen the translation that best represents Zubov's interpretation; credit is given the translator by name (see p. xx for full references). When Zubov's version differed significantly from the standard English translations or, of course, if no translation was available, the translations are mine.

ACKNOWLEDGMENTS

This translation was undertaken upon the suggestion of Bruce F. Kingsbury of Education Development Center, Inc., Newton, Massachusetts, and was sponsored by that organization.

I am grateful to Professor Carlo Pedretti and Mrs. Elena Levin for their evaluation of my manuscript and for their comments. I wish to thank my wife, Mary, in particular, and also Carl Benoit, of Lexington, Massachusetts, for their assistance in the preparation of the manuscript.

Thanks are due to the following publishers for permission to quote from works published by them: to Harcourt, Brace and World and

TRANSLATOR'S PREFACE

Jonathan Cape, Ltd., for quotations from Edward MacCurdy, *The Notebooks of Leonardo da Vinci;* to Harvard University Press for quotations from Loeb Classical Library editions of Horace and Ovid; to Macmillan for quotations from Gaston De Vere's translation of Vasari's *Lives of the Most Eminent Painters, Sculptors, and Architects;* to Philosophical Library for quotations from Wade Baskin, translator, *Leonardo da Vinci. Philosophical Diary;* to Princeton University Press for quotations from Philip A. McMahon's translation of the *Treatise on Painting;* and to Charles Scribner's Sons for lines from Rolfe Humphries' translation of Virgil's *Aeneid.* For illustrations, thanks are due to the Biblioteca Ambrosiana; Biblioteca Apostolica Vaticana; Biblioteca Reale, Turin; British Museum; Governing Body of Christ Church, Oxford; Hermitage Museum; Institut de France; Musée Bonnat; Royal Library, Windsor Castle; Uffizi Gallery; and Victoria and Albert Museum.

AUTHOR'S PREFACE

THIS IS NOT A CHRONICLE of the life of Leonardo da Vinci. Such a chronicle, if it could be written, would be as vast and varied as the notebooks of this great artist and scientist. I take biography in the literal sense of the Greek word, as a description of life, in the way a portrait may describe life, embracing the basic and unique features of a great creative personality. In this sense the Turin self-portrait of Leonardo can be called an unsurpassed autobiography, summarizing his life in the fold of his lips, his overhanging brows, his intent look full of bitter wisdom.

Even if the chronology of the manuscripts and individual notes—over which researchers have labored so long and continue to labor—were determined in the smallest detail, a strictly chronological presentation of the works and days of Leonardo da Vinci would lead the reader into an inextricable labyrinth. It seems to me that comparison of Leonardo's notes written at various times is one of the most important duties of "Leonardology." Investigations conducted along these lines convince me more and more that Leonardo inevitably returned (sometimes after many years) to the same problems and the same questions. In his various notebooks we may trace "leitmotifs" in different versions that are mutually explanatory when compared but are otherwise quite incomprehensible and seemingly random.

Therefore, after presenting an introductory sketch, in which are traced the main events in Leonardo's life from the cradle to the grave, I treat successively the principal areas, the main themes of his work, his relationship to different aspects of nature and human activity. In an interpretive biography of a scientist, artist, and thinker such as Leonardo da Vinci it seems important first to throw light upon his character, not so much to give the sum and balance of his discoveries as to understand, insofar as possible, how he made these discoveries, the devices he employed, his style, his "stamp." This is the primary difference between a biography and a monograph.

Those who advance history are important to the history of science as well, that is, to the history of human knowledge. Without this human factor the history of science becomes a mere catalogue or inventory of discoveries. In speaking of the human factor, of course, I have

AUTHOR'S PREFACE

in mind not only and not so much individuals as groups, society as a whole. Therefore, it is natural and fitting to portray the figure of Leonardo da Vinci against a broad background of past and future. However, I do not wish to commit the error of many researchers who have underrated the importance of Leonardo's own epoch. Pierre Duhem attempted to view Leonardo from the past and suffered a curious optical illusion in seeing him as the "heir of the Parisian scholasticists," without considering all the truly new contributions of Leonardo's genius. Others have viewed him only from the standpoint of the future, unwittingly attributing to him the characteristics of later scientists. Leonardo was not exclusively a predecessor any more than he was exclusively a successor. Please do not misunderstand me. If the legacy of Leonardo is to be understood and evaluated correctly, he must be compared with the past and the future, but we must neither archaize nor modernize.

One final remark. Too often Leonardo's tragedy is simplified to a conflict between him and his environment, and this is then used to explain both his solitude and the oblivion to which his scientific and technical discoveries were relegated. I have set myself the task of revealing his inner conflicts as well, that struggle of contradictions that made the titanic figure of Leonardo da Vinci truly tragic. This struggle must be shown dynamically and its various aspects disclosed in turn. Therefore I have conceived the individual chapters as integral parts of the whole, which cannot be read separately, at random, without distorting the overall perspective.

These are the basic concepts that I feel must preface this volume.

V. P. ZUBOV

CONTENTS

FIGURES

FIGURES

FIGURES

FIGURES

LEONARDO DA VINCI

ABBREVIATIONS USED IN
MANUSCRIPT CITATIONS

The numbers following these abbreviations (except for W; see above) indicate the folio numbers; r and v stand for recto and verso. The paragraphing numbers cited for the Treatise on Painting are those of the Ludwig edition (see Appendix); cross references to the paragraphing of the original manuscript (Codex Urbinas) may be found in A. Philip McMahon, *Treatise on Painting* (Princeton, 1956).

TRANSLATIONS

Baskin	Wade Baskin, *Leonardo da Vinci. Philosophical Diary,* New York, 1959
MacCurdy	Edward MacCurdy, *The Notebooks of Leonardo da Vinci,* New York, 1958
McMahon	A. Philip McMahon, *Treatise on Painting,* Princeton, 1956
Reynal	*Leonardo da Vinci,* New York: Reynal and Company, 1963
Richter	Irma A. Richter, *Selections from the Notebooks of Leonardo da Vinci,* London, Oxford, 1959
J. P. Richter	J. P. Richter, *The Literary Works of Leonardo da Vinci,* London, 1939

I.

BIOGRAPHY

"Prima morte che stanchezza"
"Better death than weariness"
W 12700

LEONARDO DA VINCI was probably born in Anchiano, a village near
the town of Vinci between Florence and Pisa. The exact date of his
birth was established only quite recently, on the basis of a document
found by E. Möller in the state archives of Florence.[1] This document,
the diary of Leonardo's grandfather, Antonio da Vinci, contains the
following entry for 1452: "A grandson of mine was born, son of Ser
Piero, my son, on April 15, Saturday, at three o'clock in the night. His
name was Lionardo. He was baptized by Priest Piero di Bartolomeo
da Vinci." The diary also lists the godparents, five men and five women.
Since the night hours were reckoned from sunset, Leonardo must
have been born about ten-thirty at night.

About Leonardo was the illegitimate son of the notary Piero da Vinci. Of
his mother, Caterina, we know only that soon after Leonardo's birth
she married a local man, Antonio, nicknamed *accattabriga* (the
brawler), who leased a small brickworks several miles from Vinci in
the years 1449–1453. There is no substantiation for the remark by
Anonimo Fiorentino[2] that Leonardo's mother was of "good family,"[3]
and there is no evidence that she was a peasant woman. In the year of
Leonardo's birth Ser Piero married Albiera di Giovanni Amadori.
Leonardo spent his childhood with his grandmother Lucia and his uncle
Francesco. Francesco was sixteen years older than Leonardo and, liv-
ing in Vinci, devoted a great deal of time to the boy.[4]

About 1464 Ser Piero moved his family to Florence. Shortly there-
after his wife Albiera died and he remarried. In 1466 the fourteen-year-
old Leonardo was apprenticed to the well-known Florentine painter
and sculptor Andrea del Verrocchio (1436–1488). It was in Florence
that Leonardo's interests formed and that he acquired his first skills.

The Florence of that time was a large industrial city, in which vari-

LEONARDO DA VINCI

ous branches of industrial technology were well developed. The studios of master jewelers, artists, and sculptors became laboratories where various technical experiments were conducted.

The forty-year friendship of the famous sculptor and architect Filippo Brunelleschi (1377–1446) with the mathematician, astronomer, and physician Paolo dal Pozzo Toscanelli (1397–1482) is indicative in this respect. According to Vasari, Toscanelli taught Brunelleschi mathematics and "although Filippo had no learning, he reasoned so well in every matter with his instinct, sharpened by practice and experience, that he would many times confound him [Toscanelli]."[5] Brunelleschi found practical solutions to complex problems of statics, hydraulics, and ballistics. The famous dome of the cathedral of Florence was the culmination of his technical genius. He also wrote treatises on mathematics, mechanics, and applied optics, but these have not survived.

It was no mere chance that a young contemporary of Brunelleschi, the sculptor Lorenzo Ghiberti (1378–1455), concerned himself with theoretical problems. Ghiberti was the creator of the famous Gates of Paradise of the Baptistery in Florence, begun in 1424 and finished in the year of Leonardo's birth, 1452. In *Commentarii* (Commentaries), written toward the end of his life, Ghiberti drew on questions of mathematics, optics, and anatomy to solve practical problems of art, perspective, and the proportionality of the human figure. Supplementing written sources (in optics, the works of Alhazen, Witelo, and John Peckham; in anatomy, the works of Marcus Vitruvius, Avicenna, and others) with his own arguments and observations, Ghiberti saw as his main goal the approximation of nature: "I have sought to imitate nature to the best of my ability," he wrote in his work on the statuaries of the Gates of Paradise.[6] Michelangelo gave Ghiberti's gates their name. When asked how he liked them, he answered that they were so beautiful they would do well for the Gates of Paradise.

When young Leonardo settled in Florence, neither Brunelleschi nor Ghiberti was still alive, but their memory was fresh. All could see the dome of the cathedral Santa Maria del Fiore, completed shortly before Leonardo's arrival (in 1467 the scaffolding was removed from the lantern which crowned the dome). This outstanding piece of architecture defined the silhouette of the city for centuries to come. The traditions of the studios of the master craftsmen (the botteghe) still lived. Andrea del Verrocchio, master, experimenter, sculptor, artist, musician,

BIOGRAPHY

and jeweler was Leonardo's teacher. Theoretical problems of perspective were worked out in his studio, and the technique of oil painting, introduced to Florence in 1449 by the Dutch artist Roger van der Weyden, was perfected there. Another Florentine artist, Antonio Pollaiuolo (1429–1498), whose studio was next to Verrocchio's, performed autopsies to study the muscles and joints, the field least studied by professional anatomists and the one most important to artists striving for accurate portrayal of the human body.[7] And these were the years when the Florentine artist Benozzo Gozzoli (1420–*ca.* 1497) studied anatomy so assiduously.

The young Leonardo grew and developed in the company of such master experimenters, observers, and researchers. In late May 1472 a golden sphere and cross were placed atop the lantern of Santa Maria del Fiore. The task had been assigned to Verrocchio in 1468, and young Leonardo had closely watched its execution. In 1472 Leonardo finished his apprenticeship with Verrocchio and was accepted into the guild of Florentine artists.

Even then his interests were not limited to painting. According to Vasari, "he was the first, although but a youth, who suggested the plan of reducing the river Arno to a navigable canal from Pisa to Florence."[8] The statement that Leonardo thought of this specific canal in his youth may not be correct, but there can be no doubt that it was Florence that first stimulated him to technical invention. His invention of machines for spinning and throwing silk for the manufacture of cloth bears witness to the mark left on him by Florence, which was a major center of the silk and wool industry at that time.

Nonetheless, social conditions did not favor the activities of Leonardo the technician. Lorenzo de' Medici, called the Magnificent, came to power in Florence in 1469, about the time Piero da Vinci and his family moved to that city. The Medici family had grown rich in the fourteenth and fifteenth centuries by trade and banking, but now its representative Lorenzo devoted little attention to promoting trade and industry. He loved splendor, brilliant and magnificent festivals, reviews, and tournaments. He patronized poets and philosophers, and wrote poetry himself. The Plato Academy, which cultivated the fashionable Platonic and Neoplatonic philosophy, flourished under his auspices.

The "spirit" of the Plato Academy was Marsilio Ficino (1433–1499),

physician and philosopher, author of what is perhaps the first special treatise on the hygiene of intellectual labor. Ficino translated Plato's dialogues from Greek and the works of the Neoplatonists and the mystical theological works which legend associated with Zoroaster and Hermes Trismegistus. Ficino and his friends set as their final goal the reconciliation of Platonism and Christianity. In 1473 Ficino took holy orders or, as his contemporaries put it, "from a pagan, he became a soldier of Christ" (*ex pagano miles Christi*).[9] However, the expression "ex pagano miles Christi" must not be taken as symbolizing some spiritual crisis, a conversion from paganism to Christianity. Here, as in other works of the time, "paganus" meant simply a worldly man, as opposed to a spiritual one.[10]

The Plato Academy was not an academy in the full sense of the word, that is, an institution whose activities are regulated by statutes and whose body is elected by its members, but rather was a free association of persons who gathered for learned discussions. Usually it met at the villa in Carreggi. Ficino's contemporaries characterized him as the second Plato (*alter Plato*). He kept an eternal light burning before the bust of Plato in his home. The Florentine admirers of the Greek philosopher celebrated his birthday by a feast with philosophical conversations at the table. Disputes were interspersed with poetry readings and the playing of musical instruments. Lorenzo de' Medici and his brother Giuliano visited Ficino and became the leading patrons of the Academy.

In dedicating his translation of Plato's dialogues to Lorenzo de' Medici, Ficino defined the mission of the new academy: "In the gardens of the Academy, beneath the laurels, poets will hear the singing Apollo, orators on the threshold will catch sight of Mercury declaiming poetry, jurists and rulers of governments on the portico and in the hall will hear Jupiter himself giving laws, defining rights, ruling states. Finally, philosophers within the building will recognize their Saturn, the contemplator of heavenly mysteries. And everywhere priests and clergy will find weapons with which to defend piety steadfastly against the profane."[11]

Ficino taught self-contemplation and the pursuit of knowledge of one's self: "He who commanded 'know thyself' invited us, as it were, to know our soul which, being the mediator between all things and, what is more, being in itself all things, allows us to know everything else once we know it."[12]

BIOGRAPHY

The list of books belonging to Leonardo da Vinci (CA 210r) includes *Theologia platonica sive de immortalitate animorum* (Platonic philosophy or on the immortality of the soul), which scholars attribute to Ficino.[13] It is even more interesting that the list contains Luigi Pulci's poem *Morgante maggiore*. This is the man who, alluding to Ficino, wrote ironically of persons who argue much about the soul, taking up the problem of where it enters and where it leaves:

> Costor che fan si gran disputazione
> Dell'anima, ond'ell'entri e ond'ell'esca.[14]

It is not surprising that in Ficino's eyes the poet Pulci was a "degenerate, attacking divine objects, Thersites who is more deserving of punishment than of correction, a man whose evil is so great that it is more difficult to rid him of it than to remove all the sand from the sea."[15] One may tell where Leonardo's sympathies lay from such words as these: "If we entertain doubts about the certainty of each thing that passes through the senses, how much more ought we to doubt things hostile to the senses, such as the essence of God and of the soul and similar things about which people are always arguing and fighting [*per le quali sempre si disputa e contende*]" (TP 33; Baskin 26). Leonardo's "sempre si disputa" is practically the same as Pulci's "gran disputazione."

We have some indication of Leonardo's physical appearance in these years. The older biographies depict his facial features most flatteringly. According to Vasari, "by his brilliant appearance and his great beauty, he returned calm to every troubled soul."[16] According to Anonimo Fiorentino "He was beautiful in person, well proportioned, graceful, and of fine appearance. He wore his red coat short to the knee, whereas custom at that time was to wear garments long. Reaching to the middle of his breast he had a fine beard, curling and well shaped."[17]

In 1478 Leonardo received his first major commission: an altar piece for the chapel of the Palazzo Vecchio, the City Hall. The work went slowly; apparently then as later Leonardo conducted preparatory experiments with colors and made numerous sketches. As a result he did not finish the altar piece, and in 1483 the commission was given to another. Not even the subject of this painting is known.

Great events took place in 1478. A group of rich Florentine citizens

LEONARDO DA VINCI

headed by Francesco Pazzi and Archbishop Francesco Salviati of Pisa, a relative of the Pope, attempted to overthrow the Medici. On April 26 in Santa Maria del Fiore during service, the conspirators fell on the brothers Medici, Giuliano and Lorenzo, with daggers in hand. Lorenzo was slightly wounded and sought refuge in the sacristy, but Giuliano was felled by the first blow. The attempt to instigate an uprising in the name of republican freedom failed. The conspirators were hanged from the windows of the Palazzo Vecchio. One of them, Bernardo Bandini de Baroncelli, the murderer of Giuliano de' Medici, fled and, after lengthy wanderings, arrived in Constantinople. However, the Sultan surrendered him, and he was brought to Florence in chains and hanged at the Palazzo Vecchio on December 20, 1479.

A sketch by Leonardo depicting the hanged Bandini has survived (see figure 1). It is now in the Bonnat Collection in Bayonne, France. On the same folio is a brief record of the colors of the clothing, but not a word about the events leading up to the hanging. Only the name of the condemned man is inserted laconically and calmly amid the details of costume: "A tan colored cap, a doublet of black serge, a lined black jerkin, a blue coat lined with fur from foxes' throats, and a collar of the jerkin faced in velvet stippled with black and red, black hose. Bernardo di Bandino Baroncelli."

About this time Leonardo made the following remark on a sheet of drawings now in the Uffizi gallery: "on [*illegible*]ber 1478 I began two Madonnas" (Uffizi 115, 446r; Richter 289). Apparently one of the paintings referred to is the *Benois Madonna,* now at the Hermitage in Leningrad. The painting of Saint Jerome belongs to approximately this same period.

In the tradition of the Middle Ages, painting was not considered a "free" or "noble" art, but a mechanical skill, that is, one of the crafts, and painters were not differentiated from the other craftsmen. Leonardo objected ardently to any such evaluation of painting: "You have set painting among the mechanical arts. Truly, were painters as ready as you are to praise their own works in writing, I doubt whether it would endure the stigma of so base a name" (BN 2038 19v; Richter 199). For Leonardo, painting was not a "mechanical skill," but a "science." It was a legitimate "daughter of nature," since it was "born of nature" (BN 2038 20r; TP 12; McMahon 6). Painting is based on the "noblest" of senses, sight. As one of the highest media of knowledge, painting

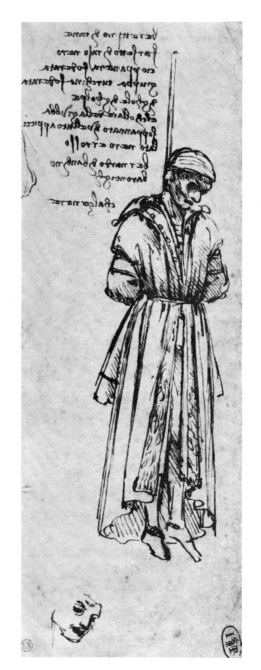

1. Bandino hanged

LEONARDO DA VINCI

merges organically with science, because in the final analysis science is also based on sensate, visual knowledge of the surrounding world.

It is difficult to say whom Leonardo had in mind when he said, "you have set painting among the mechanical arts." Values were already being reassessed in the Florence of his time, and representatives of the diverse trends were inclined to recognize painting as a free art. Ficino wrote: "Our age, our golden age, has revitalized the free arts which had been almost completely obliterated—grammar, poetry, rhetoric, painting, architecture, music, and the ancient singing of the lyre of Orpheus. And this has taken place in Florence."[18]

Only in Savonarola may one find any major pronouncements in defense of the concept of the Middle Ages that the "mechanical arts" are strictly of a "subordinate" nature. Cesare Luporini remarked on this in his book on Leonardo.[19] Savonarola differentiated two types of practical sciences, one concerned with the activity of the soul relating to external matter, and the other concerned with improvement of the soul itself (ethics). The first type included the "mechanical arts," which have no nobility (*dignitas*) either in their purpose (*ex obiecto*) or in their manner (*ex modo suo*). It is not harmful for the philosopher to know something about them, but "lack of such knowledge will not keep him from being a wise man." Hence, the arts accomplished by the body, which is the servant of the soul, are called servile (*serviles*), and those which are accomplished solely by the intellect, which is free (*qui liber est*), are called free (*liberales*).[20]

However, the crux of the matter was not so much in philosophical declarations of principle as it was attitudes, sometimes not fully conscious, a climate of opinion that continued to exist in society. The artist Giovanni Santi, father of Raphael, was not speaking idly when he extolled painting in his poems and described his contemporaries as "ungrateful, unjust, uncomprehending, and cruel," for placing painting among the "mechanical arts."[21]

It must be recalled that whatever opinions were held in Florence on the meaning of painting, the material position of Leonardo and other artists remained difficult. We know that Leonardo painted the clock of San Donato out of want.[22] Vasari tells us that the monks of the Passignano monastery treated David and Domenico Ghirlandaio, who

worked there in 1476–77, as mere workmen and fed them with scraps from the monastery table.[23]

In Leonardo's notes we find angry lines directed against "those who are the trumpeters and expositors of the works of others," that is, the presumptuous and pompous, those who pride themselves on their book learning (CA 117v b; 119v a; Baskin 20). They adorn themselves with foreign works, take pride in their ability to cite the ancient authors, and see in Leonardo "a man without learning" (*omo sanza lettere*). They, that is, the humanists, in their worship of the ancient authors have shut themselves off from life and have shut themselves in a "fenced-in garden" of artificial literature.

To avoid possible misunderstanding, I wish to clarify the terminology at this point. In speaking of Italian humanism of the fifteenth and sixteenth centuries, often no distinction is made between the two meanings of the term, and this leads to obscurities in discussion and evaluation of it. In one meaning, humanism is belief in the higher qualities of man, hence "humanism" in the broadest sense. The other is "humanity" (*humanitas*), as understood by the people of the time in the narrow, technical sense, following Aulus Gellius,[24] in which meaning the essence of humanity consists in cultivation of the "noble" or "good" arts, that is, activity in the field of the so-called "humanitarian sciences" (*humaniora*), primarily classical philology. This concept led to the aristocratic opposition of "learned persons" to the "unenlightened rabble." Leonardo's attacks were aimed primarily at humanists of this type, the "presumptuous and the pompous."

Yet even in this case it is difficult to find any specific person whom Leonardo could have had in mind. In any event, he could not have meant the most prominent representatives of Italian humanism. Whatever differences may have separated Leonardo from, say, Angelo Poliziano, one must remember that Poliziano spoke out just as energetically as did Leonardo against the "apers," "parrots," and "magpies" who repeated the words of others and who lacked any sort of creative originality.[25] Others, such as Giorgio Valla and Erasmus, expressed themselves in a similar vein.[26]

One can see why Leonardo the inventor and mechanic turned from Medicean Florence, with its cult of Plato and its refined artificial literature in imiation of the ancients, to Milan.

LEONARDO DA VINCI

Milan was at this time one of the richest cities of Italy. It officially was ruled by Giangaleazzo Sforza, a minor, but actually was ruled by his uncle, Lodovico Sforza, nicknamed Il Moro, the Moor.* Poets, humanists, and scientists swarmed to his court as they did to the court of the Medici, "like bees to honey," as a contemporary put it. However, the learned environment was somewhat different in character from that in Florence. Here the mathematical and natural sciences were given greater weight, reflecting the proximity of the University of Pavia. Florence was primarily a textile city, while Milan was a city of armorers, of metal workers. The dukes of Milan devoted much attention to engineering, particularly military engineering.

About 1482 Leonardo sent Lodovico il Moro a letter in which he offered his services as an engineer. At that time Milan was allied with Ferrara and was at war with Venice. Nine points in Leonardo's letter are devoted to military inventions, points which he felt would be of special interest to the rulers of Milan: "Most Illustrious Lord, having now sufficiently seen and considered the proofs of all those who proclaim themselves masters and inventors of instruments of war, and finding that their invention and use of the said instruments do not differ in any respect from those in common practice, I am emboldened without prejudice to anyone else to put myself in communication with Your Excellency, in order to acquaint you with my secrets, thereafter offering myself at your pleasure effectually to demonstrate at any convenient time all those matters which are in part briefly recorded below."

An enumeration of his secrets follows: "I have plans for bridges, very light and strong and suitable for carrying very easily, with which to pursue the enemy and," Leonardo added prudently, "at times to flee from him." He mentions bridges which are "sturdy and indestructible

* Lomazzo, in his *Trattato dell'arte della pittura*, 1.7.25, attributes the nickname "Il Moro" to the duke's swarthy complexion (*fu di color bruno, e pero hebbe il sopranome di Moro*). Others dispute this. Volynskii (*Leonardo da Vinci*, pp. 447–448) refers to the sonnets of the court poet Bernardo Bellincioni, from which it would appear that Moro had a light complexion and that by *moro* one should understand the mulberry tree, which "summons its strength and then quickly bears fruit." However, could not such an interpretation of the widely known nickname be merely court flattery, and the mention of the whiteness of his face a courtly "touching up" of the portrait? Leonardo's notebooks contain a somewhat enigmatic outline of an allegorical composition: "Il Moro with spectacles, and Envy depicted with False Report, and Justice black for Il Moro" (H 88v).

by fire or assault, easy and convenient to carry away and place in position . . . plans for burning and destroying those of the enemy," plans for "cutting off water from the trenches" in case of siege, plans for constructing siege bridges, mantlets, and scaling ladders, and plans for destroying fortifications inaccessible to cannon. He speaks of different kinds of cannons, convenient and easy to transport, "with which to hurl small stones with an effect almost of hail, causing great terror to the enemy from their smoke, and great loss and confusion"; ways of "arriving at a certain fixed spot by tunnels and secret winding passages, made without any noise even though it may be necessary to pass underneath trenches or a river"; and vehicles that are reminiscent of modern tanks: "I can make armored vehicles, safe and unassailable, which will enter the ranks of the enemy with their artillery, and there is no company of men at arms so great that they will not break it. And behind these the infantry will be able to follow quite unharmed and without any opposition." Again the artillery is enumerated: cannons, mortars, and light ordnance "of very beautiful and useful shapes, quite different from those in common use," catapults, and so forth. "In short," concludes Leonardo, "as the variety of circumstances shall necessitate, I can supply an infinite number of different engines of attack and defense."

After remarking briefly on methods of naval warfare, as his last point Leonardo turns to architecture, sculpture, and painting: "In times of peace, I believe that I can give you as complete satisfaction as anyone else in architecture, in the construction of buildings both public and private, and in conducting water from one place to another. Also I can execute sculpture in marble, bronze, or clay, and also painting, in which my work will stand comparison with that of anyone else, whoever he may be."

At the end of the letter the young Leonardo casts a proud challenge to anyone who dares to doubt his talents: "And if any of the aforesaid things should seem impossible or impracticable to anyone, I offer myself as ready to make trial of them in your park or in whatever place shall please Your Excellency, to whom I commend myself with all possible humility" (CA 391r a; MacCurdy 1152, 1153).

Leonardo's notes contain a list of the things he took with him when he moved, including:

LEONARDO DA VINCI

Many flowers drawn from nature
Certain figures of Saint Jerome
Drawings of furnaces
8 Saint Sebastians
Many throats of old women
Several heads of old men
Several figures, complete
Several arms, legs, feet, and postures

and

A Madonna, finished
Another, almost finished, in profile.

This other Madonna is the *Madonna Litta,* now in the Hermitage.[27]

Thus, Leonardo moved to Milan and there began the Milan period of his life (1483–1499) that was so richly creative. Leonardo was accepted into the College of Ducal Engineers,* and in Milan he emerged as a military engineer, architect, hydraulic engineer, sculptor, and painter. It is characteristic that in the documents of the time he is called first an engineer and then an artist.

In the first months of his sojourn in Milan, Leonardo engaged in all branches of military engineering in real earnest. His notes and sketches of that period are, as it were, a realization of the program he had outlined in his letter to the duke: the rearmament of the fortifications of the castle of Milan, siege equipment, portable ladders, rams, and so forth. Leonardo made an intensive study of Roberto Valturio's book on war,[28] a book which enjoyed great success. It was first printed in Latin in 1472, then three times in Italian (Verona, 1483; Bologna, 1483; Venice, 1493), and in French after Leonardo's death (Paris, 1532, 1534, 1535, and 1555). It was the first printed technical treatise. Working at the court of Malatesta in Rimini, Valturio followed primarily historical, antiquarian goals. As he said in the introduction, he did not intend to "teach anything new," but rather to "resurrect what had been lost." However, the reconstruction of the military machines of ancient epochs on the basis of literary sources, as any reconstruction of ancient

* Carlo Pedretti has pointed out to me that Leonardo was not one of the ducal engineers, citing C. Baroni, *Rendiconti del R. Istituto Lombardo di scienze e lettere,* vol. LXX, no. 3 (1937). [Translator's note.]

BIOGRAPHY

monuments during the Renaissance, was bound to be influenced by new ideas. It is curious, for example, that the remarks on projectile equipment of antiquity (*tormenta*) were accompanied by a picture of a cannon, and one of the books of the treatise contains a description of the fortifications of Rimini.

In 1487–90 Leonardo entered the competition for construction of the crossing tower (*tiburio*) of the Milan cathedral. The draft of the letter that accompanied his model has been preserved. Likening the architect to an experienced physician, Leonardo presented his initial principles in general form:

> You know that medicines when well used restore health to the sick, and he who knows them well will use them well when he also knows what man is, and what life and constitution are, and what health is. Knowing these well, he will know their opposites, and being thus equipped he will be nearer to devising a remedy than anyone else. In just the same way, a cathedral in need of repair requires a doctor-architect who understands well what a building is, on what rules the correct method of construction is based, whence these rules are derived, into how many parts they are divided, and what the causes are that hold the structure together and make it permanent, what the nature of weight is and what the desire of strength is, how these should be interwoven and bound up together, and what effect their union produces. Whoever shall have a true knowledge of the above-named things will satisfy you both by his intelligence and his work.

After this declaration, which was clearly intended to show that architecture, like painting, is a science and not a simple trade, Leonardo laid down a program for a large treatise on architecture: "For this reason I shall endeavor without disparaging and without defaming anyone to satisfy you partly by arguments and partly by demonstration, sometimes revealing the effects from the causes, sometimes confirming the reasoning from experience, fitting with them certain of the principles of the architects of antiquity and the evidence of the buildings they constructed and showing what were the reasons for their destruction or their permanence."

Only after this long introduction does Leonardo proceed directly to his task: "But to keep from being too wordy, I will first speak to Your Excellencies of the invention of the first architect of the cathedral, and will show you clearly what his purpose was, confirming this by the

building which has been commenced, and when I have made you understand this, you will be able clearly to recognize that the model which I have constructed possesses in itself that symmetry, that harmony, and that regularity which belongs to the building already begun" (CA 270r c; MacCurdy 1144).

The rest of the draft has been lost or, perhaps, there never was more, but at any rate it is evident that the preface contained a broad plan of not just one, but of several treatises on architecture. In essence, Leonardo proposed to the city fathers a research program in construction and architecture. In setting the physician the task of "knowing what man is, what life and constitution are, and what health is," Leonardo placed equally complex tasks before the architect—to learn what constitutes the nature of gravity, the direction of force, and so forth. This was a program for a whole lifetime, many lifetimes, the engineering ideal, based on reasonable scientific principles. The solution of all these problems in their whole latitude, as posed by Leonardo, would have delayed the solution of the specific problem of the Milan cathedral for an indefinite term.

Leonardo received neither approval of his model nor a command to direct the construction work. The competition was renewed in 1490, but Leonardo had taken his model back shortly before that, promising to return it. He neither returned it nor participated in the new contest. The builders Amadeo and Dolcebuono won the contest and completed the tower in 1500.

Although Leonardo's project did not produce any direct practical results, it was very important for his creative biography. The large number of sketches of that period show how persistently he pondered the problems of the cupola roof and the various means of its architectural solution. The sketches show that he experimented mentally, as it were, turning over in his mind the possible variants.[29]

Leonardo's notes on structural mechanics, on the theory of arches and vaults, belong to his Milan period. He also treated problems of the resistance of materials both theoretically and experimentally, being in this respect the predecessor of Galileo. Later he planned special treatises on cracks in walls and means of preventing them.

Much of Leonardo's creative effort was devoted to hydraulic engineering projects. The political and economic conditions were such that these plans were not realized in his lifetime. He conceived his projects in Florence, Milan, Rome, and even in France, during his declin-

BIOGRAPHY

ing years. But there can be no doubt that he reached his fulfillment as a hydraulic engineer during his first Milan period, in Lombardy, which was the most advanced region of Italy in this respect. The canals of Lombardy were the first navigable canals built in western Europe.[30] The first attempts to exploit the waters of the Ticino were made in the twelfth century, of the Adda in the thirteenth century. In the fourteenth century the waters of the Ticino were regulated as far as Milan (Pavia canal), and the Po was regulated from Pont'Alberto to its mouth. By the end of the fourteenth century a sluice canal had been built to join Milan with Verbano, the city which furnished the stone for the Milan cathedral. Bertola da Novate, an engineer in the service of Francesco Sforza, began construction on the Martesana canal in 1457. These works were continued by Bartolomeo della Valle, perhaps together with Leonardo.

During his stay in Milan, Leonardo worked on the problem of irrigating the Lomellina, a barren locale near Milan where Il Moro owned estates (1494). In 1494–98 Leonardo directed the construction of the Martesana canal, bringing it to the inner moat of Milan. His earlier notes contain drafts of letters of the following type: "There are here, my Lord, many gentlemen who will undertake this expense between them, if they are allowed to enjoy the use of the waters, the mills, and the passage of vessels; and when their expenses shall have been repaid them, they will give back the canal of the Martesana" (Forst III 15r; Richter 314).[31]

As in Florence, Leonardo had to squander his technical inventiveness on showy, pompous festivals and ventures. Soon after the wedding in 1489 of Il Moro's nephew Giangaleazzo, the nominal Duke of Milan, to Isabel of Aragon, the granddaughter of the Neapolitan king, Leonardo constructed "with great inventiveness and art" (to quote a contemporary) a paradise, in which the sky was presented as a colossal circle. The deities of all the planets described their preassigned orbits and, reciting poetry, appeared before the young couple (January 13, 1490).*

*See E. Solmi, *Scritti vinciani*, pp. 1–14. Recently Guatelli attempted to reconstruct the revolving stage of the "paradise"—on the basis of the information in the British Museum manuscript—for exhibition at the Los Angeles County Museum; see Steinitz, "A Reconstruction of Leonardo da Vinci's Revolving Stage." Later Pedretti showed that the notes and sketches in BM 224r and 231v, which formed the basis for Guatelli's reconstruction, pertained to another theatrical mechanism constructed by Leonardo for the presentation of Poliziano's *Orfeo* in Mantua in 1490; according to Pedretti, the mechanism itself differs considerably from the one constructed by Guatelli. "In Leonardo's manuscripts," writes Pedretti, "there are no traces of the 'Paradise' project" (Pedretti, *Studi vinciani,* pp. 90–98).

LEONARDO DA VINCI

Even in such cases Leonardo preserved his role of scientific observer. The construction of the revolving stage gave him occasion to ponder the laws of mechanics and their practical application. He probably was recalling his Milanese paradise when he wrote: "Mechanics is the paradise of the mathematical sciences, because by means of it one comes to the fruits of mathematics" (E 8 v; MacCurdy 613).

In 1491 Leonardo was assigned the task of organizing the elaborate jousts for the wedding of Lodovico il Moro and Beatrice d'Este, daughter of the Duke of Ferrara. He designed the costumes and decorations for this celebration. Was it not during these jousts that Leonardo made his observations on the mechanics of human motions? In his notes we read, for example, "When a jouster takes his lance by the handle, he shifts his center of gravity forward on the horse" (A 32 v), or "the jouster who stands motionless immobilizes the attacker, whereby the motionless one takes motion from the one who has now lost his motion" (CA 211r a).

One gets an idea of the allegorical works Leonardo composed in Milan from a note which draws the figure of the duke and his secretary Gualtieri: "Il Moro as the figure of Fortune, with hair and robes and with hands held in front, and Messer Gualtieri with act of obeisance plucks him by the robes from below as he presents himself before him. Also Poverty as a hideous figure running behind a youth, whom Il Moro covers with the skirt of his robe while he threatens the monster with his gilded scepter" (I 138 v; MacCurdy 1095).

In Milan, Leonardo came into contact with university science, with the Aristotelian scientific traditions, not in the strictly scholastic form of the Middle Ages, but with traditions considerably renovated by trends characteristic of the Renaissance. The physicist and humanist Giorgio Valla (1447–1500) lived in Milan at this time. He was the author of the extensive encyclopedia *De expetendis et fugiendis rebus opus* (What to seek and what to avoid) and assiduously studied (true, not always with equal success) the texts of the ancient mathematicians, the texts of Aristotle and of Galen. The wealthy lawyer Fazio Cardano, father of the famous mathematician and physician, also lived in Milan. He expressed a lively interest in the natural sciences, studied Euclid, and published John Peckham's work on optics,[32] a work well known to Leonardo, as indicated by his Italian translation of a passage from the preface (CA 203r a). Leonardo made the following note: "Get Messer

BIOGRAPHY

Fazio to show you the book on proportion" (CA 225r b; Richter 304). The sons of the physician, philosopher, and mathematician Giovanni Marliani, professor at Pavia University (died 1483), also lived in Milan. They, too, were mathematicians and physicians and kept their father's manuscripts. Leonardo made this entry in his notebook: "An algebra which the Marliani have, written by their father" (CA 225r b; Richter 303).

In Milan Leonardo associated with the engineer and philosopher Pietro Monti, author of the book *De dignoscendis hominibus* (On differentiating people), in which he defended the experimental method and declaimed ardently against blind belief in authority. Later (early in the sixteenth century), he published two books on war. Leonardo wrote: "Speak with Pietro Monti on these ways of throwing spears" (I 120v; Richter 335).

While in Milan, Leonardo also came to know Luca Pacioli or, as he called him, Luca di Borgo San Sepolcro (*ca.* 1445 to *ca.* 1514), who wrote the *Summa de arithmetica geometrica. Proportione et proportionalita* (Sum of arithmetic, geometry, proportions, and proportionality). He is considered the father of bookkeeping, to which a special section of the book is devoted. Pacioli came to Milan in 1496. Leonardo wrote: "Learn how to multiply roots from Messer Luca" (CA 120r; MacCurdy 1176). "Get your brother from Borgo to show you the book 'On Weights' "[33] (CA 90v). In 1496 Pacioli completed his *De divina proportione* (On divine proportion), for which Leonardo did the illustrations,[34] as stated by Pacioli himself: "they were made by the worthiest of painters, perspectivists, architects, and musicians, one endowed with all perfections, Leonardo da Vinci, a Florentine in Milan at the time we were both sponsored by the most illustrious duke of Milan, Lodovico Maria Sforza Anglo, in the years of our Lord 1496–1499, whence we departed together for various reasons and then shared quarters in Florence."[35]

De divina proportione contains the so-called golden section, which was of interest to the artists and architects of the time ("the whole is related to its largest part as the largest part is related to the smallest"). In the first part of the book, Pacioli outlines the theory of the golden section and in the second, the theory of regular polyhedra (in which the golden section or proportion is applied). The third and last part is a treatise on architecture. Recently, C. Pedretti made a study of an

LEONARDO DA VINCI

unpublished work by Pacioli, *De viribus quantitatis* (On the forces of quantity), in which he also found reflections of the friendship of Leonardo and Pacioli.[36]

Even more indicative of Leonardo's attitude is the interest he showed in practical experience. His notes include the following: "Memorandum, to ask Giannino Bombardieri how the tower in Ferrara is walled without holes" (CA 225r b; Richter 304). "Ask Maestro Antonio how mortars are placed on bastions by day or by night" (CA 225r b; Richter 304). This Giannino Bombardieri was Giannino Alberghetti of Ferrara, a renowned founder.

Leonardo became a close friend of the celebrated architect Bramante (1444–1514), who was working in Milan at the time as an engineer and artist for the Duke. One of Leonardo's manuscripts (M 53v; Mac-Curdy 837) contains this note accompanied by a drawing: "Plan of drawbridge which Donnino showed me." Donnino is the diminutive of Donato, Bramante's first name.

Undoubtedly Leonardo was concerned with anatomy even during his apprenticeship with Verrocchio, but it was not until Milan, in 1487–1495, that he began to devise his first broad plans for anatomical studies and to carry them out on a scale beyond the requirements of painting. At that time he was particularly interested in the nervous system. His manuscript with the caption "The tree of veins" belongs to this period. The style of this sketch, as others of this period, differs considerably from those of the later periods.

Leonardo composed the famous *Last Supper* during his Milan period. Comparing the different forms of art, Leonardo considered painting to be the most enduring, above "unfortunate music," which dies as it is born. When he set about work on the *Last Supper* in the refectory of the monastery of Santa Maria delle Grazie, conducting various experiments with paints, he did not imagine these experiments would subject the painting to a fate that differed little from that of a musical sound. In writing of the *Last Supper* in the latter part of the sixteenth century, Lomazzo said that the painting was already completely ruined. Elsewhere, in speaking of the damage done to the painting by the priming, he adds, "it is regrettable that such beautiful works [the *Last Supper* and the *Battle of Anghiari*] are perishing and that only the ᵗches remain, which cannot be bested either by time, death, or ᵘch things; they will remain through the ages, bringing him

BIOGRAPHY

great praise and fame."[37] When Vasari visited Milan in 1566, on completing the second edition of his work, he found only a "faint spot" on the wall. In the 1580's, Armenini, enraptured by what was left of the painting, also stated that it was ruined.[38]

The tragedy of Leonardo's creative work lay in the discrepancy between his grand projects and the possibility of their execution, which is illustrated especially clearly by his long labor over the equestrian statue of Francesco Sforza, in planning which he had to solve a number of complex and diverse technical problems.[39] In his famous letter to Il Moro, Leonardo wrote: "Moreover, I would undertake the work of the bronze horse, which shall endue with immortal glory and eternal honor the auspicious memory of the Prince your father and of the illustrious house of Sforza" (CA 391r a; MacCurdy 1153).

An equestrian statue of Francesco Sforza had been considered by the rulers of Milan in 1473, before Leonardo's arrival. Leonardo began work on it shortly after his arrival in Milan and continued for sixteen years. His notebooks contain sketches of scaffolding, lifting devices, and a description of casting methods. Evidently the emotional, unfinished note in the Codex Atlanticus pertains to this work: "Tell me if ever, tell me if ever anything like this was built in Rome" (CA 216v b; Reynal 127). The statue was to be 12 braccia high (about 23 feet) and to consume 200,000 pounds* of copper.[40]

However, the work dragged and dragged, partly because of Leonardo himself, who contemplated ever newer variants and new experiments, and partly because of unfavorable political conditions. Lodovico il Moro wrote in 1489: "Although I entrusted this matter to Leonardo da Vinci, I do not think that he will be able to execute it." In 1493 a clay model of the statue was erected on the city square on the occasion of the marriage of a niece of Il Moro, Bianca Maria Sforza, to Emperor Maximilian. According to Vasari, "those who saw the great model that Leonardo made in clay vow that they have never seen a more beautiful thing, or more superb."[41] Paolo Giovio wrote that "the vehement life-like action of this horse as if panting is amazing, not less so the sculptor's skill and his consummate knowledge of nature [*rerum naturae eruditio summa*]."[42] But the statue itself was never cast. The great mass of bronze intended for the casting was sold to the Duke of Ferrara, an ally of Milan, to make cannon. Giannino Bombardieri helped cast

* Pacioli states 20,000 bronze libbre. [Translator's note.]

LEONARDO DA VINCI

these artillery pieces. In one of his letters of entreaty to Il Moro in the 1490's Leonardo wrote: "Of the horse I will say nothing, because I know the times" (CA 335 v; Richter 328).

In Milan, Leonardo began studies in fields in which he had to depend on his own resources, for which he had no sponsor. Remarks on aviation, drawing, and drafting already appear in his manuscripts of that period. In one of the notes from about 1487 he speaks of experiments contemplated for the Corte Vecchio in Milan: "Bolt the upper hall and make a large and tall model; and you will have room on the upper roof. That is the best place in Italy in all respects. And if you stand on the roof, to one side of the tower [St. Gotthard], people in the tower marquee [*tiburio*] will not see you" (CA 361v).

Evidently the earliest surviving plan of a flying apparatus by Leonardo belongs to this period (CA 276r b). It still calls for metal parts, and for a man in horizontal position to set the mechanism in motion with his arms and legs. Later Leonardo strove to replace metal with wood, reeds, and ropes and to have, insofar as possible, rigid transmissions. He also worked on means of keeping the operator's hands free. (Projects of this type can be found in CA 320v a and B 74 v.)

Still later Leonardo turned to apparatuses in which the man was in a vertical position (see figure 2). This plan, which Beltrami described as "Leonardo's aeroplane," foresaw springs as a motive force, whereby Leonardo did not restrict himself to the muscular power of a man. This plan belongs to the period around 1495 (CA 314r b). There was no text with the drawing, so Beltrami had to rely on other material in the Codex Atlanticus for his interpretation. The last plan of a flying machine (1499) is glued to the back of the same sheet of the Codex Atlanticus as the earliest one (CA 276v b).

Leonardo proceeded logically from observations of birds to construction of flying machines, but chronologically the largest number of notes on "artificial birds" preceded the notes containing detailed studies of the flight of real birds. Most of Leonardo's notes on airplanes are in Manuscript B (*ca.* 1488–1489), supplemented by notes in the Codex Atlanticus that also pertain in part to the same years.

The Milan period of Leonardo's life ended in catastrophe. In the summer of 1499 the French armies invaded the territory of Milan and in the fall took the city. Il Moro fled. Early the next year he managed to return to Milan for a short while, but in April was taken prisoner

BIOGRAPHY

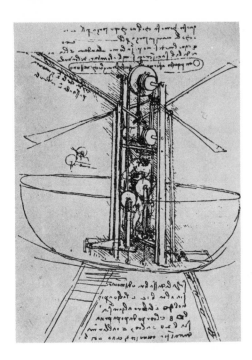

2. Plan of four-winged flying apparatus

and sent to France, where he died after languishing in prison for ten years. A laconic note by Leonardo reads: "The Duke lost the state, his property, and his liberty and none of his enterprises has been completed" (L cover; Richter 340). But none of Leonardo's major projects was finished either. The clay model of the horse fell victim to the sport of the Gascon bowmen of Louis XII. Late in 1499 Leonardo and his friend Luca Pacioli left Milan for Venice by way of Mantua.

In April of 1500 Leonardo was back in his native Florence. This begins his second Florentine period, which lasted till the middle of 1506, except for a brief period spent in the service of Cesare Borgia.

Great changes had taken place in Florence during Leonardo's absence. Lorenzo de' Medici had died on April 8, 1492. In that same year a new Pope, Alexander VI, a member of the Borgia family, was elected in Rome. Two years later, in 1494, there was an uprising in Florence against the tyranny of Piero de' Medici, Lorenzo's son. New organs of government administration were set up, some democratic changes were made, a tax was levied on income from real estate, and the usurers were driven from the city. For a time the Dominican

LEONARDO DA VINCI

Girolamo Savonarola exerted an enormous influence. He condemned the luxury of the rich, those who "appropriate wages of the simple people"; instead of money they "give the people their wornout shoes." He attacked the luxury, licentiousness, and worldliness of the clergy. Savonarola's influence led to public burning of the "temptations of worldly vanity," "immoral books," paintings, and objects of luxury. However, this did not prevent him from conducting schools where painting, sculpture, architecture, and the art of book writing and illustrating (miniatures) were taught.

Savonarola's fiery denunciations of "evil prelates" and of the Pope himself led Alexander VI to excommunicate him, but Savonarola refused to acquiesce. On May 23, 1498, the insurgent monk and his closest adherents were hanged and their bodies burned, so that their "souls would finally be separated from their bodies."

Savonarola was an implacable indicter of the antiquarian humanism that reached its peak in the Medici epoch. According to Savonarola, "some have so narrowed their minds and fettered them with the chains of antiquity and so subjected their own thought to the tyranny of the ancients that not only do they refuse to speak save as the ancients spoke, but will say nothing that has not been said by them. What reasoning is this, what new power of argument? That if the ancients spoke not thus, neither will we speak thus. Therefore, if no good deed was done by the ancients, then must we do none?"[43] Savonarola's own experience, "the teacher, life" opposed the imitation of the ancient false authorities: "There are persons who pretend to the rank of poet, but who can do nothing but follow the Greeks and Romans, repeating their ideas... Experience, which is the teacher of life, has shown so clearly all the harm that comes from misuse of the poetic art that there is no need to labor over proof of it."*

Savonarola cited Plato, who would drive immoral poets from his ideal republic: "Plato held it necessary to pass a law against such poets, a law which our present Christians wish neither to understand nor to observe... specifically he says that laws must be passed and observed which would banish poets from the cities if they followed the example and authority of false, profane gods, and in vile poems sang the praises of foul, carnal passions and moral depravity. And what are our rulers

* Cited in Villari, *Life and Times of Girolamo Savonarola*, I, 105. This passage was written about 1492.

BIOGRAPHY

doing? Why do they conceal this evil? Why do they not issue laws by which such poets would not only be turned out of the cities, but also their books, along with the books of other ancient authors who wrote of the art of love, fornicatresses, idols, and the vilest and most despicable demonic superstition?"[44]

When Leonardo returned to Florence, the prosperous families who were opposed to both the Medici and Savonarola were in power. In 1502 Pietro Soderini was proclaimed Gonfaloniere (Head of the Republic) for life. The position of Florentine industry at this time was shaky. Textile production had ceased. The rich Florentine merchants and industrialists showed an increasing tendency to invest their capital in land. Mystic, idealistic tendencies took firmer hold among the Florentine intelligentsia. Botticelli was seized with mystic exaltation. Fra Bartolomeo della Porta, shortly after the death of his teacher Savonarola, ceased painting for a time and entered a monastery. All the Della Robbias were admirers of Savonarola, and two of them took monastic vows under his influence. In the words of Vasari, Lorenzo di Credi was a "member of the sect of Fra Girolamo." Of Cronaca, Vasari says that "he has gone out of his mind over Savonarola and does not want to speak of anything else." The same applied to Sandro Botticelli. Michelangelo attended Savonarola's sermons diligently and even as an old man kept rereading them, recalling the powerful impression the voice and gestures of this orator had made on him.[45]

Leonardo would certainly have felt strange in such surroundings. Fra Pietro da Novellara, former tutor of Isabella d'Este, complained in 1501 that Leonardo was "working hard on geometry" and had abandoned painting to such an extent that he was "most impatient with the brush." In another letter, written the following day, he states that Leonardo's "mathematical experiments" had so distracted him from painting that he "cannot abide the brush."[46] Very soon after his arrival from Milan, Leonardo realized that in Florence he would not find a broad field of activity, an arena for implementing the grand technical plans that occupied his mind. Evidently this was the reason he entered the service of Cesare Borgia—son of Pope Alexander VI—who was engaged in subjecting the Romagna and adjacent lands. At seventeen years of age Cesare was raised to the rank of Cardinal, but five years later, in 1498, he renounced the cloth and was granted the title of Duke of Valentinois by Louis XII of France.

LEONARDO DA VINCI

Leonardo was in the service of Cesare Borgia from the summer of 1502 to March of 1503. This was soon after Cesare had inhumanly executed the young duke of Faenza, Astorre Manfredi, who had surrendered himself on the condition that his life would be spared and that he would be set free. Leonardo (together with Machiavelli) witnessed the slaughter of the Senigallia conspirators, when Cesare with his detachment entered the city in the guise of humble petitioners and in several hours became masters of the situation (December 31, 1502).

On August 18, 1502, Leonardo was commissioned as a military engineer to examine the fortresses and fortifications and to "make in them such changes and revisions as he deems necessary." First Leonardo visited the cities on the Adriatic coast, from about Pesaro to Ravenna. He was in Imola when it was besieged by the insurgent *condottieri*. Next he inspected the large region between Siena and Foligno. Finally, he again came to the sea, in Piombino on the west coast of the Apennine peninsula.

During this period Leonardo drew a number of maps. They were made primarily for strategic purposes, but in fact were documents displaying great scientific knowledge: the observational powers of the scientist and the genius of the artist fused here into an organic whole.

Leonardo's itinerary can be traced in considerable detail in his dated notes in Manuscript L, which also gives some idea of the diversity of his interests. "Dove cote at Urbino. 30 July 1502" (L 6r; MacCurdy 366). There is a sketch of Urbino fortress (L 78v) which Cesare had captured by treachery shortly before (June 21, 1502); there are also two notes pertaining to staircases (L 19v and 40r). On August 1, Leonardo was in Pesaro, after a ride of several hours, and visited the library; "at Pesaro, the library" (L cover r). A week later he wrote: "There is harmony in the different falls of water, as you saw at the fountain of Rimini, on the eighth day of August 1502" (L 78r; Richter 346). In mid-August, Leonardo was in Cesena (L 36v). He made a whole series of sketches and notes while there: "The fortress of the harbor of Cesena is four points to the southwest" (L 67r; MacCurdy 367); "Window at Cesena" (L 47r; MacCurdy 367); "Thus grapes are carried at Cesena" (L 77r; Richter 347). The drawing of Cesena harbor is dated with unusual precision: "6th day of September 1502 at the 15th hour" (L 66v; Richter 348). Next he visited Imola, about which he made quite a number of notes of a topographic nature

BIOGRAPHY

3. *Fortress of*
Cesena

(L 88v; W 12284). His map of Imola is inscribed in a circle with orienting radii. He abandoned the traditional manner of depicting the buildings of a city in perspective and painted the map in water colors: the environs of the city are light green, the city moat and river are blue, the sections of the city adjacent to the river are yellow ocher, and dark groups of houses within the city are red. The distances between neighboring fortresses and Imola are indicated in the notes to the map. Perhaps the map was made somewhat later, at the beginning of October, when the revolt of the *condottieri* forced Borgia to sit out a siege of several weeks.[47]

An observation, written later from memory, pertains to this period of service with Borgia: "The shepherds in the Romagna at the foot of the Apennines make peculiar large cavities in the mountains in the form of a horn, and on one side they fasten a horn. This little horn becomes one with the said cavity and thus they produce a very loud sound by blowing into it" (K 2r; Richter 347).

Borgia set out against Pisa and Florence from Piombino. Leonardo recalls this city in his later notes (1504–1506), in which he tells how to depict a flood and supplements his instructions to painters with observations on the motion of sea waves: "The waves of the sea that beats against the shelving base of the mountains which confine it, rush foaming in speed up to the ridge of these same hills, and in turning back meet the onset of the succeeding wave, and after loud roaring return in a mighty flood to the sea whence they came." After this brief note he specifies the point of observation: "Waves of the sea at Piombino, all of foaming water" (W 12665; MacCurdy 919). Further: "Of water that leaps up—of the winds of Piombino. Eddies of winds

LEONARDO DA VINCI

*4. Bell of Siena and
staircase at Urbino*

and of rain with branches and trees mingled with the air. The empty-
ing of rain water from the boats" (W 12665; Richter 343). This was all,
but it was quite sufficient for Leonardo whose memory retained a deep
impression of this spectacular image in all its details. The small sketch
of waves in Manuscript L (6v; MacCurdy 366) bears the inscription:
"Made by the sea in Piombino."

At Siena Leonardo drew a bell, accompanied by the remark: "Bell
of Siena, the manner of its movement and the position of the attach-
ment of its clapper" (L 33v; Richter 344). Orvieto was the southernmost
point of Leonardo's journey (L 10v).

Leonardo's service as a military engineer with Cesare Borgia was but
a brief episode. Pope Alexander VI died on August 18, 1503, and
events moved very swiftly after his death. The star of Cesare Borgia
faded rapidly, but Leonardo had returned to Florence on March
5, 1503, before these events took place.

Quite recently a paper was found in Constantinople with the Turkish
translation of a letter by Leonardo to the Sultan, Bajazet II, apparently
written about 1502 or 1503.[48] The letter is preserved in the Topkapi
Sarayi Archive (inventory number: E, 6184). In this letter, Leonardo
proposes several of his inventions and projects, including the plan for
a bridge to join Galata with Constantinople. Galata is a suburb of

BIOGRAPHY

Constantinople on the opposite bank of the Golden Horn. In those days many Genoese lived in Galata. The first bridge across the strait was not built until 1836. The Florentines were on friendly terms with the Turks in Leonardo's time. In his letter to the Sultan Leonardo wrote: "I have heard that you intend to build a bridge from Galata to Constantinople but that you have not built it for want of a skilled master [architect]." Leonardo proposed building a bridge beneath which sailing ships could pass.

In Leonardo's notebook of this period, we find the following entry accompanied by a sketch: "Bridge of Pera at Constantinople. Width forty braccia, height above the water seventy braccia, length six hundred braccia, that is, four hundred above the sea and two hundred resting on land, thus forming abutments to itself" (L 66r; MacCurdy 368). In essence, Leonardo's plan was to build a bridge in the form of a very gentle arch rigidly supported at the ends by "swallow's nests," a technique which Leonardo had conceived somewhat earlier, as Heydenreich noted, in connection with his plan for the dome of the Milan cathedral. The Florentine braccio was about 23 inches; thus the bridge would have been 76.26 feet wide, 134.11 feet high, and 1150 feet long, of which 766.7 feet would have been above water. These dimensions are clearly fantastic. The largest bridge of this type over the Adda, constructed in 1370–77, had a span of about 235 feet and was about 68 feet high. The gigantic bridge over the Bosporus may be compared with Leonardo's plan of the Sforza monument (see figure 5).

When Leonardo returned to Florence in 1503 the Florentines were at war with recalcitrant Pisa, which is downstream from Florence and controls the outlet of the Arno to the sea. In the autumn of 1503 Leonardo drew plans for diverting the Arno from Pisa. The Florentines began the work, trying to deprive the besieged city of water. The project was carried on for two months and abandoned. Many had foreseen failure.[49] Several years later, in one of his notes, Leonardo denounced the method of "stopping at nothing," employed in the attempt to divert the Arno: "a river which has to be diverted from one place to another ought to be coaxed and not coerced with violence" (Leic 13r; MacCurdy 782).

Leonardo's idea was completely different: not to divert the water from Pisa, but to regulate the flow of the Arno over its entire course. In Milan, on the plain of Lombardy in the Po basin, the canal

LEONARDO DA VINCI

*5. Sketch of the bridge
across the Bosporus*

builder's task was, primarily, to expand the network of trade routes, but in Tuscany, in the Arno basin, the main problem was to regulate the river, to combat flooding and shoaling at various times of the year.

Leonardo's interesting plan for a large canal to connect Florence with coastal Pisa is preserved in the Codex Atlanticus (CA 46r b; MacCurdy 775). Above it is written: "The canal of Florence," and below are the geographic points (reading right to left): Florence, Prato, Pistoia, Serravalle, Lago [di Sesto], Lucca, Pisa. Leonardo adds: "and let this canal be twenty braccia wide at the bottom and thirty at the surface and the general level two braccia or four, because two of these braccia serve the mills and the meadows. This will fertilize the country, and Prato, Pistoia, and Pisa, together with Florence, will have a yearly revenue of more than two hundred thousand ducats, and they will supply labor and money for this useful work, and the Lucchesi likewise. Since the Lago di Sesto will be navigable, make it pass by way of Prato and Pistoia and cut through at Serravalle and go out into the lake, for then there will be no need of locks or supports, which are not permanent but require a constant supply of labor to work them and to maintain them." He then gives an account of the cost of the variants of the plan. This shows that his hydraulic engineering plans were not empty projects, but were thought out to the end, to

BIOGRAPHY

the details, with knowledge in keeping with practice. His detailed calculation of the labor involved in excavation is of the same nature (CA 210v b; MacCurdy 775).

The Codex Atlanticus also contains a sheet (46v a) with a description of the reinforcement of the banks (top of the page); in the middle of the page is the plan of a bridge; and below, the plan of a single-chamber sluice (*conca*) and canal, with an inscription reading from right to left: "Sluice. Upper line of the bank. Bottom of the canal." Somewhat lower, to the right, is: "Canal. Florence." Here, too, besides the technical notes, there are precise economic calculations: "And know that this canal cannot be dug for less than four denari per braccio, paying each laborer at the rate of four soldi per day. And the time of construction of the canal should be between the middle of March and the middle of June, because the peasants are not then occupied with their ordinary work, and the days are long, and the heat does not prove exhausting" (CA 46v a; MacCurdy 775). The words on another page of the Codex Atlanticus are highly instructive: "By guiding the Arno upstream and down, anyone who wishes will find a treasure in each acre of ground" (CA 289r e). Leonardo's remarks on the means of supplying stone show his thoughtful, professional engineering approach to problems of efficient organization of work. One of his notes reads: "means of performing the work rapidly" (B 51v; see figure 6).

In Florence, Leonardo renewed his studies of anatomy, which had been cut short during the last years of his sojourn in Milan. Now he embarked on a new stage of study. From the broad programs and first attempts at specific study, he turned to profound study of the internal organs (the heart and the lungs), the skeleton, and the muscles, always devoting special attention to their functions, attempting to discover the fundamental physiological laws of movement. He conducted his work at the hospital of Santa Maria Nuova. In one of his notes Leonardo mentions his observations of a hundred-year-old man in that hospital, who "while sitting upon a bed in the hospital of Santa Maria Nuova at Florence, without any movement or sign of anything amiss, passed away from this life. And I made an autopsy to ascertain the cause of so peaceful a death" (W An B 10v; MacCurdy 116).

Leonardo worked long on a painting for the Grand Council Hall (Sala del Gran Consiglio) in the Palazzo Vecchio, which housed

LEONARDO DA VINCI

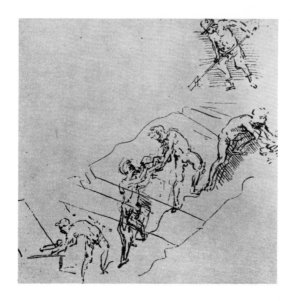

6. *Method for rapid work*

the government of the Florentine Republic. He was commissioned to depict the battle of Anghiari, which had taken place in June 1440 and ended in a victory for the Florentines over the Milanese. Leonardo's notes on how to depict a battle apparently pertain to this painting: how to portray artillery smoke, mixed with dust-laden air; how to make the figures of combatants, the bodies of horses; how to illuminate such figures; and so forth. These notes were later assembled in the Treatise on Painting.

Leonardo began work on the cartoon in the Papal Hall (Sala del Papa) of the church of Santa Maria Novella on October 24, 1503. Anonimo Fiorentino informs us that the cartoon depicted the battle of Anghiari at the moment the Florentines attacked Niccolò Piccinino, a captain in the service of Filippo, Duke of Milan.[50]

The work on the Papal Hall fresco itself was begun in 1505. However, as Vasari relates: "And conceiving the wish to color on the wall in oils, he made a composition of so gross an admixture, to act as a binder on the wall, that, going on to paint in the said hall, it began to peel off in such a manner that in a short time he abandoned it, seeing it spoiling."[51] Paolo Giovio spoke of the "defective plaster which persistently rejected the colors ground in walnut oil."[52] According to Anonimo Fiorentino, Leonardo drew the recipe from Pliny, but

BIOGRAPHY

"understood it poorly." This is hardly likely; it is much more probable that the great artist was experimenting independently. Anonimo Fiorentino also wrote: "Before making the cartoon on the wall, Leonardo fanned up a great fire in the coals, whose heat was supposed to draw moisture out of the aforesaid material and dry it. Then he set about the painting in the hall, and below, where the fire reached, the wall was dry, but higher up, where the heat did not reach because of the distance, the wall was damp."[53]

Leonardo's experiment ended unsuccessfully. Even the treatment of the subject he chose could not have satisfied those who commissioned him. As we know, the victor in this event was Michelangelo, who prepared an episode from the war between Florence and Pisa (1364) on another wall of the same hall. The glorification of the subject by Michelangelo was more flattering to the narrow local patriotism of the Florentines. But war between Florence and Pisa was the very thing that had blocked Leonardo's major hydraulic engineering projects; could he really have derived inspiration from episodes in the struggles between Florence and Milan or Florence and Pisa?

Cellini was in error in asserting in his autobiography that both painters were to have depicted the capture of Pisa by the Florentines, choosing merely different instances in the same historic event: "The admirable Leonardo da Vinci" depicted a "battle of horses with the capture of some standards"; Michelangelo depicted a "number of foot-soldiers who, the season being summer, had gone to bathe in the Arno. He drew them at the very moment the alarm was sounded and the men, all naked, ran to arms." These two cartoons, concluded Cellini, "stood one in the palace of the Medici, and the other in the hall of Popes. So long as they remained intact, they were the school of the world."[54]

Ser Piero da Vinci, Leonardo's father, died in 1504. The Codex Atlanticus contains the following brief note: "On Wednesday, at seven o'clock, died Ser Piero da Vinci, on the ninth day of July 1504" (CA 71v b; MacCurdy 1159). In another manuscript Leonardo recorded the event in somewhat more detail: "On the ninth day of July 1504 on Wednesday at seven o'clock at the Palace of the Podestà died Ser Piero da Vinci, notary, my father. He was eighty years old, and left ten sons and two daughters" (BM 272r; Richter 355). Only the repetition of "at seven o'clock" hints at some kind of suppressed emotion on the part of the writer. There is no confirmation of the note that Ser

LEONARDO DA VINCI

Piero died at the age of eighty. It has been assumed that he was born in 1426. He did not have children by either his first wife, Albiera di Giovanni Amadori, whom he married in 1452, or by his second wife, Francesca Manfredini, whom he married in 1465. His third wife, Margherita di Francesco di Jacopo di Guglielmo, bore him six children. In 1485 Piero married a fourth time. This wife, Lucrezia di Guglielmo Cortigiani, bore him five sons and a daughter.[55]

Leonardo continued to be interested in aviation after his return to Florence. The Codex on the Flight of Birds (Sul volo degli uccelli) contains an indication that Leonardo had planned to make his first flight from Monte Ceceri (Swan Mountain) near Fiesole. On the inside cover of the manuscript, Leonardo wrote: "From the mountain which takes its name from the great bird, the famous bird will take its flight, which will fill the world with its great renown" (VU 18v; MacCurdy 420).

However, during these years (1503–1505), without abandoning his cherished thought of flight, Leonardo entered in his notebooks only sketches and drawings pertaining to serious but limited problems of design and the theory of flight. At this time he was especially interested in problems of the use of wind force and of soaring without wing movements.

These were the years in which he began to make entries in his Manuscript K, which he continued at different times between 1504 and 1512. These notes are devoted almost exclusively to the flight of birds and make little mention of flying machines. Most of his notes on the flight of birds are included in still another, later manuscript, Manuscript E, 1513–1514. We do not know the extent to which Leonardo realized his projected flying machines, but certainly he became ever more aware of the difficulty and complexity of the problem. He came to realize the need for new observations, new experiments, and new methods.

Now let us pass to the second Milan period of Leonardo's life, from 1506 to the autumn of 1513. Milan was in the hands of the French, and Leonardo came at the invitation of the French governor of Milan, Charles d'Amboise. During his stay Leonardo visited Florence several times, especially on matters of his inheritance, but his principal residence was Milan. He lived there as a celebrated painter. About 1507 he completed *Leda,* and in 1508–12 he worked on *Saint Anne* and *John the Baptist.*

BIOGRAPHY

Leonardo's letter describing a court garden with chirping birds and transparent brooks may be compared with his famous letter to Il Moro on his projects and talents. It is presumed that this garden was for Charles d'Amboise and that the letter was written in 1506. "By means of a mill, I shall be able at any time to produce a current of air; in the summer, I shall make the water spring up fresh and bubbling . . . and other water should flow through the garden, moistening the orange and citron trees." Leonardo places special emphasis on the pleasant translucency of the water: "The herbage of the little brooks ought to be cut frequently so that the clearness of the water may be seen upon its shingly bed, and only those plants should be left which serve the fishes for food, such as watercress and other plants like these. The fish should be such as will not make the water muddy, that is to say, eels should not be put there nor tench, nor pike, because they destroy the other fish." Subsequently he states: "By means of the mill you will make many water conduits through the house, and springs in various places, and a certain passage where, when anyone passes, water will leap up from all sides, and so it will be there ready in case anyone should wish to give a shower bath from below to the women and others who shall pass there." Finally, this imaginary garden was to re-sound with the pleasantness of sounds: "Overhead we must construct a very fine net of copper which will cover the garden and shut in be-neath it many different kinds of birds, and so you will have perpetual music together with the scents of the blossom of the citrons and the lemons." And, as if the natural music were not enough, artificial music was to be added: "With the help of the mill, I will make unending sounds from all sorts of instruments, which will sound for so long as the mill shall continue to move" (CA 271v a; MacCurdy 1037).

Leonardo continued to be interested in hydraulic engineering. Among his notes one finds, for example, the following one with an accompanying sketch: "Canal of San Cristofano [Cristoforo] at Milan, made on the third day of May 1509" (CA 395r a; Richter 370). He designed a canal to join Lago di Lecco with Milan through cliffs that were difficult to navigate (CA 141v b). Along with the large navigable canals, he wrote of the need for constructing irrigation ditches:

Of the canal of Martesana. By the making of the Martesana canal, the amount of water in the Adda is lessened owing to it being distrib-

uted over many districts in order to supply the meadows. A remedy for this would be to make many small channels, because the water which has been drunk up by the earth does no service to anyone, nor any injury, because it has been taken from no one; and by the construction of such channels, the water which before was lost returns again and is once more of service and use to mankind. And unless such channels have first been constructed, it is not possible to make these runlets in the lower-lying country. We should say, therefore, that if such channels are made in the Martesana, the same water, drunk in by the soil of the meadows, will be sent back upon the other meadows by means of runlets, this being water which had previously disappeared; and if there were a scarcity of water at Chiara d'Adda and in the Mucca and the inhabitants were able to make these channels, it would be seen that the same water drunk in by the meadows serves several times for this purpose (F 76v; MacCurdy 778).

Leonardo continued his anatomical studies in Milan. Those of 1510–1512 are particularly interesting. At that time he systematized the facts he had gathered in Florence, turning his attention more and more to problems of general biology, and to the mechanism and functions of the organs. He devoted constant attention to the functions and structure of the heart, and to the respiratory and digestive organs.

Marcantonio della Torre (1481–1511) moved from Padua to Pavia in 1506. Vasari wrote of this scientist: "He was one of the first (as I have heard tell) that began to illustrate the problems of medicine with the doctrine of Galen, and to throw true light on anatomy."[56] Researchers have proved[57] that Leonardo met Della Torre in Pavia only shortly before the latter's death. He had died prematurely while ministering to the victims of the bubonic plague. Therefore, there is no basis for Vasari's statement that the Pavian anatomist "found marvelous aid in the brain, work, and hand of Leonardo, who made a book drawn in red chalk, and annotated with the pen, of the bodies that he dissected with his own hand, and drew with the greatest diligence, wherein he showed all the frame of the bones; and then added to them, in order, all the nerves, and covered them with muscles; the first attached to the bone, the second that hold the body firm, and the third that move it."[58] Leonardo had made extensive anatomical studies for twenty years or more before meeting Della Torre and could not have been a simple illustrator for a scientist who died at the age of thirty and left no finished work.

BIOGRAPHY

Leonardo entertained the hope of summarizing his anatomical studies and wrote: "and this winter of the year 1510, I look to finish all this anatomy" (W An A 17r; MacCurdy 106). However, he actually worked on anatomy in the following years as well.

On December 23, 1512, Maximilian Sforza, son of Lodovico il Moro, seized Milan with the aid of 20,000 Swiss and drove out the French. According to a contemporary, there ensued a time of "disturbances, vengeance, and universal ruin." Leonardo left Milan and took his students with him to Rome. A note in his hand states: "I left Milan for Rome on the 24th day of September 1513 with Gianfrancesco de' Melzi, Salai, Lorenzo, and Fanfoia" (E 1r).

In Rome in May of that year Giovanni de' Medici, son of Lorenzo, had been elected Pope, assuming the name Leo X. He is supposed to have said: "We shall take delight in the office of Pope, if God should give it us." He surrounded himself with artists and poets; Raphael and Michelangelo worked for him. But the Pope mistrusted Leonardo. When Leonardo received a small commission from the Pope, according to Vasari, "straightway he began to distil oils and herbs, in order to make the varnish." At this, Pope Leo said: "Alas! this man will never do anything, for he begins by thinking of the end of the work, before the beginning."[59]

Leonardo's immediate protector in Rome was the duke Giuliano de' Medici, brother of the Pope. A page of the Codex Atlanticus filled with geometric constructions has the following remark: "Finished on the seventh day of July at the twenty-third hour at the Belvedere in the studio given me by il Magnifico" (CA 90v a; Richter 376). But life was not easy for Leonardo in Rome. His anatomical activities exposed him to slanderous denunciations addressed to the Pope and to the director of the hospital which provided Leonardo with bodies for dissection. Eventually the director refused him cadavers and forbade dissection.

From a rough draft of a letter to Giuliano de' Medici, it is evident that some German master mirror maker named Giovanni (Johann) did him harm in this respect, causing the great artist and scientist much unpleasantness: "This other has hindered me in anatomy, belittling me before the Pope and also at the hospital, and he has filled the whole of this Belvedere with workshops for mirrors, and workmen" (CA 182v c; MacCurdy 1137).

Leonardo was especially indignant that Johann had lured to his side

another German master, Georg, who was working with Leonardo and tried to worm from him trade secrets concerning the art of polishing mirrors. Leonardo kept his techniques in this field especially well guarded. Besides his usual mirror writing, he used the names of planets to refer to metals (Venus for copper, Jupiter for tin, Saturn for lead, Neptune for bronze), following the traditions of alchemy. What is more, he wrote these and some other names in the ordinary manner so that they read backwards when held to a mirror; examples Anglicized would be *Sunev* for Venus, *Ssalg* for glass, *Xarob* for borax, and *Yreme* for emery. Further, he used figures of speech ("throw into the mother's lap" meant "to smelt in a mold") and neologisms (*invulghanare*, to vulcanize, from the mythical Vulcan, that is, to heat on a fire; *s'innectun-nare*, to turn into bronze, from Nectunno, that is, Nettuno or Neptune) (G 75v; G 53r).

One can understand Leonardo's resentment toward Georg, for whom "I have left nothing undone which I thought might give him pleasure . . . I invited him to have meals with me, so that he could save money and moreover acquire Italian." However, Georg "wanted to have models finished in wood, just as they were to be in iron, and wished to take them to his own country." "He made himself another workshop, and pincers and tools in his room, where he slept, and there he worked for others . . . At last I found that the mirror maker Giovanni was to blame for everything." This "young German, who makes the mirrors, was always in the workshop and wanted to see and to know all that was being done there and he then spread the news abroad, condemning what he didn't understand." From Leonardo's letter to Giovanni de' Medici, it appears that Johann considered himself aggrieved: "my coming here has deprived him of the countenance and favor of Your Lordship." What is more, Johann wished to take possession of the ironworker's rooms, which "suited him more for working at mirrors." Johann bought all Georg's equipment and began to manufacture, "employing a number of workmen, making numerous mirrors to sell at the fairs" (CA 247v b; MacCurdy 1142, 1143). All these senile complaints create a truly sad impression of desertion and neglect.

It is just as sad to find that in the Belvedere, where Leonardo's workroom and the mirror workshops were located, Leonardo amused himself with fantastic diversions: "On the back of a most bizarre lizard, found by the vine-dresser of the Belvedere, he fixed, with a mixture of quicksilver, wings composed of scales stripped from other

BIOGRAPHY

lizards, which, as it walked, quivered with the motion; and having given it eyes, horns, and beard, taming it, and keeping it in a box, he made all his friends, to whom he showed it, fly for fear."[60] One is inclined to compare this story of Vasari's to another of his about how the young Leonardo worked on a shield that was to inspire fear in all, something like the head of the Medusa:

> For this purpose, then, Leonardo carried to a room of his own into which no one entered save himself alone, lizards great and small, crickets, serpents, butterflies, grasshoppers, bats, and other strange kinds of suchlike animals, out of the numbers of which, variously put together, he formed a great ugly creature, most horrible and terrifying, which emitted a poisonous breath and turned the air to flame; and he made it come out of a dark and jagged rock, belching forth venom from its open throat, fire from its eyes, and smoke from its nostrils, in so strange a fashion that it appeared altogether a monstrous and horrible thing; and so long did he labor over making it that the stench of the dead animals in that room was past bearing, but Leonardo did not notice it, so great was the love that he bore toward art.[61]

While in Rome, Leonardo continued to think about the flight of birds, but his absorption with the creation of flying machines, which marked his first Milan period, was a thing of the past. The flying figurines of which Vasari spoke give a grotesque impression compared with the sketches of the enormous wings "of an artificial bird" which one finds in Manuscript B (88v): "Forming a paste of a certain kind of wax, as he walked he shaped animals very thin and full of wind,* and, by blowing into them, made them fly through the air, but when the wind ceased, they fell to the ground."[62] Nevertheless, through all the adversities and disillusion, Leonardo remained Leonardo. In 1514–16 he worked on a plan for draining the Pontine marshes, later taken up by Giovanni Scotti da Como, who probably was personally acquainted with Leonardo.[63]

Leonardo's masterpiece, *La Gioconda* or *Monna Lisa,* belongs to the period 1514–16. Until quite recently it was believed that this portrait was painted much earlier, in Florence, around 1503. Vasari's story was believed. He wrote: "Leonardo undertook to execute, for Francesco

* Giacomelli is quite right ("Leonardo da Vinci aerodinamico, aerologo, aerotecnico ed osservatore del volo degli uccelli," p. 364) in pointing out that the attempt to interpret *vento* as heated air in this case is unfounded.

del Giocondo, the portrait of Monna Lisa, his wife; and after toiling over it for four years, he left it unfinished; and the work is now in the collection of King Francis of France, at Fontainebleau . . . He made use, also, of this device: Monna Lisa being very beautiful, he always employed, while he was painting her portrait, persons to play or sing, and jesters, who might make her remain merry, in order to take away that melancholy which painters are often wont to give to the portraits they paint."[64]

This story is untrue from beginning to end. Venturi holds that "Monna Lisa, later Gioconda, was a creature of the fancy of a short story writer, the Aretine biographer, Giorgio Vasari."[65] In 1925 Venturi proposed that *La Gioconda* was the portrait of the duchess Constanza d'Avalos, widow of Federico del Balzo, celebrated in a short poem by Enea Irpino, who also referred to the portrait painted by Leonardo.[66] Constanza was a mistress of Giuliano de' Medici, who returned the portrait to Leonardo after marrying Filiberta of Savoy.

Quite recently Pedretti proposed a new hypothesis, namely, that the Louvre portrait depicts Pacifica, widow of Giovanni Antonio Brandano, who was also a mistress of Giuliano de' Medici and bore him a son, Ippolito, in 1511.[67]

However this may be, the Vasari version is doubtful because, among other things, it does not explain why the portrait of the wife of Francesco del Giocondo remained in Leonardo's possession and was taken by him to France.

Giuliano de' Medici left Rome early in 1515. Leonardo noted: "Il Magnifico, Giuliano de' Medici, set out on the ninth day of January 1515 at daybreak from Rome, to go and marry a wife in Savoy. And on that day came the news of the death of [Louis XII] the king of France" (G cover v; MacCurdy 1162). In September of that year, after the battle of Marignano, the French armies again occupied Milan. Leonardo was sixty-three years old, alone again, and without support. Giuliano de' Medici died on March 17, 1516. This laconic note, a sad summary, was written by Leonardo during the Roman period: "The Medici made me and ruined me" (CA 159r c; Richter 382).

The Turin self-portrait of Leonardo belongs to the last years of his life and, apparently, Lomazzo's description of Leonardo is taken from this portrait: "He had long hair, and eyebrows and beard so long that he appeared one of learning's true nobility, as was in former times the Druid Hermes or the ancient Prometheus."[68]

BIOGRAPHY

In 1516 Leonardo left Italy and settled in France at the invitation of the French king, Francis I.[69] He was received as an illustrious artist, as the "divine" Leonardo. The artistic culture of the Italian Renaissance impressed the French of that time. Leonardo became the arbiter of fashions at the court of Francis I. Again, as in Italy, he planned extravagant festivals. As an architect he designed a new court for the king. According to Benvenuto Cellini, Francis I once commented that no other man had been born into the world who knew as much as Leonardo—not so much speaking of sculpture, painting, and architecture, as saying that he was a very great philosopher.[70] After Leonardo's death Francis intended to publish a large atlas of anatomy, evidently under the influence of conversations with Leonardo on the meaning of anatomy. The death of the scientist Andrea del Sarto, Rosso Fiorentino, in 1541 kept the work from being finished. Only the title sheet with the anatomical figures was printed.[71]

Leonardo lived in Cloux (Clos-Lucé) at the southern edge of the small city of Amboise, on the banks of the Loire, near the royal residence. On October 10, 1517, Antonio de' Beatis, secretary of the Cardinal of Aragon, visited there. He left an interesting description of what he saw, telling of three excellent pictures by Leonardo: "One of a certain Florentine lady, posed at the instance of Giuliano de' Medici, the Magnificent, another of Saint John the Baptist as a youth, and one of a madonna and child on the lap of Saint Anne; all most perfect, though one can no longer expect good work from him because of a certain paralysis in his right arm."[72]

Leonardo's grand plan for connecting the Loire and the Saône belongs to the last years of his life. The canal was to begin near Tours or Blois, pass through Romorantin (with a loading dock at Villefranche), cross the Allier beyond Bourges, pass through Doullens to Digoin and to the other bank of the Loire, bypassing Mount Charolette, and join the Saône near Mâcon. This canal would have insured direct communication across the Saône between Touraine and the Lyonnais, the center of trade between France and Italy and, thus, would have brought Italy to the heart of France. Evidently Leonardo studied the Romorantin region with special attention. The following is noted on one of the sheets of the plan: "The eve of St. Anthony I returned from Romorantin to Amboise and the king left Romorantin two days before" (CA 336v b; Richter 387). Leonardo planned to raise the river level to a height such that many mills could be activated

along the stream gradient. The inhabitants would have to expend their efforts to divert the Villefranche river to Romorantin. Prefabricated wooden houses would be transported there on barges. If the Villefranche were diverted, wrote Leonardo, "it would render the country fertile, capable of supplying food for all the inhabitants, and would serve as a navigable canal profitable for commerce" (BM 270v; Richter 387).

On April 23, 1518, Leonardo, "considering the certainty of death and the uncertainty of its hour" signed a will, by which he left all his manuscripts and books to his disciple Francesco de' Melzi.[73] Nonetheless, Leonardo continued to work after that date. A page with geometric determinations and calculations in the Codex Atlanticus is dated: "On the 24th of June 1518, the day of St. John, at Amboise in the palace of Cloux" (CA 249r b; Richter 387). Leonardo died on May 2, 1519.

One must mention the notes that characterize Leonardo's indefatigable creative energy: "May I be deprived of movement, ere I weary of being useful"; "Better death than weariness"; "No labor is capable of tiring me." Perhaps in trying ever newer turns of speech to express the same thought Leonardo was attempting to find merely the most fitting slogan for a carnival and may have intended to attribute such words to Lorenzo de' Medici or Lodovico il Moro. Essentially, however, Leonardo was characterizing himself. Here are the lines in all their original frankness (W 12700; MacCurdy 92):

May I be deprived of movement ere I weary of being useful.

Movement will fail sooner than usefulness.

Death rather than weariness.

I never weary of being useful.

I do not tire of serving others.

Slogan for the carnival: *Sine lassitudine,* Without fatigue!

No labor is capable of tiring me.

Hands into which ducats and precious stones fall like snow, these never tire of serving, but such service is only for its usefulness and not for our own advantage.

I never weary of being useful.

Naturally nature has so fashioned me.

2.

WRITINGS

"They will say that because of my lack of book learning,
I cannot properly express what I desire to treat of. Do
they not know that my subjects require for their exposition
experience rather than the words of others? And since
experience has been the mistress of whoever has written
well, I take her as my mistress, and to her in all points
make my appeal."
 CA 119v a; MacCurdy 58

UOMO SANZA LETTERE, "a man without letters," "not well read." This
is the description of himself that Leonardo placed in the mouths of the
learned humanists of his time, those who admired pure Latin and who
bowed before the old authorities. He addressed these proud, provoca-
tive words to the erudite humanist philosophers: "Though I can not
like others cite authors, I shall cite something much greater and more
worthy: experience, the mistress of their masters. They go about
capacious and pompous, decked out not in their own performances
but in the accomplishments of others; and they will not credit me with
my own. If they disdain me as an inventor, how much more blame
might be cast on the trumpeters and expositors of the works of
others" (CA 117v b; Baskin 20)?

Duhem, in his *Etudes sur Léonard de Vinci*, which has the instructive
subtitle "Ceux qu'il a lu et ceux qui l'ont lu" (Those whom he read
and those who read him) creates the impression, intentional or not,
that Leonardo was some sort of "bookworm" who was guided by the
reading of books and not by action. Recently the opposite tendency
has emerged, that is, to claim that Leonardo read little and actually
was an *uomo sanza lettere*.[1]

This latter opinion is fully justified insofar as the scholastic philoso-
phers are concerned, those Duhem placed first on his list, Albert of
Saxony and Themon the Jew. At the Jubilee Colloquium held in Paris
in 1952, R. Dugas justly criticized Duhem for turning Leonardo into a
kind of "library rat who fed on scholasticism." Dugas noted that "at-

LEONARDO DA VINCI

tempts to find traces of the scholastic tradition in Leonardo, or *vice versa,* to find any reflections of Leonardo's thought in the later Italian school, have yielded comparatively few results."[2] At that same colloquium Koyré stated that Duhem had created "an improbable picture of Leonardo the erudite, or at least Duhem's equal in erudition." According to Koyré, Leonardo would not have had to study the actual texts of Albert of Saxony, Bradwardine, Nicholas of Cusa, Buridan, Suisett, and Nicholas of Oresme, for the traditions of these scholars "were in the air, everywhere, in university lectures and in popular books in the Italian language."[3]

The tendency to contrast oral tradition with literary sources, specifically to confute Duhem, is clearly expressed in the address of another participant in the colloquium, Giorgio Santillana, as indicated by the very title of his address, "Leonardo and those he did not read." What did he actually read of the past?" asks Santillana.

> Primarily poets, that is evident. He was well grounded in Dante, the poet of his native city. Pulci's poem *Morgante maggiore* exerted a great influence on him. He was well acquainted with that strange *pot pourri* of Cecco d'Ascoli, *L'Acerba.* For things in general he studied the *Petit Larousse* and the "popular sciences" of his time: Ristoro d'Arezzo, the Quadriregio, and Valturio. He was more than forty years old before he began to study Latin, and then he devoured Ovid, that treasury of medieval fantasy. He had a feeling for the philosophy of the Stoics and through them penetrated the intuition of Heraclitus. He knew the works of Horace and studied Pliny and Vitruvius. But one need only look at the lists of words and simple grammatical exercises compiled by Leonardo at that time to see that for him Latin was a foreign tongue . . . His knowledge of Latin remained uncertain and rudimentary, he foundered in the syntax, and confused the subject and object in his exercises. He could never analyze a text without help.

Santillana shifts the main stress to oral tradition.

> He acted on what he heard. Books and his personal acquaintances were mines of information in which he sought the material he needed. Only thus did he use some of Archimedes' results or the abridged Hero, published by Giorgio Valla. He made notes on conversations and thoughts heard at random. For example, his famous statement "the sun does not move" is most likely an opinion he heard somewhere,

perhaps in conversations about Philoleus [Philo Judaeus], for it has
no bearing on his other thoughts [see the remarks on this below,
Chapter 4]. This is why Leonardo hated abridgment. He needed facts
and results, not outlines. He sought them everywhere in conversations
and thus, without realizing it, imbibed enormous doses of Aristotle,
which his mind retained . . . We can picture him leafing through *De
Ponderibus,* the Parisian Anonymous, Buridan, Albert of Saxony, and
even Themon, son of Judea; he conferred with friends, deciphered the
texts with difficulty, looked here and there, where instinct told him he
would find some results.[4]

Santillana exaggerates somewhat, as his colleagues pointed out to
him. "This does not mean that Leonardo could not have waded
through the Latin texts if need be; it was the literary texts which were
difficult for him, not the scientific, especially those on familiar sub-
jects such as geometry, perspective, and medicine. Even we 'bookish'
people can make out texts written in languages we have not studied."[5]
However, this is not the crux of the matter. It is not terribly important
whether Leonardo read or heard particular thoughts, whether he came
into contact with the thoughts of a particular author through the
"more noble" (to use Leonardo's terminology) sense of sight or the
"less noble" sense of hearing.

It can hardly be denied, for example, that his praise of optics or
"perspective" in the Codex Atlanticus is an Italian translation of the
Latin preface to John Peckham's *Perspectiva communis:* "Intra li studi
delle naturali considerazioni la luce diletta più i contemplanti" (Among
the various studies of natural processes, that of light gives most
pleasure to those who contemplate it) (CA 203r a; MacCurdy 989) is
the Italian of "Inter physicae considerationis studia lux jucundius
afficit meditantes."[6] Let us assume that Leonardo did not translate
this text, but that the translation was dictated to him by his friend
Fazio Cardano, who published Peckham's treatise. Is this important?
What is important is that this fifteenth century Italian scientist
learned of the work and thoughts of the thirteenth century English
scientist.

How are we to explain the continual references to various works in
Leonardo's notebooks? "Vitruvius . . . Philosophy of Aristotle . . .
Archimedes: On the Center of Gravity . . . Albertuccio and Marliano:
De Calculatione" (F cover IV; MacCurdy 1170). "See: Concerning

LEONARDO DA VINCI

Ships by Messer Battista Alberti, and Frontinus: Concerning Aqueducts" (Leic 13r; MacCurdy 1173). "Hero: On Water" (CA 96v a). Or, still more specifically, with an indication of the location of the book: "Messer Ottaviano Pallavicino for his Vitruvius" (F cover 1v; MacCurdy 1171) and "Messer Vincenzo Aliprando who lives near the inn of the Corso has Giacomo Andrea's Vitruvius" (K 109v; MacCurdy 1170).

Leonardo searched diligently through the works of Archimedes: "There is a complete Archimedes in the possession of the brother of the Monsignor of Santa Giusta in Rome. The latter is said to have given it to his brother who lives in Sardinia. It was formerly in the library of the duke of Urbino and was carried off from there in the time of the Duke Valentino" (CA 349v f; MacCurdy 1169). "Borges will get the Archimedes of the bishop of Padua for you, and Vitellozzo that of Borgo San Sepolcro" (L 2r; MacCurdy 1170). "Archimedes from the bishop of Padua" (L 94v; MacCurdy 1171).[7]

Leonardo showed a persistent interest in Witelo's [Vitolone's] *De Perspectiva* (On perspective), written in the 1270's. During his first Milan period he wrote, "take the book of Vitolone" (CA 247r a; MacCurdy 1123); and elsewhere, "In Vitolone there are eight hundred and five conclusions about perspective" (B 58r; MacCurdy 996). When Leonardo returned to Florence, he continued to show interest in this work: "Vitolone in San Marco" (BM 79v; MacCurdy 1171). Finally, on his return to Milan, he again mentioned Witelo (evidently in 1506–07, when he visited Pavia): "Try to see Vitolone, which is in the library at Pavia and treats of mathematics" (CA 225r b; MacCurdy 1168).

Can these notes be merely a sign of bibliographic zeal, a tendency to record a book without actually using it? Of course Leonardo read books, but for him books were just one of the sources of knowledge. Duhem, the science historian, made a twofold error: he exaggerated the value of books as a primary source of Leonardo's creative scientific work,* and he exaggerated to the extreme the importance of the scholastic philosophers whom Leonardo read, particularly Albert of Saxony. However, this does not settle the matter of the range of Leonardo's reading.

* I have already had occasion to point out that "for Duhem, history is a great reading room in which one scientist reads the works of another" (Zubov, "Kontseptsii Diuema," p. 99).

WRITINGS

Often we find the word "ask" in Leonardo's notebooks: "Ask Benedetto Portinari how the people go on the ice in Flanders" (CA 225r b; Richter 304). "Ask the wife of Biagino Crivelli how the capon rears and hatches the eggs of the hen when he is in the mating season" (W An III 12r; MacCurdy 172). Leonardo turned to books with such questions, in order to get primary evidence on a question that occupied him, and he turned to them when he had just developed or thought through a viewpoint of his own.

Leonardo's notes are not only the fruit of his independent observations as a scientist and artist, but reveal the diversity of his reading. Solmi's remarks are quite correct in this respect, although his studies of Leonardo's sources are dated in places, especially where he skips over the intermediaries and has Da Vinci reading a number of Arab and ancient authors whose books would scarcely have been read by the great Italian scientist.[8]

Now let us take a close look at Leonardo da Vinci's attitude toward the books he read, using as our example two works he definitely knew: Leon Battista Alberti's three books on painting and ten books on architecture.[9] We might say that as Leonardo read the books on painting, he entered into conversation with the author. His notes and remarks are comments addressed to a collocutor. On comparing Leonardo's texts with those of Alberti, we seem to be witnessing a dialogue, a metamorphosis and continual development of ideas, leading at times to a direct clash of opinions. This gives individual shadings to assertions which at first glance seem to be identical.

Here is a notable example. Alberti spoke rather cursorily of the reflections of the faces of persons walking through a meadow: "We see in the faces of people that are walking over grass that they always have a greenish hue."[10] Leonardo spoke of the same thing in a much more specific and accurate manner: "If the surface of the ground near to her be meadows, and the woman be placed between a meadow lit by the sun and the sun itself, you will find that all the parts of the folds [of her dress] which are turned toward the meadow will be dyed by the reflected rays to the color of the meadow" (BN 2038 20r; MacCurdy 867). And, he states further: "that part [of the woman] which is exposed to the luminous air, through the weaving and penetrating of the sun's rays, will tend toward blue, since the air is blue" (BN 2038 20r; McMahon 786).

LEONARDO DA VINCI

Let us take another example. Alberti stressed the difficulty of distinguishing between the features of someone laughing and someone crying: "Who that has not tried the experiment would imagine that it is a very hard matter, when you are trying to draw a face laughing, to avoid making it seem to weep? And, indeed, how is it possible, without great study and application, to represent a countenance, in which every feature, mouth, chin, eyes, cheeks, forehead, and eyebrows shall all unite jointly to represent either grief or joy"?[11] Leonardo was inspired by a similar thought. He sought differences and, as an experienced and able observer, found them: "Between one who laughs and one who weeps there is no difference in the eyes, or mouth, or cheeks, but only in the rigidity of the eyebrows, which are drawn together by him who weeps and are raised by him who laughs" (TP 384; McMahon 420).

Let us recall a remarkable and well-known passage where Leonardo speaks of spots on old walls in which the artist can discern the first features of his future product, like the sound of bells in which one can hear all the names and words that fill the imagination: "If you have to invent some scene, you can see there [in these various spots] resemblances to a number of landscapes adorned in various ways, with mountains, rivers, rocks, trees, great plains, wide valleys, and various groups of hills. Moreover you can see various battles and quick movements of figures, strange expressions of faces, and outlandish costumes, and an infinite number of things which you can then reduce to good, integrated forms. This happens thus on varicolored walls and stones, as in the sound of bells, in whose pealing you can find every name and word that you can imagine" (TP 66; McMahon 76). But let us not forget that for Leonardo this was merely the first stage of artistic creativeness: "Although those stains may give you inventions, they will not teach you how to finish any detail" (TP 60; McMahon 93).

Evidently this thought was especially dear to Leonardo, for he repeated it several times. "It is really true that various inventions are seen in such a stain. I say that a man should look into it and find heads of men, diverse animals, battles, rocks, seas, clouds, woods, and similar things, and note how like it is to the sound of bells, in which you can hear what you like" (TP 60; McMahon 93). "I have seen clouds and stains on walls which have given rise to beautiful inventions of different things" (TP 189; McMahon 261).

WRITINGS

These texts of Leonardo's have something in common with a passage in Alberti, in which he spoke of centaurs and figures of bearded kings that could, at times, be seen in cracks in marble. However, the difference between Alberti and Leonardo is enormous. For Leonardo the crux of the matter is the imagination of the artist who has invented or, to be more accurate, has found in himself that which he sought outside himself, while for Alberti the artist finds a ready picture created by nature: "We find that Nature herself is fond of exercizing her talent in this way, by those stones which she stamps with the figures of Centaurs and bearded Kings."[12]

This difference appears in other passages that, at first glance, seem to be completely identical. Alberti says of painting, "It sets before our eyes those that have been dead whole ages" and, thanks to painting, "persons of the deceased have a sort of additional life bestowed upon them by this art."[13] Here is a parallel text in Leonardo: "How many paintings have preserved the likeness of a divine beauty of which nature's example has been destroyed by time or death and the work of the painter has thus become of greater value than that of nature, his teacher" (TP 30; McMahon 43). For Alberti the dead person continues to live thanks to painting, while for Leonardo the work of the artist outlives the subject of the painting.

Most of the fragments which indicate that Leonardo studied Alberti's treatise intensively appear in BN 2038 17v to 24v. Of course, it is difficult to establish accurate dates for the various passages of Da Vinci's Treatise on Painting, but it seems quite probable that they were written in 1488–89. Characteristically, the order of Leonardo's notes does not strictly follow the order of Alberti's text. Evidently Leonardo entered his own reflections on what he read after and not as he was reading Alberti's treatise.

Let us turn to Alberti's other work that Leonardo read, namely, his ten books on architecture, first published in 1485. Here, as in the books on painting, Leonardo used Alberti's text only as a starting point for his own thoughts. Alberti's remarks gave Leonardo cause not only for stating his own views, but for embodying them in drawings. One may say that the first illustrations for the ten books on architecture were made by Leonardo. We know that the Latin editions (1485, 1512, 1541) had no illustrations and that illustrations appeared in the Italian translation made by Cosimo Bartoli in 1550.

LEONARDO DA VINCI

7. *House with a single entrance*

Alberti wrote: "The house should not have more than one entrance, so that no one may enter nor anything be carried out of the house without the knowledge of the porter."[14] This laconic remark evoked the following thoughts in Leonardo: "If you have your servants in your house, make their habitations in such a way that at night neither they nor the strangers to whom you give lodgings are in control of the egress of the house; in order that they may not be able to enter the habitation where you live or sleep, close the exit m, and you will have closed the whole house" (B 12v; MacCurdy 1040). The text is accompanied by a drawing illustrating the initial concept (figure 7).

Similarly, in speaking of the streets of Jerusalem, Alberti wrote: "Aristaes tells us that in Jerusalem there were some very beautiful streets, though narrow, through which the magistrates and nobles only were allowed to pass, to the intent chiefly that the sacred things which they carried might not be polluted by the touch of anything profane."[15] Was this not the text that inspired Leonardo's celebrated plan of streets built at different levels? According to Leonardo, such streets would facilitate social differentiation, exactly as the streets of Jerusalem, "through which the magistrates and nobles only were allowed to pass." I shall not quote Leonardo's complete text, but merely stress the following lines: "The high-level roads are not to be used by wagons or vehicles such as these, but are solely for the convenience of the gentle-folk. All carts and loads for the service and convenience of the common people should be confined to the low-level roads" (B 16r; MacCurdy 1041).

WRITINGS

8. Multilevel
street plan

It is remarkable that Alberti's hazy information becomes a very precise and specific description in Leonardo's text. Leonardo immediately introduced *in medias res,* indicating precise dimensions and values: "The roads m are six braccia higher than the roads p s, and each road ought to be twenty braccia wide and have a fall of half a braccio from the edges to the center. And in this center at every braccio there should be an opening one braccio long and the width of a finger, through which rain water may drain off into holes made at the levels of the roads p s" (B 16r; MacCurdy 1041).[16] (See figure 8.)

I shall limit myself to this one example. The reader will find others. From what has been said, it is clear that in studying the scope of Leonardo's reading, we inevitably enter his own creative world.

It is very difficult to read Leonardo da Vinci's manuscripts. They were written backwards, from right to left, and can be made out only in a mirror. For even greater secrecy, sometimes he wrote individual words from left to right, and these, of course, could not be read in a mirror. It is curious that Leonardo's notebooks contain a large sheet of rebuses.[17] Libri wrote thus of Leonardo da Vinci's manuscripts in a letter dated 1830: "There is everything here: physics, mathematics, astronomy, history, philosophy, short stories, mechanics. It is a wonder, but it is written in such a devilish manner that once I spent a whole morning in comprehending and copying two or three small pages."[18]

The difficulties encountered in reading some pages have been pointed up by Carlo Pedretti's recent study, in which he used infrared rays to read parts of lines beneath an ink spot (CA 71 a).[19]

Leonardo wrote in Italian, firmly convinced that he did not need Latin for scientific purposes: "I have so many words in my mother tongue that I ought rather to complain of the lack of a right understanding of things, than of a lack of words with which fully to express the conception that is in my mind" (W An II 16r; MacCurdy 1130). His orthography is unique. Sometimes two words are written together. The inscriptions give the features of pronunciation, representing the phonetic characteristics of the living speech. For example, Leonardo wrote *frusso* for *flusso*, but *complendere* for *comprendere*. In his lofty and solemn prediction about the great bird, which "will take its first flight from the back of the great swan" (VU inside cover; MacCurdy 420), one is taken somewhat aback by the Florentine colloquialism *groria* for *gloria*, but there is a certain charm in the combination of the conversational *cecero* (instead of the Latinized and literary *cigno*) and the Latinism *magno* (instead of the conversational *grande*): "Piglierà il primo volo il grande uccello sopra del dosso del suo magno cecero."

Leonardo did not hold strictly to any terminology. A word will reflect various shadings, and to penetrate its meaning, one must always think of it and interpret it in its context, then compare it with other passages. For example, Leonardo wrote: "You cannot combine utility with beauty as it appears in fortresses and men" (CA 147r b; MacCurdy 1017). To understand what particular sense the word "beauty" (*bellezza*) has here, and to convince oneself that Leonardo by no means contrasts genuine beauty with the "prosaic" utilitarian world, one should turn to other texts, in particular to a passage in the Treatise on Painting where he states: "What is beautiful [*bello*] is not always good [*buono*]. I say this in reference to those painters who so love the beauty of colors [*la bellezza de'colori*] that, not without great regret, they give their paintings very weak and almost imperceptible shadows ... In this error they are like good speakers [*belli parlatori*] whose words are without any sense whatsoever" (TP 236; McMahon 110).

In these passages beauty is understood as external beauty, but elsewhere he regards adornments (*ornamenti*) as an integral part of the

WRITINGS

organic whole. Attacking the "epitomizers," the compilers of dry excerpts and compendia, Leonardo compares their error to that committed by a man who strips a tree of "the adornment [*ornamento*] of branches laden with leaves, mingled with fragrant flowers or fruit . . . in order to demonstrate the suitability of the tree for making planks, even as Justinus did in making an epitome of the histories of Trogus Pompeius, who had written an elaborate [*ornatamente*] account of all the great deeds of his ancestors, which were full of marvelously picturesque beauty [*mirabilissimi ornamenti*]" (W An II 14r; MacCurdy 84). Here the *ornamenti* are as essential, as organic a part of the whole, as the leaves of the tree, and its fruit and flowers.

Again we find a diametrically opposite meaning of the same word: "Do you not see that among human beauties it is a very beautiful face and not rich ornaments [*ornamenti*] that stops passersby? And this I say to you who adorn your figures with gold or other rich trimmings, do you not see beautiful young people diminish their excellence with excessive ornamentation" (TP 404; McMahon 442)? [20]

The same may be said about his natural-science terminology. One cannot translate *gravità, grave,* and *peso* identically in every case. Of course, the primary meaning of *gravità* is gravity, in the sense of the force or properties of a body. However, the same word is used to mean a *heavy body* (for example, *gravità che discende,* a weight which descends; M 44v). The word *peso* also has several meanings. Primarily it is a load, a heavy body; that is why Leonardo used a phrase such as *la gravità d'un peso* (the weight of a load; BM 164v). However, *peso* is also used in the meaning of *gravità,* that is, the force of gravity, while *gravità* can mean a heavy body, a load. For example, Leonardo says (BM 37v) that a blow creates gravity (*peso*) when it causes a heavy body (*gravità*) to leap into the air. The possibility of using *gravità* and *peso* in the same meaning and as substitudes for each other is shown by two almost identical variants of the same thought, where *peso* is used in one case and *gravità* in the other: "Gravity [*il peso*] is the accidental power created by the movement of one element entrained by another" (BM 164v); "Gravity [*gravità*] is a power created by movement which transports one element into another by means of force" (BM 151v; MacCurdy 588).

Leonardo's mathematical terminology is quite unique. By "cylinder" he understood a rectangle with a square base that is higher than

LEONARDO DA VINCI

*9. Manuscript page with
lists of Italian words*

a side of the base, in contrast to a plate (*tavola*) which is shorter than a side of the base. Sometimes by "cube" he meant a hexagon with unequal faces; and he understood "pyramid" in an equally unusual sense. In all such cases, one must refer to the accompanying drawing to understand the text.

The notes Leonardo made around 1492 and again around 1497 on Latin morphology and syntax, with whole lists of Italian scientific borrowings from Latin and explanations of the Latin words, have given rise to many proposals and interpretations. It has been proposed variously that these are outlines of a Latin grammar, a dictionary of Italian, a Latin-Italian dictionary, a philosophy of language, and so forth. (See figure 9.)

Recently it was revealed that Leonardo had made excerpts from Perotti's *Rudimenta grammatices* (Rome, 1474), Pulci's *Vocaboli latini*, and an Italian translation of Valturio's treatise on war as a means of self-teaching and to enrich his Italian vocabulary with Latinisms not well known to him.[21]

Usually Leonardo's texts are inseparable from their accompanying

WRITINGS

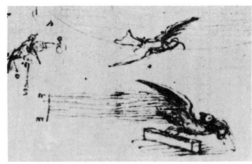

10. Flight of birds *11. Bird taking wing*

sketches. Often a sketch or drawing encroaches on the text, and at times the text is merely an explanation of the sketch, becomes lost in the sketch, and can be understood only by careful examination of the drawing, in which case Leonardo did not give a whit about careful wording. Two fields, anatomy and technology, are practically all in drawings and sketches, with the text often at a minimum. In any case, the text played a subordinate role.

Leonardo's sketches of the flight of birds are very indicative and informative in this respect. It is difficult to say which is more important, the drawing or the text, as they are mutually explanatory: the drawing illustrates the text and the text serves as a commentary on the drawing. In his drafts he abstracted, took what he needed, but by no means always reduced the material to a simple sketch.

For example, he wrote: "The wings, extended on one side and drawn up on the other, show the bird dropping with a circular movement round the wing that is drawn up." The drawing (see figure 10) illustrates this principle, and the spiral motion is indicated by a corresponding line. Further: "Wings drawn up equally show that the bird wishes to descend in a straight line" (CA 66r a; MacCurdy 422). Again there is an accompanying sketch in which the main attention is focused on the position of the wings, and again there is an illustrative line of motion.

Here is another example: "When a bird flies upward from some place, the wind aids it considerably. If it wishes to use the wind to its advantage, whatever the direction of the wind, it places itself at

LEONARDO DA VINCI

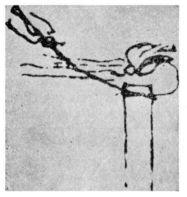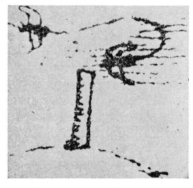

12. Descent of bird	*13. Descent of bird flying against the wind*

an angle to the flow of the wind, gathering the wind beneath it in the form of a wedge and begins its flight, hopping somewhat on taking off" (CA 214v a). The wind is depicted conventionally, by horizontal lines, and the letters alongside emphasize the schematic nature of the drawing; despite the schematization, the motion of the bird is depicted very distinctly and not merely designated: it is the motion of the bird that is depicted, not the bird itself (see figure 11).

Infinite examples could be cited. "In order that a bird flying against the wind may be able to settle on a high spot, it has to fly above the spot and then turn back and without beating its wings descend upon the said place"; Leonardo adds "proof," which consists of the following: "if the bird should wish to abandon its flight in order to settle, the wind would throw it backward" (E 51r; MacCurdy 466). Of course, the real proof is given by the drawing, in which the wind again is indicated by horizontal lines, and exactly as required, without any descriptive details (figures 12 and 13).

The page of the Codex Atlanticus devoted to the ways in which birds rise "without beating their wings, but by circles, with the help of the wind" (CA 308r b; MacCurdy 435) is very interesting. Leonardo composed this page from the top downward, from sketch to text (this is clear from the first line at the bottom, which was written after the sketch had been made). The sketches begin with an abstract spiral line in the upper left-hand corner, which line is specified and analyzed, "thought through," as it moves downward on the page, then becomes a word picture of what Leonardo saw and contemplated (figure 14).

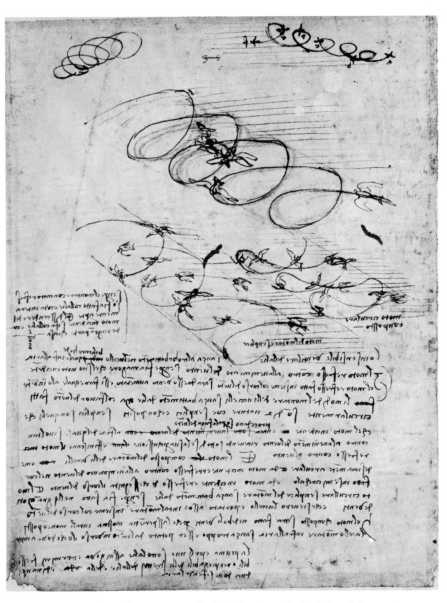

14. Page devoted to ways in which birds rise with the help of the wind

LEONARDO DA VINCI

In his very choice of words, his articulation of the period, his rhythmic sketch, Leonardo reached maximum expressiveness or, to be more exact, a pictorial expression of movement. For example, he spoke of a bird which: "After a certain amount of slanting descent, will set itself to rise by a reflex movement / and to rise in a circle, / after the manner of the cranes when they break up the ordinary lines of their flight and gather into a flock / and describe many turns after the manner of a screw / and then, having gone back to their first line, / they follow their first movement again, dropping with a gentle descent, / then again becoming a flock and describing circles, / raise themselves anew" (CA 220v c; MacCurdy 434). No translation can convey fully the melodic nature of the original and the accuracy of the subsequent description: "userà, dopo alquanto discenso obliquo, di rilevarsi per moto refresso, / e aggirarsi montando, / a similitudine de'gru quando disfanno le ordinate linie nel loro volare e si riducano in torma, / e vanno co'molte volture innalzandosi a vite, / e poi, ritornati alla prima linia, / riseguitano il primo lor moto, il quale cala con dolce obliquità, / e poi ritornando di novo in torma e raggirando / s'innalzano."

Leonardo had no rigid technical terminology. He used such truly poetic expressions as *dolce obliquità,* gentle obliquity, or descriptive formulas such as *del fine del volare che è fatto di giù in su* (on the end of flight made from below upward; G 63v). We would use a more prosaic or laconic term. Archaisms such as *altura* for *altezza* (altitude) lend a poetic touch. Leonardo does not say *aprire le ali* or *chiudere le ali* (open or close the wings), but *dilatare, allargare, restringere* (stretch, extend, shorten).[22] However, circumlocutions (*vie di circuizione*) and prolix confusion (*lunghezze confuse*) were distasteful to him: "When you wish to produce a result by means of an instrument, do not allow yourself to complicate it by introducing many subsidiary parts, but follow the briefest way possible, and do not act as those who, when they do not know how to express a thing in its own proper vocabulary, proceed by a method of circumlocution and with great prolixity and confusion" (CA 206v a; MacCurdy 65).

It is remarkable that Leonardo described the flight of birds just as accurately in his literary works as in his scientific works. This is demonstrated by a short passage from his fable about the unfortunate willow: "So the magpie ... cocked his tail and lowered his head, and cast-

WRITINGS

ing himself loose from the bough, let himself float on his wings; and beating about with these in the fleeting air, seeking hither and thither, and guiding himself by using his tail as a rudder, he came to a gourd" (CA 67r b; MacCurdy 1063). Let us compare this description with the scientific passage: "When birds in descending are near the ground, and the head is below the tail, they then lower the tail, which is spread wide open, and take short strokes with the wings; consequently, the head becomes higher than the tail, and the speed is checked to such an extent that the bird alights on the ground without any shock" (L 58v; MacCurdy 488). Or: "A bird beats its wings frequently as it settles when it has descended from a height, in order to break the impetus of the descent, to settle itself on the ground, and to diminish the force of the impact" (K 58r; MacCurdy 484).

The relation of text to drawing is distinctive in Leonardo's anatomical works. He did not try to give an accurate verbal description of an accompanying drawing, as Vesalius did later. Leonardo's text supplements his drawing, which speaks for itself. He was not only indifferent to but even skeptical of a text representing a purely anatomical description.

> With what words, O writer, can you describe the whole arrangement with the perfection of this drawing? For lack of due knowledge, you describe it so confusedly as to convey but little perception of the true shapes of things, and deceiving yourself as to these, you persuade yourself that you can completely satisfy the hearer when you speak of the representation of anything that possesses substance and is surrounded by surface. I counsel you not to cumber yourself with words unless you are speaking to the blind . . . How in words can you describe this heart without filling a whole book? Yet the more detail you write concerning it, the more you will confuse the mind of the hearer. And you will always then need commentators or to go back to experience; and this with you is very brief, and has to do only with a few things as compared with the extent of the subject concerning which you desire complete knowledge (W An II 1r; MacCurdy 167).

In a sense Leonardo was right, because the anatomical terminology of his time was still very poor, and Leonardo the writer had to wage battle with a long heritage of confused and unstable terminology, to make his way through a mass of Greek and Arabic scholastic terms—

for example, the Arabic words *mirac* (stomach wall), *sifac* (peritoneum), and *meri* (esophagus). Some Arabic words got into the medieval anatomical literature in unfortunate Latinized translations. Instances of such expressions in Leonardo's works are *parte dimesticha* and *parte silvestra,* meaning, literally, the domestic side and the wild side and pertaining to inside and the outside surfaces, for example, of the hand.

Leonardo's own anatomical terminology was very unstable. His *nervi* had several meanings: nerves in our sense, but also sinews (more often called *corde*). *Vene* meant both veins in the narrow sense, and blood vessels in general. *Pannicolo,* meaning, literally, a small piece of cloth or fabric, was vague and had many meanings; it was used for the most diverse membranes, the pia and dura mater, the mitral valve, layers of vesicular and intestinal wall, and so forth.

However, Leonardo was always interested in the function of the organ, as well as its morphology, and this required a text. The function is sometimes indicated in a cursory manner in the explanation of the drawing, but more often it is the subject of an entire fragment, a whole piece of anatomical text.

There was no other human organ (except, perhaps, the eye) to which Leonardo devoted as many texts as the heart.[23] The passages devoted to the heart are the most extensive, running page after page. Although Leonardo exclaimed: "How in words can you describe this heart?" (W An II 1r; MacCurdy 167), among the passages pertaining to this organ we find the lines: "Not abbreviators but forgetters (*obbliatori*) should they be called who abridge such works as these" (W An I 4r; MacCurdy 163). Leonardo felt that in this case one should not spare words. But of what did he write primarily? True to himself, he devoted little space to morphological description, but concentrated on the functions of the heart and its components. He did not know the real laws of the circulation of blood, but he strove ardently to discover them by observation and experimentation, by discussions and arguments with an imaginary adversary.

As a graphic artist Leonardo faced a number of specific problems in dealing with anatomy. The goal of the artist is to represent the diversity of the reality he sees in a single plane, while anatomical drawings of an organ must give a comprehensive picture of the object, reveal it in all its aspects, sculpture it, so to speak. The plastic feeling of the great

WRITINGS

artist, his perception of depth, are revealed with special force in the anatomical sketches. One may say that at times Leonardo saw before him a sectional model. Eloquent evidence of this may be found, for example, in the anatomical sketches on the sheet preserved at Weimar.

One can understand why so many of Leonardo's notes pertain to the selection of consecutive aspects. He thought an organ should be depicted as a set of closely coordinated drawings, and he called the individual drawings of the series *dimostrazioni.* "One possesses a true conception of all figures when one knows their breadth, length, and depth; if, therefore, I observe the same in the figure of the man, I shall give a true conception of it in the opinion of everyone of sound intelligence" (W An A 4v; MacCurdy 96). Or, even more to the point: "Should the actual thing in relief seem to you to be more recognizable than what is drawn here, which impression springs from the fact of your being able to see the object from different aspects, you must understand that in this representation of mine, the same result will be obtained from the same aspects; and, therefore, no part of these limbs will be hidden from you" (W An A 14v; MacCurdy 101). One more fragment from this notebook must be cited: "The true knowledge of the shape of any body will be arrived at by seeing it from different aspects. Consequently, in order to convey a notion of the true shape of any limb of man, who ranks among the animals as first of the beasts, I will observe the aforesaid rule, making four demonstrations for the four sides of each limb, and for the bones I will make five, cutting them in half and showing the hollow of each of them" (W An A 1v; MacCurdy 93). But this is not the end of it. It is not just a matter of selecting aspects; one must show the bones, muscles, nerves, blood vessels, and so forth individually and skillfully in every part of the body. The fragment in which Leonardo spoke of ten different drawings of the same foot is especially informative in this respect:

You will show first the bones separated and somewhat out of position, so that it may be possible to distinguish better the shape of each piece of bone by itself. Afterwards you join them together in such a way that they do not diverge from the first demonstration, except in the part which is occupied by their contact. Having done this, you will make the third demonstration of those muscles that bind the bones

LEONARDO DA VINCI

together. Afterwards you will make the fourth—of the nerves which convey sensation. And then follows the fifth—of the nerves that move or give direction to the first joints of the toes. And in the sixth you will make the upper muscles of the foot where the sensory nerves are ranged. And the seventh will be that of the veins which feed these muscles of the foot. The eighth will be that of the nerves that move the points of the toes. The ninth of the veins and arteries that are interposed between the flesh and the skin. The tenth and last will be the completed foot with all its powers of feeling" (W An A 18r; MacCurdy 108).

And, grasping the relation of the ten drawings, he dreamed of the impossible: "You could make the eleventh in the form of a transparent foot, in which you could see all the aforesaid things" (W An A 18r; MacCurdy 108).

Although one might doubt that Leonardo was able to make a drawing of the foot that could embrace all the diversity of the ten drawings, he was able, for example, to depict artfully the transparent membrane of the lung, behind which the heart, the blood vessels, and the bronchial tubes could be seen (W An B 37v). He depicted the muscles as bundles, slightly parted, so that the muscles below them could be seen (W An A 4v). In depicting the details, he indicated the whole by conventional shading, for example, giving the "shadow" of the foot (W An B 18r).[24]

It would seem that Leonardo had forgotten that he had extolled the painter, the graphic artist, over the poet and musician for his ability to show the whole "in an instant." His concept of anatomical drawing was diametrically opposed to this opinion: here the sequence of time is prevalent, a factor which he had regarded as an unavoidable defect of poetry and music. A set of anatomical drawings was designed to show the organ sequentially from all aspects, to show it as if one were holding it in one's hands and turning it around: "For when you have seen any member from the front with the nerves, tendons, and veins which have their origin on the opposite side, you will be shown the same member either from a side view or from behind, just as though you had the very member in your hand and went on turning it from side to side until you had a full understanding of all that you desire to know" (W An I 2r; MacCurdy 161).

Many other examples could be cited to show how attentive Leonardo

was to the order of his "demonstrations" and the selection of pertinent aspects. He did not resort to the type of contrived, spectacular postures that may be found in the anatomical illustrations of the Baroque period.[25] The sedate form of the geographic atlas appealed to him as the model for his anatomical sketches. Several times Leonardo mentioned Ptolemy's *Cosmography* in this connection: "Therefore there shall be revealed to you here in fifteen entire figures the cosmography of the lesser world (*minor mondo*) in the same order as was used by Ptolemy before me in his Cosmography. And, therefore, I shall divide the members as he divided the whole, into provinces" (W An I 2r; MacCurdy 161). Or: "follow the method of Ptolemy in his *Cosmography* in the reverse order: put first the knowledge of the parts and then you will have a better understanding of the whole put together" (W An III 10v; MacCurdy 174). The expression "geography of the heart" (W An II 8v) is instructive in this respect.

Only after anatomical demonstrations of the organs and the whole had been made was the living being to be presented in all the diversity of its movements. Concerning his plan for anatomical books Leonardo wrote: "Then represent in four histories, four universal conditions of mankind, namely, joy, with various modes of laughing, and represent the cause of the laughter; weeping, the various ways with their cause; strife, with various movements expressive of slaughterings, flights, fear, acts of ferocity, daring, homicide, and all the things connected with cases such as these. Then make a figure to represent labor, in the act of dragging, pushing, carrying, restraining, supporting, and conditions such as these. Then describe the attitude and movement" (W An B 20v; MacCurdy 131).

Leonardo's aspiration to find general laws and general distinctive features, and to individualize and specify them, emerges clearly and with all its contradictions in his notes on the muscles. Before Leonardo this had been the area least studied by the anatomists. Galen had based his studies primarily on the dissection of apes. In Mondino's treatise (1316) discussion of the muscles is at a minimum. The painters and sculptors of the Renaissance fixed their attention on this branch of anatomy, which was essential to their realistic portrayal of the human body, but their knowledge had not been set down in treatises. Although the painters and anatomists had a common theme, one must keep in mind the essential differences between them.

LEONARDO DA VINCI

Professional anatomists were obliged to give a full description, an inventory of the muscles, and could restrict themselves to this, but sculptors and painters could not. They were more interested in how certain muscles functioned in a specific attitude or movement; therefore Leonardo was right to caution the "painter-anatomist" against "excessive indication of the bones, tendons, and muscles" (E 19v, TP 125; McMahon 126). It is thought that here Leonardo had in mind his adversary Michelangelo, who studied anatomy intensively.[26] Be that as it may, it is evident in this and other statements that Leonardo made a clear distinction between the sedate drawings of an anatomical atlas and detailed investigations of the functions and aspect of the muscles in various movements. One need but recall the dynamic, expressive figure of Saint Jerome.

Leonardo gave the best characterization of the content and division of his notes on the first page of the Arundel Manuscript 263, now in the British Museum (BM 1r; Richter 363). He calls the manuscript, begun "in Florence, in the house of Piero di Braccio Martelli, on the 22nd day of March 1508," a "collection without order, made up of many sheets which I have copied here, hoping afterwards to arrange them in order in their proper places, according to the subjects of which they treat." Leonardo asks the future reader not to complain about unavoidable repetitions, because "subjects are many, and the memory cannot retain them and say 'this I will not write because I have already written it'" (BM 1r; MacCurdy 59).

In the surviving notes of Leonardo da Vinci quite often we find references to or indications of works of a different kind. For example, in Manuscript E (15v) there is a reference to the fourth proposition of the 113th book on things in nature, and in the Notebooks on Anatomy (W An I 13v) there is mention of 120 books on anatomy. In the manuscripts, as in the Treatise on Painting, we find constant references to some proposition in a particular book. These references have long intrigued researchers. They have been interpreted as indications of works considered but never accomplished. If this were the case, how could we explain the specific numbering? Yet if the books had already been written, why the strange lack of coordination in the references? For example, the proposition "the surface of every body is privy to the color of the object opposite it" is referred to in the Treatise on Painting as the first proposition of the fourth book (TP 767), as the fourth

WRITINGS

proposition of "this" book (TP 196, 781), as the third proposition of the ninth book (TP 708), as the seventh proposition of the ninth book (TP 631), as the ninth proposition (TP 438b, 762), as the eleventh proposition (TP 467) of an unnamed book, and so forth.

Sometimes the propositions are specified with respect to context. For example, the fourth proposition of an unknown book is formulated in the Treatise on Painting (518; MacMahon 530) in general form: "Among colors of the same kind, the most remote one will be most tinted with the color of the medium lying between it and the eye which sees it" (see also TP 786). Elsewhere in this treatise (508; McMahon 525) the proposition is rephrased to meet a specific case: "That submerged object will be the most transmuted from its natural color into the green color of the water which has the greatest amount of water above it."

It has been proposed that Leonardo must have had some books in which he recorded the general results of his observations, in addition to the notebooks which were "stenographic" records of the observations themselves. There can be no argument that Leonardo transferred notes from one book to another. This is indicated by the many notes which were crossed out because they had been copied elsewhere—not because Leonardo considered them unreliable or incomplete. Leonardo's own remarks are very significant in this respect: "See tomorrow to all these matters and the copies, and then efface the originals and leave them in Florence, so that if you lose those that you take with you, the invention will not be lost" (CA 214r d; MacCurdy 431). This is also documented in the manuscript in the British Museum: "which I have copied here" (BM 1r; Richter 363); this same fragment makes it clear that these notes were made "without order."

In my opinion, the manuscript references to the second, third, fourth, and so on books cannot be interpreted as references to some general summaries because of the references to "this" book and the "present book" (*questo libro*), that is, to the manuscript before us, which does not have any such numbered propositions.

There is one more possibility: references of this type were a means by which Leonardo tried to show that in a given instance he was basing his remarks on an earlier proof, which he also considered to be proof in the given context. Undoubtedly Leonardo drew on Euclid's *Elements* for this form, which for centuries had been the model of propositions

more geometrico. One need but open *Elements* to any page. Take the first phrases of Proposition 46 of Book I: "On a given straight line describe a square. Let AB be the given straight line; now let a square be constructed on the straight line AB. Let AC be drawn at right angles to the straight line AB from the point A on it (proposition 11) and let AD be made equal to AB (proposition 3); through the point D let DE be drawn (proposition 31) parallel to AB and let BE (proposition 31) be drawn through point B parallel to AD."

Medieval science knew two basic forms of a statement: one strictly scholastic, the other Euclidian or "geometric." The form of the statement *more geometrico* was rather rarely used outside mathematics. In the fifth century Boëthius used it for nonmathematical purposes, as did Alan of Lille in the twelfth century, and Thomas Bradwardine in the fourteenth.[27] Until Leonardo's time the traditional form of the scholastic statement was the "question" based on weighing the proofs "pro" and "con." The question (*quaestio*) was usually constructed thus: first the answer was formulated (positive or negative), together with an enumeration of the proofs ("it is proved first, second"). Then the argument followed for the opposite opinion. After the two opinions had been contrasted, the author gave his argument based on a number of conclusions. Usually the author's position was opposite that formulated initially. Finally, a point-by-point answer was given to the arguments first introduced, whereby they were either rejected entirely or accepted with limitations. Thus, the *quaestio* form was like a school debate. A statement in the form of a *quaestio* was polemic, in contrast to the statement *more geometrico.* The arguments could be either purely logical, references to authorities, or references to given observations.

In reading the manuscripts of Leonardo that have come down to us, we find only uncoordinated elements, *membra disjecta,* of a particular form of statement: references to the propositions of some book or expressions such as "if the opponent should say," "the answer to be given the opponent is." What Leonardo lacked was that extreme formalism and baring of the "skeleton" of the proofs, which one finds in a number of scholastic treatises, in which a syllogism was constructed (categorical, conditional, or partitive), and then the proof was introduced with constant instructions of this type: "the major premise is obvious, the minor is proved thus"; "the consequent is false, thus, so is the antecedent." What is more, Leonardo never grouped all the arguments for and against separately; the replies to the arguments of

the opponent follow immediately. The polemics with the imaginary opponent is not mummified and dry; instead of a school debate, he provides a lively argument.

The lack of a compositional connection between the fragments by no means implies that there is no deeper, internal relation between them. Quite the contrary, some deep, imperceptible currents undoubtedly run through Leonardo's works, currents which carried off his thoughts and returned them to the same shores, to the same problems. These invisible threads connect the fragments, even those separated by a considerable interval of time. Regarded superficially, a Leonardo note such as "If a chimney sweep weighs two hundred pounds, how much force does he exert with his feet and back against the walls of the chimney?" (Forst III 19v) may appear to be a question generated by simple inquisitiveness or curiosity, a question posed in passing and unsolved. This is not the case, as can be seen if one compares it with a note, written at another time, which reveals just why Leonardo could have been interested in such a question. He spoke of the curved tips of birds' wings which help the bird stay aloft: "The flight of birds has but little force unless the tips of the wings are flexible . . . as may be seen in the case of a man pressing his feet and back against two opposite walls, as one sees chimney sweeps do. This, in great measure, the bird does by the lateral twistings of the tips of its wings against the air" (E 36r; MacCurdy 443). There can be no doubt of the logical connection, that the questions concerning the chimney sweep are associated with Leonardo's observations of the flight of birds and finally with his design research in aviation.

"Describe the tongue of the woodpecker and the jaw of the crocodile" (W An I 13v; MacCurdy 193). At first glance this seems to be another example of Leonardo's "random curiosity," but actually it is connected with his persistent interest in the mechanics of the movements of jaws and the tongue, with the general laws of their movements. According to the old concepts, the crocodile was the only animal with a mobile upper jaw. The tongue of the woodpecker drew Leonardo's attention because of its unique movements. In another manuscript (W An IV 10r; MacCurdy 193) Leonardo spoke in detail of the muscles of the human tongue and of the part played by the tongue in the pronunciation and articulation of words. This fragment ends with the note: "Analyze the movement of the tongue of the woodpecker."

Thus, a careful distinction must be made between the question

LEONARDO DA VINCI

whether there is some logical internal connection between the fragments and the question whether they can be combined into a composite whole (and the question whether Leonardo himself formed such an integral, that is, whether he wrote connected texts). Before we can treat this latter question in more detail, before we can determine the extent to which the fragments can be systematized and grouped, we must examine the earliest examples of such systematization made after Leonardo's death, namely, the Treatise on Painting and the Treatise on the Movement of Water.

First, let us mention that the Treatise on Painting (or Book on Painting) by no means includes all the fragments pertaining directly to the art of painting. For example, the Treatise does not include the quite numerous formulas for paints and varnishes known from Leonardo's manuscripts—which certainly could not be summarized in the few that appear in the Treatise (TP 211, 212, 513, 514).

What is more, the Treatise does not contain many of the natural-science passages on painting and on problems of geometric and physiological optics, meteorology, botany, anatomy, and physiology. The fragments of this sort that were included seem to be of a random nature, for the most part. The passages relating to the structure and function of the eye, which are closely related to Leonardo's thoughts on perspective, were cast aside entirely. The functions of the pupil were mentioned in only a few places (TP 202, 477, 628, 741), though the manuscripts contain numerous observations on the subject. The paragraph on the laws of the flight of birds (TP 435) creates the impression of an isolated fragment included at random, especially if one considers the amazing wealth of observations of this type in the surviving manuscripts. The geological fragments on orogeny (TP 804, 805) seem to be equally random. Evidently the compiler of the Treatise, governed by purely superficial evidence, decided to use them to supplement the numerous notes on the colors of mountains, notes which are of genuine interest to the artist.

Certainly an artist is not vitally interested in the notes on the speed of shadows, Leonardo was interested in such questions from a different standpoint, as demonstrated by a passage in one of his manuscripts (G 92v): by determining the relationship between the speed of shadows and clouds, one may judge the speed of the upper air currents, a problem of interest to Leonardo the meteorologist and designer of

flying machines. This is why the paragraphs on the speed of shadows (TP 575–577, 582, 593) or the fragment devoted to the perception of motion (TP 791) give the impression of being alien and extraneous in the Treatise on Painting.

The compiler of the Treatise included Leonardo's observations on the durability and qualities of different types of wood (TP 851–856). Again, he was governed by purely formal evidence, feeling it necessary to use all the available passages on mountains, light and shadow, trees, and so forth.

One may get an idea of how the compiler grouped the fragments from the sixth book of the Treatise, entitled "Of Trees and Verdure." Comparison with Manuscript G, now in Paris, shows that the compiler did not follow the manuscript sheet by sheet.

Paragraph in the Treatise on Painting	Sheets of Manuscript G
898–899	22r
900	22v
901	21r
902–903	20v
914	27r
916	21r

Much is vulgarized by being taken out of context. On reading Leonardo's notebooks one sees that he was deeply interested in Aristotle's teachings on continuity and infinite divisibility: a point is not a component of a line, but its limit; a line is the limit of a plane, not a part of it. These notebooks show the subtle transitions between Aristotle's teachings on the continuum and Leonardo's own artistic contemplations of chiaroscuro and "smoke" (*sfumato*). If one does not know this background, the first paragraph of the Treatise is incomprehensible and its discussion of a line and a point as "limits" seems a foreign, "wooden" addition that does not fit at all.

Since the selection of the fragments in the Treatise was a loose one, all other attempts to regroup them by a stricter system have left material that does not fit into a strict painting arrangement. Ludwig, in attempting a quite decisive rearrangement, had to put these "left-overs" under arbitrary headings, such as "Anatomy Supplement,"

"Descriptive Anatomy Supplement," "Some Technical Instructions," and the like.

The very diversity of the inhomogeneous material, selected without proper discretion, was bound to affect the structure of the Treatise. A mere cursory glance will show the lack of systematic arrangement: the fragment on human equilibrium (TP 510) is lost among others on different themes and is separated from those on the same question (TP 323, and others). The completely isolated fragment on the technique of sculpture (TP 512) also seems random. Perhaps the individual inadequacies can be explained by the conditions under which the Treatise was compiled. For example, in the Vatican Manuscript (Codex Urbinas) there is a postscript to paragraph 46: "This chapter . . . was found after the whole [first] book had been written." Then an opinion is expressed as to where this passage should be placed in the book. However, these chance findings do not justify the structural defects.

Not only the selection of the fragments but their grouping by books or parts is open to criticism. For instance, the sixth part of the Treatise ("Of Trees and Verdure") is separated quite artificially from the preceding section ("Of Light and Shadows") and is directly associated with it in respect to the painting instructions: in the sixth part Leonardo examines some of the most complex examples of the distribution of light and shadow in application to the illumination of trees and foliage. The treatment of the illumination of trees in other parts of the Treatise (TP 91, 420, and others) also demonstrates the artificiality of the arrangement.

The grouping of fragments on clouds into a separate section (part 7) is likewise arbitrary. This section includes fragments which are not directly connected with the subject of the Treatise on Painting, but rather characterize Leonardo as a meteorologist. The fragments of immediate interest to a painter could have been placed in other parts of the Treatise, for example, in the sections on dust, mist, and smoke (TP 468f).

But why should we attack the compiler for omissions, excesses, and defects of grouping? Let us suppose that there were no such faults and that all the fragments were chosen correctly and arranged properly within the system. How should they be arranged within each section?

One must remember that Leonardo's notebooks, from which the compiler of the Treatise drew his material, were written primarily for

WRITINGS

Leonardo himself. He jotted down what most interested him and, therefore, did not expand on problems already solved. For example, he wrote comparatively little on linear perspective but much on aerial perspective. Thus, however much one may wish to assemble a full treatise on painting from the Leonardo fragments, one which would pursue didactic aims, it is impossible to do so. This accounts for the unevenness of the Treatise, which cannot be eliminated by any re-arrangement. If Leonardo had actually undertaken a complete treatise on painting, he undoubtedly would have begun by reworking and supplementing and not simply by "sewing together" or assembling his rough notes. The incompleteness, the fragmentary nature of the notes are one of their inescapable features. One can no more introduce complete definitiveness and finality into them than into the famous enigmatic smile of his portraits, or into the haziness (*sfumato*) that characterizes this great artist.

Seidlitz attempted to restate the content of the Treatise on Painting in systematic form. He divided it into the following sections: (1) Comparison of the Arts (*Paragone*); (2) General Remarks (*Allgemeines*); (3) Depiction of Figures; (4) Light and Shadow; (5) Perspective; (6) Landscape. This attempt, too, was a Procrustean bed.*

In 1643 the Dominican Arconati compiled from the Da Vinci fragments a collection entitled "Trattato del moto e della misura dell'acqua" (Treatise on the Movement and Measurement of Water). It was commissioned by Cardinal Barberini. The fragments were arranged in nine books: (1) On the Sphere of Water; (2) On the Movement of Water; (3) On Waves; (4) On Whirlpools; (5) On Falling Water; (6) On Damage Done by Water; (7) On Objects Carried by Water; (8) On the Measurement of Water and on Pipes; (9) On Mills and Other Water Mechanisms. This arrangement cannot be considered fortunate in all respects; in some cases Leonardo's thread of thought is broken, in other cases it is scholasticized. Some of the manuscripts and fragments were not used at all in the compilation. Sometimes the

* Cf. Seidlitz *Leonardo da Vinci. Malerbuch.* Noting that the "material of the Codex Urbinas," that is, the most complete text of the Treatise on Painting, is very fragmentary, Heydenreich ("Quellenstudien zu Leonardos Malereitraktat") made a number of valuable remarks on the need for a complete, systematic edition of the fragments of the Treatise together with fragments from the notebooks. As he put it, such an edition would be a "genuine encyclopedia," but it would destroy the "traditional framework" of the Treatise on Painting. I am convinced, however, that even with the additional material, a systematic, coherent entity would not be produced.

Libro Primo.
Della sfera dell'acqua.

Capitolo primo

Diffinitioni de nomi, e vocaboli più usitati nella
materia dell'acqua.

Pelago è detto quello, il quale hà figura larga, e profonda, nel
quale l'acque stanno con poco moto.

Gorgo è di natura di Pelago, saluando la variatione d'alcu-
na parte, e questo è che l'acque, ch'entrano nel Pelago, sono sen-
za percussioni, e quelle del gorgo sono con gran cadute, e ribolli-
menti, e sorgimenti fatti dalle continue revolutioni dell'acqua.

Tutti li laghi, e tutti li golfi del mare, et tutti li mari medi-
terranei nascono dà fiumi, che in quelli spandono le loro acque, e dall'impedimen-
ti delle loro declinationi; sichè sono congregationi dell'acque de fiumi.

Fiume è quello, che possede il sito della più bassa parte delle valli,
e corre continuamente.

Torrente è quello, che corre solo per le pioggie, e ancora lui si ridu-
ce nelle basse delle valli, et s'accompagna co' fiumi.

Cannale si dice delle acque regolate infra argine per humano ag-
giunto.

Fonte è detto nascimento de fiumi.

Lago è quello, dove l'acque de fiumi pigliano gran larghezza.

15. *The first page of Book One of the Treatise on the Movement and Measurement of Water*

WRITINGS

text diverges stylistically (less often in substance) from Leonardo's autographic manuscripts. Thus, the second attempt to systematize Leonardo's fragments was also unsuccessful.

Da Vinci scholars have often been astounded that the notebooks contain practically no reflections of two of the most important events in the cultural history of man, events that were contemporary with Leonardo, namely, the discovery of America and the invention of the printing press. The silence on America is even stranger when we consider that Leonardo knew Amerigo Vespucci. In one of his notes we find: "Il Vespucci wishes to give me a book on geometry" (BM 132v; MacCurdy 1172).*

Concerning printing, it might seem at first that Leonardo regarded it negatively. In lauding the "singleness," the uniqueness of the artist's work, Leonardo stated that painting "does not have an infinity of progeny as does the printing of books" (TP 8; McMahon 18). True, this statement was made in the comparison of the arts, *paragone*, which is full of paradoxes and intentional rhetorical vagaries. Just the same, it remains significant, characterizing the "manuscript nature" of Leonardo's literary legacy. This great scientist did not dismiss the thought that his anatomical sketches might be printed: "I am marking how these drawings should be reprinted in order and I ask you, the successors, not to let stinginess cause you to print them in . . ." The note breaks off here (W An A 9v). There is no snobbery in this, such as that practiced by certain Italian humanists who would not hear of typography. In a very interesting article Pedretti[28] discussed the drafts of the technical details of typography in Leonardo's manuscripts. Leonardo's words on the plan for a textile machine are highly important: "This machine, second to the printing machine, is equally useful and equally used by people, is more profitable, and therefore is a more perfect and subtler invention" (CA 356r a).

For all of that, Leonardo's legacy remained unprinted until the nineteenth century, not because a publisher was not found, but

* Vasari (*Lives*, p. 197) mentions a charcoal drawing (which has not survived) depicting the head of a "very handsome old man," Amerigo Vespucci. It is now disputed that Leonardo had a map depicting America; see Almagià, "Leonardo da Vinci geografo e cartografo." The map, preserved at Windsor, has been reproduced and discussed in various works: by Nordenskiöld, *Facsimile-Atlas,* p. 77; Kretschmer, et al., *Allgemeine Geographie,* p. 17; Efimov, *Iz istorii velikikh russkikh geograficheskikh otkrytii,* p. 34; and Gavrilova, "Karty Leonardo da Vinchi."

LEONARDO DA VINCI

because this legacy is "manuscript" in its very substance. One may conceive of it being printed in facsimile, but one cannot imagine it being printed by such as the house of Aldo Manuzio or the "Dependents of the Heirs of Ottaviano Scotti" in Venice. What would these publishers have done with a monotonous page of continuous, compact text in two columns, full of abbreviations, with only a few capital letters to break the monotony, and a page completely covered with writing, sometimes continuous, sometimes in two columns and sometimes in three, alternating with drawings and accounts? They would have returned it to Leonardo as unsuitable for printing.

Let us return to the question whether there were other Leonardo manuscripts. The works on anatomy appear to cover the longest span of time. For example, the following inscription appears in one of the Windsor manuscripts: "On the second day of April 1489 the book entitled 'Of the Human Figure' [*De figura humana*]" (W An B 42r; MacCurdy 158). In another manuscript we read: "this winter of the year 1510 I look to finish all this anatomy" (W An A 17r; MacCurdy 106). However, some of the pages of other Windsor manuscripts (W An I and W An II) show that he continued with anatomy even later.

At one point (W An I 13v) Leonardo spoke of 120 books he composed on anatomy. It is difficult to say what these books were and to what extent they coincided with his anatomical manuscripts extant today. They could have been small books, mainly of drawings and treating specific organs or specific problems. Antonio de Beatis, secretary to the Cardinal of Aragon, reported that Leonardo da Vinci "wrote a remarkable work on the relation of anatomy to painting; he describes the bones, members, muscles, sinews, veins, joints, internal organs, in a word, all that is necessary for studying both the male and the female body, and which no one had done before him." And he added, "We ourselves saw this work." [29]

In 1550 Girolamo Cardano mentioned the "superb portrayal of the entire human body, undertaken not long ago by the Florentine, Leonardo da Vinci, and nearly completed by him." [30] At this same time Vasari wrote of the anatomical manuscripts of Leonardo, most of which, he claimed, were in the hands of Messer Francesco da Melzo, a student of Leonardo's. Vasari asserted that Leonardo "made a book drawn in red chalk, and annotated with the pen . . . with the greatest

WRITINGS

diligence, wherein he showed all the frame of the bones, and then added to them, in order, all the nerves, and covered them with muscles, the first attached to the bones, the second that hold the body firm, and the third that move it; and beside them, part by part, he wrote in letters of an ill-shaped character, which he made with the left hand, backward, and whoever is not practiced in reading them cannot understand them, since they are not to be read save with a mirror." [31]

Lomazzo wrote in the same vein: "Leonardo da Vinci taught the anatomy of human bodies and of the horse, which I have seen in the home of Francesco Melzi, drawn divinely by his hand. Besides that, he has drawn anatomically the proportions of horses and human bodies." [32]

The reports of De Beatis, Cardano, Vasari, and Lomazzo are not sufficient ground for concluding that the books they saw differed essentially from the Windsor Manuscript A, which we have today. (The other Windsor manuscripts on anatomy are collections of individual folios written at different times.) There is no reason to believe that the books these men reported were systematic, finished works, especially because Leonardo did not appear to have any firm plan. The various drafts contain different versions of the plan for a future work.

In an earlier version Leonardo thought of beginning his anatomical work with the conception of man, then tracing the subsequent growth of the organism, the stages of development.

This work should commence with the conception of man, and should describe the nature of the womb, and how the child inhabits it, and in what stage it dwells there, and the manner of quickening and feeding, and its growth, and what interval there is between one stage of growth and another, and what thing drives it forth from the body of the mother, and for what reason it sometimes emerges from the belly of its mother before the due time. Then you should describe which are the limbs that grow more than the others after the child is born; and give the measurements of a child of one year. Then describe the man fully grown, and the woman, and their measurements, and the nature of their complexions, color, and physiognomy. Afterwards describe how he is composed of veins, nerves, muscles, and bones. This you should do at the end of the book (W An B 20v; MacCurdy 130).

LEONARDO DA VINCI

In these early years (1489–1490), he proposed other variants, for example: "Begin your anatomy with the mature man, then depict him as an old man and less muscular, and then gradually remove everything from him, to the bones. And then depict an infant together with the mother" (W An B 42r).

Later (1509–1511) Leonardo wrote: "You have to represent in your anatomy all the stages of the limbs, from the creation of man down to his death, and down to the death of the bones, and (to show) which part of these is first consumed and which part is preserved longer" (W An VI 22r; MacCurdy 184). In another variant Leonardo proposed an anatomy in the traditional order, from head to feet (as, for example, in Avicenna's *Canon of Medicine*): "Commence your anatomy with the head and finish it with the soles of the feet" (W An A 3r; MacCurdy 94).

Leonardo's plans for books on hydrodynamics and hydraulic engineering are even more informative. In mentioning his writing programs, Leonardo never listed such a multitude of future works as on problems of hydromechanics and associated disciplines.[33] In this case it was not so much books that were listed as specific cases, problems, and questions, without a strict system, at times with repetitions. The drafts in the manuscripts at the British Museum illustrate this with special clarity: "A book of how to drive back armies by the fury of floods caused by loosing waters. A book of how to inundate armies by closing the outlets of the valleys. A book to show how the waters bring down in safety logs hewn in the mountains. A book of how boats are forced against the rush of the rivers. A book of how to raise great weights by the simple increase of the waters. A book of how to guard against the rush of rivers so that cities may not be struck by them" (BM 35r; MacCurdy 733). And, as if this were not enough, he projected separate books on the individual parts of a ship: "Book of the inequality in the hollow of a ship. Book of the inequality of the curve of the sides of ships. Book of the inequality in the position of the helm. Book of the inequality in the keel of ships." And there is another endless list of "books" on the most diverse themes: "Book of the difference in the holes through which water is poured out. Book of the water contained in vessels with air and of its movements. Book of the motion of water through a syphon. Book of the clashing together and concourse of water proceeding from different directions.

WRITINGS

Book of the varying shapes of the banks along which the rivers pass. Book of the various shoals formed below the locks of the rivers" (BM 45r; MacCurdy 733).

We get quite the same picture when we examine Leonardo's attempt to collect terms used in the "science of water." First, one gets the impression that he wished to make something like a dictionary with explanatory words or definitions: *"Beginning of the book of water.* The name *pelago* (sea, large lake) is applied to an area large and deep in form, in which the waters lie with little movement. *Gorgo* (whirlpool) is of the same nature as the *pelago* except for a certain difference, and this is that the waters that enter the *pelago* do so without percussions, while those of the *gorgo* are made up of great falls, and bubblings up, and surgings occasioned by the continuous revolutions of the waters. *Fiume* (river) is that which occupies the site of the lowest part of the valleys and which flows continuously. *Torrente* (torrent) is that which flows only with the rains: it also makes its way in the low parts of the valleys and joins itself to the rivers" (I 72r; MacCurdy 714). But after these definitions of *pelago, gorgo, fiume, torrente,* and many other concepts, Leonardo turns to a simple enumeration, as if a powerful torrent had burst forth, ready to sweep everything aside. It is difficult, indeed almost impossible, to translate the melody of Leonardo's speech: "Risaltatione, circulatione, revolutione, revoltamento, ragiramento, risaltamento, sommergimento, surgimento, declinatione, elevatione, cavamento, consumamento, percussione, ruinamento, discienso, impetuosità" (Rebound, circulation, revolution, rotation, turning, repercussion, submersion, heaving, declination, elevation, depression, depletion, impact, destruction, descension, impetuousness; I 71v–72r) in all, sixty-four words, following each other without a breath.

One can only guess why Leonardo gave them in this particular sequence. Did he see before him some sort of unifying visual image of seething water? Hardly! More likely the words at times were arranged by sense (*circulatione–revolutione*), at times by consonance (*revolutione–revoltamento*), and at times by contrast (*declinatione–elevatione*). But the whole created a highly expressive and complex rhythmical fabric, with unexpected alternations of rhyming words, with sudden rises and falls. Let us try to hear this rhythm:

LEONARDO DA VINCI

Risaltatione, circulatione, revolutione,
　　　Revoltamento, ragiramento, risaltamento,
　　　　　　sommergimento, surgimento,
　　　Declinatione, elevatione,
　　　Cavamento, consumamento,
　　　Percussione,
　　　Ruinamento,
　　　Discienso,
　　　Impetuosità.

If we examine the further listing—"ritardamenti, rompimenti, divisamenti, aprimenti, celerità, vehementià, furiosità, impetuosità, concurso" (retardations, breakings, separations, openings, rapidity, force, furiosity, impetuousness, fusion)—which includes some of the same words as above, it becomes quite clear that Leonardo had not composed a mere vocabulary for the sedate dictionary he had started. This was a special sound picture of the eternally rebellious water element, parallel to his instructions on how to depict a deluge in painting. These instructions were by no means practical advice to the painter on composition, working the details, and so forth. Leonardo's "let" was purely conventional, because he was not speaking about the canvas, but of *actual* water eternally changing before the eyes of the artist. Let us try to grasp the meaning of lines such as these: "Let the swollen waters course round the pool which confines them, let them strike against various obstacles with whirling eddies, leaping up into the air in turbid foam, and *then* let them fall back and cause the water where they strike to be dashed up into the air; and let the circling waves which recede from the point of contact be impelled by their impetus right across the course of the other circling waves which move in a direction opposite to them, and *after* striking against these, let them leap up into the air without becoming detached from their base" (W 12665r; MacCurdy 918; the italics are mine). From these lines we can see that he is telling not so much *how* to depict as *what* to depict —provided one can grasp and depict such motion. Is there any major difference between this flow of changing scenes and the rhapsodic listing of books on the "curved lines" of a ship, its rudder, keel, and so forth?

Literally bridling himself, Leonardo remarked in another notebook:

WRITINGS

"Write first of all of water in each of its movements, then describe all its beds and the substances in them, adducing always the propositions as to the aforesaid waters, and let the order be good, as otherwise the work will be in confusion. Describe all the shapes that water assumes, from its largest to its smallest wave, and their causes" (F 87v; MacCurdy 693). This would-be strictness is adhered to as long as he speaks of the most general features of the book, but when it comes to the specific enumeration of "all the shapes that water assumes," his thoughts again run free. This is how Leonardo began his listing of waves:

> *Of waves.* The waves are of [twelve] kinds, of which the first is made in the upper parts of the waters; the second is made above and below by the same path; the third is made above and below by contrary paths, and is not in the center; the fourth is made so that from its center upward it runs in one direction and from this center downward it makes the opposite movement; the fifth flows downward and not upward; the sixth flows downward, and above has a contrary movement; the seventh is that of the submersions of waters by means of a spring that enters into the earth; the eighth is that of the submersions by means of eddies which are narrow above and wide below; the ninth is that of the eddies wide at the surface and narrow at the base; the tenth is of cylindrical eddies; the eleventh of eddies that bend in regular curves; the twelfth is of the slanting eddies.

I supplied the number twelve at the beginning of this passage; it was not in the original, because when Leonardo began to write evidently he did not yet know how many types of waves he would get. He continues: "Make here all the waves together, and all the movements by themselves, and all the eddies by themselves. Arrange thus the series in order separated one from the other. And so also the rebounds of how many kinds they are in themselves and also the falls." But the outline did not help and he again lapses into unrestrained detail: "And set down the differences that there are in turbid waters, in their movements and percussions, and those that are clear; and similarly in waters that are violent and those that are sluggish; in those that are swollen and those that are shallow; and between the fury of pent-up rivers and those with a wide course; and of those that run over great stones or small ones or sand or tufa; and of those that fall

from a height, striking upon different stones with various leaps and bounds, and of those that fall by a straight path touching and resting upon a level bed; and of those that fall through the air in shapes that are round, or thin, or wide, or separated, or united." And he continues thus until a specific, single picture appears amid the generalizations: "And if you give movement to a sheet of water, whether by opening its sluices above, or in the middle, or below, show the differences that are caused by it falling or moving on the surface, and what effect it makes in entering with such fall upon the ground or in stagnant water, and how that by which it is moved at first maintains itself in a channel level or uneven, and how it produces all at once eddies and their recesses, *as one sees in the basins of Milan*" (I 87v–88v; MacCurdy 722; the italics are mine). The enormous variety of particular and even individual cases is overwhelming and one finally gets lost among them.

In examining the question whether Leonardo wrote the books he planned, let us suppose for the moment that he did. Next we must ask what form these books took. It is clear that they could not have been mechanical "sewings together" of fragments. The failure of the Treatise on Painting and the Treatise on the Movement of Water points this up. To become organic parts of a treatise, the fragments would have to be reworked thoroughly, they would have to be well thought out and reconsidered. Did Leonardo wish to give his treatises a didactic or deductive format in the manner of Euclid, dividing them into postulates supported by proofs? Where would he put the lyrical exclamations, the polemic expressions such as: "Oh, you, who speak ... you are in error" which lend such charm to the fragments? Would this not be, to use the words of this brilliant master, like stripping a tree of its "adornment of branches laden with leaves intermingled with fragrant flowers or fruits," and converting his works into "planks"? Could Leonardo have wished to give his fragments the final form of a scholastic *quaestio,* with a subsequent analysis of the arguments for and against? This thought seems wild. Would he have turned to the traditional form of the popular encyclopedia or have reworked the fragments into "dialogues" like those written later by Galileo? It would not have been easy to do either. He would have had to begin life anew, to be rejuvenated, like Faust.

It is difficult to conceive of the form such finished works would have

WRITINGS

taken under Leonardo's pen, but we can say confidently that they would be unlike anything left us in the legacy of this great Italian. Their author would have been entirely unlike the Leonardo we know, one of whom we know nothing at present, and whom we probably will never know.

Garin is correct in calling Leonardo's notebooks "the result of the intensely lived day of an unusual man recorded at times in the subtlest nuances," and not "fragments of a book," or "material for a book." [34]

There are notes in which an observation is recorded as an inimitable unit: "When the bird has great breadth of wings and a small tail and wishes to raise itself, it will raise its wings vigorously and will in turning receive the wind under its wings; this wind forming itself into a wedge will drive the bird up to a height swiftly, as is the case with the cortone, a bird of prey which I saw in going to Fiesole above the place of the Barbiga in 5 (the year 1505) on the fourteenth day of March" (VU 17v; MacCurdy 419). Undoubtedly the date, March 14, 1505, held some special significance for Leonardo. This exact localization in time and space leads us to believe that not everything was recorded. The first part of this note, containing a general description of the ascent of a bird, apparently was just a first draft, and the main object of the note was to fix in his memory for subsequent, more profound consideration, the visual image of a particular soaring bird of prey he saw on the way to Fiesole on a particular day.

Such specific observations are rarely dated. Leonardo's notebooks are not diaries. However, many retrospective observations with their biographic (autobiographic) overtones have been preserved: "And I *once* saw how a lamb was licked by a lion *in our city of Florence,* where there are always from twenty-five to thirty of them and they bear young. With a few strokes of his tongue the lion stripped off the whole fleece with which the lamb was covered, and having thus made it bare he ate it" (W An IV 9v; MacCurdy 176; here and in what follows the italics are mine, and denote the uniqueness of a particular observation). This was written in Milan in the period 1509–1512: "*On one occasion above Milan, over in the direction of Lake Maggiore,* I saw a cloud shaped like a huge mountain, made up of banks of fire, because the rays of the sun which was then setting red on the horizon dyed it with their color. This great cloud drew to itself all the little clouds which were round about it. And the great cloud remained stationary,

LEONARDO DA VINCI

and it retained the light of the sun on its apex for an hour and a half after sunset, so enormous was its size. And about two hours after night had fallen, there arose a stupendous storm of wind" (Leic 28r; MacCurdy 761). This was written in Florence between 1504 and 1506. Leonardo devoted special attention to the occurrence of wind, because in his conception: "clouds generate winds when they are created as well as when they are destroyed" (TP 928; McMahon 987).

This word picture of a water spout seen in the Arno valley is also retrospective: "How at the mouths of certain valleys the gusts of wind strike down upon the waters and scoop them out in a great hollow, and carry the water up into the air in the shape of a column and of the color of a cloud. And this same thing I once saw taking place on a sand bank in the Arno, where the sand was hollowed out to a depth of more than a man's stature, and the gravel of it was removed and whirled a great distance apart, and assumed in the air the form of a mighty campanile; and the summit of it grew like the branches of a great pine, and then it bent on meeting the swift wind which passed over the mountains" (Leic 22v; MacCurdy 747). Another example, this time less definite, without indication of the city, reads: "I have already seen one case where it [the heart] burst as a man was fleeing before his enemies, and he poured out perspiration mingled with blood through all the pores of his skin" (W An IV 13r; MacCurdy 181). Was not this witnessed while Leonardo served under Cesare Borgia?

Here is one more example, this time nonspecific: "Once I saw a woman dressed in black, with a white kerchief on her head, and this kerchief seemed to be twice as wide as her shoulders, which were clothed in black" (TP 445). * These individual observations ("once I saw"), mingled with the fabric of general discussion, often anticipate generalizing theses, but they retain their unique, visual character.

A passage in an earlier manuscript (1492) serves as valuable documentation of the creative mind of Leonardo. First Leonardo notes very specific, individual characteristics of an observation: "A blow on a stone in water gathers all the fish and other animals below and near. A blow on the tendon of the throat doubles the pain in the neck. A blow against the side of a grain sack lowers the level of the grain in it" (A 31r). But then, it would seem, a thought suddenly occurred to

* In his "Leonardo e l'ottica," Ronchi (p. 177) holds that Leonardo must have been near-sighted, because this phenomenon cannot be explained by irradiation alone.

WRITINGS

Leonardo and he wrote himself an admonition: "Remind yourself that you arrange the propositions written above in the form of an example, and not as propositions, which would be too simple. And you will speak thus." All three observations are crossed out together with the admonition. The final text reads: "*Experiment.* A blow against a dense and heavy body is transferred naturally beyond the confines of that body and strikes an object in ambient bodies, dense or loose, whichever they may be. For example, many fish are in water that flows under a stone; if you strike this stone sharply, all the fish below and beside the stone will float to the surface as if dead. The reason for this is . . ." We will not pursue this further because we are interested here only in the form of the statement: the first observation is transformed into an illustration of the general thesis, but remains before Leonardo's eyes in all its initial clarity. It may be said that the preceding general thesis explains the observation, causing one to examine the subject anew, more profoundly, to detect in it universal features. Thus, it would be more correct to say that the general thesis is an explanation of the ob-servation, than that the observation is an illustration of the thesis posed initially.

It is quite clear that many of Leonardo's notes are just such "converted" individual observations generalized into a formula. The remarks on meadow grass and tree leaves are examples (TP 223). In some passages on sunset (TP 474, 477b, 479), one senses clearly that the central and initial individual observation is a picture that is merely supplemented by the analysis and practical instructions, although the text begins with a generalization, and in the heading it is even under-lined: "*Precept* for painting," "*Precept,*" and so forth. Here is one such passage: "*Precept.* The sun provides a beautiful spectacle when it is in the west, and illuminates the high buildings of cities, and castles, and the tall trees of the countryside, and tinges them with its color. Everything else has little relief, because, illuminated only by the air, the other things differ but slightly in their shadows and lights, and therefore do not stand out very much. The things which rise highest are touched by the solar rays, and, as has been said, are tinged by their color" (TP 479; McMahon 482). Can the following analytical descrip-tion of an evening landscape be called a precept? "When the sun is in the west, the mist which falls thickens the air and things which do not face toward the sun remain obscure and indistinct, and those which are

LEONARDO DA VINCI

illuminated by the sun grow reddish and yellowish according to the way the sun appears on the horizon. The houses, also, which are illuminated by the setting sun become very clearly visible and especially the buildings and houses of cities and villages, because their shadows are darker. Their sharp forms seem to arise from indistinct and uncertain foundations, because there everything is the same color, since it is not in the light of the sun" (TP 477b; McMahon 483). Or this description of evening clouds and evening illumination? "When the sun reddens the clouds on the horizon, things which through distance are clothed with blue take on that redness, which results in a mixture of blue and red, which makes the countryside gay and cheerful, and all the things that are clearly illuminated by that redness, if they are dense, will be very clearly visible and turn reddish. The air, because it is transparent, will be thoroughly infused with that redness, whence it will tend to have the color of irises" (TP 474; McMahon 480).

Other fragments do not contain a description (or, to be more exact, an analysis) of the individual picture. Leonardo compares two observations made under opposite conditions in the passage "On the reflection of the color of sea water seen in different aspects" (that is, from the land and from the sea): "The surging sea does not have a single, general color. He who views it from the land sees it as dark, and it is the darker the closer it is to the horizon, and he sees on it a certain brightness or patches of light, which move slowly, like white lambs in a flock. He who views it from the open sea, sees it as blue." Then follows the explanation: "This comes about because from land the sea seems dark, since there you see the waves which reflect the darkness of the earth, and from the high sea they seem blue, because you see the blue air reflected by the waves" (TP 237; McMahon 213).

The fragment on rain is constructed similarly: "The rain falls through the air, obscuring it with a yellowish-black tinge, taking the light of the sun on one side and the shadows on the opposite side, as is seen in mist. The earth grows dark, for the splendor of the sun is taken away by the rain. Things seen beyond the rain have indistinct and unintelligible outlines, while objects nearer the eye are more distinct." Then Leonardo notes this difference: "and the objects which are nearest to the eye are clearer than those in illuminated rain," followed by the explanation: "This happens because objects seen in shadowed rain lose only their principal lights, but those seen

WRITINGS

in illuminated rain lose both light and shade, for the luminous parts mingle with the luminosity of the illuminated air, and the shadowed parts are brightened by the same brightness of the illuminated air" (TP 503; McMahon 552).

There are many more abstract, generalizing moments in a fragment of this type, but here, too, one senses the eye of the analytic artist discussing what he sees immediately before him. It is significant that in the Vatican manuscript (Codex Urbinas) of the Treatise on Painting there is a note indicating that in the manuscript which served as the primary source this text was accompanied by an original drawing by Leonardo depicting "a city foreshortened, on which rain fell, illuminated in places by the sun."

At first glance Leonardo's works seem to contain many repetitions. This is particularly evident in the Treatise on Painting, where passages on the same subject are grouped together insofar as possible. The attentive reader, however, will find these repetitions interesting, similar to musical themes and their variations. It would seem Leonardo constantly varied the distance of his object of study, at times placing it in the foreground with details, at times placing it in the background and examining it as a whole, in various stages of abstraction, running the gamut from a specific description to an abstract mathematical theorem.

Let us follow this in a graphic illustration, the illumination of tree leaves. The entire complexity of the distribution of light and shadow becomes particularly tangible in this case if we recall that here we are treating not only the diversity of the illumination as such, not only the different positions of the source of light (sun) and the eye, but the shape of the illuminated object as well. This accounts for Leonardo's intense interest in the characteristics of various botanical species, in the laws of the branchings, the disposition of the leaves, the peculiarities of their shape, the thickness of the foliage in different parts of the tree, and so forth.

In some cases Leonardo schematized the discussion, on the assumption that "Every shadowed body, whatever its shape, seems spherical at a great distance" (TP 888; McMahon 956). That is why he depicted trees as circles or spheres in his geometric drafts (cf. TP 867, 879, 906, 918) or as conventional abstractions (TP 860, 913). In other cases he fixed his attention on the illumination of individual elements. He described the shadows on a single leaf (TP 803), leaves which shade one

another (TP 860), the illumination of branchings seen from different vantage points (TP 866), shadows of boughs in different positions (TP 897), and so forth. By no means were these observations always synthesized in an analysis of a single complex case which included simultaneously all the indicated moments. They were not generalized in systematic form. At times Leonardo regarded the objects from a distance, at times close up, ranging from the undifferentiated mass of the tree's crown to a tiny, individual leaf illuminated by the sun.

This constant shifting from the concrete to the abstract, from the abstract to the concrete, invites comparison with Leonardo's remarks on the composition of the *Last Supper*. We find such specific notes as: "Alessandro Carissimo of Parma for the hand of Christ" (Forst II 6r; MacCurdy 1014), and an abstract description of one of the variants of the future composition where not a single person is named, neither the apostles nor Christ, who is given the purely abstract title *proponitore* (the speaker): "One who was drinking and left the cup in its place turns his head toward the speaker. Another twists the fingers of his hands together and turns with stern brows to his companion. Another with hands opened showing their palms raises his shoulders toward his ears and gapes in astonishment. Another speaks in the ear of his neighbor, and he who listens turns toward him and gives him his ear, holding a knife in one hand and in the other the bread half divided by this knife. Another as he turns holding a knife in his hand tips over a glass onto the table. Another rests his hands upon the table and stares. Another breathes heavily with open mouth. Another leans forward to look at the speaker and shades his eyes with his hand. Another draws himself back behind the one who is leaning forward and watches the speaker through the space between the wall and the one who is leaning" (Forst II 62v and 63r; MacCurdy 1014).

In speaking of the gradations of abstractions and generalizations, one must return to Leonardo's anatomical drawings. Leonardo the artist, the painter-realist, enriched anatomical science with his splendid drawings, before which the schematic representations of his predecessors and contemporaries pale. To arrive at a true historical perspective of Leonardo's drawings, one need but compare his anatomical drawing of a woman with the nearly contemporary illustration in the *Fasciculus medicinae* (1491).

Olschki spoke haughtily of the "scrupulously accurate portrayal of the observed facts by means of a drawing," noting that only in rare

cases do we have a verbal description. Further, these drawings are not simple sketches of isolated observations. Leonardo wrote that to obtain an exact and complete knowledge of "some few veins" he had dissected more than ten human bodies, "destroying all the various members, and removing even the smallest particles of flesh which surrounded these veins, without causing any effusion of blood other than the imperceptible bleeding of the capillary veins. And as one single body did not suffice for so long a time, it was necessary to proceed by stages with as many bodies as would render my knowledge complete; and this I repeated twice over in order to discover the differences" (W An I 13v; MacCurdy 166).

Leonardo's anatomical drawings are synthetic; they are not sketches of a single observation but a generalization of results obtained from many postmortems. The fragment cited above begins with the words: "And you who say that it is better to look at an anatomical demonstration than to see these drawings, you would be right, if it were possible to observe all the details shown in these drawings in a single figure in which, whatever your ability, you would not see nor acquire knowledge of more than some few veins."

For his generalized drawings, Leonardo often resorted to the dissection of animals to depict the human organs. For example, in studying the heart and the circulation of the blood he used information from the dissections of human bodies and of other mammals (an ox, a pig, and others). His concepts of the breathing mechanism were based exclusively on dissections of animals (see the drawing in W An V 16r, and others). In studying the voice apparatus Leonardo did not fully recognize the differences between the human apparatus and that of birds (see W An A 3r). All this led him into some errors, but the drawings show clearly the analytic mind of the scientist as well as the hand of the artist.

Leonardo's scientific fragments and his drawings both reveal what is general in the individual case rather than merely recording the particulars. The picture is not a snapshot of reality and the scientific text is not a simple diary entry of a single phenomenon. Almost always what is general remains associated with the specific visual image, with the picture of the phenomenon. This is why the individual drawings can be combined in series, into a larger integral composition, but cannot be fused into a systematic treatise, and why Leonardo's texts cannot be combined structurally into a literary whole, but can only be

grouped with varying degrees of success, just as a painting can be hung on a wall more or less logically. Each fragment always retains its individuality; the relation of the fragments to each other, their internal logic, can be discovered only by intensive and diligent study.

In this brief analysis of the main features of Leonardo's artistic and scientific abstractions, we need one more literary form, namely, the riddles, known as the "prophecies." This was the literary genre in which Leonardo played with abstractions and in so doing created peculiar, grotesque forms. In the prophecies everything is true, but the features are distorted. Too general a definition will not allow one to guess the specific object meant; Leonardo exaggerated a particular feature, making it the main one, as he did in his famous caricatures. Here are examples of his abstract descriptions: "Creatures of the water will die in boiling water" (boiled fish), and: "The trees and shrubs of the vast forests shall be changed to ashes" (burning wood) (CA 370r a; MacCurdy 1103). Everything is true, but nothing can be comprehended if one does not know the riddle.

Then there is the optical phantasmagoria: "There shall appear huge figures in human shape, and the nearer to you they approach, the more will their immense size diminish" (Forst II 50v; MacCurdy 1118). The riddle is simple: it is the shadow cast by a man walking at night with a candle in hand.

Using such distorted abstractions the simplest phenomena become enigmas. Who could guess that he had sawyers in mind in this strange description: "There will be many who will be moving one against the other, holding in their hands the sharp cutting iron. These will not do each other any hurt other than that caused by fatigue, for as one leans forward the other draws back an equal space; but woe to him who intervenes between them, for in the end he will be left cut in pieces" (CA 370r a; MacCurdy 1102). Who would recognize dice in this ominous picture: "You shall behold the bones of the dead, which by their rapid movement direct the fortunes of their mover" (I 65r; MacCurdy 1116).

On reading the abstract definitions in the classical books of scholastic philosophy Leonardo must have sometimes recalled his own prophecies. Out of context, could anyone guess that Aristotle's "excitation of what is transparent to actuality" referred to light?[35] And could not any fragment of Leonardo's manuscripts be transformed into a prophecy? Take, for example: "A man who goes up stairs puts as much of

his weight in front and at the side of his upper foot as he puts as counterpoise to his lower leg, and, consequently, the work of the lower leg is limited to moving itself" (W An B 21r; MacCurdy 134). If we take the words "A man who goes up stairs" from the beginning and put it at the end (as the solution), we will have a ready-made prophecy. This is the requirement Leonardo placed on all his notes: to place the general thesis at the beginning, and make the primary observation his illustration.

What would we have if we separated a particular action or operation from its motives and treated it separately, out of context? About sowing, one could say that men "will throw out of their houses the victuals they have saved, as the freebooty of the birds and beasts of the field, without taking any care of them" (CA 370r a; MacCurdy 1102) or, in another version, "Men shall throw out of their houses those victuals which were meant for the sustenance of their lives" (BM 212v; MacCurdy 1120).

Sometimes a prophecy is based on the double meaning of a word: "The fierce horns of powerful bulls will protect the light used at night from the impetuous fury of the winds" (CA 370r a; MacCurdy 1105). Who could guess that the "horn" here was the horn plate of a lantern? He used this same type of plate in another prophecy: "Oxen by their horns shall protect the fire from death" (I 64v; MacCurdy 1116). These oxen appear in another form: "Many there will be who will die a painful death by means of the horns of cattle" (bows made of oxhorn) (CA 370r a; MacCurdy 1114).

Sometimes the prophecy-riddle becomes a simple allegory: "All those things which are concealed and hidden beneath the snow in winter will be left bare and exposed in summer" (said of a lie which cannot remain hidden) (I 39v; MacCurdy 1114).

There is a completely different category of prophecies that reveal and display actual absurdities of human actions. "The works of men's hands will become the cause of their death" (swords and spears) (I 64v; MacCurdy 1115). And he is scrupulously correct about soldiers on horseback: "Many shall be seen carried by large animals with great speed, to the loss of their lives and to instant death. In the air and on the earth shall be seen animals of different colors, bearing men furiously to the destruction of their lives" (CA 370r a; MacCurdy 1107). A famous prophecy belongs in this category: "Out of cavernous pits a thing shall come which will make all the nations of the world toil and

LEONARDO DA VINCI

sweat with the greatest torments, anxiety, and labor, that they may gain its aid" (CA 37v c; MacCurdy 1098). This "thing" is gold. Once again, and with truly ominous pathos, he speaks of it as a monstrous beast: "There shall come forth out of dark and gloomy caves that which shall cause the whole human race to undergo great afflictions, perils, and death. To many of those who follow it, after much tribulation it will yield delight; but whosoever pays it no homage will die in want and misery. It shall bring to pass an endless number of crimes; it shall prompt and incite wretched men to assassinate, to steal, and to enslave; it shall hold its own followers in suspicion; it shall deprive free cities of their rank; it shall take away life itself from many; it shall make men torment each other with many kinds of subterfuge, deceits, and treacheries." This prophecy ends with the exclamation: "O vile monster! How much better were it for men that thou shouldst go back to hell!" As for the future: "For this the vast forests shall be stripped of their trees; for this an infinite number of creatures shall lose their lives" (CA 370r a; MacCurdy 1110).

The question arises: why are these descriptions called prophecies when they deal with the present? After all, there was gold in Leonardo's time, and its power was as great then as now. This form was used because the future tense stresses the universal, abstract nature of the statements, and makes them the rule and the inevitable. The future tense here is used in approximately the same way as it is in his postulates of physics, optics, and mechanics, for example, in his description of resonance phenomena: "The blow which the bell *will receive will cause* a slight sound and movement in another bell similar to itself, and the string of a lute as it is struck *will produce* movement and response in another similar string of like tone in another lute" (A 22v; MacCurdy 267). Or in his postulate on perspective: "The size [of the bodies] *will vary* according to their distance from the eye which sees them, but it *will be* in inverse proportion" (E 80v; MacCurdy 998). Or, finally; "One support *will have* less weight on it than the other." (CA 316v a; the italics are mine, stressing the future tense). In essence, the term "prophecy" means "thus it is and thus it will be, since it must be, but let not our moral judgment condone it." We shall return, in another connection, to this deep conflict in Leonardo's ideology.

3.

SCIENCE

"La sapientia e figliola della sperientia"
"Wisdom is the daughter of experience"
Forst III 14r; MacCurdy 80

IN UNDERTAKING AN ANALYSIS of the fundamental, the most profound, elements of the creative life of Leonardo da Vinci, we must recall the words of Paul Valéry, whatever we may think of his ideas on Leonardo's "method": "The problem is that there are no mistresses, no creditors, no anecdotes, no adventures . . . The problem is one of attempting to understand what another understood and not of depicting a character in a novel on the basis of certain documents." [1]

Vasari's biography of Leonardo contains the following lines: "Philosophizing of natural things, he set himself to seek out the properties of herbs, going on even to observe the motions of the heavens, the path of the moon, and the courses of the sun." [2] In the first edition (1550) this is followed by the phrase: "That is why he formed in his mind a heretical view of things, not in agreement with any religion; evidently he preferred being a philosopher to being a Christian." In the next edition (1568) he omitted this phrase, remarking that he had been poorly informed, but he could not reconcile things and left in his biography the story that Leonardo, on his deathbed, "asked to have himself diligently informed of the teaching of the Catholic faith, and of the good way and the holy Christian religion," and that he repented of "how much he had offended God and mankind in not having worked at his art as he should have done." [3] It did not occur to Vasari that his picture of Leonardo's deathbed repentance indirectly confirmed his earlier statement that throughout life Leonardo preferred to be a "philosopher."

"Pharisees—that is to say, holy friars," we read in the Codex Trivulzio (Triv 34r; Richter 283). The following castigating lines are devoted to indulgences, the "dealing in paradise": "Numberless

throngs will sell publicly and undisturbed things of the highest worth without the consent of the owner; things which were never theirs nor in their power, and human justice will not intervene" (CA 370v a; Baskin 79). This same sheet of the Codex contains the following lines on the worshiping of pictures of saints: "they will ask pardon from one who has ears and does not hear; they will offer light to one who is blind" (MacCurdy 1106).

Leonardo declared that he would not speak against "sacred books," that is, the Bible, for they are the "supreme truth" (W An IV 10r; MacCurdy 179), but this statement is quite reminiscent of the words of his contemporary and countryman Machiavelli. In analyzing the contemporary forms of principalities, and coming to the ecclesiastical principalities, Machiavelli wrote: "Since they are governed by a higher power, beyond human understanding, I refuse to speak of them; they are exalted and protected by God, and it would be presumptuous and audacious for a man to judge them." [4] However, this did not keep Machiavelli from making devastating remarks about the activities of the popes. The same applies to Leonardo, who stated that he would leave the sacred books untouched, but actually did not. "In all the parts of Europe there shall be lamentations by great nations for the death of one man who died in the East," he wrote with regard to "lamentations made on Good Friday" (CA 370r a; MacCurdy 1109). When he stated, "The spirit . . . if it should assume a body, could not penetrate or enter where the doors are shut" (B 4v; MacCurdy 68), he was rejecting the biblical story of the appearance of Christ before the learned men after his resurrection. An indirect comment on the Eucharist may be found in Leonardo's words on reverence for great persons: "But I would impress upon you that their images are not to be eaten by you, as happens in a certain district of India. For there, when in the judgment of the priests these images have worked some miracle, they cut them in pieces, being of wood, and distribute them to all the people of the locality—not without payment. And each of them then grates his portion very fine and spreads it over the first food he eats; and so they consider that symbolically by faith they have eaten their saint, and they believe that he will then guard them from all dangers" (W An II 14r; MacCurdy 85).

On examining the problem of how the remains of sea animals could appear on the summits of high mountains far from the sea, Leonardo disputed the biblical legend of the universal flood during the

SCIENCE

time of Noah. Irony is evident in his words addressed to the author of the "sacred book": "If you should say that the shells which can be seen at present within the borders of Italy, far from the sea and at great heights, were deposited there by the Flood, I reply that, granting this Flood to have risen seven cubits above the highest mountain, as he has written who measured it . . . " (Leic 8v; MacCurdy 330). And, somewhat later he adds that these shells would not have "traveled a distance of two hundred and fifty miles in forty days, as he has said who kept a record of this time."

For Leonardo, another book was more authoritative, the book written by nature: "Since things are far more ancient than letters, it is not to be wondered at if in our days there exists no record of how the aforesaid seas extended over so many countries; and if, moreover, such records ever existed, the wars, the conflagrations, the changes in speech and habits, the deluges of the waters, have destroyed every vestige of the past. But sufficient for us is the testimony of things produced in the salt waters and now found again in the high mountains, sometimes at a distance from the present seas" (Leic 31r; MacCurdy 345).

It is appropriate in this connection to mention Leonardo's "facetiae" (which have a long literary tradition), with anecdotes from the lives of priests and monks and some unexpected, slightly humorous comparisons of the "worldly" and the "sacred" in technical descriptions. Speaking of "leather bags with which a man falling from a height of six braccia will not do himself any harm, whether he falls into water or on land," Leonardo notes that these leather bags are tied together after the fashion of "rosary beads" (VU 16r; MacCurdy 418). Or, in another manuscript: "Have the privy seat turn like a monk's window, and return to its original position by means of a counterweight" (B 53r).

In the Treatise on Painting (TP 77; McMahon 80) Leonardo speaks of those "fools" and "hypocrites" who reproach painters for studying the works of nature on feast days: "But let those detractors be silent, for this is the manner of getting to know the creator of so many wonderful things, the manner of growing to love this great inventor." What Leonardo meant by the "creator" is evident at another point in the Treatise—it is nature. "All visible things were engendered by nature" (TP 12; McMahon 6), and "The works of a painter represent the works of nature" (TP 9; McMahon 58).

Leonardo's reference to the "prime mover" (A 24r) is figurative, in-

dicating the fixed order of natural laws. A perfect analogy appears elsewhere (CA 345v b), where Leonardo refers to "marvelous" or "wonderful" necessity, personifying it.

In describing the functions of the eye on the basis of experience, Leonardo contrasted his method with that of the ancients who strove "to define the soul and life, things that are not demonstrable" (CA 119v a; Baskin 20). Treating the influence of the mother's psyche on the condition of the infant in the womb, he ironically granted "the rest of the definition of the soul to the wisdom of the friars, those fathers of the people who by inspiration know all mysteries" (W An IV 10r; MacCurdy 179). The questions on the essence of God and the soul "rebel against the senses," as it were, and are always in conflict with the senses; "they are always quarreling and fighting" (TP 33; McMahon 19).

To get a true historical perspective of this deep indifference of Leonardo da Vinci to problems of the "essence of God and the soul," one must recall the reproofs addressed by his contemporary Girolamo Savonarola (born September 21, 1452) to the Aristotelian scholasticists. "Your Aristotle," he kept saying, "does not even succeed in proving the immortality of the soul, is uncertain upon so many capital points that in truth I fail to comprehend why you should waste so much labor on his writings."[5] In these words Savonarola expressed the medieval concept of the relative merits of the arts and the sciences, namely, their "nobility" and "worth" are proportional to the "nobility" and "worth" of the subjects they treat. For Leonardo, another rule took precedence; he had another criterion, whereby the authenticity (*certezza*) of the knowledge was the important thing, not the nobility of the subject.

Even the early humanists continued to hold to the old criteria. For example, Coluccio Salutati (1330–1406), a friend of Petrarch, placed jurisprudence above medicine because the rules of jurisprudence, which derived from an understanding of justice (*aequitas*), are a direct reflection of divine wisdom, whereas medicine, which studies the mortal and the transient, is rather an art than a science. "I am created of earth," says Salutati's Medicine personified, "while Law is created from divine thought." Laws are "more necessary" than medicine, since they stem "directly from God."[6]

Savonarola's discourses reflecting the medieval concepts are also quite revealing: the "mechanical arts" are without "nobility" (*dignitas*)

either in subject or in manner of execution. In other remarks Savonarola combined the two criteria of nobility and worth: "A science which is more authentic, relatively more worthy, will be less worthy in an absolute sense if it treats less worthy things. Therefore, we call the real sciences more noble in an absolute sense than rational science, because their object is more noble; real being is more noble than rational being (*ens rationis*)." Proceeding from this, Savonarola considered mathematical sciences, although they are more authentic than physical sciences, to be less noble in an absolute sense. Astronomy is more worthy than optics and the theory of music because its subject is more noble and worthy. Optics is more worthy in an absolute sense than is the theory of music because the object of vision is more noble than the object of hearing and because it is more stable (*stabilius est*).[7]

Leonardo clarified his attitude toward chimeric deliberations on "great and high-sounding discourses" in this polished aphorism: "Falsehood is so utterly vile that though it should praise the great works of God, it offends against His divinity. Truth is of such excellence that if it praises the meanest things, they become ennobled." Or, in another variant, placed beside it: "Without doubt truth stands to falsehood as does light to darkness, and truth is in itself of such excellence that even when it treats of humble and lowly matters, it still immeasurably outweighs the sophistries and falsehoods which are spread out over great and high-sounding discourses [*magni e altissimi discorsi*]." And Leonardo concludes: "But you who live in dreams, the specious reasonings, the feints which *palla* players might use, if only they treat of things vast and uncertain [*cose grande e incerte*], please you more than do the things which are sure and natural and of no such high pretention [*non di tanta altura*]" (VU 12 [11]r; MacCurdy 87).

Leonardo always contrasted the sobriety of a vigilant mind with the world of dreams, of "empty dreams," of fantasies. It is quite characteristic and indicative that in Leonardo's mind fantasy and imagination were not creative possibilities, as they were to become later for the romanticists. He used another word to designate creativity in art and technology, *invenzione,* which may be translated "invention" or "inventiveness." Invention creates things that do not exist but are possible in nature. Imagination, however, is directed toward fantastic things, impossible and unattainable. Imagination is a brittle, hollow reed. "In Tuscany reeds are put to support beds, to signify that here

LEONARDO DA VINCI

occur vain dreams, and here is consumed a great part of life: here is squandered much useful time, namely, that of the morning when the mind is composed and refreshed, and the body therefore is fitted to resume new labors. There also are taken many vain pleasures, both with the mind imagining impossible things, and with the body taking those pleasures which are often the cause of the failing of life; so that for this, the reed is held as representing such foundations" (Ox A 29v; MacCurdy 1097).

For Leonardo, belief in magic was a fanciful dream. Attacking belief in magic, in the supernatural gift of "calling up the spirits," and then refuting what was to be called spiritualism, he stated that the "necromancer and the enchanter are supreme fools" (W An I 13r; MacCurdy 83). "But of all human discourses, that one must be considered most foolish which affirms a belief in necromancy . . . this necromancy, an ensign or flying banner, blown by the wind, is the guide of the foolish multitude" (W An B 31v; MacCurdy 81). Could Leonardo have had some specific person in mind? Giovanni Corsi, the biographer of Marsilio Ficino, a countryman and older contemporary of Da Vinci's, thought Ficino "had the exceptional, divine gift of magic; he expelled and put to flight evil demons and many souls of the dead" and, what is more, "everywhere he was the most fervent champion of religion," and the "irreconcilable foe of superstition." *

Pandolfini, in a letter written to Donato Acciaioli at the turn of the 1460's, said that often conversations in the "manner of the Peripatetics" were conducted at the home of the learned Greek scholar Giovanni Argiropulo, then living in Florence, and that during one of these conversations "a difficult and at the same time delicate argument arose as to whether the Angel Gabriel made his announcement to the Virgin Mary in a material or an immaterial voice."[8] And belief in the supernatural continued in Florence even later. Savonarola spent whole hours on questions of how angels appear in dreams to men, and how supernatural voices are heard. His thoughts on such subjects are scattered through his sermons, his epistles, all his works; but in

* The pertinent text by Corsi (chap. 20) is printed as an appendix to Marcel, *Marsile Ficin* (p. 687). The relation of Ficino to "demonic magic" is treated in more detail in a recent book by Walker, *Spiritual and Demonic Magic* (pp. 30–53). It is quite significant that Ficino translated the treatise *De daemonibus* by the Byzantine philosopher Michael Psellus, which treats of such problems as "demons that settle into a person, speak, move, change appearance" (Ficino, *Opera,* II, 880–885).

SCIENCE

his *Discourses on the Truth of Prophecies*, published in 1497, he collected all these thoughts into a kind of learned treatise.[9]

The work by a younger contemporary of Leonardo da Vinci, Agostino Nifo of Sessa (Suessanus, 1473–1546), entitled *De daemonibus* (On demons),* is important in this respect. Although Nifo allocated to theologians such problems as how the spirits "converse and communicate with each other" and how "one obeys another," he was convinced that magicians could make people invisible, citing as his authority the testimony of the Inquisitor of Padua.

"Can a spirit speak or not?" asked Leonardo. "The spirit cannot produce a voice without movement of air, and there is no air within it, and it cannot expel air from itself if it has it not, and if it wishes to move that within which it is diffused, the spirit must multiply itself, and this it cannot do unless it has quantity" (W An B 30v; MacCurdy 148). Earlier, he had written: "There cannot be any sound where there is no movement or percussion of the air. There cannot be any percussion of the air where there is no instrument. There cannot be any instrument without a body. This being so, a spirit cannot have either sound or form or force, and if it should assume a body, it cannot penetrate or enter where the doors are shut. And if any should say that through air being collected together and compressed, a spirit may assume bodies of various shapes, and by such instrument may speak and move with force, my reply to this would be that where there are neither nerves nor bones, there cannot be any force exerted in any movement made by imaginary spirits." In conclusion, he exclaims: "Shun the precepts of those speculators whose arguments are not confirmed by experience" (B 4v; MacCurdy 68). We find this same thought, expressed very concisely, in another manuscript: "O mathematicians, throw light on this error! The spirit has no voice, for where there is voice there is a body, and where there is a body, there is occupation of space which prevents the eye from seeing things situated beyond this space" (CA 190v b; MacCurdy 64).

Leonardo devoted a long discussion to proof that a spirit cannot exist without a body (W An B 30v–31v). It is interesting to trace how

* Published together with his work *De intellectu* in Venice in 1503, 1527, and 1554. For more details, see Thorndike, *A History of Magic*, pp. 69–93. I have seen the 1503 edition in the State Library in Leningrad. In *De daemonibus* he follows all the rules of contemporary university science in discussing whether or not demons exist, what they are, of what they consist, why they exist, and so forth (*an sint, quid sint, quales sint, propter quid sint*).

he gradually explains that there is no place for incorporeal spirits in nature. If it is granted that a spirit occupying space is a quantity without a body, such space would be a vacuum, and a vacuum is impossible in nature; thus this space would be filled instantly by the element surrounding it and would be forced upward toward the sky. If it is granted that the spirit "assumes the form" of the element that contains it, that is, the body of air, it would either make the air lighter and draw it upward or would necessity "spread itself" through this air, thereby becoming modified and losing something of its former nature. "This body of air assumed by the spirit is exposed to the penetrating force of the winds, which are incessantly severing and tearing in pieces the connected portions of the air, spinning them round and whirling them amid the other air." And with the dynamic expressiveness characteristic of him, Leonardo drew the fate of the unfortunate spirit "spread out through the air . . . torn to pieces by the winds": "it would be dismembered or rent in pieces and broken, together with the rendering in pieces of the air within which it was spread" (W An B 31r; MacCurdy 147).

The clarity of mind with which Leonardo approached faith in spirits is remarkable not only for his time, but for a much later period.* It should not be forgotten that belief in magic continued to hold on stubbornly through the sixteenth century. One need but recall the names of Girolamo Cardano and Paracelsus. What would Leonardo have said about those narratives that are so abundant in Cardano's autobiography, for example, the story of how a mysterious guest entered his room: "On the night of 13 August 1572, a candle burned in my room and I was still awake, for it was not yet two at night; suddenly I heard to the right of me a terrible noise, as if a wagon load of boards was being unloaded,—this noise went from the entrance door into my bedroom; I looked and I saw that a peasant was entering from the room where my servant boy slept (the door was open). With strained attention I began to study him, but he, hardly having crossed the threshold, said, 'Te sin casa,' and so saying, disappeared. Neither his voice nor his face were familiar to me, and I could not understand the meaning of these words nor the tongue in which they were spoken." Cardano does not explain such things, but confesses that his shoulders are "not strong enough to bear such a burden," and advises "turning

* Timpanaro ("Leonardo e gli spiriti") was correct in noting that in this respect Leonardo was ahead not only of the Middle Ages, but of the Renaissance as well.

to the theologians." He is satisfied that he has told "the honest truth."[10]

The kingdom "of deceptive mental sciences [*bugiarde scientie mentali*]" was a kingdom of clamor hateful to Leonardo: "Truly it always happens that where reason is lacking, loud protesting takes place, but this does not occur in the case of certainties. For this reason, where there is loud protesting, there is no true science" (TP 33; McMahon 19). In "confused and false discourses—they cannot be called sciences— quarrels are always conducted with great shouting and waving of hands" (TP 16). This is the exact opposite of mathematics, where "any manifestation of imagination" is destroyed by proof and is reduced to "eternal silence" (TP 33). Such is the eternal silence of a painting, "silent poetry," appealing to the "noblest sense," sight. "Since its executers were incapable of stating its laws, it remained for long without advocates; a painting does not speak, but exhibits itself and is limited to what has happened; poetry is achieved by the words with which it praises itself, by its own fluency" (TP 46).

"Mental things which have not passed through the understanding are vain and give birth to no truth other than what is deceptive. And because such discourses spring from poverty of intellect, those who make them are always poor, and if they have been born rich, they shall die poor in their old age. For nature, as it would seem, takes vengeance on such as would work miracles and they come to have less than other men who are more quiet (*più quieti*)." Such a fate awaits alchemists, seekers of perpetual motion, and necromancers: "and those who wish to grow rich in a day shall live a long time in great poverty, as happens and will to all eternity happen to the alchemists, the would-be creators of gold and silver, and to the engineers who think to make dead water stir itself into life with perpetual motion, and to those supreme fools, the necromancer and the enchanter" (W An I 13v; MacCurdy 83).

Leonardo placed the alchemists in the same category as the visionaries, the seekers of *perpetuum mobile*. He exclaims contemptuously: "Oh, speculators on perpetual motion, how many vain projects of like character you have created! Go and be the companion of the searchers for gold" (Forst II 67r; J. P. Richter 1206). However, he did distinguish between alchemy and other "mysterious sciences." He did not deny that alchemists had found many useful things through experimentation and that this was worthy of "eternal praise," and would deserve them

LEONARDO DA VINCI

even more "if they had not been the inventors of noxious things like poisons and other similar things which destroy the life or the intellect; but they are not exempt from blame in that by much striving and contriving they are seeking to create not, indeed, the meanest of nature's products, but the most excellent, namely gold, which is begotten of the sun, inasmuch as it has more resemblance to it than to anything else that is" (W An B 28v; MacCurdy 143).

Why did Leonardo consider the artificial creation of gold to be a fantasy? He was governed by the attitude that man is incapable of creating the "ordinary things" (*le ordinarie spezie*), that is, the elementary things of nature. "She does not change the ordinary kinds of things which she creates in the same way that the things which have been created by man are changed from time to time; and, indeed, man is nature's chief instrument [*massimo strumento di natura*], because nature is concerned only with the production of elementary things, but man from these elementary things produces an infinite number of compounds, although he has no power to create any natural thing except another like himself, that is, his children. And of this, the old alchemists will serve as my witnesses, who have never either by chance nor deliberate experiment succeeded in creating the smallest thing which can be created by nature" (W An B 28v; MacCurdy 143). Thus, man is not capable of creating the elementary things, but as nature's chief instrument he can continue nature's work, artificially creating an infinite number of compound substances which are not present in nature.

Leonardo recognized the existence of a large number of simple or primary substances. This is clear from his retort: "The lying interpreters of nature assert that mercury is a common factor in all metals; they forget that nature varies its seed according to the variety of things which it desires to produce in the world" (CA 76v a; MacCurdy 308). But what basis did he have for including gold among the elementary things? Evidently because "no created thing is more enduring than gold." Gold "is immune to destruction by fire, which has power over all the rest of created things, reducing them to ashes, glass, or smoke." Leonardo invites us to prove to ourselves that the natural conditions under which gold is formed are not reproducible in the laboratory, where the chief agent is fire, and that neither alchemist's mercury nor sulphur can produce gold. "If, however, insensate avarice should

SCIENCE

drive you into such error, why do you not go to the mines where nature produces this gold, and there become her disciple? She will completely cure you of your folly by showing you that nothing which you employ in your furnace will be numbered among the things which she employs in order to produce this gold. For there is no quicksilver there, no sulphur of any kind, no fire nor other heat than that of nature giving life to our world; and she will show you the veins of gold spreading through the stone, the blue lapis lazuli, whose color is unaffected by the power of fire. And consider carefully this ramification of the gold, and you will see that the extremities of it are continually expanding in slow movement, transmuting into gold whatever they come in contact with, and note that therein is a living organism which it is not within your power to produce (W An B 28v; MacCurdy 143).

Later, Leonardo wrote: "You who speculate on the nature of things, I praise you not for knowing the processes which nature ordinarily effects of herself, but rejoice if you know the issue of such things as your mind conceives [*il fine di quelle cose che son disegnate dalla mente tua*]" (G 47r; MacCurdy 70).

A comparison of opposites sometimes offers enormous advantages of clarity and intelligibility. Let us make use of these advantages. "All our knowledge has its origins in our perceptions" (Triv 20v; Richter 4). "In any study, one should begin with what is most familiar." "That part of a science which pertains to sensible-perceptible substance takes precedence in order of knowledge over that part which does not pertain to substance, which cannot be perceived. The sensible-perceptible substance is better known to us than the imperceptible, inasmuch as it is closer to the [kind of] perception with which we begin knowledge; as was stated above, one should always begin with the more familiar." Who said this? Leonardo again? No, Girolamo Savonarola.[11]

Let us take one more comparison. "Many will believe that they can with reason censure me, alleging that my proofs are contrary to the authority of certain men who are held in great reverence by their inexperienced judgments, not taking into account that my conclusions were arrived at as a result of simple and plain experience, which is the true teacher." Thus spoke Leonardo (CA 119v a; MacCurdy 58). Now, let us look at another passage: "Whereas in this book we shall only discuss by the light of reason, we will refer to no authorities, but will proceed as though no reliance could be placed on any man in the

LEONARDO DA VINCI

world, however wise, but only on natural reason [*ragione naturale*]."
Leonardo? No, Savonarola again.[12]

Should one consider Leonardo da Vinci and Savonarola to be of the
same mind, simply because they both repeated the old, very old, thesis
of Aristotle that no one can learn or understand anything in the
absence of sense?[13] Of course not, one must keep in mind not only the
origin but also the object of knowledge.

The following represents Savonarola's concept of the road to knowl-
edge: "It is by visible things that we must arrive at knowledge of the
invisible, inasmuch as all our knowledge is derived from sensation
[*ogni nostra cognitione comincia dal senso*], which only comprehends
outer, bodily attributes, whereas by intellect, which is subtle, we can
penetrate to the very substance of natural things and, after consider-
ing these, attain to the knowledge of invisible things."[14]

In contrast to Aristotle, who taught that general knowledge can be
attained through a single physical demonstration and that this general
knowledge should be examined in a sensual "phantasm," Savonarola
drew his thought from perceptible to "invisible objects," as did
Marsilio Ficino who, in speaking of the sun, stated that he was not so
much interested in astronomy as in "allegories of the divine": "we are
not so much interested in studying the sun, which is before us and
evident to all, as in clearing the eyes, uncovering them, averting them,
and, to the best of our ability, adapting them to that [abstract sun]."[15]
Leonardo always oriented his thought to the sensible and the visible.

The philosophy of experience was the basis of Leonardo's philoso-
phy of experimentation. In this philosophy one may trace the influence
of two traditions. First, Leonardo's experimentation was closely con-
nected with the tradition of the studios of the master craftsmen.
Second, he could not help but be affected to a certain extent by the
Aristotelian traditions of the northern Italian universities.

Leonardo asserted, with much greater persistence than his predeces-
sors, like Brunelleschi and Ghiberti, that the practical efforts of the
technician and artist should be based on conscious generalizations, on
general laws. These words of Leonardo must be interpreted in that
light: "science is the captain, practice the soldiers" (I 130r; MacCurdy
72). This means that no technician or artist, no *homo faber,* can act
blindly, seeking a solution by groping. It must be interpreted in this
way and not as an indication of the superiority of contemplation over

SCIENCE

practice. Another fragment, entitled "Of the error made by those who practice without science" (G 8r), must be interpreted in the same way. Here Leonardo wrote: "Those who are enamored of practice without science are like a pilot who goes into a ship without rudder or compass and never is certain where he is going. Practice should always be based upon a sound knowledge of theory" (G 8r; MacCurdy 910). This same thought crept into the draft of a future work: "First you must explain the theory and then the practice" (BM 171r; J. P. Richter 110). The relation of theory to practice is stressed even more sharply in these lines: "When you put together the science of the movements of water, remember to put beneath each proposition its applications, so that such science may not be without its uses" (F 2v; MacCurdy 670).

There is no evidence that Leonardo wrote or intended to write a general treatise on the scientific method, something similar to Francis Bacon's *Novum Organum* or Descartes' *Discourse on Method.* However, this does not mean that there are no statements on science and the scientific method in Leonardo's notebooks. Such statements do not appear in his manuscripts merely as fragmentary, independent aphorisms; more often they are interspersed among the special natural science discourses. Therefore, later "anthologies" of passages from Leonardo's notebooks, intended for a wide circle of readers, do not give an adequate idea of the originality of Leonardo's thinking. The thoughts of this great Italian are inevitably "atomized," separated, and converted into isolated aphorisms. His philosophical statements become didactic pronouncements "from the pulpit," not brooking any contradiction, though actually most of them were the fruit of deep and solitary meditation on specific, indeed highly specific, problems. Leonardo himself approved of digressions, saying: "One should not be censured for grafting into the scheme of scientific procedure any general rule derived from a previous conclusion" (BM 32v; Baskin 28). This comment appeared among his remarks on compound balances.

Leonardo often stated his conviction that "The nature of causes becomes clear from their effects, and the nature of the effects becomes clear from the causes" (BM 82v). This particular comment was inserted among the discussions of the laws of recoil. This theme of Leonardo's, who was living in Milan at the time, can be found in the preface of Peckham's *Perspectiva communis,* published by Fazio Cardano. As we know, Leonardo's manuscripts contain an Italian translation of this

LEONARDO DA VINCI

preface. Peckham says: "nunc effectus ex causis, nunc ex effectibus causas conclusimus"; in Leonardo it is: "alcuna volta conchiudendo gli effetti per le cagioni, e alcuna volta le cagioni per li effetti" (sometimes drawing conclusions about effects from causes, sometimes about causes from effects; CA 103r a). Leonardo included this same formula in the rough draft of his explanatory note for the model of the dome of the cathedral of Milan: "now drawing effect from causes (*cagioni*), now confirming reason (*ragioni*) through experiences" (CA 270r c).

This theme is woven as a leitmotiv into the fabric of specific deliberations. One may judge the nature and properties of wind by smoke coming from a cannon or by dust raised by the wind, by ships' flags fluttering "in different ways," since: "all these effects reveal to us the nature of their causes . . . We see how on the sea one part of the water is struck and not another; and the same thing happens in the piazzas and on the sandbanks of the rivers, where the dust is swept together furiously in one part and not in another" (CA 270v a; MacCurdy 384). Or, in this note on the flight of birds: "Here, by means of the attitudes of the birds, one sees the results of the effects." That is, from the positions of the birds, one may draw conclusions about the ensuing movements. "The wings, extended on one side and drawn up on the other, show the bird dropping with a circular movement around the wing that is drawn up. Wings drawn up equally show that the bird wishes to descend in a straight line" (CA 66r a; MacCurdy 422). This thesis is illustrated by two small drawings with graphic lines showing the directions of movement (figures 10 and 11).

The drawing together of causes (*cagioni*) and grounds for reason (*ragioni*) in this fragment of the notes on the Milan model is no mere play of consonance. For Leonardo, both concepts were closely bound: to discover the "cause" meant to discover the "reason," that is, the laws of the phenomenon. His method is defined concisely in the following excerpt on mechanics: "But first I will make some experiment before proceeding farther because it is my intention first to cite experience then to show by reasoning why this experience is required to act in this manner. And this is the rule by which speculators on natural effects have to proceed. And although nature commences with reason [*ragione*] and ends in experience, we must do the opposite, that is, to commence as I said before with experience and from this to proceed to investigate the reason" (E 55r; MacCurdy 528).

SCIENCE

Leonardo had no need to make his way through stacks of enormous folios to find a formulation of the principles of antiquity, particularly those of Aristotle. These ideas were common knowledge. Aristotle's instructions were repeated by his commentators in Padua, Pavia, and Bologna. For them, however, Aristotle's formulas were dogma, not a guide.

As we know, Aristotle distinguished between proof proceeding from cause to effect, that is, knowledge of "why" (*dioti*), and proof proceeding from an effect, an evident fact, to its cause, that is, proceeding from knowledge of "what is" (*hoti*).[16] The first type of proof is employed by mathematics, the second is employed by sciences based on sensual perception. Even among the ancient physicians, like Galen, and the medieval physicians of the East and of western Europe, this difference was posed in connection with the concepts of synthesis and analysis (*compositio et resolutio*) of the Greek geometricians. Let us skip the intervening historical stages and say, merely, that the northern Italian Aristotelians of Leonardo's time knew these differences well, and in the second half of the sixteenth century Giacomo Zabarella (1533–1589) developed a detailed theory of *resolutio et compositio,* paths from results based on the senses to their causes and back from hypothetically confirmed causes to their results.[17]

Experiments, according to Leonardo, are necessary when the causes of (*cagioni*) and the reasons for (*ragioni*) the phenomena are unknown. If they are known, experiments are unnecessary. He wrote: "There is no result in nature without a reason [*ragione*]; understand the cause and you will have no need of the experiment" (CA 147v a; MacCurdy 64). One cannot help but recall a statement by Salviati, one of the participants in Galileo's famous Dialogue.[18] In discussing the question, where on a ship a stone would fall if that ship stood still or moved at a particular speed, Salviati said: "Even without experiment, I am certain that the result would be as I tell you, since it must follow that . . ." In another work, Galileo says that "knowledge of a single fact acquired through a discovery of its causes prepares the mind to understand and ascertain other facts without need of recourse to experiment."[19]

In such cases, where the cause is known, experiment is merely a further verification of a known "law" (*ragione*) or, to be more exact, a graphic, convincing illustration, its demonstration. For Leonardo,

LEONARDO DA VINCI

dimostrazione was primarily an illustration of a general rule by a specific example, and for him *dimostrazione* also meant application of a particular case to a general, known law, with references to the corresponding book and postulate where it was (or should have been) formulated. He used the word *prova* in the same sense, but *prova* also meant trial, experimental clarification of a result which could not be predicted, which was still unknown, that is, what we call a "test" or an "experiment."

If the cause is not known, one experiment will not be enough to explain it, Leonardo asserted. One must learn to understand how trials or tests deceive those who have not grasped their nature, for "trials, often seeming identical, very often prove to be different" (I 102v). Leonardo required that an experiment be conducted two or three times or even more before a general law (*ragione*) could be derived from it: "But before you derive a general law from this case, conduct the test two or three times and see whether the tests give identical results" (A 47r). These remarks were made in connection with his experimental investigation of a vertical weight. Elsewhere, in application to his studies of the laws of falling bodies, he imposed a similar requirement: "And this experiment should be made many times so that no accident may occur to hinder or falsify this proof—for the experiment might be false, whether it deceived the investigator or no" (M 57r; MacCurdy 575).

The term "law of nature" had not yet been established in Leonardo's time and was not yet widely used. Leonardo used the word *regola* (rule) in this sense. For example, he called necessity the "rule (law) of nature" (Forst III 43v). As we shall see later, the expression "law of nature" still had a figurative shading for Leonardo. One of the fragments on levers (CA 153v d) ends with these solemn words: "And this answers the laws of nature and, therefore, cannot be avoided."

Experience is not a simple expression of some empirically stated phenomenon. Experience leads to knowledge of the need for the phenomenon. According to Leonardo: "Experience the interpreter between resourceful nature and the human species teaches that that which this nature works out among mortals constrained by necessity cannot operate in any other way than that in which reason which is its rudder teaches it to work" (CA 86r a; MacCurdy 63). "Nature does not break her own law [*non rompe sua legge*]" (E 43v; MacCurdy 454);

SCIENCE

it is "constrained by the workings of its law, which lives infused within it [*in lui infusamente vive*]" (C 23v; MacCurdy 664). "Necessity is the mistress and guardian of nature. Necessity is the theme and artificer of nature—the bridle, the law, and the theme" (Forst III 43v; MacCurdy 91). "How admirable Thy justice, O Thou Prime Mover! Thou hast not willed that any power should lack the processes or qualities necessary for its results" (A 24r; MacCurdy 519).

This law of necessity is simultaneously the law of minimum action. "O, marvelous Necessity, thou with supreme reason [*ragione*] constrainest all effects to be the direct result of their causes, and by a supreme and irrevocable law [*con irrevocabile legge*] every natural action obeys thee by the shortest possible process!" (CA 34v b; MacCurdy 238). "Any action performed by nature cannot be performed more quickly using the same means. If the causes are given, nature gives birth to the effects by the shortest means possible" (BM 175v). Or: "No act of nature can be shortened. Every act of nature is performed by nature by the shortest possible means that can be found" (CA 112v a).

A particular application of this general principle is the descent of bodies. "Every natural action is made in the shortest way: this is why the free descent of the heavy body is made toward the center of the world, because it is the shortest space between the movable things and the lowest depth of the universe" (G 75r; MacCurdy 551). Or: "Every weight tends to fall to the center by the shortest way" (C 28v; MacCurdy 525).

In discussing percussion, Leonardo defined the value of the natural laws he had discovered. "If you should ask me: 'what issues from your rules? Of what use are they?' I should answer that they restrain inventors and investigators, preventing them from promising to themselves or to others impossible things and thus being called fools or frauds" (CA 337r; Baskin 21). Or, in another version: "These rules enable you to distinguish the true from the false, and thus to set before yourselves only things possible and of more moderation; and they forbid you to use a cloak of ignorance, whereby you attain to no result and in despair abandon yourself to melancholy" (CA 119v a; MacCurdy 58).

Leonardo contrasted restraint, constraint, tranquility, and ability to set attainable goals with the unbridled strivings of those who attempt

LEONARDO DA VINCI

to accomplish the impossible, who wish to "perform miracles." The lot of such persons is melancholy and poverty. He repeated this constantly: "One ought not to desire the impossible" (E 31v; MacCurdy 69).*

Did Leonardo's sermon on "contentment with little," restraint and self-limitation, constraint, and tranquility show him to be the predecessor of Mill or Spencerian positivism? No, of course not! Let us take this aphorism: "To the ambitious, whom neither the boon of life, nor the beauty of the world suffice to content, it comes as penance that their life is squandered, and that they possess neither the benefits nor the beauty of the world" (CA 91v a; MacCurdy 63). This means that the "false sciences," based on "dreams" and fancies, lead from the "boons and beauties of the world" to a realm of impossible fancies, while science based on experience leads to the very heart of real life. Leonardo was infinitely far from agnosticism and pragmatism.

To trace in more detail an example of how Leonardo applied the method of *compositio et resolutio,* movements from causes to effects and from effects to causes, let us use the passages on the question whether a bat makes its sound with its mouth or its wings. Actually, the subject of the discussion is indifferent, it could be a mouse, an elephant, a lever, a human eye, a theorem from his study of aerial perspective, or something else.

Leonardo presents his first explanation in the form of a hypothesis: the cause of the sound is the breathing out of air. This hypothesis produces results that do not conform with experience: "If flies made with their mouths the sound that is heard when they fly, then since it is very long and sustained, they would need a great pair of bellows for lungs in order to drive out so great and so long a wind, and then there would be a long silence in order to draw into themselves an equal volume of air." Leonardo concludes: "Therefore, where there is a long duration of sound, there will be a long intermission" (BM 257v; MacCurdy 271). A further, implied conclusion is given *per modum tollentem,* by the destructive mode of an arbitrary syllogism, by the transition "from negation of the consequence to negation of the antecedent": since such an intermission does not occur, the fly does not produce the sound with its mouth (BM 257v; MacCurdy 272).

* Brion (*Génie et destinée,* p. 431) compares these words with a line from the second part of Goethe's *Faust*: "Den lieb' ich, der Unmögliches begehrt" (I love the one who attains the impossible).

SCIENCE

Thus, the path from the proposed cause to the result, the synthetic path, gives an equivocal result if the conclusion is negative. Even if the conclusion is in agreement with experience, this does not mean that the actual cause of the phenomenon has been found (if the sun is shining, it is light in the room; but it does not follow that the sun is shining because the room is light).

Leonardo often turned to discourse based on the destructive mode of a conditional syllogism when he had to refute false theories. He constructed all his arguments on fossil animals in this manner: "*If you should say* that the shells which are visible at the present time within the borders of Italy, far from the sea and at great heights, were deposited there by the Flood, I reply that, granting this Flood to have risen seven cubits above the highest mountain, as he has written who measured it, these shells which always inhabit near the shores of the sea ought to be found lying on the mountain sides, and not at so short a distance above their bases, and all at the same level, layer upon layer" (Leic 8v; MacCurdy 330). "*And should you say* that these shells . . . left their former place and followed the rising waters up to their highest level:—to this I reply that the cockle, when out of water, is a creature incapable of more rapid movement than a snail, or is even somewhat slower . . . and, therefore, with such a rate of motion it would not have traveled from the Adriatic Sea as far as Monferrato in Lombardy, a distance of two hundred and fifty miles in forty days, as he has said who kept a record of this time." Further: "*And if you say* that the waves carried them there,—they could not, by reason of their weight, move except upon their base . . . and *if you should say* that the shells were empty and dead when carried by the waves, I reply that where the dead ones dropped, they were not separated from the living ones" (Leic 8v; MacCurdy 331).

Leonardo argued just as consistently against astrological explanations. "As for those who say that these shells were created in ancient times at a distance from the sea by the nature of the locality and the disposition of the heavens, which moves and influences the place to create such animal life, to these it may be answered that such an influence, creating animals and acting along a single line, would create animals of the same species and age, and not the old with the young" (Leic 9r; MacCurdy 332).

But let us return to a fly in flight. To give a positive answer to the

cause of its sound, Leonardo turned to experiment, using the method which later was called the method of attendant changes. "That the sound which flies make proceeds from their wings, you will see by cutting them a little, or better still by smearing them a little with honey in such a way as not entirely to prevent them from flying, and you will see that the sound made by the movement of the wings will become hoarse and the note will change from high to deep to the same extent as the fly has lost the free use of its wings" (W An A 15v; MacCurdy 272).

After this, can one agree with Olschki that Leonardo "definitely lacked a sense of method," that he lacked "logical strictness"? We have just seen that Leonardo made splendid use of syllogisms when necessary, in polemics with his opponents, in the struggle against obsolete views. Using deduction and demonstration of the disagreement between the conclusion and the experimental results, he also destroyed the Pythagorian concept of the music of the spheres (F 56v). However, he paid little heed to this approach when it came to the discovery of new facts, the creation of a positive theory; in such cases he sought and experimented repeatedly, varying the experimental conditions.

Recently S. Lilley wrote a special report on Leonardo's experimental method. He was quite right in his statement that "the experimental method should not be confused with mere proliferation of experimentation,"[20] and he correctly differentiated two main traditions, the productive or craftsman's tradition and the university or theoretical tradition. He assumed that the first genuine fusion of the two occurred in Galileo's work. He did not discern the characteristics of authentic *resolutio et compositio* in Leonardo. Leonardo did not do what Galileo did, that is, he did not draw mathematical and logical conclusions from a hypothesis and then confirm it by experiment, according to Lilley, but always began with the experiment in order to end with a theory. I cannot agree with this, although the difference between Leonardo and Galileo is great. Lilley's assertion is refuted not only by the cited passage on the buzzing of the fly, but by the verification of all initial hypotheses based on analogy, of which we shall speak in more detail later.

Leonardo's realm of experimentation was indeed unlimited. One need but recall Lomazzo's story of the experiments which Leonardo

SCIENCE

the artist performed on living persons. "Once he wished to make a picture of some laughing peasants. He picked out certain men whom he thought appropriate for his purpose and, after getting acquainted with them, arranged a feast for them with some of his friends and, sitting close to them, he proceeded to tell the maddest and most ridiculous tales imaginable, making them, who were unaware of his intention, laugh uproariously. Whereupon he observed all their gestures very attentively and those ridiculous things they were doing and impressed them on his mind and, after they had left, he retired to his room and there made a perfect drawing which moved those who looked at it to laughter as if they had been moved by Leonardo's stories at the feast."[21]

It is quite generally accepted that Leonardo's scientific pursuits, in particular his experimentation, was closely affiliated with his painting. One should not interpret this statement in the sense that the two types of creative work were indistinguishable. Of course, the anatomical drawings delight the artist, and the accuracy of the details of his paintings can draw the admiration of the geologist or botanist.[22]

One must recall the *Virgin of the Rocks,* where the great painter masterfully depicted various types of trees, different stages of the erosion, and the destruction of rocks by water. As a hydraulic engineer Leonardo must have devoted special attention to the action of water, and as a construction engineer, chemist, and physiologist he studied vegetation on a much broader basis than was necessary for a painter.

Even if Leonardo did arrive at botany through painting, he understood perfectly well that many of his observations were "of no importance in painting" (TP 829; Richter 175), for example, his observations on concentric annual tree rings, by which he determined the age of trees, and, to a certain extent, his studies of the laws of leaf distribution (phyllotaxis).

Among Leonardo's botanical notes one may find observations of geotropic and heliotropic phenomena, experiments on the movement of tree sap. "When a tree has had part of its bark stripped off, nature, in order to provide for it, supplies to the stripped portion a far greater quantity of nutritive moisture than to any other part; so that because of the first scarcity which has been referred to, the bark grows much more thickly there than in any other place. And this moisture has such power of movement that after having reached the spot where its help

is needed, it raises itself partly up like a ball rebounding, and makes various buddings and sproutings, somewhat after the manner of water when it boils" (CA 76r a; MacCurdy 299). He sought to trace the nourishing of plants through an interesting experiment with a gourd. "The sun gives spirit and life to plants, and the earth nourishes them with moisture. In this connection, I once made the experiment of leaving only one small root on a gourd and keeping this nourished with water; and the gourd brought to perfection all the fruits that it could produce, which were about sixty gourds of the long species; and I set myself diligently to consider the source of its life, and I perceived that it was the dew of the night which steeped it abundantly with its moisture through the joints of its great leaves, and thereby nourished the tree and its offspring, or rather the seeds which were to produce its offspring" (G 32v; MacCurdy 939).

To study how humus formed, Leonardo planned a ten-year experiment. "Take a vase, fill it full of pure earth, and set it up on a roof. You will see how immediately the green herbs will begin to shoot up, and how these, when fully grown, will cast their various seeds; and after the children have thus fallen at the feet of their parents, you will see the herbs that have cast their seeds becoming withered and falling back again to the earth, and within a short time becoming changed into the earth's substance and giving it increase; after this you will see the seeds springing up and passing through the same course, and so you will always see the successive generations after completing their natural course, by their death and corruption giving increase to the earth. And if you let ten years elapse and then measure the increase in the soil, you will be able to discover how much the earth in general has increased, and then by multiplying you will see how great has been the increase of the earth in the world during a thousand years" (CA 265r a; MacCurdy 317).

Leonardo also arrived at human anatomy through painting, but not all his anatomical activities were associated with art. Here is eloquent evidence: "You will make an anatomy of the wings of a bird together with the muscles of the breast, which are the movers of these wings. And you will do the same for a man, in order to show the possibility that man has for sustaining himself amid the air by the beating of wings" (CA 45r a, written 1503–1505; MacCurdy 421). In this case his anatomical studies were associated with the field in which his genius for innovation was especially apparent, aviation.

SCIENCE

Problems connected with the flight of birds were not discussed in the old literature, except for legendary tales (the artificial dove of Architus) and scanty and obscure remarks of individual authors, for example, Aristotle and Galen. Such discussions did not crop up specifically and persistently until the Middle Ages, namely, in the art of falconry and the treatises devoted to it. These treatises bear traces of intent study of the flight of birds and the details of their anatomical structure. For instance, the functions of the "little wing" (*alula*), which Leonardo called the "rudder" or the "thumb" of the wing, was described in part in the thirteenth century treatise *De arte venandi cum avibus* (On the art of hunting with birds) by Frederick II. What Leonardo called reflected movement on the wind (ascent of a bird due to the kinetic energy it acquired and the change of position of the wings) was known to French authors of works on hunting with falcons.[23] Falconry was very popular in Milan, but it is quite difficult to assess the extent to which Leonardo used such works.

Vasari relates how the great artist, "passing by the places where birds were sold, took them with his own hand out of their cages, and having paid to those who sold them the price that was asked, let them fly away into the air, restoring to them their lost liberty."[24] Vasari cites this story as an example of Leonardo's great love of animals, but Leonardo the naturalist and Leonardo the designer could have been observing the characteristics of the movements of the flying birds at the same time.

In 1460 G. B. Danti of Perugia made the first attempt to fly with moving wings. It suffices to say that this unsuccessful flight was not preceded by the mass of observations and experiments that Leonardo conducted. It is important that Leonardo's observations were supplemented by the construction of models. A small drawing in the manuscript *Sul volo degli uccelli* (On the Flight of Birds) depicts a device for determining the center of gravity of a bird, without which, Leonardo states, the flying machine would not be worth much (VU 15v). He designed a special model to help study the part played by the tail: "Let there be suspended here a body like that of a bird in which the tail turns at various angles. With such a model, you can give general rules for different turnings of birds for the case of movements made by bending of the tail" (L 61v).

Model building was a distinctive feature of Leonardo's scientific activities in various fields: one need but recall the glass models of the

LEONARDO DA VINCI

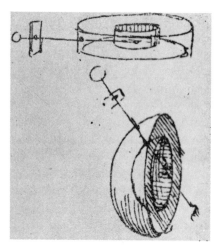

16. "How the solar rays penetrate this curve of the sphere of the air"

eye (D 3v), the river bed (Leic 9v; I 115r), the Mediterranean Sea (CA 84v a). "In order to see how the solar rays penetrate this curve of the sphere of the air, have two balls made of glass, one twice as large as the other and let them be as round as possible. Then cut them in half, place one inside the other, close them in front and fill them with water" (F 33v; MacCurdy 280). (See figure 16.) Leonardo turned his thoughts toward glass models on several occasions, models which would allow one to "see in the glass what the blood does in the heart, when it closes the flaps of the heart" (W An II 6v; Reynal 383). (See figure 17.)

One can get an idea of the ease with which Leonardo went from the small to the large. From a description of the movement of water in two small canals he drew bold conclusions about sea tides. "I have seen in the case of two small canals, each two braccia wide and serving as a line of demarcation between the road and the estates, how their waters clashed together with unequal force, and then united, and bent at a right angle, and passed underneath a small bridge by this road and continued their course. But what I want to refer to in them is that they formed there a flow and ebb, with a height of a quarter of a braccio." Having described in detail the movement of the streams and the change in levels, Leonardo concluded: "And if this ebb and flow created within so small a quantity of water has a variation of a quarter of a braccio, what will it be in the great channels of the seas which are shut in between the islands and the mainland? It will be so

SCIENCE

17. Glass model of the heart

much the more in proportion as its waters are greater" (Leic 35r; MacCurdy 768, 769).

The Roman architect Marcus Vitruvius concluded his work on architecture with an entertaining story about the Rhodian architect Diognetius, by which he illustrated the proposition that "not all things are practicable on identical principles, but there are some things which, when enlarged in imitation of small models, are effective, others cannot have models, but are constructed independently of them, while there are some which appear feasible in models, but when they have begun to increase in size are impracticable."[25]

This thought was developed subsequently by Galileo at the very beginning of his Dialogues. He posed the question, why "many devices which succeed on a small scale do not work on a large scale." On the Second Day of these Discourses, Galileo wrote of "the impossibility of building ships, palaces, or temples of enormous size in such a way that their oars, yards, beams, iron bolts, and, in short, all their other parts will hold together." On the contrary, "if the size of a body be diminished, the strength of that body is not diminished in the same proportion." Galileo illustrated his thoughts with all kinds of examples. An oak 200 braccia high would not be able to sustain its branches if they were distributed as in a tree of ordinary size; and nature cannot produce a horse as large as twenty ordinary horses or a giant ten times taller than an ordinary man unless by miracle or by greatly altering the proportions of his limbs and especially of his bones, which would have to be enlarged over the ordinary." Galileo referred to the

LEONARDO DA VINCI

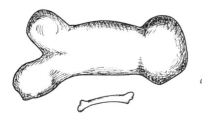

*18. Bones of a giant
and of a normal human*

poet Ariosto, who said, in describing a giant: "Impossible it is to reckon his height, so beyond measure is his size."[26] He also made a clear attempt to determine, on the basis of the laws he had found, the shape which the bones of a giant would have if they were to be as strong as the bones of an ordinary man, and he placed pictures of such bones in his book (figure 18).[27]

An older contemporary of Leonardo's, Leon Battista Alberti, ignored the instructions of Vitruvius and spoke of the similarity of figures. He developed, in general form, the study of the relativity of large and small, the retention of the same proportions in the large and the small. "Nor was there any other proportion in the limbs of Hercules than there was in those of Antaeas the giant, for as the hand answered in proportion to the arm, and the arm to the head and other members, in equal measure with respect to each other, so it is in these triangles, which upon measuring each of the parts respectively, correspond the greater with the smaller in all respects, except in bigness."[28]

Leonardo shared Alberti's point of view. He openly opposed Vitruvius. "Vitruvius says that small models are not confirmed in any operation by the effect of large ones. As to this, I propose to show here that his conclusion is false, and especially by deducing the self-same arguments from which he formed his opinion, that is, by the example of the auger [*trivella*], as to which he shows that when the power of a man has made a hole of a certain diameter, a hole of double the diameter cannot then be made by double the power of the said man but by much greater power. As to this, one may very well reply by pointing out that the auger of double the size cannot be moved by double the power, inasmuch as the surface of every body similar in shape and of double the bulk is quadruple the quantity of the other, as is shown by the two figures a and n. Here one removes by each of these two augers a similar thickness of wood from each of the holes that they make; but in order that the holes or augers may be of double quantity, the one

SCIENCE

19. "The surface of every body similar in shape and of double the bulk is quadruple the quantity of the other"

of the other, they must be fourfold in extent of surface and in power" (L 53v–53r; MacCurdy 624). (Figure 19.)

This type of thinking by Leonardo was expressed most clearly in his discourses on a vertical load. As we know, Leonardo's formula for the resistance of vertical rods can be expressed as $a^2:l/a$, where a^2 is the base of the cross section, and l is the relative height. It was not until the eighteenth century that Leonhard Euler established that the formula is more complex. Thus even in this case Leonardo did not distinguish between geometric and mechanical similarity. The fragments on this subject show that Leonardo carried out experimental studies; but from them it is clear that his orientation point was the initial formula $a^2: l/a$, which needed verification. There are errors in calculating it, but it remained for him the guide in most of the specific examples he analyzed. In a number of cases Leonardo departed from the thesis that everything must be identical for large and small; for example, the proportion of wing size and weight is not identical for the eagle and the bat. However, in this instance Leonardo sought the basis for the differences in a whole complex of features of anatomical structure and not in some equivocal mechanical law, as did Galileo.

Leonardo did not have any special laboratories for his various experiments, but in some of his notes we find explicit instructions for laboratory technicians, for example: "Carry out this experiment with a small glass sphere striking against the smooth surface of a stone; and take a long rod, marked with different colors; and when you have everything ready, have someone hold the rod and observe, standing at a distance, the recoils, observe to what colors on the rod the ball reaches in bouncing. And if there are as many markers as there are recoils, it will be easier to remember each one" (A 60r).

It is interesting that the first grounds for experimentation were sometimes things that Leonardo had observed in folk practice. For example,

LEONARDO DA VINCI

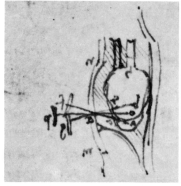

20. *Experiments with the
heart of a pig*

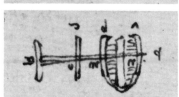

on observing the slaughtering of pigs in Tuscany, he decided to make an experimental study of heart beat. We cite only the excerpt with a description of the experiment itself, omitting the subsequent discussion and details. "The change of the heart at its death is similar to the change which it undergoes during the expulsion of its blood, and is somewhat less. This is shown when one sees the pigs in Tuscany, where they pierce the hearts of the pigs by means of an instrument called a borer [*spillo*], which is used for drawing wine out of casks." Leonardo set up the following experiment on the basis of the technique used to slaughter pigs (see figure 20).

And thus, turning the pig over and tying it up well, they pierce its right side and its heart at the same time with the borer, thrusting it in a straight line. And if this borer pierces the heart when it is distended,

SCIENCE

the heart as it expels the blood becomes contracted and draws the wound to the top together with the point of the borer; and the more it raises the point of the borer within, the more it lowers the handle of the borer outside; and afterwards when the heart is distended and drives this wound downward, the part of this borer which is outside makes a movement that is the opposite to that of the part within, which moves together with the movement of the heart. And this it does many times, so that at the end of life that part of the borer that is outside remains in the middle of the two extremities, where were the last contrary movements of the heart when it was alive. And when the heart becomes quite cold, it shrinks somewhat and contracts as much as it had extended when warm, because heat causes a body to increase or diminish when it enters into it or leaves it; and this I have seen many times and have observed such measurements, having allowed the instrument to remain in the heart until the animal was cut up" (W An I 6r; MacCurdy 164).*

He attempted to bring another folk technique, used as an amusement, to the level of a deliberate, judicious experiment. To learn how "sound is produced in the front of the trachea," Leonardo deliberated on how to extract it together with the lung from a cadaver: "If this lung be filled with air and then closed rapidly, one will be able immediately to see in what way the pipe called the trachea produces this sound; and this can be preceived and heard well in the neck of a swan or a goose, which often continues to sing after it is dead" (W An A 3r; MacCurdy 94).

The problem of building models is closely allied with analogies in Leonardo's scientific activity. The fragments of Leonardo's manuscripts that contain the rudiments of comparative anatomy have long been of interest. These fragments, of course, do not contain any hint of evolution. Leonardo stated firmly and definitely that "nature is the same always and in all things"; "she does not change the ordinary kind of things that she creates" (W An B 28v; MacCurdy 142).

Although Leonardo believed in strict isolation of biological species, he posed the problem of their comparative study: "for whoever knows

* Referring to van Leersum, Imbert (*Un Anatomiste de la Renaissance,* p. 31) writes that Leonardo's method "formed the basis for Schiff's experiments on heart nerves" and that "thanks to this method, Wagner in 1854 was able to determine the rate of heart contraction, and somewhat later (1891) J. Berry Haycraft employed this method in constructing the cardiograph."

how to represent man can then attain to universality, for all animals which live upon the earth resemble each other in their limbs, that is, in muscles, sinews [*nervi*], and bones, and they do not vary at all, except in length or thickness, as will be shown in the Anatomy. There are also the aquatic animals, of which there are many different kinds; but with regard to these, I do not advise the painter to make a fixed standard, for they are of almost infinite variety; and the same is also true of the insect world" (G 5v; MacCurdy 909).

His attempt to classify related species of land animals can be seen in this fragment: "The description of man, in which is contained those who are almost of the same species, like the baboon, the ape, and others such as these, which are many. Lion and its followers: such as panthers, jaguars, tigers, leopards, lynxes, Spanish cats, gannetti, and ordinary cats, and the like. Horse and its followers: such as the mule, the ass, and the like, which have teeth above and below. Bull and its followers: which are horned and without upper teeth, such as buffalo, stag, fallow deer, roebuck, goats, sheep, ibex, milch cows, chamois, giraffes" (W An B 13r; MacCurdy 191).*

Leonardo returned many times to a comparison of the extremities of animals. "For this comparison you should represent the legs of frogs, for these have a great resemblance to the legs of man, both in the bones and in the muscles; you should afterwards follow this with the hind legs of the hare, for these are very muscular and the muscles are well defined because they are not hampered by fat" (W An V 23r; MacCurdy 194). In examining the similarities he often mentioned the differences as well. "Represent here the foot of the bear, the monkey, and other animals, insofar as they differ from the foot of man; and include the feet of some of the birds" (W An A 17r; MacCurdy 105). In comparing the upper extremities of the leopard, Leonardo said that when the sinew draws the bone closer to the hand (*mano*), this hand raises a greater weight "and this is the case with the monkey, which is more powerful in its arms than man is according to his proportion" (W An B 9v; MacCurdy 191).

The page with the drawings of the extremities of various animals and the following text is very interesting: "Show a man on tiptoes, so

* One can get an idea of how indefinite Leonardo's terminology was, especially in the field of entomology, from his description of a "fly" (*mosca*), which actually was a bee (G 92r). He speaks of the upper and lower wings of a "fly." But, as Bodenheimer ("Léonard de Vinci et les insects," p. 149) remarked, even much later Aldrovandi (1522–1607) and Moffet (*ca.* 1550–*ca.* 1600) spoke of four-winged "flies."

SCIENCE

that you may better compare a man with other animals. Represent the knee of a man bent like that of a horse. To compare the bone structure of a horse with that of a man, you should show the man on tiptoe in representing the legs. Show the relationship that exists between the arrangement of the bones and muscles of animals and of man" (W An V 22r; MacCurdy 193). Later Leonardo wrote: "Here I make a note to show the difference there is between man and horse and in the same way with the other animals" (K 109v; MacCurdy 197).

Leonardo placed similar requirements on descriptions of the intestines. "Write of the varieties of the intestines of the human species, apes, and such like; then of the differences that are found in the leonine species, then the bovine, and lastly the birds; and make this description in the form of a discourse" (W An B 37r; MacCurdy 192). He attempted to make similar comparisons elsewhere in the same manuscript (W An B 14v).

One should also recall the comparison of the differences in the eyes of the "leonine" species and of man (W An B 13r), or the pupils of the eyes of various animals, especially the nocturnal ones, a comparison which concludes with these words: "Study the anatomy of the various eyes and see which are the muscles that open and close the said pupils of the eyes of animals" (G 44r; Richter 166).

To get a proper perspective of Leonardo's notes on comparative anatomy, one should recall that he was not so much interested in comparing the morphological structure as such, as in discovering the general laws of their particular functions, primarily the *mechanism of movements.* "After the demonstration of all the parts of the limbs of man and of the other animals, you will represent the proper method of action of these limbs, that is, in rising after lying down, in moving, running, and jumping in various attitudes, in lifting and carrying heavy weights, in throwing things to a distance and in swimming, and in every act you will show which limbs and which muscles are the causes of the said actions, and especially in the play of the arms" (W An A 11v; MacCurdy 98). The practical aim of such observations of comparative anatomy and comparative functions becomes quite obvious, among other things, from the following discussion of the flight of birds and the possibility that man might fly.

> You will perhaps say that the sinews and muscles of a bird are incomparably more powerful than those of man . . . But the reply to this

is that such great strength gives it a reserve of power beyond what it ordinarily uses to support itself on its wings, since it is necessary for it, whenever it may so desire, either to double or treble its rate of speed in order to escape from its pursuer or to follow its prey. Consequently, in such a case it becomes necessary for it to put forth double or treble the amount of effort, and in addition, to carry through the air in its talons a weight corresponding to its own weight. So one sees a falcon carrying a duck and an eagle carrying a hare, which circumstance shows clearly enough where the excess of strength is spent, for they need but little force to sustain themselves, and to balance themselves on their wings, and to flap them in the pathway of the wind and so direct the course of their journeyings; and a slight movement of the wings is sufficient for this, and the movement will be slower in proportion as the bird is greater in size (VU 16r; MacCurdy 417).

Leonardo felt the analogy between swimming and flying was decisive for aviation: "Write of swimming under water and you will have the flight of the bird through the air" (CA 214r d; MacCurdy 431). He did not use analogies for their own sake, however. Analogy invited a search for differences. Leonardo asked: Does the point of the wings of a bird serve to guide it through the air as the arm of a swimmer under water, or does it act in the opposite direction (K 13r; MacCurdy 483)? In another note (VU 18r) Leonardo decided in favor of the latter explanation. This question long remained unclear and controversial, and Leonardo was not proved correct until the second half of the nineteenth century.

Olschki[29] was completely wrong when, in finding that Leonardo drew a comparison between the surface of water and stockings "which cover the legs and reveal what is hidden beneath them" (A 59v; MacCurdy 660), he didactically concluded that such an explanation "would perhaps satisfy the curiosity of a child." Leonardo was by no means satisfied with this type of analogy—all the variants of the different observations and experiments, the multitude of notes, were to have revealed very specifically the means by which the properties of a water surface "reveal what is hidden beneath it." Is this not the meaning of the discussion of the underwater stone and how it changes the flow of water on the surface? "If the rock in a river projects above and divides the course of the water which rejoins after this rock, the interval that is found to exist between the rock and the reunion of the water will be the place where the sand becomes deposited. But if the

SCIENCE

rock that divides the course of the waters is covered by the flowing waters only in its lower parts, the water that passes above will fall behind it and form a hollow at its feet and cause it to turn; and the water that falls headlong into this chasm turns in vortices upward and downward, for the uniting of the two streams of water which had been divided by the rock does not allow the water immediately to pursue its journey" (I 67v; MacCurdy 712). And is not the following pictorial description devoted to the same subject? "*Why does a solitary rock in the level bed of a stream cause the water beyond to form many protuberances?* The reason for this is that the water which strikes this rock afterwards descends and makes a kind of pit, in which in its course it searches for the hollow and then leaps back to a height and again falls down to the bottom and does the same, so continuing many times, like a ball that is thrown on the ground, which before it finishes its course, makes many bounds each smaller than the one before it" (A 60r; MacCurdy 660).

In the old biological-medical literature an analogy was often drawn between the ebb and flow of the tides and the movement of blood and breathing. Leonardo also followed this approach, but in a number of cases he proceeded from the opposite direction, characterizing geophysical processes in biological terms. Some authors are inclined to rebuke him for this approach, blaming it for his most fantastic analogies. Leonardo wrote, for example: "The body of the earth is of the nature of a fish, a grampus, or sperm whale, because it draws water as its breath instead of air" (CA 203r b; MacCurdy 64).

Again Olschki is wrong in asserting that "Leonardo gives himself over to play with imaginary analogies, he compares the movement of the heart to the movement of the earth, compares the flow of blood with the flow of water and *is satisfied* with these effective combinations. For him they *suffice* to explain the laws of truth."[30] It must be remembered that for Leonardo such statements were the beginning, not the end of a thought process. A declaration such as "the body of the earth is the body of a grampus" was a starting point for further verification by carrying the analogy to its ultimate conclusion and, if need be, rejecting it. For example, after drawing the initial analogy, Leonardo made calculations to determine the magnitude of the "light" Earth, and these calculations evidently led him to reject the initial analogy. For one thing, the dimensions of his calculated light Earth did not conform to the magnitude of the ebb and flow tides, and

LEONARDO DA VINCI

for another, "The Earth does not move as a breast moves," otherwise "the wind emerging from the Earth during the 6 hours of the flow tide would be the most powerful, and the second most powerful wind would blow during the other 6 hours" (CA 260r a).

At this stage of history, when the mechanism of tides and the movement of the blood and respiration were equally unresolved processes, it was quite proper to attempt to compare the two, to try to determine whether the laws that govern them had something in common. This, not an animistic interpretation, is the essence of the comparison. The analogy was not meant as an explanation, but as an attempt to continue along the hypothetical path from "cause" to "effect," and was subject to further experimental verification.

One must also recall that in some of these analogues we are not concerned with Leonardo's original thoughts, but with excerpts from the works of others. One need but compare the Leonardo text cited below with Ristoro d'Arezzo's *Della composizione del mondo* (On the composition of the world), published in 1282. Leonardo wrote:

> Nothing grows in a spot where there is neither sentient, fibrous, nor rational life. The feathers grow upon birds and change every year; hair grows upon animals and changes every year, except a part, such as the hair of the beard in lions and cats and creatures like these. The grass grows in the fields, the leaves upon the trees, and every year these are renewed in great part. So then we may say that the Earth has a spirit of growth, and that its flesh is the soil; its bonds are the successive strata of the rocks which form the mountains; its cartilage is the tufa stone; its blood the springs of its waters. The lake of blood that lies about the heart is the ocean. Its breathing, the ebb and flow of the blood in its pulses, is the ebb and flow of the sea in the Earth. And the vital heat of the world is fire, which is spread throughout the Earth; and the dwelling place of its creative spirit is in the fires, which in divers parts of the Earth are breathed out in baths and sulphur mines, and in volcanoes, such as Mount Etna in Sicily, and in many other places (Leic 34r; MacCurdy 86).

Ristoro d'Arezzo[31] wrote:

> And if we examine the origin of things and think of it, inside the Earth we will find hardened earth and generated soft stones, which

SCIENCE

differ little from earth, and they for the Earth are like the sinews of an animal. And going a step farther, we will find generated stones that are harder and differ more from earth; and they for the Earth shall be as bones for an animal. And we may draw an analogy and compare the body of an animal with the body of the Earth, and we may liken the meat to earth, the soft stones to sinews, the hard rocks to the bones, the blood which flows through the veins to water which flows about the body of the Earth, and the hair to plants.*

In the middle of the seventeenth century the Florentine Academy of Experimentation (*Accademia del Cimento*) used the motto *Provando e Riprovando* (Test and Test Again). It set as its goal the experimental verification of new and old postulates, going back as far as the Aristotelian theory of antiperistasis. Essentially Leonardo followed this motto, subjecting to reason and experimentation the propositions he encountered in books such as Ristoro d'Arezzo's. In other words, Leonardo used analogies not only to prove (*provare*) various postulates, but more often to verify and test them, and the Italian word for this is also *provare*.

* I spell Earth with a capital letter wherever it refers to our planet, and with a small letter when it refers to one of the four elements. The frequent repetition of *terra* in the original is retained in the translation.

4.

THE EYE, SOVEREIGN
OF THE SENSES

*"What moves you, man, to abandon your home in town
and leave relatives and friends, going to country places
over mountains and up valleys, if not the natural beauty
of the world, which, if you consider well, you know you
enjoy with the sense of sight alone?"*
TP 23; McMahon 42

ARISTOTLE'S *Metaphysics* begins: "All men by nature desire to know.
An indication of this is the delight we take in our senses, for even apart
from their usefulness, they are loved for themselves; and above all others
the sense of sight. For not only with a view to action, but even when
we are not going to do anything, we prefer seeing to everything else.
The reason is that this sense, most of all the senses, makes us know
and brings to light many differences between things."[1] This quotation
was widely known in Leonardo's time, as evidenced by a paraphrase
of it in Savonarola's *Compendium totius*.[2]

Referring to Aristotle, Leonardo's friend Luca Pacioli wrote: "On
the authority of those who know, sight is the source of knowledge."
Or, as he stated elsewhere: "there is nothing in the intellect that was
not previously in sensation. In other words, there is nothing in the mind
which had not been given it beforehand in some manner by sensation.
And of our senses, the sages say, sight is the most noble. That is why
even the common people, justifiably, call the eye the first door through
which the mind perceives and receives things."[3]

An older contemporary of Leonardo's, Leon Battista Alberti, having
chosen a winged eye as his emblem, defined sight as the "shrewdest"
sense, allowing one "immediately to hit upon what is right and wrong
in the contrivance or execution of things."[4] Compare his other, more
expressive statement: "There is nothing more powerful, nothing more

THE EYE

rapid, nothing more worthy than the eye. What more can be said? The eye is such that among the members of the body it is first, the chief one, it is king and, as it were, God." [5]

However, none of these authors spoke so much and so exaltedly of the eye as did Leonardo da Vinci. The excerpt from the Treatise on Painting that can justly be called "In praise of the Eye" (TP 28; McMahon 34) is twice interrupted by emotional exclamations: "O, most excellent above all other things created by God, what praises are there to express your nobility? What peoples, what tongues, can describe your scope?" And, further: "But what need is there for me to carry my discourse to such heights and lengths? What is there that is not accomplished by the eye?"

For Leonardo, the loss of vision is equivalent to expulsion from the world, such a life is the "sister of death," unbearable, unceasing "torment." "Who is there who would not wish to lose the senses of hearing, smell, and touch before losing sight? For he who loses his sight is like one expelled from the world, for he does not see it any more, nor anything in it. And such a life is a sister to death" (TP 15 a; McMahon 27). "The eye is the window of the human body through which the soul views and enjoys the beauties of the world. Because of it, the soul is content in its human prison, and without it this human prison is its torment" (TP 28; McMahon 34). Or, in another variant: "The eye, which is called the window of the soul, is the chief means whereby the understanding may most fully and abundantly appreciate the infinite works of nature" (BN 2038 19r; MacCurdy 852). That is why "He who loses his sight, loses the beauty of the world and all the forms of created things" (TP 27; McMahon 158).

Leonardo, as an observant artist, returned to this theme in a new variant, describing in detail and analyzing all the movements of a man trying to protect his eye, "the window of his soul," from imminent danger. "Since the eye is the window of the soul, the latter is always in fear of being deprived of it, to such an extent that when anything moves in front of it which causes a man sudden fear, he does not use his hand to protect his heart, the source of his life, nor his head, where dwells the lord of the senses, nor his hearing, nor sense of smell, nor taste; but the affrighted sense, not contented with shutting his eyes and pressing their lids together with the utmost force, causes him to turn suddenly in the opposite direction; and not as yet feeling secure, he covers them

with one hand and stretches out the other to form a screen against the object of his fear" (CA 119v a; MacCurdy 232).

The legend of Democritus, who was said to have blinded himself, was widespread in ancient literature. The motivations were given differently, however. According to Cicero, he did this so that "his spirit would be less removed from his reasoning." Similarly, Aulus Gellius held that Democritus acted thus to "attain more penetrating thoughts." Tertullian gives the motivation as Christian asceticism, the struggle against sensual temptations, the "desires of the flesh."[6] Taking this legend as his basis, Leonardo protested against the insanity of one who would "pluck out his eyes in order to remove the impediment to his discourses" (TP 16; McMahon 13).

However, his polemic was not really directed against the materialist Democritus, but against the Platonic homily of separation from the world or dying to separate the soul from the body. "Is there any certainty in human sight and hearing, or is it true, as the poets are always dinning into our ears, that we neither hear nor see anything clearly and accurately, the rest can hardly be so, because they are all inferior to the first two." The soul attains to truth when "it is free of all distractions such as hearing or sight or pain or pleasure of any kind—that is, when it ignores the body and becomes as far as possible independent, avoiding all physical contacts and associations as much as it can, in its search for reality." The person who is likely to succeed in understanding "is the one who approaches each object, as far as possible, with the unaided intellect, without taking account of the sense of sight in his thinking, or dragging any other sense into his reckoning . . . cutting himself off as much as possible from his eyes and ears and virtually all the rest of his body." The mind is such, according to Plato, that it is purified by being "separated as much as possible from the body."[7] For Plato, blindness to the world and deliverance from the sensate world were indispensable traits of the philosopher and sage. In *Theaetetus* (174a) he tells the story of Thales, who fell into a well while looking at the stars. About this a Thracian servant girl jested that he was so eager to know what was going on in the heavens that he could not see what was before his feet.

Leonardo held the diametrically opposite view: "The soul desires to dwell with the body because without the members of that body it can neither act nor feel" (CA 59r b; MacCurdy 61). The body is the prod-

THE EYE

uct of the soul and, therefore, "we part from the body with extreme reluctance." "And I indeed believe," adds Leonardo, "that its grief and lamentation are not without cause" (W An A 2r; MacCurdy 80). This interpretation of the ancients' picture of the body prison is important. For the Orphics and for Plato, the body was a prison because in it the soul was separated from its "heavenly home." For Leonardo it was a prison if the soul could not communicate directly with the surrounding world by means of the eye.

N. Ivanov[8] attempted to draw a parallel between Leonardo's view of the soul departing unwillingly from the body and Marsilio Ficino's approach, but such a comparison can only be superficial. A. Chastel[9] was quite correct in pointing out that the statements of Ficino and Leonardo are essentially contradictory: for Leonardo, the soul does not wish to part from the body, but for Ficino, the body does not wish to part from the soul. This is what the Florentine Platonist Ficino says: "There is an attachment of God for angels, angels for souls, souls for bodies, which they govern, but bodies most avidly [*avidissime*] combine with their souls and most unwillingly [*molestissime*] part from them." [10] In another work, *Theologia platonica de immortalitate animorum,*[11] which Leonardo had in his library, Ficino devotes special attention to the problem of "why souls part unwillingly from bodies," even though they are of "heavenly origin." He notes, in particular, that not all the dying weep, while all newborn without exception cry; even in those who fear death "not all the soul is seized with fear," and so forth. How far this is from Leonardo's view!

Ficino wrote his treatise *De lumine* (On light)[12] in 1476, when Leonardo was twenty-four years old. In it he said that "light is the smile of heaven, as it were, stemming from the rejoicing of the heavenly spirits." In 1480 he wrote on the Orphic likening of the sun to God,[13] and he developed the same themes later, in 1492, in his treatise *De sole* (On the sun).[14] In the final analysis the sun for Ficino was a symbol intended to give knowledge of "transheavenly" light. This "heliosophy" of the Florentine Platonist was foreign to Leonardo, whose sun was not symbolic, but the real, warming southern sun, the sun of the astronomers.

The Platonist precept "we should make all speed to take flight from this world to the other" (*enthend'ekeise*)[15] was sounded by another contemporary of Leonardo's, Savonarola. One of Savonarola's Latin

poems contains the following lines. "I have sought Thee everywhere, but I have not found Thee. I asked the Earth: Art Thou not my God? And it answered: Thales is deceived, I am not thy God. I asked the air, and it answered me: Rise still farther. I asked the sky, the stars, the sun, and they answered me: He who created us from nothing, he is God. He fills the heaven and the earth, he is in thy heart. Thus, Lord, I sought Thee afar, and Thou wert near. I asked my eyes whether Thou couldst not come through them to me, but they answered me that they knew only color. I asked my ears, and they answered that they knew only sound. Thus, our senses do not know Thee, O Lord." [16]

The Augustinian motif *noli foras ire, in te ipsum redi: in interiore homine habitat veritas* (Do not go out, return to your own self: truth dwells inside man)[17] is the opposite of that voiced by Leonardo: "What moves you, man, to abandon your home in town and leave relatives and friends, going to country places over mountains and up valleys, if not the natural beauty of the world" (TP 23; McMahon 42).

In solving the problem of which is superior, painting or poetry, Leonardo returned several times to a comparison of the world of the blind with the world of the deaf and dumb: "Now think, which is the more damaging affliction, that of the blind man or that of the mute?" (TP 19; McMahon 42). "If a painting represents the actions appropriate in every situation to the mental attitudes of the figures in it, doubtless he who is born deaf will understand the actions and intentions of the actors. But he who is born blind will never understand what the poet relates, those things which do honor to poetry." The deaf man, even if he knows no language, "will understand every physical condition of human bodies better than one who speaks and hears" (TP 20; McMahon 29). The blind man, through hearing, "understands only sounds and human speech, in which the names of all things exist, each having its own name." However, "even without knowledge of these names, one can really live happily," says Leonardo, citing the example of the deaf and dumb who learned by means of a drawing and "found delight in it" (TP 16; McMahon 13).

This attempt to examine separately the testimony of the individual organs of sense is reminiscent of the later intellectual experiment of Etienne de Condillac. This French thinker of the eighteenth century conceived of an animated statue devoid of all sensations and ideas, which then was provided in turn with one and several types of sensa-

tions.[18] However, closer examination shows enormous differences between Condillac and Leonardo. For Condillac, the sensations "are not qualities of the objects themselves, but merely modifications of our soul." [19] Leonardo did not doubt for a minute the objectivity of the qualities perceived by the eye. For Condillac, the primary content of the visual sensation was limited to light and color: "I consider myself right in saying that our statue sees only light and color and that it is unable to decide whether anything exists outside it."[20] It was Leonardo's deep conviction that the eye reveals the beauty of the real world in all its richness.

Condillac's ideas were developed by Diderot,[21] who also attempted to explain a number of conceptions capable of growing on the soil of one isolated sense, to develop—to use his expression—a special "metaphysical anatomy" of the senses. Diderot remarked that "five persons, each given his individual sense, would make an amusing group" (*un société plaisante*).[22]

Eighteenth century observations of those born blind showed that after an operation restoring sight such persons did not learn immediately to coordinate their space and motor concepts with their visual sensations and, thus, apparently confirmed Condillac's thesis that the primary attributes of vision are light and color. According to Condillac, "the eye requires the aid of the sense of touch . . . in order to learn to relate its sensations to the end, or approximately to the end, of the rays and thus to gain an idea of distances, magnitudes, postures, and shapes on the basis of this"; "touch is the only teacher of the eyes." [23]

However, there is no need to go so far afield, to turn to later discourses on the world of the blind and the world of the deaf. The question of the content of visual sensations had been posed long before, and the statement of the question was well known to Leonardo.

For Aristotle (as later for Condillac), the immediate objects of sight were light and color. Only by comparing the testimony of the different sense organs could one judge such general categories as motion, rest, number, form, and size.[24] Later students of optics such as Alhazen and Witelo considered that such "common properties" may also be attained by the "common sense" (*sensus communis*) from the testimony of just *one* sense organ, for example, the eyes. The eye itself may compare the data of the sensations and judge the Aristotelian "common proper-

ties" (*xoina aistheta*). Therefore, Witelo distinguished between a visual sensation as such (*aspectus simplex*) and the "interpretation" of these sensations by the eye (*intuitio diligens,* diligent examination). *Aspectus simplex* was defined by him as the "action by which the shape of the object seen is simply imprinted on the surface of the eye," while *intuitio diligens* is the "process by which sight, diligently examining, acquires a true understanding of the shape of the object." [25]

Leonardo held to Alhazen's and Witelo's opinions, assigning motion, rest, and form to the realm of the "function [*ufizio*] of the eye" (TP 438; TP 511–BN 2038 22v; McMahon 427). "The beauty of the world," or "the ten ornaments of nature," are light, darkness, color, body, shape, place, distance, nearness, movement, and rest" (TP 20; McMahon 29). They are the "ten different attributes of external objects" (*dieci varie nature d'obietti*) (CA 906r). However, Leonardo called them "parts" (*parti*), that is, the prime elements, of painting (TP 131), or the "scientific and true principles of painting, which are comprehended by the mind" (TP 33; McMahon 19).

Thus, when Leonardo praised the "eye" and "sight," he had in mind that thoroughly sensory visual conception of the world, that *intuitio diligens,* which went far beyond simple visual sensation. He criticized the naive sensualistic point of view of those who asserted that the "sun is only as large as it appears" (F6r, 8v, 10r, and elsewhere; MacCurdy 279). Leonardo stated that a painter is wrong who "draws without reason." He is "like a mirror that reproduces within itself all the objects which are set opposite to it without knowledge of the same" (CA 76r a; MacCurdy 901). A painter must not only have vision, but must "know how to see" (*saper vedere*). This *saper vedere* was for Leonardo equivalent to the motto *sapere aude,* dare to think. That is why painting was for him a "science," not a "mechanical art."

It is interesting to compare Leonardo's opinion with that of Luca Pacioli, who challenged the traditional quadrivium: arithmetic, geometry, astronomy, and music. According to Pacioli either music should be excluded, as subordinate to the other three, or perspective, that is, painting, should be added to music. "If you say that music satisfies hearing, one of the natural senses, then perspective satisfies sight, which is the more worthy, since it is the first door of the intellect." [26]

The painting of the artist and not an amorphous mass of sensual data was what Leonardo considered to be illustrious about "sight." One can see why the words "eye" and "painting" were practically

THE EYE

synonymous for him. Leonardo said that the eye "is the master of astronomy, it makes cosmography, it advises and corrects all human arts." "The eye carries men to different parts of the world, it is the prince of mathematics, its sciences are most certain, it has measured the heights and the dimensions of the stars, it has found the elements and their locations. It has predicted future events through the course of the stars, it has created architecture, and perspective, and divine painting." The eye "carries men from east to west, it has discovered navigation." "Through it, human industry discovered fire, by which the eye has regained what darkness first took away. It has adorned nature with agriculture and pleasant gardens" (TP 28; MaMahon 34).

But is not this what Leonardo said about painting? The divinity of the science of painting "teaches the architect to make his edifice so that it will be agreeable to the eye, and teaches the composers of variously shaped vases, as well as goldsmiths, weavers, and embroiderers. It has discovered the characters by which different languages are expressed, has given numerals to arithmeticians, has taught us how to represent the figures of geometry; it teaches masters of perspective and astronomy, machinists, and engineers" (TP 23; McMahon 42). In astronomy "there is no part which is not a product of visual lines and of perspective, daughter of painting" (TP 17; McMahon 15). Astronomy "cannot function without perspective, which is a principal element of painting" (TP 25; McMahon 33). "The science of painting" is the "mother of perspective," and perspective "has given birth to the science of astronomy" (TP 6; McMahon 5). Need we go on? Need more examples be cited?

Later we shall return to Leonardo's "philosophy of the eye" and attempt to discover the aporias it conceals, but now we shall turn to another aspect of this philosophy. The "eye" occupies a central position in Leonardo's theory of knowledge, but for him the science of sight inevitably becomes a means of "self-cognizance"; optics becomes the realization of the ancient precept "know thyself." If one is really to master the instrument of sight, that is, to "learn how to see," one must study this most delicate instrument of knowledge in detail.

First, let us recall that originally optics was the science of sight, as indicated by the name itself. In addition to the physical properties of light and color, ancient optics investigated the structure and properties of the human eye, the characteristics of human vision. Thus, it combined what are now called geometrical, physical, and physiologi-

LEONARDO DA VINCI

cal optics. The Latin term *perspectiva* at first corresponded fully to the Greek *optike*. In the Middle Ages it meant optics in this broad sense. This meaning was retained by Leonardo, who defined "perspective" as the science of "visual lines" (*linee visuali*) and subdivided it into three parts: "The first part includes only the outlines of bodies, the second includes the diminution of colors at varying distances, and the third embraces loss of comprehension* of bodies at various distances" (TP 6; McMahon 5). By Leonardo's time "natural" perspective had been detached from the so-called *perspectiva artificialis,* artificial or artistic perspective, namely, the applied study of linear perspective in our sense. (The Italians often call this *prospettiva prattica.*)

Let us attempt to answer the question how the visual perception of an object led, in ancient times, to the formulation of a theory that sight amounts to touch: sight rays emerge from the eye, touching the object, as it were. However strange this theory may appear to be, it fitted in nicely with geometric concepts and the construction of sight cones (or pyramids) with the apex in the eye and the base on the surface of the visual object.† It is significant that the theory persisted longest in treatises on geometric optics. Euclid held to it in his *Optics,* although other ancient authors who wrote on geometric optics stated that actually it does not matter for this discipline whether the "images" pass from the object to the eye or whether the sight rays pass from the eye to the object; the geometric constructions are the same.[27]

Perspective constructions are obtained easily by truncating the cone of the sight rays by a plane to the axis of sight. Some recent scholars have assumed[28] that the ancient theorists and practitioners regarded the plane dissecting the cone of sight rays as part of a spherical surface (hence the study of the proportionality of visible magnitude of objects to the angles of sight). For the Renaissance theorists, however, this surface was the picture plane. Alberti regarded it as if it "were of glass or of some other substance so transparent that the whole visual pyramid might pierce through it," but Leonardo compared it to a glass wall, abbreviating it to *pariete,* "wall" (A IV).‡

* I follow Ludwig here in reading *congientione* for *cognitione.*

† Alexander of Aphrodisias ("Commentaria in librum De sensu," p. 28) directly ascribed the theory of rays emanating from the eye to the geometricians. Cf. Haas, "Antike Lichttheorien."

‡ Alberti, *Of Painting,* bk. 1, p. 6. Somewhat farther on (p. 8), Alberti likens the picture plane to an open window, and still later (bk. 2, p. 13) to a "transparent veil." Leonardo also compared it to a window (TP 797).

THE EYE

The geometric scheme of construction is quite the same whether the rays are drawn from the point "eye" to the surface of the object or from points on the surface of the object to point "eye." Therefore, Alberti, following mainly practical and didactic aims in presenting his theory of perspective, made only occasionally cursory mention of the theory of the "philosophers" who spoke of the rays as some sort of "servants of sight," and preferred to substitute for them a system of fine threads stretching from the surface of the object to the eye.[29]

Some practical fundamental conclusions had been drawn from this initial principle of linear perspective in Leonardo's time. According to Pacioli, Leonardo rejected the idea of writing a treatise on linear perspective when he learned that one had already been written by Piero della Francesca (died 1492).[30] The treatise by Piero della Francesca[31] is written in a patently scientific form. It is divided into postulates and theorems; however, these are not really theorems but "problems" or "assignments" arranged in order of increasing difficulty. The first book is devoted to plane figures, the second to three-dimensional figures, and the third to the portrayal of the human face and of architectural works in perspective. Although Piero della Francesca differentiated the three "main parts" of painting, namely, design, proportionality, and color, he did not develop the problem of color in his treatise, but devoted all his attention to the mathematical aspect of linear perspective.

Leonardo's attention was drawn more to the defects of linear perspective, the inadequacy of its purely geometric laws for the true portrayal of reality. In answering the question "why a painting can never appear to have as much relief as do objects in nature" (TP 118; McMahon 220), Leonardo pointed out that a perspective representation in a painting is the result of monocular vision: the visual triangle has its apex *solely* in the eye of the observer, whereas the perception of relief is based on binocular vision (cf. TP 118, 494, 496).*

Simple geometric projection to the picture plane cannot always represent distances correctly: large and small objects at various distances may yield projections of the same magnitude (TP 481; see figure 21). An object higher than the eye, depicted in the picture plane, may seem

* It is of interest that Galen (*De usu partium,* 19.2) had described the differences in the perception of a column seen by the left eye and the right eye separately then together. Cf. Boring, *Sensation and Perception,* (p. 283).

LEONARDO DA VINCI

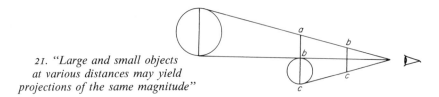

*21. "Large and small objects
at various distances may yield
projections of the same magnitude"*

lower (TP 476). Thus, "the eye without moving, will never know, by means of linear perspective, how much distance there is between the object that lies between it and another object" (TP 517; McMahon 521).

In all such cases one must resort to other techniques and media. First, draw the figures with different degrees of finality or clarity. A second means is light and shadow (TP 151). The final, or third, means is aerial perspective or, as Leonardo sometimes called it, the "perspective of color" (cf. BN 2038 22v). Edwin Boring[32] points out that the very term "aerial perspective" was first used by Leonardo. If four buildings on the surface of the painting are of different heights and one must show that they are at different distances from the eye, they must be given different colors. "Therefore, paint the first building above the wall its true color, the next in distance make less sharp in outline and bluer, another which you wish to place an equal distance away, paint correspondingly bluer still, and one which you wish to show as five times more distant, make five times bluer" (TP 262; McMahon 238).[33]

Leonardo did not take these ideas out of thin air. Alhazen and Witelo, scientists of the Middle Ages, worked on questions of the psychology of visual perception along with geometrical optics, problems which Leonardo the painter and theorist of painting pursued actively. However, Alhazen and Witelo were interested in them in quite another connection. They treated the visual perception of size, shape, color, and other features of a viewed object as a function of distance, position, properties of the intervening medium, and so forth, and regarded them as "optical illusions." They studied such illusions primarily to introduce the visual corrections required for astronomical observations. Leonardo, as a painter, approached these problems differently. He did not attempt to *eliminate* the medium which changed the per-

THE EYE

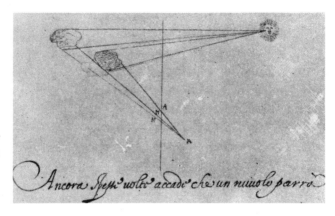

22. Perception of distance between objects

ception of the object, but to study it in order to *express* it in painting, to transmit correctly the blue of distant hills, the shades of color seen through fog. Although there are considerable differences between Leonardo's approach and inquiries and those of Alhazen and Witelo, all three concentrated on the same objective laws of visual perception and, therefore, Leonardo was able to use many of their results for his purposes.[34]

Let us examine the three aforementioned painting techniques in more detail: the use of different degrees of finality, light and shadow, and aerial perspective. First, let us treat what Leonardo called the "loss of distinctness of outline" (*i perdimenti*). It does not suffice merely to reproduce on the surface of the painting the projection of the object with appropriate reduction. Several times Leonardo repeated the indisputable and generally known postulate that small objects disappear with increasing distance sooner than large objects, explains this by the size of the angle of sight (TP 455, 456, 459), and illustrates it with examples of the figure of a deer (TP 460) and the figure of a man. From this he concludes that in depicting objects with different degrees of sharpness, the artist gives the painting different degrees of remoteness of these objects (TP 128, 152, 153, 443, 473, 486, 694f, 797). "The painter should show forms and objects remote from the eye only as stains, and not give them shadows with sharp outlines, but rather with indistinct edges." From afar, sharply defined light and shadows seem daubed and result in "heavy, unattractive works" (TP 487; McMahon 468), or, as Leonardo says elsewhere, "your work will look wooden" (TP 135; McMahon 130).

LEONARDO DA VINCI

The sharpness of outline is affected not only by the distance of the object, but by the degree of density (*densità*) or transparency of the intervening medium, air. *"Of cities and other things seen through dense air.* City buildings seen below the eye in misty weather or in air thickened with the smoke of fires, or other vapors, will always be less clear the lower they are, and conversely, they will be sharper and clearer the higher they are with respect to the eye" (TP 446; McMahon 533, the proof and a drawing are included in the manuscript).* "That part of a building will be least clear which is seen in densest air and, conversely, it will be nearest when seen in thinnest air" (TP 449; McMahon 536). A tower is used as an example. However, since objects become less distinct in "thicker" air—mist—and the eye is accustomed to connect loss of clarity with increasing distance, objects which become less distinct in mist seem more distant than they really are, and thus we take them to be larger (TP 462, 477a; cf. TP 444). The same should be said of density, which varies with height.

Distance (the thickness of the air layer) and the height at which the object and the eye stand (the degree of atmospheric density) affect not only the sharpness of outlines, but the quality of light, shadow, and color. Shadows are lost at great distances, because the quantity of luminous air between the eye and the object tinges the shadow of that object with its color (TP 646), and the difference between the lights and shadows of a shadowed body will be smaller the farther it is from the eye (TP 821). The same applies to colors (TP 220, 234, 235, 257). Further, the thinner the air is, that is, the higher the eye and the object are, the less the light, color, and shadow will show. Thus it follows that if the brightness of the object increases with distance from the viewer, the darker objects should seem to be nearer the viewer than the lighter objects. He used the dark summits of mountains and their light bases as examples (TP 450).

Let us proceed. The perception of size of an object is influenced not only by distance and the density or transparency of the medium, but by the surrounding objects. Again, this is based on the very simple idea that contrasts reinforce one another: beauty and ugliness, light and

* Perhaps this is the place to mention two accurately dated drawings depicting fires set by the Swiss mercenaries on December 16 and 19, 1511, near Milan. One drawing depicts the flames in a wind, the other in calm air (W 12416). See Giacomelli "La Scienza dei venti di Leonardo da Vinci," pp. 397–398.

THE EYE

dark. "Beauty and ugliness seem more effective through one another" (TP 139; McMahon 277). The darker the background is, the lighter the shadow will appear and, vice versa, the lighter the background is, the darker the shadow will be (TP 649, 817).* This is also true of contrasting colors (TP 257, 258). "A white object looks whiter when it is against a dark background, and darker when it is against a whiter background. Falling snow teaches us this, for when we see it against the background of air, it seems dark to us, but when we see it against the background of an open window, through which the dark shadows of an interior are seen, the snow appears very white" (TP 231; McMahon 154).

Another example, the moon, is equally instructive. "Nothing appears in its natural whiteness, because the locations in which objects are seen render them proportionately clearer or less clear to the eye, as the location is darker or less dark. This is illustrated by the moon in the sky, which by day appears to possess little brightness, but at night appears with so much splendor that it makes itself the image of the sun in the day, as it drives away darkness."

Leonardo does not limit himself to a simple reference to the phenomenon of contrast, but attempts to explain it by a change in the pupil. He continues: "This comes about for two reasons. The first is the striving of nature to display objects as more perfect in the images of their colors, the more these are unlike one another. The second is that the pupil of the eye is larger at night than in the day, as has been proved, and a larger pupil sees a luminous body with a more splendid brilliance than the smaller pupil, as is proved when anybody looks at the stars through a small hole made in a sheet of paper" (TP 628; McMahon 753). One must recall in this connection how much attention Leonardo devoted to the change in the size of the pupil, studying it not only in man, but in cats and night birds: the owl, the eagle owl, and others (E 17v, G 44r, Forst II 158v, H 86r, H 88r, H 91v, H 109r, L 41v, D 5r, CA 262r d, BM 64v).

However, let us continue our discussion. As I have pointed out, the brighter and lighter objects seem more distant and therefore larger. Consequently, if the object becomes brighter because of the dark background, it will seem larger (TP 258a) and, vice versa, a dark object will

* Leonardo returned to this theme many times. See TP 163, 197, 204, 232, 238, 252, 258c, 553e, 555, 605, 628, 649, 650, 670, 745, 769, 817.

seem smaller against a light background (TP 463). These postulates are illustrated by examples. If the sun shines through trees without leaves, all their branches "are so diminished that they become invisible" (TP 445; McMahon 457). "Parallel towers in the mist look thinner at the base than at the top, because the mist which makes a background for them is thicker and whiter below than above" (TP 457; McMahon 540). Or, another lucid example concerning the glow of a fire: "A shaded body will appear smaller when it is surrounded by a very luminous background, and a luminous body will appear greater when it is set against a darker background; this is shown in the heights of buildings at night when the glow is behind them. Consequently, it appears that the glow lessens their height. And from this it comes to pass that these buildings appear larger when there is mist, or by night, than when the air is clear and illumined" (CA 126r b; MacCurdy 948).

Thus, the representation of the size of the object and its distance from the eye cannot be achieved by a simple geometric (perspectival) reduction on the surface of the painting. Both the size of the object and its distance are functions of a number of interdependent factors, namely, properties of the intervening medium, the proximity of other objects, and so forth.

I shall not deal with all the details of Leonardo's studies of light and shadow, the second principal division of his theory, but I should like to call attention to one more circumstance. In the fifth part of the Treatise on Painting, the section on light and shadow, we find many purely geometric examples: the source of light and the body casting the shadow are regarded as perfect geometric spheres. It is a long way from such schematic figures to Leonardo's *sfumato,* to painting in general. How did they get into the Treatise? Did its compiler arbitrarily take from Leonardo's notebooks all the available fragments containing the words light and shadow? Perhaps. These were not random fragments in Leonardo's optics, a field he developed in a broader sense than merely as an adjunct of painting, but they seem alien in the Treatise on Painting, although the use of geometrically perfect spheres instead of specific physical entities of different shapes facilitates and simplifies the proof. We know that these passages were an essential part of Leonardo's science of optics from the direct parallels that can be found for some of them in his earlier treatises on geometric optics.

Two theorems concerning shadows and illustrated schematically by

THE EYE

drawings of spherical bodies can be found in adjoining paragraphs of the Treatise on Painting. In the first of these Leonardo states: "That body which is illuminated by the smallest luminous body will be covered with the greatest quantity of shadow" (TP 638; McMahon 601). In Witelo's *Perspectiva* (bk. II, para. 28), we read: "If the diameter of a luminous spherical body is smaller than the diameter of an illuminated spherical body, less than half of it will be illuminated."

In the next paragraph of the Treatise on Painting we read: "That body which is illuminated by the greatest light takes on the greatest quantity of light" (TP 639; McMahon 603). In *Perspectiva* (bk. II, para. 27) Witelo states: "If the diameter of the luminous spherical body is greater than the diameter of an illuminated spherical body, more than half of this body will be illuminated and the base of the shadow will be smaller than the major circumference of the illuminated body."

These theorems are supplemented by theorems in which it is proved that if a luminous spherical body is equal in size to a shadowed one, the shadowed and illuminated parts will be equal, and it is shown that a luminous spherical body that is larger than a shadowed one cannot illuminate exactly half of the shadowed one (TP 697, 698).

The basis for this whole cycle of theorems of Leonardo's and the corresponding postulates of Witelo's is the second proposition in the book *On the Sizes and Distances of the Sun and Moon* by Aristarchus of Samos: "If a sphere is illuminated by a sphere larger than itself, more than half of it will be illuminated."[35]

The derivation of various forms of what Leonardo called a "derivative shadow," that is, a shadow cast by a body and not lying on its actual surface, is of this same geometric nature. John Peckham's *Perspectiva communis*, which Leonardo read, contains the following proposition (bk. I, proposition 24): "A shadowed spherical body that is smaller than the illuminating body, casts a pyramidal shadow; one of the same size casts a cylindrical shadow, one larger casts a truncated and inverted pyramid," that is, a pyramid whose apex is the inverse of that of the first pyramid. Leonardo writes: "The shapes of the derivative shadow are three in number; the first is pyramidal, derived from a shadowed body smaller than the luminous body; the second, with parallel sides, is derived from a shadowed body equal in size to the luminous body; the third is one which expands to infinity, and that which is columnar in shape is infinite also, as is that which is pyramidal,

for after the first pyramid it comes to an intersection and there creates an infinite pyramid with its point against that of the finite pyramid, provided that it finds infinite space in which to expand" (TP 574; McMahon 615).

As in the study of the "disappearance of outlines," the geometric constructions are merely a beginning. In fact, one might say that they do not fit rationally into the Treatise on Painting. For Leonardo, as for his predecessors, these optical geometric constructions were bound up with problems of astronomy, whereas the study of shadows, in connection with the different forms of illumination and the surroundings, posed incomparably more complex problems in the case of painting. In solving these problems Leonardo felt that "experience"—keen, sensitive observation—should be the basis for any "geometrization." Therefore: "The shadow in a picture is matter for much greater investigation and reflection than is its outlines. The proof of this is that the outlines can be traced by means of veils or glass panes placed between the eye and the thing to be traced, but shadows are not attained by any such method because their edges are indistinguishable and usually confused, as will be shown in the book on shadow and light" (TP 413; McMahon 435). But a comparison of any one of Leonardo's paintings, for example, *John the Baptist*, with these optical geometric definitions and theorems will be even more indicative and will immediately demonstrate the chasm that separates the two. Leonardo may have taken his individual, simple definitions and theorems from Witelo or Peckham, but the more complex observations were his own.

Leonardo stressed the practical importance—"the painter should pay great attention to" (TP 655; McMahon 794) or "you should have great regard for" (TP 767; McMahon 795)—of a proposition which he considered basic for the theory of aerial perspective, namely "The surface of any opaque body takes on the color of the object opposite it." (This postulate is numbered differently in Leonardo's notes, sometimes it is the fourth postulate, sometimes the ninth, sometimes the eleventh, and so forth.) The blue color of shadows on a white background is explained by this postulate (TP 196, 247, 467), as is the change in the whiteness of the foam of water (TP 508), the color of an illuminated face (TP 644, 708), and the reflections on flesh from other flesh (TP 174). Leonardo uses this theorem to explain why the color of objects

is lost, becoming darker, with distance from the viewer's eye (cf. TP 240, 241). Besides the illumination and the amount of light and shadow on objects (TP 195 and 218), the density of the medium (air) and the quality of the color play a role in this case (TP 195). For example, an object nearest in color to black will appear bluest and, conversely, an object which is least like black will retain its own color. Therefore, "the green of fields will transmute itself into blue more than yellow or white will" (TP 244, cf. 698a).

Since the density of air decreases with distance from the ground (TP 149, 446, 691, 793) and less dense air colors bodies less with its own color, mountains should be painted lighter at the base, where the air is denser, than at the summit, where the air is rarer (cf. TP 149, 691, 793–796, 798–799, 803, 808).

Leonardo designated colors created by surrounding objects as "false" (*falsi*) (TP 702), in contrast to colors inherent in the body. His intention was to show the local, natural, color. However, his keen powers of observation enabled him to capture the hues which we have begun to seek so carefully in his paintings. One need but reread this fragment: *"Of the shadows of faces when seen along streets that are wet, and which do not seem to be consistent with the flesh tones.* This problem arises with regard to something that often happens when the face is high in color or white, and its shadows tend toward yellow. This occurs because wet streets tend toward yellow more than do dry ones, and the parts of the face that are turned toward these streets are tinted by the yellowness and darkness of the streets, which are opposite them" (TP 710; McMahon 802).

The passage cited earlier concerning a woman in white walking through a green meadow (TP 785; McMahon 786) should be understood as a "warning" against "false" colors. It is entitled: "How white bodies should be represented." The sense of the instruction is to avoid placing white objects in situations where their white color no longer appears pure. It should be remembered that the text of the Treatise on Painting is distorted and filled in with BN 2038 20v. In Leonardo's original manuscript the passage reads: "If you would represent a white body, it should be surrounded [*sia circundato*] by a large amount of air" (so that it will remain white). The compiler of the Treatise on Painting omitted the word *sia* and the phrase begins: "If you would represent a white object surrounded by a large amount of air..."

There is no main proposal. Ludwig reconstructed it, without sufficient grounds (albeit with a question mark), as follows: "pay attention to the colors of the surrounding objects (*abbi rispetto alli colori delli suoi obietti*)." Actually, as we see, the sense of the instruction is approximately: as far as possible, try to avoid the influence of the color of surrounding objects, that is, try to put the white object in the proper settings.

Then how can we explain Leonardo's praise of the eye, in which he states that the "sciences of the eye are the most noble" (TP 28; McMahon 34)? The answer is that according to Leonardo the painter does not reflect the properties of an isolated object, taken by itself, but its relation and position with respect to the beholder. In depicting distant mountains as blue, in depicting the shades of color seen through a mist, the artist transmits "optical illusions." The artist, however, is not concerned with optical illusions, but with truth: the blue represents the distance of the mountains, the shades of color represent the properties of the intervening medium. This prompted these wise words of Leonardo's: "If you, painter, would make those outlines sharp and noticeable, as is customary, do not seek to represent the object *at so great a distance,* for such a method makes it appear close" (TP 443; McMahon 501). Or: "Therefore, in your portrayal see that those things have the proper clarity to *indicate the distances*" (TP 473; McMahon 507). Consequently, if the painter only "contemplates" individual figures but does not finish them in detail, he will "misrepresent the effects of nature, his teacher" (TP 417), since he will not be indicating the position of the object with respect to other objects, and first of all, with respect to the eye of the observer.

The techniques of which Leonardo spoke allow one to overcome the one-sidedness and severity of mathematical perspective based on the concept of a one-eyed observer "rooted to the spot." They allow one to emerge into the world of the most complex relations between things. The eye is only one of the things. Characteristically, Leonardo used the word "see" every time the object was treated as a point on which the rays of another object converged. In this sense, he considered it possible to say that the mirror "sees" the object reflected in it, the sun sees the sea, or, vice versa, the sea sees the sun, and so forth. The shadings of the words *sensibile, insensibile, impressione,* and others used by Leonardo are also interesting. For Leonardo, sensation

THE EYE

(*sentimento, senso*) is the physical process of interaction between material bodies. That is why he considered himself justified in saying that a bell is "sensing" when it continues to ring even after the blow which has caused the sound has ceased. On the other hand, he called mirrors insensate, for they "do not retain the images of things before them"; insensate was any "polished thing, for it soon loses the impression (*impressione*) of an object reflected in it as the object moves away from it" (CA 360r a).

Although the ancient theory of rays emerging from the eye was the starting point for the development of linear perspective, another old theory, that of "idols," "sacred images," and "likenesses," most closely corresponds to the outlined concept of a complex network of inter-relations connecting individual objects (including the eye) with each other. This theory existed in antiquity in two variants. According to the first, light and color are material emanations from the object to the eye. These emanations bring to the eye not only the tiniest particles, but the "image" or "likeness" of the object. The ancient atomists, such as Democritus, Epicurus, and Lucretius, held to this version. According to the other version, the "images" were not material emanations, but some sort of modifications of the medium between the object and the eye. The Stoics characterized this condition as a kind of tension (*tonos*) of the medium, the air. This gave rise to the concepts of the Middle Ages concerning the so-called *species intentionales* that are capable of penetrating each other. In speaking of the "images" (*spetie*) or "likenesses" (*similitudini*) of objects distributed through the medium (TP 15), Leonardo reflected the influence of this second version of the theory of images.

In an earlier manuscript he wrote: "Every body fills the surround-ing air with its likenesses, likenesses which are all in everything and all in each part. The air is full of infinite straight and radiating lines intersected and interwoven with one another. They represent to every object the true form of their cause" (A 2v). It was this postulate in its geometrized form that Leonardo declared to be "the basis of the science of painting." "*The basis of the science of painting.* The plane surface has its complete image in another plane surface which is the object opposite it. This is proved as follows: let RS be the first plane surface, and OQ be the second plane surface placed opposite the first. I say that the first surface RS is entirely on the surface OQ and entirely

LEONARDO DA VINCI

23. "The plane surface has its complete image in another plane surface which is the object opposite it"

at Q and entirely at P, since RS is the base of the angle at O, and of the angle at P, and thus of an infinity of angles produced on OQ" (TP 4; McMahon 2). (See figure 23.)

This text clarifies what Leonardo understood by the words "likenesses which are all in everything and all in each part." These are the most delicate and complex relationships between things (including the eye), profoundly different from those things discovered by the vision of a one-eyed person, a cyclops viewer rooted to the ground, from the presumption upon which the elementary geometric theory of linear perspective was based.[36]

Our review of Leonardo's postulates on the "disappearance of outlines," light and shadow, and aerial perspective has shown clearly the paths which Leonardo took in explaining the latent "logic of the eye," which perceives in the visual object (a painting) not only the sensual properties of the individual objects, but also their highly complex relations to each other, to the surrounding space, to the medium, and to the eye of the observer himself. Truly, it does not suffice merely to see, one must "learn to see," one must possess what Witelo called *intuitio diligens*.

Leonardo's aspiration to visualize the most subtle relationships, his belief in the "power of the eye," found expression in those numerous notes in which he attempted to associate the most abstract Aristotelian teachings on the continuum with the practical problems of the painter.

In entering into polemics over the concepts of mathematical atomism, Aristotle and his followers developed the doctrine of points, lines, and surfaces as the limits of a line, a surface, and a body, respectively. A line does not consist of points, as the mathematical atomists thought; therefore, a point is not part of a line, it is a limit. Similarly, a line is not part of a surface, it is a limit of a surface. The surface is not part of a body, but a limit of it.

THE EYE

Leonardo was quite familiar with these definitions. One may find them in his early Codex Trivulzio (1487–1490) (Triv 35r), in the Codex Atlanticus (CA 132r b), and in the manuscript at the British Museum (BM 132r). In these notes the definitions are treated in an abstract mathematical manner. However, there is another group of notes as well. For example, in Manuscript G (37r) Leonardo first gives a philosophical mathematical description of a limit, then passes on to practical deductions for the painter. At times the philosophical-mathematical and artistic motives are interwoven in the closest manner (cf. TP 694f). The Aristotelian teaching on the continuum (a limit is not part of a body) forms the background of Leonardo's concept of "smoke" (*sfumato*). This is the background against which he gave his special, individual instructions to the painter, for instance, the advice: "do not break up individual articulations with sharply defined contours" as they do who want "every little stroke of charcoal to stand" (TP 189; McMahon 261). Or: "Do not make definite or finite the shadows which you can distinguish with difficulty and the edges of which you cannot recognize. Thus, with your judgement uncertain on these matters, transfer them to your work, but do not make them finished or definite, for if you do, your work will look wooden" (TP 135; McMahon 130).

According to Leonardo, "Perspective (optics) gave birth to the science of astronomy" (TP 6). The optical, visual moments actually occupy a dominant position in Leonardo's astronomical fragments. There are no astronomical calculations, or discussions of the calendar, or in general anything arithmetic or algebraic in the notes of this great Italian scientist. Leonardo's astronomy is a kind of applied optics: the science of how we see the heavenly bodies and the science of how these heavenly bodies see us (that is, our earth), to use his accustomed terms. The magnification of the bodies at the horizon, the light of the moon and the moon spots, the scintillation of the stars, these are the themes to which he always returns. Therefore, Leonardo was right in his own way in regarding astrology, that is, astronomy as a part of "perspective," of optics: "There is no part of astrology which is not a product of the visual lines and of perspective, daughter of painting, because the painter is he who, through the requirements of his art, has brought forth that perspective" (TP 17; McMahon 15). This is why one may say that the eye is the "master of astrology" (TP 28; McMahon 34), that astrology "cannot function without perspective,

which is a principal element of painting" (TP 25; McMahon 33), that "the science of visual lines has given birth to the science of astronomy, which is simple perspective, since it is all visual lines and sections of pyramids" (TP 6; McMahon 5).

Leonardo himself pointed out (TP 25; McMahon 33) that in speaking of astrology he had in mind "mathematical astrology," astronomy in our sense; he contrasted it to "false divination or popular astrology," that is, astrology in the sense generally used today, adding: "Let him who makes a living from fools by means of it forgive me." Only once (TP 28) did Leonardo, in lauding sight, state that the eye had made it possible to "predict future events through the course of the stars." But remember that this was done in his rhetorical "praise of the eye," adapted to the psychology of an imaginary audience and aimed mainly at convincing that audience, not at proving a point.

His conviction of the universality of optical laws was connected with his belief in the homogeneity of the universe: we see the moon and the other luminaries just as they see us. The earth is surrounded by its elements (water, air, and fire) just as the moon is surrounded by its elements. The earth and the moon remain in cosmic space because the "heavy" elements are balanced by the "light." Turning to an old image, Leonardo wrote in this connection: "The redness or yolk of the egg remains in the center of the albumen without sinking" (BM 94v; MacCurdy 631).

The analogy between the egg and the universe appeared extensively in the literature of the Middle Ages. For example, Guillaume de Conches (died *ca.* 1154) wrote: "The world is disposed like an egg. For earth is in the center, like the yolk in the egg. Around it is water, like the white around the yolk. Around the water is air, like the membrane holding the white. And on the outside, including everything, is fire, the sun, which is like the shell of the egg."[37] This too general comparison still does not contain what was specific for Leonardo: thoughts on the balance of the heavy and the light elements. This thought was expressed definitively by a contemporary of Leonardo's, Brunetto Latini: "If the white of the egg, surrounding the yolk, did not hold within itself, it would fall onto the shell. And if the yolk did not hold its white, the white would fall into the egg. Therefore, in all things the hardest and heaviest is always amidst the others ... and this is why earth, which is the heaviest element and has the densest substance, is

THE EYE

at rest among all spheres and all surroundings, i.e., it is in the midst of the heavens and the elements."[38]

However, even Latini's formulation, which Leonardo undoubtedly knew, does not correspond completely to what Leonardo had in mind. For Latini, the comparison served to confirm geocentrism. Leonardo used it to explain the idea that any celestial body surrounded by heavy and light "elements," particularly the moon, cannot "fall from its place." "The moon has no weight amid its elements and cannot fall from its place" (CA 112v a). This equilibrium of the elements is reflected very clearly in the laconic and oft cited rhetorical question, both parts of which are symmetrically balanced: "The moon, dense and heavy, dense and heavy, how does it stay there, the moon? [*La luna densa e grave, densa e grave, come sta la luna?*]" (K 1r, Baskin 48). Leonardo says: "The moon is clothed with its own elements, namely water, air, and fire and so sustains itself by itself in that part of space, as does our earth with its elements in this other part of space; and that the heavy bodies perform the same function in its elements which the other heavy bodies do in ours" (Leic 2r; MacCurdy 295).

The earth shines in cosmic space because of the reflection of the sun in its oceans. This, according to Leonardo, is also the origin of moonlight: "My book attempts to show how the ocean with the other seas makes our world, by means of the sun, shine after the manner of a moon, and to the more remote world it appears as a star" (F 94v; MacCurdy 288).

In this, Leonardo da Vinci concurs with Nicholas of Cusa, who, in conflict with tradition, deprived the earth of its central position in the universe. Leonardo wrote: "The earth is not in the center of the circle of the sun, nor in the center of the universe, but is in fact in the center of its elements which accompany it and are united to it. And if one were to be upon the moon, then to the extent to which it together with the sun is above us, so far below it would our earth appear with the element of water, performing the same office" (F 41v; MacCurdy 281).

Leonardo kept comparing the earth with a point in the universe and, true to his "optical philosophy," tried to depict for himself with maximum clarity, as in a painting, the earth seen from the limitless distances of the universe: "If you look at the stars without their rays, as may be done by looking at them through a small hole made with the extreme

point of a fine needle and placed so as almost to touch the eye, you will perceive these stars to be so small that nothing appears less; and in truth the great distance gives them a natural diminution, although there are many there which are a great many times larger than the star which is our earth together with the water. Think, then, what this star of ours would seem like at so great a distance, and then consider how many stars might be set longitudinally and latitudinally amid these stars which are scattered throughout this dark expanse" (F 5r; MacCurdy 277).

This portrayal of the earth as a small point did not arouse the feeling that we were lost in the cosmos; on the contrary, it was in keeping with the concept of the earth as the "noble planet." Let us recall that in the traditional Aristotelian concepts the world of the earth was qualitatively different from the world of the "imperishable planets": Here, below, the elements change continually; there, above, they are the immutable, constantly moving planets, consisting of indestructible heavenly substance, the quintessence, or the "fifth element."

For Nicholas of Cusa, the earth was a "noble star" (*stella nobilis*);[39] for Leonardo, to prove that the earth was a "star" (*stella*) meant to prove the "majesty of our world." "All your discourse points to the conclusion that the earth is a star [*stella*] almost like the moon, and thus you will prove the majesty of our universe" (F 56r; MacCurdy 281).

Leonardo compared the earth, surrounded by its elements, with the moon. Nicholas of Cusa had already made such a comparison between the earth and the sun. The sun, according to Nicholas, also is surrounded by its elements and only the outer envelope of fire creates the impression that it is entirely hot: "If someone were on the sun, he would not see the brightness we see. If the body of the sun were examined, one could see in its center something like earth, on its periphery, some sort of light, like the light of a fire, and between them a watery cloud and brighter air. The earth has the same elements. That is why if someone were outside the region of fire, our earth would appear on the periphery of its region as a bright star because of the fire, as the sun appears exceedingly bright to us, who are outside the periphery of the solar region."[40] This should be compared with Leonardo's remark about the sun: "The sun in its nature is hot" (F 85v; G 34r; MacCurdy 786, 289).

THE EYE

Leonardo "marveled greatly" that Socrates likened the sun to a red-hot stone. He could not find words to refute those "who would fain extol the worship of men above that of the sun." "For in the whole universe I do not perceive a body greater and more powerful than this, and its light illuminates all the celestial bodies which are distributed throughout the universe." Even if a man were as large as our world (that is, the earth), he "would seem like one of the least of the stars, which appears but a speck in the universe" (F 4v–5r; MacCurdy 278).

Leonardo's anatomical manuscripts contain the following laconic note: "The sun does not move" (WAn V 25r; MacCurdy 293). However one understands this note, it is clear that the conception of the earth as "but a speck in the universe" and of the sun as the "greatest and most powerful body in the whole universe" are not concerned with the geocentric system, or, to be more exact, with the cosmic hierarchy which inspired it.

I shall not discuss other possible points of contact between Leonardo da Vinci and Nicholas of Cusa, but I must point out one other peculiarity mentioned by Duhem. Having compared individual excerpts from the works of the two, this French scholar stated that "we have just seen that Leonardo became imbued with thoughts on geometry developed by Nicholas of Cusa. In the writings of Nicholas and the books of the Platonist philosophers which this German Cardinal imitated, these thoughts are directed toward an essentially theological object; they are designed to arouse in our mind at least conjecture on the divine being, its mysterious origins, its affiliations with created nature. Taking these thoughts, Leonardo transformed them, keeping what was geometric in them and doing away with all its theological affiliations; he carefully struck the name of God from them."[41]

Leonardo could have used two editions of the works of Nicholas of Cusa, the Strasbourg edition of 1488 or the Corte Maggiore of 1502 (subsequent sixteenth century editions were published in Paris in 1514 and Basel in 1575). One may say almost for certain that he knew the edition of 1502. It was prepared by order of the Marquis of Pallavicino, mentioned in Leonardo's notes—"Messr Ottaviano Pallavicino, because of his Vitruvius" (F inside cover)—and dedicated to Leonardo's patron, the Count of Chaumont. As in the case of Albert of Saxony, Duhem exaggerated the influence of Nicholas of Cusa on Leonardo; on this see Klibansky's remarks.[42] Santillana[43] also objects to Duhem's exaggera-

tions. On the other hand the denial of any connection between Leonardo and Nicholas of Cusa in Garin's papers[44] seems to me to be the other extreme.

Leonardo's discussion of the nature of moonlight is a characteristic example of his "optical-visual" approach to problems of astronomy. According to Leonardo the light of the moon is to be explained by the reflection of the sun from the lunar seas which are furrowed with waves. If the reflecting convex surface were smooth, only a small part of it would reflect the sun, as "is clearly shown in the gilded balls placed on the summits of tall buildings." "But if these gilded balls were furrowed or made up of many small globules like mulberries, which are a black fruit composed of minute round balls, then each of the parts of this rounded mass visible to the sun and to the eye would reveal to the eye the radiance produced by the reflection of the sun. And thus in the same body there would be seen many minute suns and very often on account of their great distance they would blend one with another and seem continuous" (BM 94v; MacCurdy 291).

This theory was bound in the closest manner with the concept that the same elements exist on the moon and on the earth: "If there are waves on the moon and waves do not exist without wind, and wind does not arise without vapors from the earth caused by moisture which is attracted by the heat of the air, the body of the moon must have earth, water, air, and fire with the same laws of motion as have our elements" (CA 112v a).

This is the specific reason why Leonardo so carefully studied the characteristics of the sun's reflection in the waves of the sea. He constructed geometric systems, made sketches, drew on postulates from his study of light and shadows, all to substantiate and fortify his theory of moonlight and moon spots. Here is clear demonstration that the study of light and shadow interested Leonardo da Vinci not only from an artistic standpoint, but for purposes of solving a whole series of problems involving other ends and other needs.

Was Leonardo's explanation completely original? On the inside cover of Manuscript F (1508–1509) there is the note: "Albert, on the heavens and the earth, from Fra Bernardino." This refers to the work of Albert of Saxony (died 1390), a student of Jean Buridan's who taught in Paris in the 1350's and early 1360's.[45] Duhem made a detailed comparison of the Da Vinci texts pertaining to the spots on

THE EYE

the moon and the corresponding passages in Albert of Saxony. However, he greatly exaggerated the influence of Albert on Leonardo, and, what is more, he even exaggerated Albert's originality, as he was forced to admit later.[46]

But enough of that: Duhem did not take into consideration that Leonardo had worked out his own point of view on the origin of the moon spots before he became acquainted with Albert's book, or at any rate before he wrote the notes of 1508–1509, which show definite traces of his having read this work. Leonardo had mentioned the hypothesis of lunar seas furrowed with waves in the so-called Leicester Codex (1504–1506), that is, before he became closely acquainted with Albert's work: "Reply to Maestro Andrea da Imola, who said that the solar rays reflected by the surface of the convex mirror intermingled and became lost at a short distance, and therefore it is altogether denied that the luminous side of the moon is of the nature of a mirror, and that in consequence this light is not produced by the innumerable multitude of the waves of that sea, which I have demonstrated to be that part of the moon which is illuminated by the solar rays" (Leic IV; MacCurdy 294).

Leonardo undertook his careful study of Albert of Saxony's work after he had established his own view. What then could Leonardo get from Albert? The demonstration and criticism of other theories, as we may see by comparing texts.*

Leonardo subsequently repudiated the explanations of those who thought that the moon spots were caused by vapors or clouds (F 84r), that they were caused by a difference in the density of the matter, and, finally, that the surface of the moon was a smooth spherical mirror (F 85r). All this is in Albert of Saxony's work. Leonardo did not copy the Parisian scholar, however, but each time developed his own argument. More important is that Leonardo criticized Albert's theory, not naming him, but speaking in general: "This opinion was held by philosophers, Aristotle in particular." One can see what Albert had in mind by comparing texts. Albert said: "There is a third opinion, namely of the Commentator (Averroës), which I consider true; that a spot like this originated from the difference in the parts of the moon in the sense of their greater or lesser rarefaction or density. For the

* Duhem gave the comparisons in French translation only. I checked them against the original.

LEONARDO DA VINCI

parts in which the spot appears are thinner (rarer), and therefore can shine less, while the parts alongside them are denser, and therefore shine more. This is evident from a comparison with alabaster. That is why a portion that is very dense or opaque is very white, while a transparent part, like glass, is dark and becomes black" (bk. II, question 24). Leonardo commented: "Others have said that the moon consists of parts, some more, some less transparent, as though one part were after the manner of alabaster and another like crystal or glass" (F 84v; MacCurdy 285). Leonardo then criticized Albert of Saxony's opinion. Thus, there is no basis for stating that Leonardo took the book *Quaestiones de caelo et mundo* as his starting point. On the contrary, there is reason to think that Leonardo began to read it after he had developed his own point of view; perhaps he turned to the book after an argument with Andrea da Imola or even on his advice.

It should not be forgotten that Dante had criticized the opinion of Averroës (shared by Albert of Saxony). After reaching the first heaven, that is, the heaven of the moon, the great poet heard from the lips of Beatrice a detailed refutation of this theory of Averroës', bolstered by a reference to experience (*esperienza*): "For us, it is the source of all sciences" (*fonte ai rivi di vost'arti*). Many scholars have compared this with Leonardo's words "La sapienta e figliola della sperientia" (Wisdom is the daughter of experience; Forst III 14r).

The discussion of the various theories outlined by Albert of Saxony was not original with him, moreover. It may be found in a book of the same title by his teacher, Jean Buridan,[47] and it goes back to Averroës in many things and thus was widely known.

There are not sufficient grounds for thinking, as did Duhem, that Leonardo found the rudiments of his own theory in Albert of Saxony's work. Albert wrote, refuting the idea that the lunar surface was a smooth spherical mirror: "Perhaps they object that if the light of the sun falls on a wall, that wall seems to us to be illuminated over its whole surface and not at one point only, corresponding to an angle of reflection equal to the angle of incidence." That this is so only because the surface of the wall is rough in this case is "clearly evident in the case of calm water . . . Only a small part of its surface reflects the light of the sun or of any other body intensively to us. However, if the water is set in motion, its surface ceases to be smooth, and the light of the sun is reflected to us intensively from a much larger part of the sur-

THE EYE

face."[48] Albert of Saxony actually anticipated Leonardo's explanation in this instance, but Leonardo did not first learn of it from Albert. As elsewhere, Albert repeated his teacher Buridan almost word for word.[49] It is very important to note what Duhem ignored completely. For Albert, the moon was a "simple body" (*corpus simplex*) or a "body simple in substance" (*simplex substantialiter*), that is, something substantially different from terrestrial bodies.[50] For Leonardo, as we have seen, the moon was a body similar to the earth, having the same elements as the earth.

I should point out in passing that Duhem[51] saw the influence of Albert of Saxony's *Quaestiones de caelo et mundo* (bk. II, question 16) in another passage of Leonardo's: "Whether the friction of the heavens makes a sound or no" (F 56v; MacCurdy 282). However, it seems much more probable that Ristoro d'Arezzo's work *Della composizione del mondo,* published in 1282, was the direct influence here. He, as later Albert of Saxony, pointed out the lack of air and the smoothness of the heavenly bodies. Parallel texts are given in Baratta's book.[52] Yet even in this case, similarities notwithstanding, one cannot ignore the differences. It is quite important that Leonardo kept only the purely physical (acoustic) aspect of the argument: sound cannot penetrate where there is no air; sound is possible only during friction of rough bodies; the irregularities of spheres would be erased over a long period of time, and so forth. Ristoro d'Arezzo's references[53] to the "perfection" of the heavens were completely omitted.

We must mention one of Leonardo's discoveries, in which once again we see his skill as an alert observer: he gave a correct explanation of the ashen color of the moon. Michael Moestlin (1550–1631), Kepler's teacher, gave exactly the same explanation, namely that it is caused by the reflection of the sun from the earth's oceans.

Leonardo gave his explanation in two similar versions. In the first he wrote: "When the eye in the east sees the moon in the west near the setting sun, it sees it with its shaded part surrounded by the luminous part; of which light the lateral and upper portions are derived from the sun and the lower portion from the western ocean, which still receives the solar rays and reflects them in the lower seas of the moon, and moreover it imparts as much radiance to the whole of the shaded part of the moon as the moon gives to the earth at midnight, and therefore it does not become absolutely dark. Consequently, some have be-

lieved that the moon has a light of its own in addition to that given it by the sun, and that this light is due to the cause already mentioned, namely that our seas are illuminated by the sun" (Leic 2r; MacCurdy 295).

The second variant inverts the first, as it were. Whereas the first begins with the thesis and ends with the polemic, the second begins with a frontal attack. "Some have believed that the moon has some light of its own, but this opinion is false, for they have based it upon that glimmer which is visible in the middle between the horns of the new moon, which appears dark where it borders on the bright part, and where it borders on the darkness of the background seems so bright that many have assumed it to be a ring of new radiance which completes the circle where the radiance of the tips of the horns illuminated by the sun ceases . . . this brightness at such a time being derived from our ocean and the other inland seas, for they are at that time illuminated by the sun, which is then on the point of setting, in such a way that the sea then performs the same office for the dark side of the moon as the moon, when at the full, does for us when the sun is set" (Leic 2r; MacCurdy 295).

As a thoughtful observer, tenaciously interested in problems of visual perception, Leonardo turned to the "difference of the background," that is, to the irregularity of the ashen light in various parts. He tried to explain this difference by the psychophysiological laws of light contrast. "And this difference in the background arises from the fact that the part of it which borders on the illuminated portion of the moon, by comparison with that brightness, shows itself darker than it is, and in the part above where appears a portion of a luminous circle of uniform breadth it comes about that there the moon being brighter than the medium or background upon which it finds itself, in comparison with this darkness shows itself on that extremity brighter than it is" (Leic 2r; MacCurdy 295).

These are the main features of Leonardo's "philosophy of the eye" and some of its applications in the field of painting and astronomy. Leonardo is not content merely to praise the eye's power of recognition, but demands that the laws of vision be studied, those general principles on which the function of the eye is based.

Theory, or, on a broader basis, scientific knowledge, was one of the roads to universality for Leonardo, a way to overcome subjective limi-

THE EYE

tations, for "poor" is that master who "can execute only one figure well" (TP 73; McMahon 95), who unconsciously and inadvertently depicts only himself and his defects in his work (see also TP 108–109, 137, 499). "The painter who has clumsy hands will make those in his works like his own, and the same will happen with any part of the body unless long study prevents it" (TP 105; McMahon 85). "It is a common vice of painters to delight in making things similar to themselves" (TP 282; McMahon 438). "If the master is quick in his speech and in his movements, his figures are similar in their quickness; and if the master is pious, his figures seem the same with their necks bent; and if the master is good for little, his figures seem idleness itself portrayed to the life; and if the master is disproportioned, his figures are the same; and if he is mad, it is shown amply in his narrative paintings where the figures are incoherent and do not attend to what they are doing, so that one looks here, and the other there, as if they were dreaming" (TP 108; McMahon 86).

Although Leonardo compared a painter who "paints senselessly" to a mirror, this did not stop him from requiring that the painter's mind should be like a clear mirror which "transmutes itself into as many colors as exist in the things placed before it" (TP 56 and 58a; McMahon 71, 72). Through this comparison Leonardo wished to emphasize the universality of painting and a dual universality at that. First, painting aspires to all the objects of the universe in their infinite variety, and secondly, it has a meaning like a universal language, comprehensible to all peoples. It is universal in that it represents objects, while the national languages of the poets name them (TP 7). "Thus, painting does not have need of interpreters for different languages as does literature and at once satisfies mankind, as do things produced by nature, and not mankind alone, but other living creatures also. This was shown by a painting, representing the father of a family, which was caressed not only by the little children when still in swaddling clothes, but likewise by the dog and the cat of the household, a marvelous thing and an extraordinary spectacle to behold" (TP 7; McMahon 17).[54]

Leonardo was convinced that a painting is more powerful than words, because "the painter will create an infinite number of things which words cannot even name, since there are no words appropriate to them" (TP 15; McMahon 24). One might say that he claimed that painting is capable of nuances not attainable by language: the shades

of blue or rose perceived by the eye are much more numerous than the words for them. The adherents of Descartes and Leibnitz were to say later that these hues are distinctive (they may be differentiated), but are not lucid (they cannot be defined verbally, they may only be shown or arbitrarily designated).

During the Middle Ages painting was generally regarded as a kind of "low literature." It was alleged to be the "literature of the illiterate," and this view was held even after Leonardo's death. Pope Gregory I, in a message to Serenus of Marseilles in 599, wrote: "Painting is used in churches so that those who do not know letters, in seeing paintings on the walls, can read what they are not capable of reading in books." [55] Lodovico Dolce, in his *Dialogo della pittura* (Dialogue on painting), first published in Venice in 1557, spoke of paintings as "books of the illiterate" (*libri degli ignoranti*).[56] But Alberti had already refuted the idea that painting was some lower form of literature. For him painting was universal art, which attracted equally the educated (*dotti*) and the uneducated (*indotti*). He remarked that "this indeed is the only art which is almost equally pleasing to the learned and the ignorant."[57] It is interesting in this connection to note his comments on Egyptian pictography. According to Alberti the Egyptian characters have an important advantage over others because of their graphic nature and ability to depict: "they must easily be understood by ingenious men of all nations, but nobody can understand the Etrurian [Etruscan] writing." [58]

For Leonardo painting is not the lowest form of literature. Indeed, it is higher than literature; it has the ability to express what eludes words. "Painting is poetry that is seen and not heard, and poetry is a painting which is heard but not seen" (TP 20; McMahon 29). Painting is mute and poetry is blind. "Now think, which is the more damaging affliction, that of the blind man or that of the mute?" (TP 19; McMahon 30).

Painting gives lovers an image of the ones they love (TP 31b). "If the poet says that he can inflame men with love, a principal concern of all kinds of living creatures, the painter has the power to do likewise" (TP 25; McMahon 33). Further: "Take the case of a poet who describes to a lover the beauties of his lady, and take that of the painter who represents her, and you will see which way nature inclines the lover who judges between the two" (TP 19; McMahon 30). "What poet can

put before you in words the true image of your adored one with as much truth as the painter?" (TP 18; McMahon 22). "If such a harmony of beauties is shown to the lover of the woman whose beauty it imitates, without a doubt he will remain stupefied with admiration and with an incomparable joy, for sight is superior to all the other senses" (TP 21; McMahon 40).

From these excerpts it is evident that universality in the sense of the fullest grasp of reality and the greatest "intelligibility" is not a part of national languages. It does not exclude, rather it proposes to capture in the most refined manner, the individual in all his diversity. We are speaking of the individual "father of a family," who is recognized by the children, the dogs, and the cats, and of the individual woman whom the lover recognizes.

Further, Leonardo advised to select the "good parts of many beautiful faces," which should be "considered beautiful by public opinion [*per publica fama*], rather than by your own preference" (TP 137; McMahon 276), that is, as if requiring a canon. "The painter ought to make his figure according to the rule [*regola*] of a natural body, which is commonly [*comunemente*] thought to be praiseworthy in its proportion [*proportione laudabile*]" (TP 109; McMahon 87). We have translated *regola* as "rule," but it could just as well be translated by the corresponding Greek word "canon." Then, how do Leonardo's words differ from the precepts of later classicism; mainly, how are these precepts affiliated with Leonardo's own strivings toward the infinite variety of the individual?

True, when Leonardo spoke of the canonic proportions of the adult, he repeated Vitruvius in some points (TP 264). Leonardo's manuscripts contain drawings that are simple illustrations of the Vitruvius text (figures of a man, drawn in a circle and in a square). However, even when speaking of laws, Leonardo spoke for himself, his main attention being directed toward the difference in proportion owing to age and build rather than establishment of a single law for the human figure (cf. TP 125, 126). Without such diversity, all figures would "seem as sisters" (TP 78) or all men would look like "brothers" (TP 136). The same applies to movements and poses. Leonardo wrote: "It is an extreme error of some masters to repeat the motions in the same composition, one along side the other in the same narrative painting" (TP 107: McMahon 274). In the next paragraph he says; "It is an ex-

treme defect when painters repeat the same movements, and the same faces and manners of drapery in the same narrative painting" (TP 108; McMahon 86). Indeed, beauty in faces "is never found repeated in nature" (TP 107; McMahon 274).

Giving his instructions in detail, Leonardo states: "I find a great difference in the length of the bones between the joints in men and children; for in a man, from the junction of the shoulder to the elbow, and from the elbow to the point of the thumb, and from one shoulder to the other, is in each case the length of the two heads, but in a child is only one, because nature first creates the size of the seat of the intellect, before that of the vital spirits" (TP 266; McMahon 289).

In this connection Leonardo sharply rebukes those painters who "wish to improve on the creations of nature" and place the diversity of proportions in the Procrustean bed of a single canon. "That painting is most praiseworthy which conforms most to the object portrayed. I put this forward to embarrass those painters who would improve on the works of nature, such as those who represent a child a year old and make the head an eighth, instead of a fifth, of his height; and the breadth of his shoulders is similar to that of his head, and they make it half the breadth of the shoulders; and thus they proceed reducing a small child a year old to the proportions of a man of thirty. They have so often made this error and seen it made that they have adopted it in practice, which has so penetrated and become established in their corrupt judgment that they make themselves believe that nature or whoever imitates nature commits a great error in not doing as they do" (TP 411; McMahon 433).

In dealing with a specific attitude of the body, with a single one and not a general attitude, the artist should single out and portray only those muscles which are in action during a given gesture, otherwise he will have a "bag of nuts," and not the human figure. Leonardo made this comparison twice (TP 334, 340; McMahon 309).

He gives similar advice in the third part of the Treatise on Painting, which treats of all the changes experienced by the joints and the muscles in various positions and gestures of the body. This advice is repeated endlessly, sometimes in general form, sometimes as specific illustrations and examples. According to Leonardo, gestures appropriate to the states of mind of each living creature, which vary continuously as a function of these states, are "the most important

things that can be found in the analysis of painting" (TP 122; McMahon 111); furthermore, they are the most difficult (TP 180). "Portray figures with gestures which will be sufficient to show what the figure has in mind, otherwise your art will not be praiseworthy" (TP 294; McMahon 398). In other words, "that figure is not praiseworthy if it does not, insofar as is possible, express in gestures the passion of its spirit" (TP 367; McMahon 400). On several occasions Leonardo called such inexpressive figures "twice dead," because there is no life in them and because they are images and, therefore, do not convey movement (TP 285, 297, 368, 376).

Leonardo advised that special attention be paid the mimicry and gesticulation of mutes, whom he called "masters of gesture" (TP 115, 180, 376; McMahon 250). He recommended that "the attitudes and actions of men in conversation, in quarreling, or laughing, or fighting each other" (TP 173, 179; McMahon 258) be sketched in a special book. "Go each Saturday to the hot baths and you will see the nudes" (F cover IV; MacCurdy 1170). "They also say that he took great delight (*si dilettava molto*) in going to see the gestures of the condemned being led to punishment, in order to observe those raised eyebrows and those expressions of the eyes and of life."[59]

Leonardo mentioned a whole program of "experimental compositions": two brave men, and a brave man and a coward "in different actions and aspects" (TP 181; McMahon 259). The sketches in his own notebooks were supplemented by descriptions of individual figures in a state of anger (TP 381) or despair (TP 382), comments on "laughing and weeping and the difference between them" (TP 384, 385; McMahon 420).

Theory, in Leonardo's eyes, was a means of overcoming subjective limitation, the limitations of the individual, and to go out into the broad field of universality. But the truly universal, nature in all its variety, was a limitless ocean of the specific, an endless multitude of individualities, of individual proportions, individual motions, and attitudes. "Nature is so delightful and abundant in its variations that among trees of the same kind there would not be found one which nearly resembles another, and this is so not only of the tree as a whole, but among the branches, the leaves, and the fruit, for not one will be found which is precisely like another" (TP 501; McMahon 548). Elsewhere he said: "One of the most praiseworthy and marvelous things

LEONARDO DA VINCI

that appears in nature" is that "none of its works in any species precisely resembles any other in detail . . . but if you wish to make your figures on the basis of one and the same measurement, know that they cannot then be distinguished from one another, which is something never seen in nature" (TP 270; McMahon 291). Could any theory, any science embrace such inexhaustible diversity? And if the object of painting (or nature) is infinite diversity, of what purpose are any (unavoidably general) techniques which are the subject of a particular discipline, that is, the sum of all the general rules that one may learn or study? "Design is free, insomuch as if you see an infinite number of faces, they will all be different, one with a long nose and one with a short; the painter therefore must also assume this liberty, and where there is liberty there is no rule" (BN 2038 1r; MacCurdy 857).

Various auxiliary techniques are discussed in passages of the Treatise on Painting, for example, the use of a mirror (TP 407–408), tracing through sheets of glass, transparent paper, or a veil (TP 39, 90, 413), the use of this glass to transmit aerial perspective (TP 216), the use of frames of threads (TP 97). For Leonardo all such approaches were merely additional means of checking on oneself, not creative techniques. In one instance (TP 39) he spoke directly of "laziness," remarking that artists who depend entirely on mechanical means are helpless when it comes to "invention" and narrative composition, that is, intelligent selection.

Leonardo placed those sciences "which cannot be left as a bequest" above those which can be imitated (*scientie imitabili*), in which the student can compare himself with the one he imitates. The first among the inimitable sciences is painting (*pittura*). "It cannot be taught to those who are not naturally fitted for it, as can mathematics, where the disciple absorbs as much as the teacher reads to him." Painting (again, *pittura*), according to Leonardo, "remains precious and unique [*resta pretiosa et unica*]." "It cannot be copied, as can words and phrases, where the copy is worth as much as the original. It cannot be cast, as can sculpture, where the cast is worth as much as the original, insofar as the excellence of the work is concerned. It does not have an infinity of progeny, as does the printing of books. Painting alone remains noble, it alone honors its author and remains precious and unique [*unica*], never bringing forth children equal to itself. Such rarity [*singolarita*] makes it more excellent than those things which are made public widely" (TP 8; McMahon 18).

THE EYE

It would seem that Leonardo had forgotten his own words: "that science is most useful, the results of which are most communicable, and, conversely, that is less useful which is less communicable." This is the very reason why Leonardo placed painting above poetry, namely, because "painting makes its end result communicable to all the generations of the world" (TP 7; McMahon 17).

What happened to Leonardo's celebrated "mathematism," since the true essence of painting cannot be learned as can mathematics, where the student absorbs as much as the teacher reads him? Where, then, is the famous "synthesis of science and art," since much earlier Aristotle, the "teacher of those who know," the philosopher with a capital P, as he became to succeeding generations and was in Leonardo's time, pronounced categorically that there can be no scientific knowledge of the individual?*

Leonardo da Vinci and Goethe have been compared many times, and such a comparison can give an answer to the question just posed. When Goethe developed his thoughts on the metamorphosis of plants to Schiller and drew on paper his scheme "of the first plant," Schiller said: "That is not experience, but an idea." Goethe answered: "Then an idea may be seen with the eyes."[60] Of course, in answering thus Goethe did not intend to reduce scientific knowledge to a sensually unified image. On another occasion he remarked that "there is a difference between vision and vision (*zwischen Sehen und Sehen*)," that "the eyes of the spirit should act in a continuous living union with the eyes of the body, for otherwise there is the danger of seeing but overlooking," or seeing past (*vorbeizusehen*).[61]

However, for Goethe, amidst the multitude of natural phenomena there are those which did not reduce to others; around them are grouped innumerable other phenomena, whose typical representatives they are. These are the "primary phenomena" or the "primeval phenomena." The primeval phenomenon is the methodological center (*methodischer Mittelpunkt*) of other phenomena,[62] the "basic phenomenon" (*Grundphänomen*).[63] The primeval phenomenon does not require further explanation, therefore it is the "limit of contemplation" (*Grenze des Schauens*). "Let the natural scientist leave the primeval phenomena standing in their perpetual calm and majesty" (*Der*

* Aristotle, *Metaphysics,* 3.4.999b. "If there is nothing apart from individuals, there will be no object of thought, but all things will be objects of sense, and there will not be knowledge of anything, unless we say that sensation is knowledge."

LEONARDO DA VINCI

Naturforscher lasse die Urphänomene in ihrer ewigen Ruhe und Herr-lichkeit da stehen).[64]

In his "Supplements to the Study of Colors"[65] Goethe in confirmation of his doctrine of the "primeval phenomenon" (light appears red through a turbid medium, while darkness appears blue), cited an entire passage from the Treatise on Painting, together with the German translation, and added the heading: "The highest authority." This is the passage: "The blue of the air comes from the density of the body of illuminating air lying between the upper darkness and the earth. The air in itself has no quality of odor, taste, or color, but takes on the semblances of the things placed beyond it, and the blue will be the more beautiful, the greater the darkness behind it, provided there is not too much space lying between or too heavy humidity. Thus, it is seen that mountains that have the most shadow are the most beautifully blue at great distances, but where they are most illuminated, they show the color of the mountains themselves rather than the blue given them by the air which lies between them and the eye" (TP 243; McMahon 225).

But is this actually close to Goethe's conception of the primeval phenomenon? From the first line to the last it is the analysis of a phenomenon, an attempt to give a causal explanation of the phenomenon which, for Goethe, should be left to pure intuition, the contemplation of "perpetual calm and majesty."

In remarking on Goethe's expression "exact sensory fantasy" (*exakte sinnliche Phantasie*), Ernst Cassirer tried to apply it to Leonardo's characteristics of sight. According to Cassirer: "Leonardo, like Goethe after him, sharply distinguished artistic 'style' from mere individual manner. And, again like Goethe, he considered style to be based on the 'deepest foundations of knowledge, on the essence of things, inasmuch as it is allowed us to recognize the essence in visible and graspable forms.'" "Even as a scientist," Cassirer continues, "Leonardo insists upon this visibility, this graspability of the form. He considers it the limit that bounds all human knowledge and comprehension. To traverse the realm of visible forms completely; to grasp each of these forms in its clear and certain contours; and to keep them in their full definiteness before both the internal and the external eye: These are the highest aims recognized by Leonardo's science. Thus, the limit of vision is also, of necessity, the limit of comprehension. Both as artist

and as scientist, he is always concerned with the 'world of the eye'; and this world must present itself to him not in bits and pieces but completely and systematically." [66]

Luporini[67] justly took exception to this "visibilistic" interpretation of Leonardo's approach, aptly pointing out that Leonardo, in contrast to Goethe, saw mathematical structure in a visual phenomenon. But he was scarcely correct in asserting that Leonardo's words on the "uniqueness" of the artist's production marked the first break with the quattrocento tradition which assimilated art and science to the utmost, namely, a break between art, the source of delight, and science, the source of knowledge, that was characteristic of the sixteenth century.

Leonardo did not draw a line between a work of art, which cannot be repeated because of its uniqueness, and science, which of necessity generalizes. The problem of the singular, the unique, excited him equally as an artist and as a scientist. How can one perceive regularity (*ragione*) in a unique phenomenon without generalizing the unique and without departing from the uniqueness? In other words, how can there be botany if nature has no plant which is exactly like another, if "among trees of the same kind there is not one which nearly resembles another, and this is so not only of trees as a whole, but among the branches, the leaves, and the fruit, for not one will be found which is precisely like another" (TP 501).

This same question arises in connection with painting, whose subjects are infinite. "That which in itself contains the greater scope and variety is to be called the more excellent, and therefore painting is to be placed before all other activities because it contains all forms that are found in nature and those that are not" (TP 31 b; McMahon 26). There are no limiting criteria and canons. Indeed, "if the painter wishes to see beauties which will make him fall in love with them, he is a lord capable of creating them, and if he wishes to see monstrous things that frighten, or those that are grotesque and laughable, or those that arouse real compassion, he is their lord and their creator" (TP 13; McMahon 35).

Thus, he faces the infinite variety of the individual as an artist and as a scientist. But how can one encompass such infinity? Would that not be the same as destroying it in its essence? Leonardo treats of this question in the following instructive passage. "What is that thing which does not give itself, and which if it were to give itself would not exist?

It is the infinite, which if it could give itself would be bounded and finite, because that which can give itself has a boundary with the thing which surrounds it in its extremities, and that which cannot give itself is that which has no boundaries" (CA 131r b; MacCurdy 612).

In other cases, borrowing his definitions and wording from Aristotelian teachings on the continuum, Leonardo attempted to introduce scientific rigor or, to be more exact, some kind of appearance of scientific rigor to the idea of the infinite variety of the universe which stirred him so deeply. For example, he systematized the infinite diversity of possible positions of the shoulders, referring to the infinite divisibility of the circle (TP 269). Indicating motion upward, downward, forward, and backward, Leonardo continued: "It might be said that such motions are infinite, because if you turn the shoulders to the side of a wall, and trace a circular figure with the arm, you will make all the motions of the shoulder. And because every circle is a continuous quantity, it is therefore a continuous quantity that is made by the motion of the arm. But that motion does not produce a continuous quantity unless continuation makes it so. Thus, the motion of the arm has been through every part of the circle, and since this circle is infinitely divisible, the different positions of the shoulders are also infinite in number" (TP 269; McMahon 359). Leonardo used a similar approach in speaking of the movements of a hand (TP 402) and, generalizing, on the movements of a man: "it will not be denied that the motion is made in space and that space is a continuous quantity and that any continuous quantity is infinitely divisible" (TP 300; McMahon 362). The variations of positions of human forms are equally infinite (TP 301), for example, the changes in the shadows of a bent figure (TP 721), or the position which that body takes in its convolutions (TP 810). In all cases Leonardo considered it necessary to recall that "a continuous quantity is infinitely divisible," that "space is a continuous quantity," and so forth. This is the distinctive refrain which is a good expression of Leonardo's emotional attitude toward the infinity of existence.

But let us assume for the moment that the infinity of shapes in the universe became accessible to the "eye." (Here, and in what follows, I shall put quotation marks around the word eye when I speak of vision in Leonardo's sense, in the sense of integral artistic perception.) What can be said of the world of "invisible" human relations, the world

of morals, the world of such concepts as Prudence, Fortitude, Justice? In his numerous allegorical sketches, his fables, Leonardo attempted to make even this world accessible to the "eye." One example will suffice, the projected figures for the festival held in 1491 on the occasion of the weddings of the duke of Milan, Lodovico il Moro, and of his retainer Galeazzo da Sanseverino.

> On the left side let there be a wheel, and let the center of it cover the center of the horse's hinder thigh piece, and in this center should be shown Prudence dressed in red, representing Charity, sitting in a fiery chariot, with a sprig of laurel in her hand to indicate the hope that springs from good service. On the opposite side let there be placed in like manner Fortitude with her necklace in hand, clothed in white which signifies . . . [omission in original] and all crowned, and Prudence with three eyes. The housing of the horse should be woven of plain gold, bedecked with many peacocks' eyes, and this applies to all the housings of the horse and the coat of the man. The crest of the man's helmet and his hauberk of peacocks' feathers, on a gold ground. Above the helmet let there be a half globe to represent our hemisphere in the form of a world, and upon it a peacock with tail spread out to pass beyond the group, richly decorated, and every ornament which belongs to the horse should be of peacocks' feathers on a gold ground, to signify the beauty that results from the grace bestowed on him who serves well. In the shield a large mirror to signify that he who really wishes for favor should be mirrored in his virtues (BM 250r; MacCurdy 1014).

Is the "eye" capable, without the aid of speech, to interpret this complex allegorical picture, especially since Leonardo always varied the meaning of his allegories, in contrast to the symbolism of the Middle Ages? For example, in another remark of Leonardo's which was, true, only an excerpt from *Fiore di virtù* (Flower of Virtue), the peacock signified vainglory. "*Vainglory*. As regards this vice, we read of the peacock being more subject to it than any other creature, because it is always contemplating the beauty of its tail, spreading it out in the form of a wheel and attracting to itself by its cries the attention of the surrounding animals. And this is the last vice that can be conquered" (H10r; MacCurdy 1078).

Let us compare Leonardo's instructions for the wedding feast with the description given by Tristano Calco, one of the duke's courtiers:

First a wonderful steed appeared, all covered with gold scales which the artist had colored like peacock eyes. From the scales protruded sparse stiff hairs and frightening tufts. The head of the horse was covered with gold, it was slightly bent and decorated with curved horns. The saddle, the breast, and the arms of the warrior were decorated in the same manner. From his head hung a winged serpent whose tail and legs touched the horse's back, a bearded face cast from gold looked out from the shield. Behind Galeazzo, who appeared thus, came his companions on horseback, depicting various peoples of the earth. The clothing of some was like that of forest barbarians, recalling the stories of the Scythians and those now usually called Tartars. Their herald, approaching the duke, spoke in a foreign language then through an interpreter in Italian announced that this was the son of the Indian emperor.[68]

Calco described the spectacle as such, without going into the allegory of which Leonardo wrote, and then simply relayed what was said, not what was depicted at the festival.

Let us recollect the complex allegorical composition preserved in the Oxford collection: Evil Thought (*Malpensiero*) and Envy or Ingratitude (*Invidia over Ingratitudine*) sitting on a frog (not a toad, as some have thought), the symbol of imperfection, and accompanied by Death (figure 24). Again, this cannot be deciphered without explanations and commentaries. The meaning of the composition is revealed through the visual image, but it is not given solely by the visual image.[69]

As Leonardo put it: "For the soul, the master of your body ... has developed the whole shape of a man, as it has deemed to be best with long, or short, or flat nose, and definitely assigned his height and shape" (TP 109; McMahon 86). Further: "Whoever would see in what state the soul dwells within the body, let him mark how this body uses its daily habitation, for if this be confused and without order, the body will be kept in disorder and confusion by the soul" (CA 76r a; MacCurdy 63).

But what about hypocrisy and the mask? Surely one cannot suppose that Il Moro as the figure of Fortune, described by Leonardo, was a genuine reflection of reality for the artist. Leonardo could have learned from his contemporary Machiavelli that in certain cases a ruler must wear the mask of a beast and of a man. "One may fight in

THE EYE

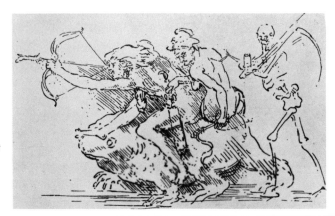

24. *Evil Thought and Envy*

two ways," wrote Machiavelli, "one means of doing battle is by laws, the other by force; the first is typical of man, the second of a beast. However, since the first is often inadequate, the second is resorted to. Consequently, a prince must know how to rule nature as a beast and as a man." According to Machiavelli the legend of the centaur Chiron, who taught Achilles and "many other ancient princes," serves as an example, "since the only meaning of their having for an instructor one who was half man and half beast is that it is necessary for a prince to know how to use both natures, and that the one without the other has no stability." "But since a prince should know how to use the beast's nature wisely, he ought of beasts to choose both the lion and the fox; for the lion cannot guard himself from the toils, nor the fox from the wolves. He must therefore be a fox to discern the toils, and a lion to drive off the wolves." Thus for Machiavelli the prince has to be a fox and a lion, or rather he must pretend to be a lion, wear the mask of a lion, in order to "drive off the wolves," to be a "great deceiver and dissembler" (*gran simulatore e dissimulatore*).[70]

Leonardo developed the image of the mask in one of his projected allegorical paintings for the stage (W 12700v; MacCurdy 1096). Here Truth is the Sun and "Falsehood assumes a mask. Nothing is hidden beneath the Sun." And, further, "fire is put for truth because it destroys all sophistry and lies, and the mask for falsity and lying by which the truth is concealed." Thus, behind the visible, apparent form may be hidden another, true form, which also may become visible or evident. However, this may be shown to the "eye" only arbitrarily, as Leonardo

did: the figure is like a mask, the viewer sees both the mask and the true face.

Is it true then that for Leonardo the "limit of vision is simultaneously the limit of comprehension"? Do we not have the right to say rather that the total comprehension of things and their relations will impose ever newer and ever more complex problems on the "eye," will broaden the "limit of vision"? Leonardo's aim was to make certain general relations and general laws "visible" in a single visual image, a "painting"; more precisely, first to attain some general relations and general laws by specifically embodying them in a single visual image.

For Leonardo the concept of the "eye" has such broad meaning that it becomes equivalent to the concept of integral specific knowledge, a vision of the individual, in which its relations to the world as a whole, to other objects, is always preserved. The general "shines forth" in the individual and does not absorb it. Let us not forget that for Leonardo painting through drawing "taught geometry to depict figures" (*ha insegnata la figuratione all geometria*)" (TP 23); let us not forget that "the painter is he who, through the requirements of his art, has brought forth perspective"; that within the limits of visual lines are included "all the different shapes of bodies created by nature and without which the art of geometry is blind" (TP 17; McMahon 15). Thus for Leonardo it is not painting that is based on geometry or painting that is born of geometry, but geometry that is born of painting; the abstract is born of the concrete and is viewed in a concrete form.* An examination of Leonardo's views on the nature of mathematics will give us a deeper insight into these problems.

* The opposite view—that geometry is the "mother of drawing"—was held by Danielo Barbaro in the middle of the sixteenth century. See the *Ten Books on Architecture* of Vitruvius with commentary by Barbaro.

5.

THE PARADISE
OF THE
MATHEMATICAL
SCIENCES

*"Mechanics is the paradise of the mathematical sciences,
because by means of it one comes to the fruits of
mathematics."*
 E 8v; MacCurdy 613

"Let no one read me who is not a mathematician," Leonardo announced (W An IV, 14v; MacCurdy 85). In his words, the mathematical sciences—arithmetic and geometry—are the height of reliability, they "silence the tongues of the contentious," bring to "eternal silence" all argument, and still clamor, a state of affairs so hateful to Leonardo (TP 33; McMahon 19). "He who defames the supreme certainty of mathematics feeds on confusion, and will never impose silence upon the contradictions of the sophistic sciences, which occasion a perpetual clamor" (W An II 14r; MacCurdy 83).

Let us compare these words with the aphorism that serves as an epigraph: "mechanics is the paradise of the mathematical sciences, because by means of it one comes to the fruits of mathematics." It would seem that everything is clear: mathematics and mechanics are proclaimed the two supreme sciences; Leonardo is not only the precursor of the mechanicomathematical outlook, but its first representative. However, the problem is actually more complex than this would indicate.

First of all, when Leonardo spoke of mechanics, he did not mean the theoretical discipline, but the practical application of theoretical postu-

lates. That is why he said that the fruits of mathematics would be attained through mechanics. A. Koyré recently pointed out that Leonardo used the word "mechanics" to mean the "science of machines,"[1] but this is not completely true, as the following examples will demonstrate. Leonardo did not use the title "Mechanics" for the books he planned, but rather "Machine elements" (*Elementi macchinali*), on the model of Euclid's *Elements* (A 10r); he also mentioned a "Book on the Science of Machines" (*Libro della scientia delle macchine*) (W An I 13v; MacCurdy 1173).[2] Similarly, Luca Pacioli did not speak of a book by Leonardo on mechanics, but of an "invaluable work devoted to spatial motion, impact, weights, and all kinds of forces, that is, accidental weights," a work which Leonardo was preparing to finish in the late 1490's.[3] Finally, Leonardo contrasted "mechanical proof" (*prova meccanica*) with "mechanics." "This proof is the more worthy of praise," he said, "the more direct it is, the more it gives the same truth that mechanics does" (CA 231r a). It is quite evident that the word "mechanics" is used here in the meaning of "mechanical art." The theoretical postulates of "mathematics" are realized through "mechanics," and mathematics includes what we now call theoretical mechanics.

For Leonardo, mathematics included not only purely mathematical disciplines but physics, as can be seen from this exclamation: "O, mathematicians, throw light on this error! The spirit has no voice, for where there is voice there is a body" (CA 190v b). Clearly, it is not mathematicians but physicists (in the modern sense of the word) who are concerned with problems of acoustics and therefore are the ones summoned to refute the "voices of the spirits." When Leonardo asserted that "a bird is an instrument working according to mathematical law" (CA 161r a; MacCurdy 493), he did not have in mind mathematics, but what we now call mechanics.

One may think that substitution of the term mathematics for mechanics (or the physical and mathematical sciences as a whole) does not change matters essentially. The ideal of the mathematicomechanical description and explanation of nature would appear to be the same in both cases. However, this is not the case.

The requirement "Let no one read me who is not a mathematician" did not refer to pure mathematics or to mathematics in the strict sense of the word, as demonstrated by another of Leonardo's aphorisms:

MATHEMATICAL SCIENCES

"There is no certainty where one cannot apply any of the mathematical sciences or any of those which are based upon the mathematical sciences" (G 96v; MacCurdy 619). This is by no means the same as Kant's statement: "In each special natural science one may find only that much actual science as there is mathematics in it."[4] Leonardo was speaking of the physicomathematical sciences, Kant about mathematics as such.

As final evidence, we shall re-examine Leonardo's statements already cited and some others not as they are usually given in anthologies, out of context, but in connection with the specific occasion which gave rise to them. "Let no one read me who is not a mathematician" was said when he was describing the mechanism of the valves of the heart. "He who defames the high reliability of mathematics" was also said in connection with a drawing of the heart. "And, therefore, o learners, study mathematics and do not build without foundations" appeared after a long discourse on the movements made during breathing and digestion (W An IV 14v). "It is my purpose here to describe and represent in full, proving these movements by means of my mathematical principles" was written about the movements of the muscles of the mouth (W An B 29r; MacCurdy 144).

But then a new question arises: what was that mathematized natural science, that "mathematics," which Leonardo considered the basis of all our knowledge? To answer that question, let us turn to a comparison.

A friend of Leonardo's, the Platonist and monk Luca Pacioli, also stated that "of all the true sciences, as Aristotle and Averroës maintain, our mathematical sciences are the truest and the most reliable, and all the other natural sciences follow them."[5]

Actually Aristotle graded the sciences on their exactness: the simpler the examined property, the more exact is the science that examines it. Geometry, in departing from the concept of motion, is more exact than mechanics; the general study of life (ontology, metaphysics), in departing from the concept of size, is more exact than geometry.[6] In other words, the more abstract the postulate, the more exact and reliable it is. Could Leonardo have subscribed to this point of view?

In his *Summa*,[7] Luca Pacioli presents a number of problems about journeys,[8] including the following. A traveler made as many trips as he had ducats in the beginning; during every trip he doubled their number and in the end had ninety ducats. Question: how many trips did

LEONARDO DA VINCI

he make? Without being embarrassed about the absurdity of the answer, Pacioli came to the conclusion that the traveler had completed $1 + \sqrt{4\frac{3}{4}}$ trips. In another problem he spoke of the number of trips as

$$3\frac{24,733}{63,308} + \sqrt{7\frac{164,348,177}{4,007,902,864}}.$$

In contrast to Pacioli, Leonardo was always interested in the physical sense of a particular algorithm, the range of its possible application to the facts of the physical world. Having determined the relation between the wing size and the weight of a bat, Leonardo warned against the hasty conclusion that the actual ratio should apply everywhere and always, that is, to the gradual increase of weight in other animals as well: "I say that if the bat weighs two ounces and measures half a braccio with wings expanded, the eagle ought, accordingly, to measure with wings expanded not less than sixty braccia, but we see by experience that its breadth is not more than three braccia. And it would seem to many who neither see nor have seen similar creatures that one of the two would not be able to fly, considering that if there exists the proper proportion between the bat's weight and the breadth of its wings, then in the case of the eagle they are not large enough, and if the eagle is properly equipped, the other has them too large and they will be inconvenient and unsuitable for its use. We see, however, both the one and the other borne with the utmost dexterity by their wings, and especially the bat which by its swift turns and feints overcomes the rapid twists and retreats of the flies and gnats and other similar creatures" (B 89v; MacCurdy 438).

Another example. Leonardo disputed Albert of Saxony, pointing out that the Peripatetic formula $v = k\frac{p}{m}$ is not universal (here v is velocity, p is force, m is the weight of a body, and k is the proportionality factor). "*Of Movement.* Albert of Saxony in his *De proportione* says that if a power moves a mobile with a certain speed, it will move the half of this mobile twice as swiftly. This does not appear so to me" (I 120v; MacCurdy 564). Returning to this same theme somewhat later, Leonardo wrote: "And if some have said that the more the mobile

MATHEMATICAL SCIENCES

[movable thing] is diminished, the more rapidly its mover drives it in proportion to its diminution on to infinity, constantly acquiring speed of movement, it would follow that an atom would be almost as rapid as thought itself, or as the eye which roves in an instant to the height of the stars." Leonardo makes his calculations and concludes: "Now if you take the weight of a small grain for the experiment, the mortar would not send it any farther than it sends its smoke when one begins to fire, but by the above reasoning it would be sent a million miles in the time it takes a hundred pound ball to go three miles." From this he draws the moral: "And so, speculators, mistrust authors who have tried to make themselves interpreters between nature and men by using nothing but their imagination. Trust only those who have exercised their minds not on the proofs of nature but on the results of their own experiments. Experiments deceive those who are not familiar with their natures; often those that seem the same differ greatly" (I 102r; MacCurdy 562, 563; Baskin 27).

This expresses what was most characteristic of Leonardo: not abstract mathematical algorithms, but laws discovered on the basis of "nature's indications" and the "results of experiments." Santillana was quite correct in stating that Leonardo's mathematics was not "contemplation of the pretersensual world, but a search for the geometric skeleton of reality."[9]

Of course, Pacioli did not separate mathematics from practice and technology. Indeed, he kept stressing the value of mathematics for fortifications, artillery, architecture, hydraulic engineering, cartography, the theory of perspective, music, and so forth. He said that "gold is tested by fire, and talent by mathematics." However, it was he who placed over the door of the Plato Academy the Plato inscription: "Let him not enter here who does not know geometry." And he held the greatest merit of mathematics to be its "great abstraction and subtlety" (*grandissima abstractione e subtigliezza*), that is, its abstraction from "sensual matter."[10]

During Leonardo and Pacioli's time there was a third viewpoint on the nature and meaning of mathematics. It was presented by Florentine Platonists of the type of Ficino and his fellow thinkers, including Giovanni Pico della Mirandola, whose five theses earned the implicit approval of Ficino. These theses stated that "mathematics is not true knowledge," that it "does not lead to bliss," that the mathematical

sciences "do not exist for their own sake," that "there is nothing more harmful for the theologian than frequent and sedentary occupation with Euclid's mathematics."[11] This type of mystical Platonism was foreign not only to Leonardo, but to Luca Pacioli who quoted Plato.

Among Leonardo's mathematical fragments one of the foremost is the larger part of Forster Codex I, which is a completed work in a sense. Leonardo himself designated it "Book entitled *On Transmutation,* i.e., on the transformation of one body into another without decreasing or increasing the matter." The practical orientation of the treatise becomes quite evident from its first lines: "Geometry extends to the transmutations of metallic bodies, which are of substance adapted to expansion and contraction according to the necessities of their observers" (Forst I 40v; MacCurdy 635). This is the most systematic of Leonardo's works and is divided into books (or sections) and numbered postulates. It is devoted to the transformation of areas into equal areas and of bodies into bodies of equal volume. Even the lines cited above make it clear that these were problems he encountered in working metal, in chasing and molding parts, in sculpture (particularly in planning the equestrian statue of the duke of Sforza), in construction and hydraulic engineering calculations, and so forth. Even when speaking of geometry, Leonardo did not lose sight of "metallic bodies." It was not a matter of narrow application; for Leonardo, the mathematical sciences were experimental disciplines.

It was no mere chance that Leonardo da Vinci invented numerous instruments for solving mathematical problems: proportional compasses, an instrument for solving the so-called problem of Alhazen (to find the point of reflection on a spherical convex mirror for given points of the eye and the source), an instrument for drawing parabolas, an instrument for constructing parabolic mirrors.[12]

According to Leonardo, "The science of weights is led into error by its practice." Why? Because the axes of the balances "in the opinion of the ancient philosophers were placed by nature as poles of a mathematical line and in some cases in mathematical points, and these points and lines are devoid of substance, whereas practice makes them possessed of substance, since necessity so constrains as needful to support the weight of these balances together with the weights which are reckoned upon them" (CA 93v; MacCurdy 503). The "ancient philosophers" erred because they confused deductions based on inves-

MATHEMATICAL SCIENCES

tigation of a purely mathematical, abstract lever with a physical, substantial lever (CA 93v b). Leonardo was interested primarily in the substantial, weighable lever, while the "unsubstantial," mathematical lever was only of secondary interest to him, as another means of getting at the more specific. This explains Leonardo's memorandum: "Verify experimentally and describe the nature of the poles of balances, when they are thick or thin, when they are in the middle, below or above, or in an intermediate position between them" (CA 146r c).

In this connection, one might recall the contrast Leonardo drew between a "mathematical" and a "natural" or "mechanical" point (CA 200r b): "There is an infinite difference between the mechanical point and the mathematical point, because the mechanical is visible and, consequently, has continuous magnitude and everything continuous is infinitely divisible. The mathematical point, on the other hand, is invisible and without magnitude, and where there is no magnitude there is no division."

In speaking of squaring the arc of the circumference, Leonardo turned to the figure of the rotating wheel: "The motion of carriages always has shown us how to square the circumference of a circle" (E 25v). Or still more definitely: "Animals that draw chariots afford us a very simple demonstration of the squaring of a circle, which is made by the wheels of these chariots by means of the track of the circumference which forms a straight line" (G 58r; MacCurdy 619).

True, Leonardo also criticized such an approach and alluded to the possibility of a stricter and more accurate method: "Vitruvius, while measuring the mile by means of many complete revolutions of the wheels that move chariots, extended the line of the circumference of these wheels over many stadia. He learnt these from the animals that are movers of these chariots, but he did not recognize that this was the means of finding the square equal to a circle. This was first discovered by Archimedes of Syracuse who found that the multiplication of the radius of a circle by half its circumference made a rectilinear quadrilateral equal to the circle" (G 96r; MacCurdy 619). Elsewhere, Leonardo attempted to add to Archimedes, recalling his own technique based on neglect of a negligibly small value: "Archimedes has given the square of a polygonal figure, but not of the circle. Therefore, Archimedes never found the square of any figure with curved sides; but I have obtained the square of the circle minus the smallest possible

portion that the intellect can conceive, that is, the smallest point visible" (W 12280v; MacCurdy 642). In other words, Leonardo was often satisfied with approximate solutions, sufficient for the engineer but not satisfying the requirements of mathematical rigor. This was his approach, for example, in constructing the described circle with a given length of a side of a polygon (B 14r).[13]

Leonardo held that "proportion is not only found in numbers and measurements, but also in sounds, weights, times, positions, and in whatsoever power there may be" (K 49r; MacCurdy 622). This accounts for the abundance of aphorisms and notes composed on the pattern *tanto-quanto*—"to this extent . . . to that extent," "the more . . . the more," "the less . . . the less"—in the most general form, most often the simplest linear relationship, describing the simplest actions having first-order magnitudes with respect to the rule of three. Accordingly, problems are simplified, stated in a primitive form. For example, the power of light is linearly dependent on distance (C 22r). The same linear dependence obtains between the intensity of color, distance, and atmospheric density.

These three theorems on the "perspective of color," stated in paragraphs 198–200 of the Treatise on Painting, should properly have appeared in reverse order. The simplest case, where the eye looks from denser to less dense layers of air at the same elevation each time, is examined last. The second case, where the eye looks at the colors downward through two layers of different density and all these colors are situated below the eye at different distances from the eye but at the same level, is examined next. The third case, the most complex one, where the eye looks at color upward successively through one, two, and more layers of different density, is examined first. Here one must determine the distances at which each color is perceived identically in all cases. Ludwig did not grasp the correct meaning of "degree" in his translation of these passages. For Ludwig, the "degrees" of density and distance were absolute values, while for Leonardo they were proportions. To fit Leonardo's text to his interpretation, Ludwig had to introduce an unfounded conjecture (namely, that the $\frac{4}{3}$ in Leonardo's sequence of degrees was to be interpreted as $1\frac{1}{3}$ degrees) and translated the word *acquista* inaccurately as "attains" instead of "acquires." In other words, Ludwig says that if density decreases successively as 4, 3, 2, 1, the distance must increase inversely, as 1, 4/3, 2, 4. Leonardo,

MATHEMATICAL SCIENCES

however, gives the sequence of degrees for density as 4, 3, 2, and 1, for distance as 1, 2, 3, and 4, since he conceived of the density decrease in "degrees" in the sequence 4/4, 3/4, 2/4, 1/4, and the increase of distance in the form 4/4, 4/3, 4/2, 4/1.

Similarly, Leonardo determined the dependence of the degree of illumination on the angle of incidence of the light rays either in a very general and indefinite form* or as a very simple proportion,† whereas actually the degree of illumination is proportional to the cosine of the angle formed by the rays normal to the illuminated part of the surface (see figure 25).

In determining the normal (canonic) proportions of the human figure, Leonardo usually gave comparatively simple proportions, as demonstrated by Richter.[14] However, it would be incorrect to think that this is certain evidence of schematization and consistent operation with "rigid" integral relations and neglect of all nuances. The prevalence of very simple integral "musical" (harmonic) proportion in the theoretical treatises of the Renaissance, from Alberti to Vignola, by no means excluded more complicated irrational proportions. On the contrary, it assumed them as one of its foundations. "Musical" proportions were merely a simpler and more intelligible, although an approximate (and always approximate), means of determining the irrational relationships which almost invariably appeared with any geometric constructions (diagonal of a square, and so forth).[15]

Luca Pacioli's deliberations are highly important in this respect. In analyzing Vitruvius's instruction that columns of the second tier of a portico surrounding a forum must be made one quarter lower than the columns of the first tier to imitate "the natural growth of trees, as in tapering trees, the fir, the cypress, the pine,"[16] Pacioli wrote in his ponderous style: "the lower columns must be, in buildings, the foot, the root, and the base for everything placed on them, like a tree trunk serving as a support for all the other limbs on it, which are always weaker than the foot. However, we do not know the exact size in its

* "That part of the illuminated body will be most luminous which is nearest the object which illuminates it" (TP 635; McMahon 670); "that side of an illuminated body will be of most intense brightness which is struck by the luminous ray between the most similar angles [that is, those nearest a straight line], and the least illuminated will be that which occurs between the most dissimilar angles of those luminous rays [that is, those deviating most from a straight line]" (TP 680; McMahon 671).

† "The proportion of the lights is the same as that of the angles" (TP 694; McMahon 675. Cf. TP 755).

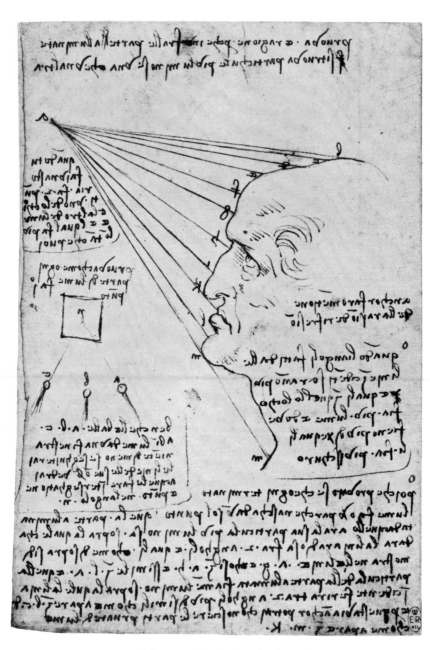

25. Light rays illuminating the face of a man

MATHEMATICAL SCIENCES

specific expression. But since art imitates nature in all its powers and Vitruvius did not take exactly the requisite ratio of branches and tops to their trunks or massifs and feet, we can never know it, for only the Most High will grant us that, as Plato says in his *Timaeus* . . . insofar that art may not move gropingly, but always with the highest possible reliability, Vitruvius points out a ratio, known to us and determined, which rationally and always may be expressed by a number, saying that the columns above should be made one fourth smaller than the columns below."[17] This passage sheds light on the enigmatic relationship between the first part of Pacioli's treatise, where he speaks of the irrational "golden section," and the third part, where all the architectural proportions are integers. The ratios of integers are merely approximations of the highly complex proportions of nature itself, which can be shown geometrically, but which cannot be expressed arithmetically with absolute accuracy.

However, even if we assume that Leonardo's whole series of numerical ratios corresponds to approximate and rounded values, it is obvious that his mathematical apparatus and formulations are almost always simple, indeed immeasurably simpler than the broad and complex tasks which he set and which could never be solved decisively with the old mathematical apparatus. This was a tragedy of Leonardo which could be explained by the nature of his mathematical education and which was characteristic of the era. In Leonardo's time the variable had not yet become a cardinal concept of mathematics; therefore the mathematics of that period could not yet cope with the complex problems of motion that evolving natural science kept posing for the scientist.

This disparity is especially evident in hydrodynamics. The first work on hydrodynamics, *Della misura dell'acque correnti* (On the measurement of moving water), by Benedetto Castelli, a pupil of Galileo's, did not appear until 1638. Daniel Bernoulli's *Hydrodynamica* appeared exactly one hundred years later, by which time the new mathematics could be applied to this field and the problems of motion could be mastered. But Leonardo was confined to observation and experiment. In reading Leonardo's many descriptions of the movement of water, we see that he made keen observations on the characteristics of riverbanks, the flow of rivers, submerged rocks, and so forth, showing his experience as a hydraulic engineer, a naval architect, and a swimmer.

LEONARDO DA VINCI

"If you wish to form a correct impression of all the shapes of the waves and the courses of the waters, observe the clear water where it is shallow beneath the rays of the sun, and you will see, by means of the sun, all the shadows and lights of the said waves and of the things carried by the water" (F 65v; MacCurdy 686). "The beds of the rivers uncovered naturally do not give true indications of the nature and quantity of the objects carried by the waters, because in the deep waters many places are filled with sand, and afterwards in the particular lateral courses of the rivers these deposits of sand are borne above the shingle on which they rested or are laid bare beneath, so causing the continual subsidence of the raised bank of this sand which, by reason of its lightness, accompanies it in its course and is then deposited where the current of the water becomes more tranquil" (L 32r; MacCurdy 731).

Some observations of moving water are specifically identified as to locality. Leonardo speaks of the river Po and of the erosion of its banks (A 23v), of the staircase in Vigevano at the Sforza castle where water tumbled down 130 steps (Leic 32r). And he made the brief note: "Waves of the sea at Piombino all of foaming water" (W 12665; MacCurdy 919).

The discrepancy between the simplicity of Leonardo's mathematical apparatus and the complexity of the physical and technological problems he tried to solve, among which the problem of motion was foremost, led him in some instances to substitute experimental confirmation of sought quantitative relations between phenomena for mathematical deduction, that is, to substitute measurement for calculation. This accounts for the considerable number of measuring instruments mentioned in Leonardo's notes, some his own inventions, some known earlier, for example, the instrument for measuring wind speed, the instruments for measuring distance traveled (with references to Vitruvius and Alberti), and the hygrometer (already known to Nicholas of Cusa and Alberti).

Leonardo expressed a definite interest in algebra. Among his notes one finds the following memoranda: "Alberto da Imola: *Algebra,* i.e., an indication of how a number and an unknown (*cosa*) are equated with [another?] unknown number (*cosa numero*)" (K 75v); "The Algebra which is in the possession of the Marliani, written by their father" (CA 225r b; MacCurdy 1168). But Leonardo da Vinci did not have

MATHEMATICAL SCIENCES

the means for making a statement like the one made three hundred years later by J. L. Lagrange in the preface to *Mécanique analytique:* "There are no drawings whatsoever in this book. The methods I expound here do not require either construction or geometric or mechanical discussions; they require only algebraic operations conforming to a systematic and uniform presentation. All those who love analysis will be satisfied that mechanics has become a new branch and they will thank me for expanding the area of its application in this way." [18] It was just the opposite with Leonardo: his discussions required sketches, and were not comprehensible without graphic geometric examples. His discussions were always geometric or geometricomechanical.

Leonardo also examined the functions of living organisms from the viewpoint of mechanics. As an artist and sculptor, he devoted considerable attention to explaining man's poses and postures by the general laws of mechanics. For example, in explaining the two types "of equilibrium or balancing of people," he advised how to depict the struggle between Hercules and Antaeus: "In representing Hercules who crushes Antaeus, lifting him above the earth between his chest and arms, place his figure as far back of the line through the center of his feet as Antaeus's center of gravity lies in front of those feet" (TP 394; McMahon 332; figure 26). The movements of a man pulling a load, running, ascending and descending stairs, are not only recorded in drawings and descriptions, but are analyzed from the viewpoint of mechanical laws. Leonardo made attentive studies of the mechanism of movement of the hand with the palm up and with the palm down (W An I IV, and elsewhere). In analyzing motion, he looked through the human body, as it were, associating these motions with the structure of the bones and the skeleton. In his drawings the skeleton is always viewed against the background of its possible movements. As Holl puts it, Leonardo's skeletons "live."[19]

Leonardo's attempt to examine the functions of the heart from the mechanical point of view is noteworthy. Although he called the heart a "marvelous instrument," invented "by the supreme Master" (W An B 12r; MacCurdy 119), he examined it from the standpoint of mechanics. Quite consciously Leonardo used figures borrowed from a field well known to him, hydraulic engineering, to describe the heart. For example, he compared it to the movement of a river flowing through a lake (W An I 4v). Examining the position of the heart as a problem

26. Struggle between Hercules and Anteus

MATHEMATICAL SCIENCES

of mechanics, he rejected the opinion that its outer wall is made thick to counterbalance the heavier right ventricle; he referred in this matter to the Fourth Postulate of *De ponderibus* (On weights) (W An II 17r). In his text on the organs of breathing Leonardo devoted much space to the mechanical explanation of physiological functions. Images and comparisons from hydromechanics appear in the passages on digestion and on the activity of the heart: "First bring in the familiar comparison with river water, then tell of the light bile which flows toward the stomach in the direction opposite that of the food. And these two opposite movements, which do not interpenetrate but which make way for each other, are like rivers with opposite currents, the bile goes to meet the chyle coming from the stomach" (W An III 8v).

Can Leonardo be regarded as a consummate mechanic in the spirit of the seventeenth and eighteenth centuries? Paul Valéry considered this possible: "'mechanics,' said Leonardo, 'is the paradise of the mathematical sciences.' This is an entirely Cartesian concept, as were his constant thoughts on physiological physics . . . The idea of the animal-machine formulated by Descartes . . . is presented in a much more lively fashion in Leonardo . . . I do not know who before him thought of examining living beings with the eyes of a mechanic. Eating, digestion, breathing, all were mechanical phenomena for him. He was more of an anatomist and more of an engineer than Descartes. The trend toward the image of the automaton, knowledge through construction was dominant in him."[20]

In the early Manuscript A (1492) Leonardo wrote: "Do not forget that the book on elements of machines with its practical information (*giovamenti*) should precede proof relating to the motion and power of man and other animals; then, on their basis, you will be able to verify any of your postulates" (A 10r). Later, around 1510, he tried to unify the laws pertaining to gravity, power, movement, and impact, as he himself said, because "nature cannot give the power of movement to animals without mechanical instruments [*strumenti machinali*]" (W An I 1r; MacCurdy 159). Actually, Leonardo proceeded from the idea that a bird is an "instrument" or a machine acting according to "mathematical law" (*legge matematica*), that the same laws of mechanics govern the movements of animals and the movements of man-made apparatuses. He intentionally used the same word *uccello* for a bird and for his flying machine. For him, the word *volatile* meant all that flies:

a bird, a butterfly, a bat, and a flying machine. In his writings on birds one finds the same problems of equilibrium, the same laws of the composition and decomposition of forces, the fall of bodies, as in mechanics. The relationship between the force of gravity, the force of resistance of air, the force of the wind, and the force of impetus (*impeto*) are the same basic themes treated by Leonardo in his studies of the motion of birds. To repeat: "Nature cannot give the power of movement to animals without mechanical instruments."

The book *De motu animalium* (On the movement of animals) by Leonardo's countryman G. A. Borelli (1608–1679), published in 1680–1681, contained a systematic study of the mechanics of the motions produced by living things. This work was in full agreement with the tendency prevalent at the time to explain all natural phenomena by the laws of mechanics. The illustrations in Borelli's book are a striking example of the amazing persistence of the mechanistic approach. Often he simplified phenomena, artificially making them conform to mechanical schemes that he had worked out previously, trying to make accurate calculations on the basis of insufficient data.[21] Later researchers discovered his oversimplification.[22] (See figure 27.)

How may Borelli be related to Leonardo da Vinci, whose notebooks he had never seen? We must regard him as a continuer of the Leonardo approach, but Leonardo, Borelli's "spiritual father," was more careful and, as an experienced draftsman, could not help but see the special characteristics that distinguish an organism from an inanimate machine. Leonardo did not try to explain the ability of a skilled acrobat to balance on rope or the ability of a bird to "maintain equilibrium" by "almost imperceptible balancing" on the basis of the purely mechanical principles he knew. For him, these were functions of the bird's "spirit," which was able to control the motions of its wings more subtly and better than a man could control the parts of his artificial, "clumsy" flying apparatus (cf. CA 161r a). A man does not have the potential that a bird has: "The simple power of the man will never work the wing of the crow with such swiftness as the crow did when it was attacked. And the proof of this will be shown in the noise they make, for that of the man will never produce so great a noise as the wing of the bird made when it was attacked" (CA 77r b; MacCurdy 424). In this context the reference to the "spirit" does not contain anything mysti-

MATHEMATICAL SCIENCES

27. Illustration from Borelli's treatise De motu animalium

cal or animistic; Leonardo understood that the "subtlest movements" of the bird could not be reproduced by the technology of his time, therefore they could not be reduced to the general laws of the mechanics he knew, but were immeasurably more complex. The subtlest nuances created by the pianist cannot be recorded accurately in words or symbols. The spirit of the bird was a kind of blank spot on Leonardo's map of mechanistic explanations.

However, the opposite was also true. He sometimes explained an accurate and subtle observation inadequately and schematically. There are several examples of the soaring of a bird in air that are sketched and described to a tee, but are explained incompletely or inaccurately. Leonardo characterized the change of air beneath the wing of a bird inaccurately, describing it as "densification" (*condensazione*), although he formulated the law of "aerodynamic reciprocity" accurately.

He did not take full account of the role of vertical thermal currents. Wind for him was always horizontal, and he preferred to attribute the departure of the wind from the horizontal to a mechanical deflection from a mountain barrier or to some similar cause: "The bird maintains itself in the air by imperceptible balancing when near mountains

LEONARDO DA VINCI

or lofty ocean crags; it does this by means of the curves of the winds which, as they strike against these projections, being forced to preserve their first impetus, bend their straight course toward the sky with divers revolutions, at the beginning of which the birds come to a stop with their wings open, receiving underneath themselves the continual buffetings of the reflected wind currents" (E 42v; MacCurdy 452).

The composition and decomposition of forces during flight downwind and upwind, performed correctly, do not always reflect the processes of which Leonardo spoke. The most recent research, for example, has shown that only "relative" wind, that is, wind produced by the actual motion of the bird, plays a role in the bird's flight against the wind; the "earth wind" affects only the change of intensity and direction of the "relative" wind. For Leonardo the "earth wind" was one of the decisive components, which he regarded schematically as a wind of constant force and direction.

One must recall the difficulties encountered in observing the flight of birds: in observing the positions and movements of birds aloft, Leonardo did not always keep in mind that the air currents aloft are not the same as those below, and therefore he came to an inaccurate conclusion about the role of the wind in the flight and soaring he observed.[23]

The abstract expressions that follow, which are based on the general principles of Leonardo's mechanics, are scarcely represented by the astounding abundance of folds of clothing to be found in Leonardo's drawings. "Everything naturally desires to remain in its own state. Drapery, being of uniform density and thickness on the reverse and on the right side, desires to lie flat, consequently whenever any folds or pleats force it to depart from this condition of flatness, it obeys the law of this force in that part of itself where it is most constrained, and the part farthest away from such constraint you will find returns most nearly to its original state, that is to say, lying extended and full" (BN 2038 4r; MacCurdy 858).

In speaking of Leonardo's "mechanism," one must not forget about another essential feature which differentiated his picture of the world from the seventeenth century mechanistic conception. In the seventeenth century, particularly in the schools of Descartes and Boyle, there was a definite tendency to explain various phenomena qualitatively by motions or forms of tiny particles imperceptible to the eye.

MATHEMATICAL SCIENCES

These were the "tiny wedges, needles, hooks, rings, bubbles, and numerous other particle shapes born in the head without any basis," which Lomonosov later called "unfortunate physical concepts."[24] Even the younger contemporaries of Descartes' sometimes poked fun at the shapes of such invisible particles: "What can one really say about the eels, of which liquids are composed, or of the particles with helical troughs running in two different directions, particles which leave a magnet and return to it, continually circulating, or of the particles which become embedded in iron en route but in no other bodies?"[25]

Models of phenomena which explained perceptible properties of things by the motion and shape of invisible particles were alien to Leonardo's mechanics, which from beginning to end was "macroscopic." For example, Leonardo took a step forward from the Galenists, who ascribed the temperature of the blood to "innate heat," by attempting to attribute the origin of the heat in the blood to mechanical causes: "The heart is warm because its heat is generated by rapid and continuous motion which the blood produces by its own friction during its circulation and by the friction against the cellular walls of the right upper ventricle, whither it always enters precipitously and whence it leaves in the same manner" (W An I 4r). He was infinitely far from attributing the heat to the motion of invisible particles.

Leonardo da Vinci's physics remained a qualitative physics or, to be more exact, it left "inviolable" such qualities as heat, light, color. In this respect, the following statement about geometry and arithmetic is very important and informative: "[Geometry and arithmetic] do not encompass anything but the investigation of continuous and discontinuous quantity. They are not concerned with quality, the beauty of nature's creations and the adornment of the world" (TP 17; McMahon 15).

His use of the word "spiritual" in a very special sense is also instructive. Leonardo's *spirituale* designated the abstract and, therefore, the invisible. For example, mathematical lines abstracted from matter were called "spiritual" and contrasted with "corporeal" (CA 100v b). He called invisible and intangible sounds and smells "spiritual powers" (CA 90r b). He contrasted spiritual (that is, light, *volatile*) particles with heavier and coarser materials (A 56v). He also used the term spiritual to describe those properties or qualities that do not increase the volume or weight of a body. For example, *forza* is "a spiritual, invisible

potency"; it is "incorporeal and invisible I said because the body that creates it increases in neither weight nor form" (B 63r; Baskin 33). Echoes of the ancient and medieval study of the "pneuma" (*spiritus*), the subtlest material of a substance, are heard when Leonardo speaks of the "spiritual motion" which inflates the muscles of animals (BM 151r; MacCurdy 587). In all these cases *spirituale* means either an invisible quality of a body, or an invisible substance like air. Such qualities and substances become visible through their actions, "inflation of the muscles," and so forth. We have already seen that Leonardo rejected the possibility of the existence of otherworldly "incorporeal spirits" (W An B 30v).[26]

Leonardo's tendency to visualize motions invisible to the eye (but not "otherworldly"), that is, "spiritual" motions, to use his own term, is clearly demonstrated in many of his experiments. "To observe the flow of wind in air and its twisting eddies, stuff hot batting into the barrel of a tube and blow into the other end: the wind breathed in with the smoke emerges from the opposite end and shows the true whirling motions produced during its motion in the said air" (CA 79r c).

Often Leonardo used grains of black millet to observe invisible water currents. "If you wish to see the movement the air makes when it is penetrated by a movable thing, take water as an example; beneath its surface mingle with it thin millet or other minute seed which floats at every stage of height of the water; and afterwards place some movable thing within it which floats in the water and you will see the revolution of the water, which ought to be poured into a square glass vessel shaped like a box" (Leic 29v; MacCurdy 609). These grains appear elsewhere in the Leicester Codex: "To tell whether a small wave is moving on the surface or on the bottom of deep water, mix water with black millet near your opening and through glass plates you will see what you need to see" (Leic 9v). At another point: "Make one side of the channel of glass and the remainder of wood; and let the water that strikes there have millet or fragments of papyrus mixed in it so that one can see the course of the water better from their movements." In this case he constructed an actual model, covering its bed "with sand mixed with small shingle" and made "the bank on the wooden side of mud" (I 115r, TA 50r; MacCurdy 724).

Leonardo also used such grains to observe boiling water. "And in

MATHEMATICAL SCIENCES

slowly boiling water you may drop a few grains of millet, because by means of the movement of these grains you can quickly know the movement of the water that carries them with it" (F 34v; MacCurdy 681).

Dye can be used in the same way to study the movement of water. "If you wish to see where water flows more rapidly—on the surface, in the middle, or on the bottom—pour some water colored with sinopia together with oil into a stream which is flowing along an uneven bed with various grades; then you can tell accurately which moves the most rapidly with the current" (CA 266v, cf. TA 43r).

Finally, or to be more exact, first of all, one should recall the dust particles which float in the sunlight, an image taken from the ancient atomists and maintained through the Middle Ages thanks to Isidore of Seville. "The air which successively surrounds the thing that is moving through it makes divers movements in itself. This is seen in the atoms [*attimi*] that are found in the sphere of the sun when they penetrate through some window into a dark place. If among these atoms one throws a stone in the path of the solar ray, one sees the atoms range themselves about the position where the course taken in this air by the movable thing was filled by the air" (F 74v; MacCurdy 543). Here and elsewhere,* for Leonardo *attimi* (literally, "atoms") are the dust particles which Isidore of Seville[27] likened to the atoms of Democritus and Epicurus: "They flit about the void of the world, as they say, in unceasing motions and are borne hither and thither like those tiny dust particles which can be seen in the rays of the sun pouring through a window."†

Only in very rare cases does Leonardo resort to the concept of invisible, imperceptibly small particles, for example, to explain evaporation processes. "The water that falls from the cloud is sometimes dissolved into such light particles that by reason of the friction that it has with the air, it cannot divide the air but seems to change itself into air." Somewhat later he clarifies what specifically he meant by light particles: rain, which "frequently is converted into such fine particles that it can no longer descend and so remains in the air" (F 35r; Mac-

* For example, in Leic 4r there are remarks about the difference between "atoms of dust or atoms of smoke in sun rays passing through a crack in walls into dark places." "Atom" and "dust grain" are used in the same meaning in I 102v.

† For a comparison of atoms with dust particles, see also Aristotle, *De Anima*, 1.2.404a. Dust particles (like atoms) "are always in motion, even in a complete calm."

Curdy 681). Elsewhere Leonardo says that "the brightness of the atmosphere is caused by the water that is dissolved in it and that has formed into imperceptible particles [*graniculi insensibili*]" (Leic. 20r; MacCurdy 343).*

Let us not forget that in Leonardo da Vinci's time there was no microscope, thus there was no powerful stimulus for forming concepts of a whole new world of things and substances beyond normal, unaided human vision. This makes all the more striking Leonardo's attempt to reach the "ultimate limits" of the visible, his attempts to grasp the tiniest motions that elude human sight. For example, Leonardo raised the question of the motion of the wings of the dragonfly, holding that the dragonfly drops its posterior wings when raising its anterior wings: "The dragonfly flies with four wings, and when the anterior are raised, the posterior are dropped. However, each pair of wings must be capable individually of supporting the entire weight of the animal" (CA 337v b). Proof of this awaited the ultrahighspeed motion picture camera (2900 frames per second). Motion pictures have shown that Leonardo was wrong, but no one can blame him, especially if we consider some of the characteristics of the motion of these wings: the anterior and posterior wings are raised simultaneously, but the posterior wings begin to drop somewhat earlier than the anterior, and the two pairs do not come into contact with each other. The wings beat thirty-six times per second; the posterior wings drop 1/80 second before the anterior.[28]

Leonardo's attempts to explain ocean tides are characteristic of his tendency to proceed in mechanics without employing the attractive-force concept. He rejected the explanation that lunar attraction causes tides, on the ground that attraction takes place between opposites. "You will not see that a warm [body] in the presence of fire attracts that fire, on the contrary it will attract cold and damp; you will not see water attract other water to itself." Therefore, the "cold" moon cannot attract the cold and moist element of the sea (A 57r). Even more important than this archaic (from our point of view) argument is his general prejudice against any type of explanation based on attractive forces. "A heavy body does not fall toward the center of the world be-

* See Hooykaas "La Théorie corpusculaire," who remarked that Leonardo employs corpuscular concepts only as a means of explaining individual, particular cases and does not employ them systematically.

MATHEMATICAL SCIENCES

cause that center attracts it" (BM 189v). We find an even more definite statement: "The motion of heavy bodies toward a common center does not take place because of some inherent tendency on the part of such bodies to find that center and not because of an attraction exerted by that center, attracting such a weight to it like a magnet" (CA 153v a). The attractive-force explanation did not offer what Leonardo held most dear, namely, a graphic mechanical picture of the phenomenon, a kinetic picture.

Although the concept of attraction did not play any role in Leonardo's theory of tides, it did play a considerable role in his explanation of how ground water gets to a mountain top. He expressed himself on this subject several times, but one gets the impression that he used the concept of attraction unwillingly, even in the considerably modified form, which, in the final analysis, amounted to a general law of motion of the elements: A light element carries a heavier one along with it, entraining it rather than attracting it.

A science historian who records primarily positive discoveries and positive attainments may consider himself justified in not dwelling long on these deliberations of Leonardo's. However, the historian who traces the formulation of a scientific thought and its significant meanderings, wanderings, and ramblings, will sometimes discover the unique, individual traits of the thinker in such material, the characteristics of the creative biography of the scientist. Therefore, it is fitting that we consider at greater length Leonardo's vacillations on this issue.

In the early Manuscript A (1492) Leonardo asserts that water cannot rise above sea level to mountain tops "because of its nature," and explains that the water found there was attracted by the sun's heat (A 56v).* At first glance there does not seem to be anything difficult about this hypothesis. No one can doubt that the sun's heat evaporates ocean water, that is, that it draws the moisture upward, or, in Leonardo's vernacular, that the light "spiritual" particles of heat can at-

* Duhem (*Etudes,* II, 159–220) assumed that Leonardo first became acquainted with this hypothesis in *Question on Aristotle's Four Books on Meteorology* by a certain Thémon (Thimon), who taught in Paris in the mid-fourteenth century (the work was printed in 1505, 1516, 1518, and 1522). Actually, Leonardo had defended this theory in 1492, sixteen years before he entered the note "Meteors" in Manuscript F, a note which Duhem identifies as a reference to Thémon's work. Duhem also noted that this hypothesis had already been formulated by Albert the Great. Therefore, there is no basis for assuming that Leonardo first became acquainted with this hypothesis through Thémon's work.

LEONARDO DA VINCI

tract "material" particles: "We see that fire, by reason of its spiritual heat [*per lo spirituale calore*], sends out of the chimney, amid the steam and smoke, matter that has body and weight; this can be seen with suet, which if you burn it, you will see it reduced to ashes." This is the reason why "fire desires to return to its element, and carries the heated vapors with it." Leonardo gives still another example, the distillation of quicksilver: "when this silver of so great weight is mingled with the heat of the fire, it ascends and then in smoke falls down again into the second container and retakes its former nature" (A 56v; Mac-Curdy 187, 188).

But a simple reference to these phenomena was too general and could not satisfy Leonardo. In searching for a more "accurate" explanation, he resorted to the more complex process that occurs in organic bodies. In his opinion there is a close and direct analogy between the lifting of water to mountain summits and the rising of the blood to a head wound. He rejects the mechanical explanation of the blood pressure because "the veins are quite capable and adapted to serve as a convenient receptacle for the increase of the blood with-out it having to flow out by the fracture of the head, as though deprived of such a receptacle" (A 56r; MacCurdy 187). Leonardo's interpreta-tion was that the lighter "spiritual" particles of heat draw along the "material" particles of blood.

Leonardo placed great importance on this analogy, adapting it to the other cases cited above (smoke, soot, mercury vapors). "If the body of the earth were not like that of man, it would be impossible for the waters of the sea, being so much lower than the mountains, by their nature to rise to the summits of these mountains. Hence, it is to be believed that the same cause which keeps the blood at the top of the head in man keeps the water at the summits of the mountains" (A 55v). He drew a direct analogy between the ascent of water to mountain tops and the rise of fluids in living things, specifically living beings. "Where there is life there is heat, and where vital heat is there is move-ment of vapor" (A 55v; Richter 42). In another manuscript we read: "Heat gives life to all things; as one sees the heat of the hen or of the turkey hen giving life and growth to the chickens, and as the sun in returning causes all the fruits to blossom and burgeon" (W An IV 13r; MacCurdy 181). Nevertheless, for Leonardo there was nothing specifi-cally vital in "living heat," since "chickens can also be hatched

MATHEMATICAL SCIENCES

by making use of ovens" (W An III 7r; MacCurdy 172). Evidently Leonardo assumed that the mechanism of movement of water toward mountain summits is more complicated than is simple evaporation, just as the movement of birds' wings is immeasurably more complicated than the movement of the artificial wings of a flying machine. In addition to the analogy of the flow of blood to the head, Leonardo drew an analogy to the movement of sap in plants. "As in the case of the grape vine: when it is cut at the top, nature sends its sap from the lowest roots to the highest point of cut, and when this sap pours out, nature provides the vine with vital fluid till the very end of its life" (H 77r). Elsewhere we find: "and as the blood that is low rises up high and streams through the severed veins of the forehead, or as from the lower part of the vine the water rises up to where its branch has been lopped, so out of the lowest depths of the sea the water rises to the summits of the mountains, and finding there the veins burst open, it falls through them and returns to the sea below" (CA 171r a; MacCurdy 646).

The following picturesque description of the circulation of water shows that for Leonardo it was this analogy with "animated bodies" that was important. "Water is just that which is appointed to serve as the vital humor [*vitale omore*] of the arid earth, and the cause which moves it through its spreading veins, contrary to the natural course of heavy things, is just what moves the humors in all the species of animated bodies. This it is which to the complete stupefaction of the beholders rises from the lowest depths of the sea to the highest summits of the mountains, and pouring out through the burst veins returns to the depths of the sea and rises again swiftly and again descends as aforesaid. So from the outer parts to the inner, so turning from the lower to the higher, at times it rises in fortuitous movement, at times rushes down in natural course. So combining these two movements in perpetual revolution, it goes ranging through the channels of the earth" (BM 236v; MacCurdy 740).

For a time (1504–1506) Leonardo rejected this "explanation." Actually it was not an explanation, but a simple analogy. The circulation of the blood in the human being and the circulation of sap in plants also required explanation, and Leonardo began to seek more graphic, purely mechanical interpretations.

If the proposed interpretation were correct, Leonardo now reasoned

that "where there is more heat, the water veins ought to be larger and more abundant . . . We see just the opposite, however, for the northern places, which are very cold, have more abundant water and rivers than the warmer southern regions." And it follows that "our rivers should discharge more water in summer than in winter," for the sun heats the mountains more at that time. Finally, "the mountains are nearer to a cold region of air than are their valleys and in northern localities the mountains are almost continuously covered with snow and ice, but many rivers have their sources there" (Leic 3v).

In this same manuscript Leonardo refers to his observations at Vernia. "The power of the sun is not sufficient to melt the ice during the greatest heat of summer, but it remains there in the hollows in which it has been lying since the winter . . . And on the northern slopes of the Alps, where the sun does not strike, the ice never melts, because the heat of the sun cannot penetrate the small thickness of the mountains" (Leic 32v; MacCurdy 349).

Should it be assumed that water "rises to the highest mountain top as if sucked up or drawn off by a sponge"? Leonardo also rejected this assumption, referring to his rules of art, Fifth Postulate, Sixth Book, which states: "Water rising of itself in a sponge, felt, or other porous body, flows out and pours out of such a porous substance only below the place it entered the body" (Leic 3v). Later he states: "Even if the water itself rises to the top of the sponge, it cannot then pour away any part of itself down from this top, unless it is squeezed by something else, whereas with the summits of the mountains, one sees it is just the opposite, for there the water always flows away of its own accord without being squeezed by anything" (Leic 32v; MacCurdy 349).

Leonardo went into great detail in refuting the opinion that water moves above sea level to mountain summits. Averroës expressed the opinion that sea level is higher than the highest mountains, and his opinion became widely known. However, it was contested as early as in the thirteenth century by Campano of Novara, and in the fourteenth century by Albert of Saxony and Thémon the Jew (Themo Judaei). Leonardo did not hold to it either, for "the lowest part visible to the sky is the surface of the sea," inasmuch as rivers flow to the sea and "when they come to the sea they stop and end their movement" (Leic 32v; MacCurdy 350). Further, it cannot be assumed that the sea is higher at a distance from its shores than near them. The water element

MATHEMATICAL SCIENCES

is spherical, that is, all its parts are equidistant from the center. Consequently, "the shore of the sea is as high as its center," and "the part of the shore that projects above the sea is higher than any part of the sea" (Leic 32v; MacCurdy 350).

Leonardo could have known the naive hydrostatic opinion expressed by Pliny in his *Natural History* (II, 24, 66): "Water penetrates the earth everywhere, inside, outside, above, along connecting veins running in all directions, and breaks through to the highest mountain summits,—there it gushes as in siphons, driven by pneuma [*spiritus*] and forced out by the weight of the earth; it would seem that the water is never in danger of falling; on the contrary, it bursts through to high places and summits. Hence, it is clear why the seas never grow from the daily influx of river water."

In 1508–09, as if in reply to Pliny, Leonardo wrote: "If the water which gushes forth from the high summits of the mountains comes from the sea, the weight of which drives it up there so that it is higher than these mountains, why has this portion of water the capacity of raising itself to so great a height, and of penetrating the earth with such difficulty and length of time, while it has not been granted to the rest of the element of water to do the same, although this borders on the air which would not be able to resist it and so prevent the whole from rising to the same height as the aforesaid part?" (F 72v; MacCurdy 690). But in answering Pliny, Leonardo also gave up his own attemps at more complex and well-conceived hydrostatic explanations. He concluded: "You who have found such an invention must needs return to the study of natural things, for you will be found lacking in cognate knowledge, and of this you have made great provisions by means of the property of the friar of which you have come into possession" (F 72v; MacCurdy 690). After long searching Leonardo returned to his former idea: water is drawn upward by the sun's action just as blood courses to a wound in a man's head. Such are the turns that Leonardo took along the thorny path of mechanical explanations.

Faithfulness to the visual image of a phenomenon and unwillingness to penetrate into the "behind-the-scene" aspect of it, into the invisible motions or invisible particles, were strongly represented in Leonardo's attitude toward chemistry, which, as its subsequent development in the seventeenth century showed, strove primarily to "take apart" a phenomenon by the senses and by analysis to penetrate the

"secrets" of the chemical composition, evincing them in a graphic model of combinations of invisible particles.[29]

Leonardo's approach was strictly empirical. His notes on chemistry are prescriptions for the most part, for example, his formulas for paints. "For yellow glaze (*vetro giallo*) take 1 ounce zinc oxide (*tuzia*), ¾ Indian saffron, ¼ borax, and grind it all together into a powder" (CA 244v b). By no means are all the prescriptions and instructions given in amounts, for instance, *"To make scent:* Take fresh rose water and moisten the hands, then take flower of lavender and rub it between the palms, and it will be good" (CA 295r a; MacCurdy 1177). Sometimes the note merely states something that should be done: "Remember the solderings which were used to solder the ball of Santa Maria del Fiore" (G 84v; MacCurdy 1178); or something that should be clarified by means of inquiries: "Get from Jean de Paris the method of coloring *a secco,* and the way of making white salt, and tinted papers either single or with many folds, and also his box of colors" (CA 247r a; MacCurdy 1123).

It should be recalled that some of Leonardo's notes were not properly interpreted and were taken as generalizing theoretical deductions, for example, "Where flame cannot live, no animal that draws breath can live" (CA 270r a; MacCurdy 382), which earlier scholars[30] felt to be almost an anticipation of the theory of oxygen.

Actually, Leonardo continued to hold to the traditional teachings on the transmutation of elements. He did not have any "new theory." During combustion, air together with the "feeding substance" of the candle transform into another element, fire. For Leonardo, breathing has an entirely different function in this case: it cools the blood which is heated by its own motion and friction against the wall of the heart. Thus, without air there actually is neither flame nor breathing, but for Leonardo the two phenomena had nothing in common. Therefore, I see no basis for Reti's statement[31] that Leonardo thought that "air contains a fluid necessary both for life and for supporting flame."

Essentially, Leonardo described but did not explain flame. In his texts on flame one can detect the eye of the artist-observer and the eye of the scientist who is interested primarily in mechanical motion. He carefully traced the movements of the vapors and the "moisture" in flame, examined their different weights, lightness, and so forth. Finally, his notes show quite clearly the metallurgist's approach, with atten-

MATHEMATICAL SCIENCES

tion directed toward the temperature of the different parts of the flame, the quality of the wood, and so on. A few brief examples will suffice to demonstrate the point.

> The bottom part of the flame . . . is blue in color and is the part in which its nutriment is purged and disposed of. This is the first to come into existence when the flame is created, and it comes into existence in spherical shape, and after a span of life produces above itself a very small flame, radiant in color and shaped like a heart with its point turned to the sky . . . Therefore, the fire comes into existence in the upper part of the blue spherical flame, in a small round figure . . . And this shape immediately and with swift dilation overcomes the power that feeds it, and penetrates the air which serves it as a covering. But this blue color remains in the base of this flame, as may be seen in the light of the candle; and this comes to pass because in this position the flame is always less warm than elsewhere, because here is where the nourishment of the flame first encounters this flame, and it is here that the first heat is produced, and this is feebler and causes less warmth because it is only the commencement of the heat (CA 270v a; MacCurdy 383).

Leonardo strove to generalize, in scientific form, his observations on the light and movement of flame, presenting them as symmetric discussions, one of which is the reverse of the other. "The hotter flame is the brighter one, Hence, the reverse follows: the brighter flame is the hotter one. That flame will be brighter which is born in more rapidly moving air; that which moves faster will be brighter . . . Of all the tongues of a flame, the highest will be over the largest amount of burning material; thus it follows that the smaller tongue will be fed by a smaller amount of material" (CA 237v a).

Here is another passage in which a "macroscopic" observation and description reaches an almost masterly stage of picturesqueness: "Fire increases from the wind which feeds it, while the opposite wind, which is born near the center of such a circulation jousts with the wind which is born outside this circulation and, meeting, they embrace and strike the flame; their impact is reflected and rebounds to the sky, taking with them the created flame" (CA 237v a). The phrase "joust" speaks for itself.

Essentially this description differs little from that given by Leonardo

in one of his fables, where one finds the same picturesqueness, the same attention to details, and the same attempt at descriptive accuracy without explanation: "Some flames had already lived for a month in the furnace of a glass blower when they saw a candle approaching in a beautiful and glittering candlestick. They strove with great longing to reach it." He goes on to describe how "one of their number left its natural course [*el suo naturale corso*]," an expression which differs little from those which Leonardo used in his scientific notes. "It wound itself into an unburnt brand upon which it fed, and then passed out at the other end by a small cleft to the candle which was near, and flung itself upon it, and devouring it with the utmost voracity and greed, consumed it almost entirely" (CA 67r b; MacCurdy 1064).

Here is another, still more picturesque description: "Then the fire, after rejoicing at the dried logs placed upon it, began to ascend and drive out the air from the spaces between the logs, twining itself in among them in sportive and joyous progress, and having commenced to blow through the spaces between the logs out of which it had made delightful windows for itself, and to emit gleaming and shining flames, it suddenly dispelled the murky darkness of the closed-in kitchen, and the flames having already increased began to play joyfully with the air that surrounded them, and singing with gentle murmur they created a sweet sound" (CA 116v b; MacCurdy 1068).

Leonardo was correct, from his point of view, in stating: "There is no science of the heat and color of flame nor of its nature, nor of the color of glass and other substances which are created in it, but only of its movements and other accidents, how to augment and decrease its force and change the color of its flame by as many different means as there are different materials that feed it and that are consumed in it" (CA 270r a). Actually, this exhausted the "science of fire" for Leonardo.

Recently Sherwood Taylor called attention to the continuously cooled stills described in the Codex Atlanticus. Two drawings (CA 79v c and 400v c) are reproduced here (figures 28 and 29). In the second drawing, in the upper left is written, "Here should be water that is continually changed"; in the middle is written, "steam enters here"; and below, "this is what is to be distilled."[32] These stills are interesting not only in themselves, but as an example of the ability of Leonardo the mechanic to innovate and introduce something essentially different in design.

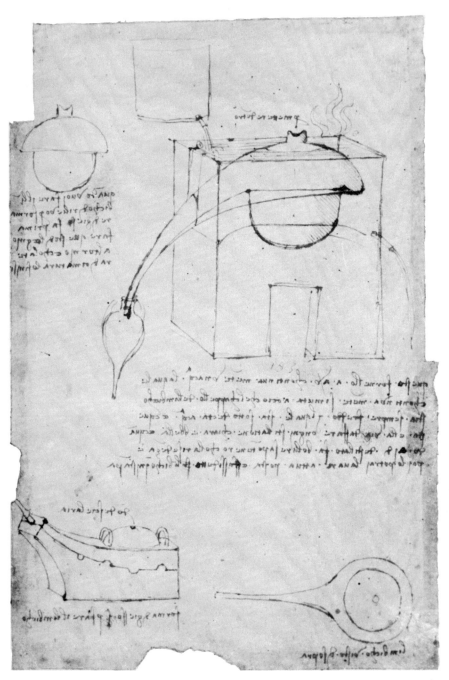

28. *Continuously cooled still*

LEONARDO DA VINCI

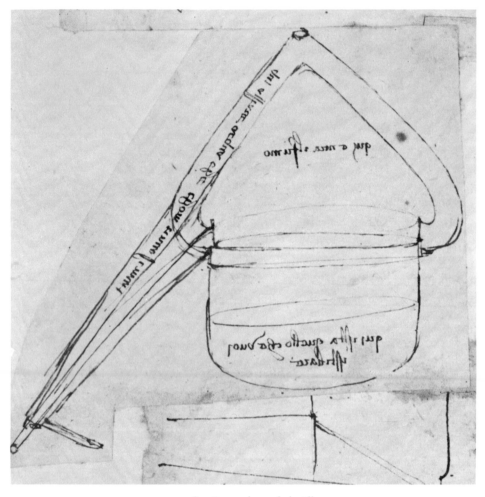

29. Continuously cooled still

Leonardo's attitude toward medicine also showed his tendency to limit himself to the empirical approach. Medicine was one of the branches of knowledge in which the medieval traditions held on most strongly and in which the most biased theories were widely accepted.[33]

Leonardo's notes contain some prescriptions, but he evinced obvious mistrust of his contemporary physicians; in fact he was almost hostile toward them. "Strive to preserve your health; and in this you will the better succeed the more you keep clear of physicians" (W An A2r; Mac-

MATHEMATICAL SCIENCES

Curdy 216). One recalls Poggio's "facet" about a physician who wrote prescriptions in the evening, put them in a bag, and on the following day gave them out to the sick at random, adding: "May God help you!"[34] "Every man desires," wrote Leonardo with irony, "to acquire wealth so that he may give it to the doctors, the destroyers of life; therefore they ought to be rich" (F 96v; MacCurdy 215). Actually, most doctors were very prosperous, and celebrities received fabulous fees. These were the "presumptuous and the pompous" of whom Leonardo spoke in another connection.

Leonardo's skepticism with respect to the physicians of his time did not prevent him from admitting that true "medicine is the restoration of discordant elements; sickness is the discord of the elements infused into the living body" (Triv 4r; Richter 279). In preparing an explanatory note for the model of the Milan cathedral he submitted for the competition, Leonardo expressed the thought, in several variants, that the true architect, in setting about to complete or reconstruct a building, should be like a physician who knows the structure and functions of the human body. "My Lords, Fathers, Deputies! . . . doctors, the tutors and guardians of the sick, must understand what man is, what life is, and what health is, and how a parity or harmony of elements maintains this, and in like manner a discord of these ruins and destroys it; and one who has acquired a good knowledge of these conditions will be better able to effect cures than one who is without it" (CA 270r c; MacCurdy 1143).

Using this analogy for rhetorical purposes, Leonardo, of course, was fully aware of the immensity of the task of determining "what man is, what life is, and what health is, and how a parity or harmony of elements maintains this." The "harmony of elements" was a formula which had only the appearance of mechanics. Medicine, like chemistry, remained beyond the limits of the "mechanical picture of the world" or, more exactly, it lay at the threshold.

Let us try to view Leonardo's mechanics from another aspect. Many passages in the notebooks contain general statements on the broadest concepts, what Leonardo called the four "potentials," of nature: weight, force, motion, and impact. Many times he attempted to formulate the relations between these potentials, introducing ever newer nuances for the purpose, but for him they were not the basis for investigations, rather an attempt to summarize. That is, the potentials formed

the basis for generalizing the fundamental concepts of mechanics, for giving them a universal, cosmic meaning.

A great deal has been written about these passages with respect to their literary merit and their scientific defects. Some of them have been included in anthologies, out of their context of ideas. What has captivated literary historians about these fragments? Primarily their style, their emotional elation. One such passage is the famous discussion of force (*forza*) which "forces all created things to change form and position, and hastens furiously to its desired death, changing as it goes according to the circumstances. When it is slow, its strength is increased, and speed enfeebles it. It is born in violence and dies in liberty; and the greater it is, the more quickly it is consumed. It drives away in fury whatever opposes its destruction. It desires to conquer and slay the cause of opposition, and in conquering destroys itself" (A 34v; Mac-Curdy 520).

The critics have quite justly seen "philosophical drama" in this text, and with equal justice they have noted that the anthropomorphism makes Leonardo's reasoning incompatible with mechanics and inapplicable to it. In both cases they have not taken proper account of one thing: what Leonardo wrote here was not an initial, working definition, but rather the consummation of his investigations in mechanics. In this and other discussions Leonardo was attempting to find some more general, universal meaning in his mechanical conceptions. The critics speak of his anthropomorphization of mechanics; it would be more correct to speak of his mechanization of the world of man.

The famous passage about the moth and the light is a striking confirmation of what I have just said. Leonardo did not anthropomorphize the study of the elements, on the contrary, he applied study of the elements to the world of man and his aspirations. He held that an element surrounded by the same element, for example, water surrounded by water of the same density, will move neither upward nor downward. Movement will occur only if it enters a foreign or alien element, and the "rush" of the element toward its "natural place" increases as the distance of the element from its natural place, from its "primal chaos," becomes greater. He gave the picturesque name "quintessence" or "spirit of the elements" to this aspiration. And he found this aspiration in man's soul, which, consequently, lives by the basic "mathematical" law of the universe. That is why Leonardo also called man a model

MATHEMATICAL SCIENCES

of the world (*modello del mondo*). Let us look at this classical passage. "Hope and longing for repatriation and return to the primal chaos is to man what light is to the moth. With a constant joyous longing he awaits the new spring, always the new state, always the new months, the new years; for always it seems to him that the things longed for come too late, and he fails to realize that he is wishing away his own life. This same longing is the quintessence, the spirit, of the elements, which finding itself imprisoned in the soul of the human body, it longs always to return to its emitter" (BM 156v; Baskin 63–64). Leonardo insistently repeats: "And I wish you to know that this desire is quintessence, the companion of nature, and man is a model of the world [*modello del mondo*]" (BM 156v; Reynal 30).

The moth (and man) desires his own destruction and therefore is an image, a symbol, a model of the world. This reasoning, which has found its way into all the Leonardo chrestomathies, can be explained by comparing it with a passage that preceded it, in which he posed the question: "Why did nature not ordain that one animal should not live by virtue of the death of another?" The attempt to answer this gave rise to a train of thought. At first Leonardo tried to explain it by some sort of higher expediency of nature, namely, the need to limit its infinite and inexhaustible creativity. "Nature is venturesome and takes pleasure in forever creating new living forms, for she knows that these increase her earthly substance. She is willing and able to create more than time can destroy; for this reason she has ordained that some animals must serve as food for others. Nor can this satisfy her desire. She often sends out certain poisonous and pestilential vapors and ever recurring plagues over the great multiplications and congregations of animals, and especially over men, who make great increase since other animals do not feed on them. Once causes are eliminated, their effects will cease" (BM 156v; Baskin 63). "Thus," Leonardo asks, "does the earth seek to take its own life, desiring continuous multiplication?" Yes, he answers, for "often the effects are like their causes. Animals serve as an example [*esemplo*] of the life of the world" (BM 156v). Then Leonardo turned to the image of the moth rushing to its own death. In other words, the moth "serves as an example," symbolizing the urge of all nature as a whole, of the macrocosm, toward its own destruction.

Leonardo said the same about "force," *forza,* which "drives away in

fury whatever opposes its destruction. It desires to conquer and slay the cause of opposition, and in conquering destroys itself" (A 34v; Mac-Curdy 520).

This is the "mechanical foundation" of the tragic sensation of human life, which while developing holds the seeds of its own destruction ("la vie c'est la mort," as Claude Bernard put it later). In the final analysis Leonardo raised this sensation to a universal law and tried to express it in terms of mechanics; the movement of the element striving toward its natural place is replaced by a state of rest, that is, destroyed when the element has reached its "primal chaos," when it has returned to its "natural place."

Here is another colorful, poetic description of an "element leaving its element," a description capable in the accuracy of its details of competing with the scientific passages on the formation of clouds and rain: "The water finding that its element was the lordly ocean, was seized with a desire to rise into the air, and being encouraged by the element of fire and rising as a very subtle vapor, it seemed as though it were really as thin as air. But having risen very high, it reached the air that was still more rare and cold, where the fire forsook it, and the minute particles, being brought together, united and became heavy; whence its haughtiness deserting it, it betook itself to flight and fell from the sky and was drunk up by the dry earth, where, being imprisoned for a long time, it did penance for its sin" (Forst III 93v; J. P. Richter 1271).

I cannot agree that Leonardo's aesthetics, in particular his teachings on harmony, "pass over the social conflicts of life in silence" and assume that "it forgets that not all in life is perfect and just," that "the dark side of reality was not treated at all in Leonardo's aesthetics." I cannot apply to Leonardo the words of Marx and Engels on Bacon's materialism: "matter smiles on every man with its poetic sensual luster."[35] Francesco Flora was more correct in stating that for Leonardo the "beauty of the world" was tragic: "But the goodness of life, and the beauty and benefit of the world are not the reality of rosy events and pleasant illusions: this is a battle and contrast of forces, which must be accepted and overcome. Reality is tragic."[36]

Leonardo wrote much on the harmony of an artistic production, and these precepts were repeated with great frequency by the later theorists of classicism. Leonardo's own teaching on harmony, however, is not coldly classical and certainly is not characterized by standards and

MATHEMATICAL SCIENCES

30. Pleasure and Pain

canons. How can one forget that the harmonic "pyramidal" composition of the *Virgin and Child with Saint Anne* is poised over a precipice which is not shown in the painting, but which is clearly indicated by the beginning of a steep drop?

Leonardo has an allegorical drawing with the following explanation: "Pleasure and Pain are represented as twins, as though they were joined together, for there is never the one without the other; and they turn their backs because they are contrary to each other. They are made growing out of the same trunk, because they have one and the same foundation, for the foundation of Pleasure is labor with Pain, and the foundations of Pain are vain and lascivious Pleasures. And, accordingly, it is represented here with a reed in the right hand, which is useless and without strength, and the wounds made with it are poisoned" (Ox A 29r; MacCurdy 1097). (See figure 30.)

The portrayal of opposites as twins went far beyond the limits of the moral theory of pleasure and pain. Leonardo saw these contradictions in all natural life as a whole. Nature is a solicitous mother and a cruel stepmother.

Leonardo added this note to his anatomical sketches of the hand: "Have you seen the carefulness of nature in having situated the nerves,

LEONARDO DA VINCI

arteries, and veins not in the center but in the sides of the fingers so that they are not in any way pierced or cut by the movements of the fingers?" (W An A 13v; MacCurdy 100). Further, he stated that for some animals nature is rather a "cruel step-mother than a mother," while for others it is "not a step-mother, but a compassionate mother" (Forst III 20v; MacCurdy 80). Sometimes cruel words came from Leonardo's lips: "It will seem as though nature should extinguish the human race, for it will be useless to the world and will bring destruction to all created things" (CA 370v a; Baskin 79).

Among Leonardo's descriptions, perhaps the most brilliant is that of the island of Cyprus (W 12591v; MacCurdy 371). It is thoroughly antinomical. At the very beginning he notes an intertwining of two contrasting themes, which are further developed poetically and truly musically. "From the southern seaboard of Cilicia may be seen to the south the beautiful island of Cyprus, which was the realm of the goddess Venus; and many there have been who, impelled by her loveliness, have had their ships and rigging broken upon the rocks which lie amidst the seething waves." After this compact description comes the first melodic, smooth, lilting theme: "Here the beauty of some pleasant hill invites the wandering mariners to take their ease among its flowery verdure, where the zephyrs continually come and go, filling with sweet odors the island and the encompassing sea." But immediately the lyrical cantilena of this serene landscape is interrupted by mournful exclamations and a picture of broken ships. "Alas! How many ships have foundered there! How many vessels have been broken upon these rocks! Here might be seen an innumerable host of ships; some broken in pieces and half-buried in the sand, here is visible the poop of one, and there a prow, here a keel and there a rib, and it seems as though the day of judgment has come when there shall be a resurrection of dead ships, so great is the mass that covers the northern shore." It all ends or, one might better say, breaks off on a pitifully lonely cadence: "There the northern winds resounding make strange and fearful noises."

Vasari tells of the colossal physical strength of Leonardo da Vinci: "By his physical force he could restrain any outburst of rage, and with his right hand he twisted the iron ring of a doorbell, or a horseshoe, as if it were lead."[37] This power dwelt in harmony with the delicacy of the lightest touch of the brush, the subtlest nuances of light, shadow, and haze. The combination of such contradictions is

MATHEMATICAL SCIENCES

reflected in Leonardo's outlook. He was permeated by a feeling of the infinite value of human life. In connection with his anatomical drawings, he wrote: "And thou, man, who by these my labors dost look upon the marvelous works of nature, if thou judgest it to be an atrocious act to destroy the same, reflect that it is an infinitely atrocious act to take away the life of a man. For thou shouldst be mindful that though what is thus compounded seems to thee of marvelous subtlety, it is as nothing compared with the soul that dwells within this structure; and in truth, whatever this may be, it is a divine thing which suffers it thus to dwell within its handiwork at its good pleasure, and wills not that thy rage or malice should destroy such a life, since in truth he who does not value it does not deserve it" (W An A 2r; MacCurdy 80).

Leonardo admonished that human talent should be valued above all else. "And if any be found virtuous and good, drive them not away from you but do them honor lest they flee from you and take refuge in hermitages and caves or other solitary places in order to escape from your deceits!" He continues, equating such persons of genius to gods upon earth: "If any such be found, pay him reverence, for as these are as gods upon the earth they deserve statues, images, and honors" (W An II 14r; MacCurdy 85).

However, in his famous praise of the sun Leonardo spoke of the insignificance of man. "I could wish that I had such power of language as should avail me to censure those who would fain extol the worship of men above that of the sun . . . Those who have wished to worship men as gods, such as Jupiter, Saturn, Mars, and the like, have made a very grave error." Indeed, even if a man were as large as our earth, he would seem "like one of the least of the stars, which appears as a speck in the universe." And can one bow to people as to gods, seeing them "mortal and subject to decay and corruption in their tombs"? (F 4v–5r; MacCurdy 278).

The hymn to man is accompanied by or has as its reverse side a merciless exposé of all that makes humans unworthy of the name. This shows that the dark side of reality by no means fell outside the realm of Leonardo's aesthetics. On the contrary, he reacted to it at times bitingly, painfully, and irritably.

Leonardo spoke of "the supreme form of wickedness which hardly exists among the animals," namely, cannibalism, understanding it in both the literal and figurative senses. This devouring of one's own

species "does not happen except among the voracious animals, as in the lion species—among leopards, panthers, lynxes, cats, and creatures like these which sometimes eat their young. But not only do you eat your children, but you eat father, mother, brothers, and friends; and this even not sufficing, you make raids on foreign islands and capture men of other races and then, after removing their genitals, you fatten them up and cram them down your gullets" (W An II 14r; MacCurdy 84).* Having exposed the "devouring of one's own species," both in the literal sense of cannibalism and in the figurative sense of persecutions which drive persons into the desert, Leonardo concluded: "What think you, Man, of your species! Are you as wise as you set yourself up to be? Are acts such as these things that men should do?" (W An II 14r; MacCurdy 85).

Leonardo spoke with hate and contempt of people as "a passage for food," "producers of dung," "fillers of privies." "Methinks that coarse men of bad habits and little power of reason do not deserve so fine an instrument or so great a variety of mechanism as those endowed with ideas and with great reasoning power, but merely a sack wherein their food is received, and whence it passes. For in truth one can only reckon them as a passage for food, since it does not seem to me that they have anything in common with the human race except speech and shape, and in all else they are far below the level of the beasts" (W An B21v; MacCurdy 133). Or, even more harshly: "Lo, some who can call themselves nothing more than a passage for food, producers of dung, fillers of privies, for them nothing else appears in the world, nor is there any virtue in their work, for nothing of them remains but full privies" (Forst III 74v; MacCurdy 80).

Leonardo's mind lived in an atmosphere of contradictions. He could state that a painter should be a "loner," and elsewhere say that "it is much better to draw in company than alone." "I declare and affirm that it is much better for many reasons for a student to draw in com-

* Richter's anthology (1939, II, 104) contains the following excerpt from a letter by Amerigo Vespucci to Pietro Soderini concerning the inhabitants of the Canary Islands, which he visited in 1503: "They feed on human meat, such that father eats son, and *vice versa,* son father, as it may befall them. I saw a thief who bragged and considered it no little merit that he had eaten more than 300 persons. I also saw a certain town, in which I spent about 27 days, where human meat, salted, was hung from the ceiling, just as we hang wild boar meat, dried in the sun or smoked, and in particular sausages and such like. What is more, these people were very much surprised that we did not eat the meat of our enemies, which, to use their words, rouses the appetite and has a remarkable flavor, and they praise it as tasty and a delicacy." As we know, Leonardo was acquainted with Amerigo Vespucci.

MATHEMATICAL SCIENCES

pany than alone. First, because if you are inadequate, you will be ashamed to be seen among the number of men drawing, and this mortification is a motive for studying well. Secondly a sound envy will stimulate you to become one of the number who are praised more than you, and the praise of others will spur you on. Another reason is that you will get something from those who are better than you. If you are better than the others, you will benefit by avoiding their defects, while the praise of others will increase your efficacy" (TP 71; McMahon 73).

This is the thesis; here is the antithesis: "If you are alone, you will be all yours. If you are accompanied by a single companion, you will be half yours, and so much less, the greater the inconsiderateness of his behavior. If you are with more people, you will be subjected to still more inconvenience . . . And if you say, I will draw so far apart that their words cannot reach and annoy me, I reply to you that you will be taken for a fool, for you see, acting this way, you would also be alone" (TP 50; McMahon 74).

These words can be properly understood only through understanding of the tragedy of Leonardo's own loneliness, the fate of the scientist innovator. Leonardo, whose mind was filled with creative projects that were never realized, knew full well that "iron rusts from disuse, stagnant water loses its purity or freezes in cold weather, even so does inaction sap the vigor of the mind" (CA 289v c; MacCurdy 89). Despite all his frustrations, he stubbornly repeated to himself: "Death rather than weariness."

The technological inventions of Leonardo da Vinci, viewed in broad historical perspective, were by no means the product of a person working in isolation, on the contrary, they were bound by many ties to the general trend of technological development in the fourteenth and fifteenth centuries.* Production experience had long been accumulating; new technical experiments were being performed in the workshops of the master craftsmen; and a technical literature was being developed.†

* For illustrations of this, we refer the reader to Gille's interesting paper (1953). He is quite right in asserting that the discovery of actual ties between Leonardo and the technology of his time is much more important than the interminable discussions of Leonardo's "priorities" and "anticipations."

† In 1449, three years before Leonardo's birth, Mariano di Giacopo Taccola wrote a work on machines in ten books. This work has not yet been given the study it merits. Recently Pedretti (in *Studi vinciani*) discussed a manuscript of the early sixteenth century containing a description of various inventions by the Florentine watchmaker Lorenzo della Golpaia and other technicians of the time, including Leonardo da Vinci.

LEONARDO DA VINCI

However, Italian industry was passing through the craftsman work-shop period; and the machine still played a minor role compared with the division of labor. That is why the remarkable technical inventions of Leonardo, his weaving, cutting, and spinning machines, could not find wide application.

The rapacious, selfish, and ambitious rulers of the separate regions of Italy, unprincipled and unscrupulous, were poor patrons of the arts. They needed Leonardo primarily as a military engineer and as a painter who would increase the luster of their courts. They had no use for bold ideas in the field of aviation. They were not interested in Leonardo as an experimental physicist, a mathematician, geologist, botanist, or anatomist. "Painter" and "Military Engineer" were the most important official titles Leonardo da Vinci bore. Aviation, geology, botany, zoology, and human anatomy were all studies "for their own sake," and for future generations.

Leonardo's manuscripts contain powerful descriptions of the forces of nature: destructive floods and inundations, storms, and thunderstorms. The pathos of these descriptions conceals a profound feeling of solitude. Leonardo recognized that his technical ideas were doomed, he could expect support from no one, as "the deluges of ravening rivers, against which no human resource can avail" (CA 108v b; Mac-Curdy 645).

The profusion of variants by which Leonardo strove to express the same thought again and again is significant. He sought, as it were, new words, new shades of meaning; he threw aside what he had begun anew. He wrote and then crossed out: "Among the mighty causes of the earth's misfortunes, rivers in flood should certainly be set before all else, nor is it, as some have thought, fire, for fire ceases its destructive work when it can find no more food." Leonardo put this aside and began again: "Among irremediable and destructive terrors, the inundations caused by impetuous rivers should certainly be set before every other awful and terrifying source of injury." He continued the comparison of water and fire in detail and concluded with a perplexing question. "But in what terms am I to describe the abominable and awful evils against which no human resource avails? With their swelling and exulting waves, they lay waste the high mountains, cast down the strongest banks, tear up the deep-rooted trees, and with ravening waves laden with mud from crossing the ploughed fields carry with them the un-

MATHEMATICAL SCIENCES

endurable labors of the wretched weary tillers of the soil, leaving the valleys bare and mean by reason of the poverty which is left there."

Even this variant did not satisfy him. He kept only the first phrase: "Among irremediable and destructive terrors," dropping the extraneous words: "should certainly." He omitted the entire comparison of water and fire and passed directly to the anxious questions and exclamations. "But in what tongue or with what words am I to express or describe the awful ruin, the inconceivable and pitiless havoc wrought by the deluges of ravening rivers? What can I say? Of course, I do not feel myself capable of such an explanation, but with the support given me by experience, I will try to describe the manner of destruction." After the somewhat prosaic aspect of the last part of the phrase, Leonardo continued perplexed and anxiously: "The deluges of ravening rivers, against which no human resource can avail . . ." (CA 108v b; Mac-Curdy 645).

These are words written with teeth clenched: "if you are alone, you will be all yours [*se tu sarai solo, sarai tutto tuo*]" (TP 50; McMahon 74). The following aphorism, based on a play on words, was dictated by thoughts of loneliness: "Savage is he who saves himself" [*Salvatico è quel che si salva*] (Triv IV; MacCurdy 89). This theme is repeated many times in Leonardo's fables.

"A stone of considerable size, only recently left uncovered by the waters, stood in a certain spot perched up at the edge of a delightful copse, above a stony road, surrounded by plants bright with various flowers of different colors, and looked upon the great mass of stones which lay heaped together in the road beneath. And she became filled with longing to let herself down there, saying within herself: 'What am I doing here with these plants? I would fain dwell in the company of my sisters yonder'; and so letting herself fall she ended her rapid course among her desired companions." And what fate awaited her there? "But when she had been there for a short time, she found herself in continual distress from the wheels of the carts, the iron hooves of the horses, and the feet of the passers-by. One rolled her over, another trampled upon her, and at times she raised herself a little as she lay covered with mud or the dung of some animal, and vainly looked up at the place whence she had departed as a place of solitude and quiet peace." Leonardo drew a moral from this tale: "So it happens to those who, leaving a life of solitude and contemplation, choose to

LEONARDO DA VINCI

31. Burning wood for the hand of Ingratitude

come and dwell in cities among people full of infinite wickedness" (CA 175v a; MacCurdy 1069, 1070).

The fates of the fig tree and of the wild grape vine also tell of life among people. "When the fig tree stood without fruit, no one looked at it. Wishing by producing this fruit to be praised by men, it was bent and broken by them" (CA 76r a; MacCurdy 1067). "The nut tree, displaying to the passers-by upon the road the richness of its fruit, every man stoned it" (CA 76r a; MacCurdy 1607). "The wild grape vine, not remaining contented in its hedge, commenced to pass across the highroad with its branches and to attach itself to the opposite hedge, whereupon it was broken by the passers-by" (CA 67v b; MacCurdy 1066). To live among people means to earn their envy or ingratitude. Indeed, "a body may sooner be without its shadow than virtue [*virtù*] without envy" (Ox A 32v; Richter 261).

"The peasant, seeing the benefit deriving from the grape vine, gave it many supports to hold it up; when he had gathered the fruit, he took away the stakes and let the vine fall, making fire with the supports" (BN 2037 44v).

"A nut which found itself carried by a crow to the top of a lofty campanile, having there fallen into a crevice and so escaping its deadly beak ... The wall, moved with compassion, was content to give it shelter in the spot where it had fallen. And within a short space of time the nut began to burst open and to put its roots in among the crevices of the stones, and push them farther apart and throw up shoots out of its hollow, and these soon rose above the top of the building; and as the twisted roots grew thicker they commenced to tear asunder the wall and force the ancient stones out of their old positions. Then the wall too late and in vain deplored the cause of its destruction, and in a short time it was torn asunder and a great part fell in ruin" (CA 67r a; MacCurdy 1061).

MATHEMATICAL SCIENCES

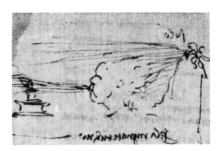

32. Extinguishing a light no longer needed; an allegory of ingratitude

Leonardo sketched burning wood and added the explanatory text: "This shall be placed in the hand of Ingratitude. Wood nourishes the fire that consumes it" (BN 2038 34v; Richter 258; figure 31). Another drawing shows a man blowing out a candle, and the text reads: "When the sun appears which drives away the general darkness, you extinguish the light that drives away the particular darkness, for your necessity and convenience" (BM 173r; MacCurdy 1095; figure 32).

To tie his fate with someone else's meant to condemn himself to the other's fate. "The vine that has grown old upon an old tree falls together with the destruction of this tree. It was by reason of its bad company that it failed together with it." And "The willow, which by reason of its long shoots and by growing so as to surpass every other plant, had become the companion of the vine which was pruned every year, and was itself always mutilated" (BM 42v; MacCurdy 1072).

Should one try to change his fate? This same willow tells what happens: "The unhappy willow concluded that she was not fated to enjoy the pleasure of seeing her slender boughs attain to such a height as she desired, or even point toward the sky, because she was continually being maimed and lopped and spoiled for the sake of the vine or any other tree which happened to be near." The magpie brought her the seeds of a gourd: "These soon began to grow and as the branches increased and opened out they began to cover all the branches of the willow and their great leaves shut away from it the beauty of the sun and the sky. And all this evil not sufficing, the gourds next began to drag down to the ground in their rude grip the tops of the slender boughs, twisting them and distorting them in strange shapes. Then the willow,

LEONARDO DA VINCI

after shaking and tossing herself to no purpose to make the gourds loose their hold and vainly for days cherishing such idle hopes, since the grasp of the gourds was so sure and firm as to forbid such thoughts, seeing the wind pass by, forthwith commended herself to it. And the wind blew hard, and it rent open the willow's old and hollow trunk, tearing it in two parts right down to its roots, and as they fell asunder she vainly bewailed her fate, confessing herself born to no good end" (CA 67r b; MacCurdy 1062, 1063). The following fable reminds one of Salaino, Leonardo's pupil, upon whom he lavished so much care and who repaid him with rank ingratitude: "The lily planted itself down upon the bank of the Ticino, and the stream carried away the bank and with it the lily" (BN 2038 14r; MacCurdy 1071). And does not this bring to mind Leonardo's words: "The Medici created and destroyed me" (CA 159r c; MacCurdy 1123)?

Should one stand aside and play the role of a disinterested observer? Should one even take pleasure in another's misfortunes? No, you yourself will become involved: "The thrushes rejoiced greatly on seeing a man catch an owl and take away her liberty by binding her feet with strong bonds. But then the owl, in the form of bird lime, was the cause of the thrushes losing not only their liberty but even their life." Leonardo adds the moral: "This is said of those states which rejoice at seeing their rulers lose their liberty, in consequence of which they afterwards lose hope of succor and remain bound in the power of their enemy, losing their liberty and often their life" (CA 117r b; MacCurdy 1068).

People do not know what is good for them and repulse their salvation: "The plant complains of the dry and old stick which was placed at its side and of the dry stakes that surround it; the one keeps it upright, the other protects it from bad companions" (Forst III 47v; MacCurdy 1073). "The cedar, arrogant by reason of its beauty, despising the plants which were round about it, caused them to be all removed from its presence, and then the wind, not meeting with any obstacle, tore it up by the roots and threw it onto the ground" (CA 67v b; MacCurdy 1065).

This helpless ignorance is a transposition, as it were, of one of Leonardo's main themes: the torments and tortures of the blind. Next to the drawing of the moth circling the flame, he wrote: "Blind ignorance leads us thus under the influence of voluptuous pleasures, because of

MATHEMATICAL SCIENCES

ignorance of true light, because of ignorance of what true light is. And vain luster takes our life from us . . . Look, because of the brilliance we enter the fire, this is how blind ignorance leads us. O, unfortunate mortals, open your eyes!" (Triv 17v).

In comparison with this exclamation, the fable of the moth becomes particularly sonorous. "The idle fluttering moth, not contented with its power to fly wherever it pleased through the air, enthralled by the seductive flame of the candle, resolved to fly into it, and its joyous movement was the occasion of instant mourning. For in the said flame its delicate wings were consumed, and the wretched moth, having fallen down at the foot of the candlestick all burnt, after much weeping and contrition, wiped the tears from its moist eyes, and lifting up its face exclaimed 'O false light, how many are there such as I who have been miserably deceived by you in times past! Alas! If my one desire was to behold the light, ought I not to have distinguished the sun from the false glimmer of filthy tallow'?" (CA 67r a; MacCurdy 1061).

This fable was written in two variants by Leonardo. In the second the moralizing element was set off sharply. The candle answered the moth: "This is what I do to those who do not know how to use me properly." Then comes a frank and open exhortation: "Said for those who, seeing before them the voluptuous worldly pleasures and like the moth rush toward them without learning their nature; such after a long time come to be known by people in all their shame and perniciousness."

The blindness of which Leonardo spoke was not limited to deceptive worldly pleasures, but was also the blindness of self-appraisals in general and of someone else's appraisal. "The paper on seeing itself all spotted by the murky blackness of the ink grieves over it, and this ink shows it that by the words which it composes upon it, it becomes the cause of its preservation" (Forst III 27r; MacCurdy 1072). "The mirror bears itself proudly, holding the queen mirrored within it, and after she has departed, the mirror remains simply a mirror" (Forst III 44v; MacCurdy 1073).

The laurel and the myrtle complained of the fate of the pear tree, which had been cut down by the peasant. "Then the pear tree replied: 'I am going with the husbandman who is cutting me down and who will take me to the workshop of a good sculptor, who by his art will cause me to assume the form of the god Jove, and I shall be dedicated

in a temple and worshipped by men in place of Jove. While you are obliged to remain always maimed and stripped of your branches which men shall set around me in order to do me honor'" (CA 67r a; MacCurdy 1060).

The privet implored the thrush not to touch it. The thrush answered it with "insolent rebuke": "Silence, rude bramble! Know you not that nature has made you to produce these fruits for my sustenance? Can you not see that you came into the world in order to supply me with this very food? Know you not, vile thing that you are, that next winter you will serve as sustenance and food for the fire?" But a short time later the thrush was caught in a snare, and a cage was made for him from the privet's branches. Then the privet "rejoiced and uttered these words, 'We are here, O thrush, not yet consumed by the fire as you said, we shall see you in prison before you see us burnt'" (CA 67r a; MacCurdy 1060).

Leonardo shows two opposite fates in the cases of the flea and the snowball. The flea perished after leaving its place, while the snowball, rolling downward, became enormous. "While the dog was asleep on a sheepskin, one of its fleas, becoming aware of the smell of the greasy wool, decided that this must be a place where the living was better." But "the hairs were so thick as almost to touch each other, and there was no space where the flea could taste the skin ... Consequently, after long labor and fatigue it began to wish to go back to its dog, which however had already departed, so that after long repentance and bitter tears, it was obliged to die of hunger" (CA 119r a; MacCurdy 1068).

Leonardo told the fable of the snowball concisely in one instance. "The snowball, the more it rolled as it descended from the snowy mountains, the more it increased in size" (BM 42v; MacCurdy 1072). In another passage he developed the theme and turned it into a story: "A certain patch of snow, finding itself clinging to the top of a rock which was perched on the extreme summit of a very high mountain, being left to its own imagination, began to reflect and to say within itself, 'Shall I not be thought haughty and proud for having placed myself in so exalted a spot, being indeed a mere morsel of snow? And for allowing that such a vast quantity of snow as I see around me should take a lower place than mine? Truly my small dimensions do not deserve this eminence, and in proof of my insignificance I may readily acquaint myself with the fate which but yesterday befell my com-

MATHEMATICAL SCIENCES

33. "The life and states of men"

panions, who in a few hours were destroyed by the sun, and this came about from their having placed themselves in a loftier station than was required of them. I will flee from the wrath of the sun, and abase myself, and find a place that befits my modest size'." Finally, when it had ended its course, it was "almost equal in size to the hill on which it rested," and was "the last of the snow which was melted that summer by the sun." Leonardo added the moral: "This is said for those who by humbling themselves are exalted" (CA 67v b; MacCurdy 1066). This sounds evangelical, but does not this contain (and in much greater measure) some of Horace's Epicurian "live inconspicuously"?

> The loftiest pines, when the wind blows,
> Are shaken hardest; tall towers drop
> With the worst crash; the lightning goes
> Straight to the highest mountain top.[38]

In his remarkable description of mountain vegetation belts (more about this later), Leonardo mentions the "bolts of lightning from the sky," whose path was blocked by high cliffs which are "not without revenge [*non sanza vendetta*]" (TP 806; McMahon 839). This is a direct reflection of the Horacian lightning that goes to the highest mountain top.

In the notebooks we find a symbolic drawing (figure 33), cruel and merciless in its naked abstraction and brevity, accompanied by a no less laconic text: "One pushes down the other. By these square blocks are meant the life and states of men" (G 89r; Richter 273).

In Leonardo's fables the theme of mutual destruction has infinite variation, wherein the stronger overpowers the weaker. "The eagle, wishing to mock the owl, got its wings smeared with bird lime and was captured by man and killed" (CA 67v b; MacCurdy 1066). "The spider, wishing to capture the fly in its secret web, was cruelly slain above it by the wasp" (CA 67v b; MacCurdy 1066). "The spider had placed itself among the grapes to catch the midges that fed on them. The time of vintage came and the spider was trodden underfoot together with the grapes" (BM 42v; MacCurdy 1071). The same theme appears again as a more developed story. "The spider, having found a bunch of grapes, which because of its sweetness was much visited by bees and

various sorts of flies, fancied that it had found a spot very suitable for its wiles. And after having lowered itself down by its fine thread and entered its new habitation, there day by day having ensconced itself in the tiny holes made by the spaces between the various grapes in the bunch, like a robber it assaulted the wretched animals that were not on their guard against it. But after some days had passed, the keeper of the vineyard cut this bunch off and placed it with the others and pressed it with them. And the grapes therefore served as trap and snare for the deceiving spider as well as for the midges whom he had deceived" (CA 67v b; MacCurdy 1065).

The same thing occurs on the seashore. "When the crab had placed itself beneath the rock in order to catch the fish that entered underneath it, the tide came with ruinous downfall on the rocks, and these by rolling themselves down destroyed the crab" (BM 42v; MacCurdy 1071). "The oyster being thrown out from the house of a fisherman near to the sea with other fish, prayed to a rat to take him to the sea; the rat, who was intending to devour him bade him open, but then as he bit the oyster, the oyster squeezed the rat's head and held it; and the cat came and killed the rat" (H 51v; MacCurdy 1071).

Do not rejoice before the time of your deliverance. "The mouse was being besieged in its tiny house by the weasel which with unceasing vigilance was awaiting its destruction, and through a tiny chink it was considering its great danger. Meanwhile, the cat came suddenly and seized hold of the weasel and immediately devoured it. Thereupon, the mouse, profoundly grateful to its deity, having offered up some of its hazel nuts as a sacrifice to Jove, issued forth from its hole in order to repossess itself of the liberty it had lost, and was instantly deprived of this and of life itself by the cruel claws and teeth of the cat" (CA 67v a; MacCurdy 1065).

Luporini is quite correct in holding that Leonardo's fables are not moral precepts or sermons, but statements of fact.[39] The fables are poignant, painful responses to the "dark side of reality" and to social conflicts. Leonardo da Vinci lived in a period when splintered Italy was being rent by continuous wars. The stern, bitter lines of the Codex Atlanticus entitled "Man's Cruelty" were written under the immediate impression of the reality about him. They are invested with the form of a "prophecy," typical of Leonardo. "There will be seen on the earth animals which constantly fight among themselves, inflicting

MATHEMATICAL SCIENCES

great harm and frequently death on each other. Their enmity will know no bounds; their savage members will fell a great part of the trees in the vast forests of the world; and after they gorge themselves, they will continue to feed on their desire to inflict death and suffering and sorrow and fear and flight on all living creatures. Through their measureless pride they will seek to raise themselves to heaven, but the excessive weight of their members will hold them fast to the earth. Nothing will remain on the earth or under the earth and water that is not pursued, chased down, or destroyed; and it will be chased from country to country. Their bodies will be the grave and passageway of all the living bodies which they have killed. O world, why do you not open and hurl into the deep clefts of your abysses and caverns and no longer show to heaven such cruel and heartless monsters?" (CA 370v a; Baskin 78). Elsewhere in the Codex Atlanticus we find the following lines: "All the animals languish, filling the air with their lamentations. They ruin forests and rend mountains to wrest from them their stores of metals. But what is more perfidious than those who praise heaven after they have rashly injured their fatherland and the human race?" (CA 382v a; Baskin 70).

We have already had occasion to say that the future tense of Leonardo's prophecies is merely a vehicle for giving the phenomenon an air of inevitability, of a natural law. Why did Leonardo regard "necromancy" as impossible? First of all because necromancy would make war impossible, and war in Leonardo's time was an irrefutable phenomenon. "If it were true, that is, that by such an art one had the power to disturb the tranquility of the air, and transform it into the hue of night, to create coruscations and tempests with dreadful thunderclaps and lightning flashes rushing through the darkness, and with impetuous storms to overthrow high buildings and uproot forests, and with these to encounter armies and break and overthrow them, and—more important even than this—to make the devastating tempests, and thereby to rob the husbandmen of the reward of their labors. For what kind of warfare can there be which can inflict such damage upon the enemy . . . In truth, whoever has control of such irresistible forces will be lord over all nations, and no human skill will be able to resist his destructive power" (W An B 31v; MacCurdy 81).

This is a familiar form of argument *per modum tollentem*, from negation of the result to negation of the cause. Leonardo could have

heard the opinion that war is a "natural state" from his contemporary Machiavelli. "A prince, therefore," wrote Machiavelli, "should have no care or thought but for war, and for the regulations and training it requires, and should apply himself exclusively to this as his peculiar province."[40] Yet Leonardo rebelled against what seemed to him to be a natural and inevitable state of affairs. War was for him "the most bestial of follies (*pazzia bestialissima*)" (TP 177).

"Where there is most feeling there is great suffering, the greatest suffering" (Triv 23v). This great suffering (*gran martire*) was born of those inner conflicts which so characterize Leonardo's philosophy.

Leonardo da Vinci's main aspiration in science was the general aspiration of the new European science: to free scientific knowledge of elements of anthropomorphism, to "deanthropomorphize" or "dehumanize" nature. The desire to perceive in dehumanized, invariable nature the highest law for man, to discover in it, as in some "model of the universe" or "microcosm," the same mechanical laws (and only mechanical laws) which govern the motion of the universe (the moth rushing toward the light), led to a dramatic collision: tomorrow will be the same as yesterday, but tomorrow does not have to be the same as yesterday. Mechanics had changed from the "paradise of the mathematical sciences" into "great suffering" (*gran martire*). Was this Leonardo's final answer? We shall see in what follows.

In conclusion, I cite just one line from the cycle of fables: "The net, which was accustomed to catch fish, was destroyed and carried away by the fury of the fish" (BM 42v; MacCurdy 1072).

6.

TIME

"O tempo, consumatore delle cose!"
"O time, consumer of all things!"
CA 71r a; MacCurdy 62

"WRITE OF THE NATURE OF TIME AS DISTINCT FROM ITS GEOMETRY," Leonardo once noted (BM 176r; MacCurdy 77). He actually did make this distinction, re-creating at various times the images Heraclitus drew of a river and a flame. "The water you touch in a river is the last of that which has passed and the first of that which is coming. Thus it is with time present" (Triv 68r; J. P. Richter 1174). "Observe the light and consider its beauty. Blink your eye and look at it. That light which you see was not there at first, and that which was there is no more. Who makes it anew if the maker dies continually?" (F 49v; MacCurdy 70).

The image of the burning candle became for Leonardo the symbol of the dialectic unity of life and death. *"How the body of the animal continually dies and is renewed.* The body of anything whatsoever that receives nourishment continually dies and is continually renewed. For the nourishment cannot enter except in those places where the preceding nourishment has been exhausted, and if it is exhausted, it no longer has life. Unless, therefore, you supply nourishment equivalent to that which has departed, the life fails in its vigor; and if you deprive it of this nourishment, the life is completely destroyed. But if you supply it with just so much as is destroyed day by day, then it renews its life just as much as it is consumed; like the light of this candle, which light is also continually renewed by swiftest succor from beneath, in proportion as the upper part is consumed and dies, and in dying becomes changed from radiant light to murky smoke. And this death extends for so long as the smoke continues; and the period of duration of the smoke is the same as that of what feeds it, and in an instant the whole light dies and is entirely regenerated by the movement of that which nourishes it" (W An B 28r; MacCurdy 141).

LEONARDO DA VINCI

The Codex Atlanticus contains a description of a special variant of the clock, an instrument which has intruded with ever increasing authority into the thought and life of man. The description is framed with unfinished phrases, mentioned then abandoned: "No dearth of ways of dividing and measuring . . . our miserable days. These instruments help us to refrain from spending and squandering them foolishly . . . and to do something praiseworthy in order to leave behind some memory of us in the minds of mortals (Baskin 72) . . . knowing how to spend . . . defend and dispute . . . for the most part causes . . . is our unfortunate life." Then there follows a completed text: "A leather bag, filled with air, can by its descent also show you the hours." Next comes the sad exclamation: "There is no lack of means and method to divide these our unfortunate days!" And again a broken phrase: "oh that our poor course shall not have passed in vain" (CA 12v a).

Ovid, in his *Metamorphoses,* sang of the grief of Helen the Beautiful who looked into a mirror after reaching old age:

Helen also weeps when she sees her aged wrinkles in the looking-glass,
And tearfully asks herself why she should twice have been a lover's
 prey.
O Time, thou great devourer, and thou, envious Age, together you
Destroy all things and, slowly gnawing with your teeth, you finally
Consume all things in lingering death! [1]

Leonardo retold these lines thus: "O time, ravisher of all things! O invidious age! You destroy all things and devour them with the hard teeth of old age—gradually, with slow death. Helen, looking into the mirror and seeing the withered wrinkles made on her face by age, groans and wonders why she was twice raped." And, again: "O time, ravisher of things, and invidious old age, destroying all things!" (CA 71r a; Baskin 72).

One aspect of this is interesting. Leonardo gave this fragment from Ovid the form of a three-part song. Helen's thoughts are framed by two almost identical apostrophes to time and old age, but the second is not a simple repetition of the first. After the middle part of the fragment, the apostrophe is like a mirror image onto which falls the light of Helen's lyrical personal and human complaints, and it becomes quite different. As in his scientific notes, where Leonardo often pre-

TIME

34. Beauty perishes

ceded a note on something individual or specific with a general postulate, here, too, Helen becomes a kind of illustration, a *dimostrazione*, of the general, somewhat rhetorical thesis. The second apostrophe to time is not just a general postulate, simply repeated, but the lament of the individual soul, that is, the same thesis, but reflected in the mirror of the individual soul, repeated by Helen's lips.[2]

A few pages later in the Codex Atlanticus there is a replica, as it were, of this lament, written in another major key and transferred to another cycle of ideas: "Wrongfully do men lament the flight of time, accusing it of being too swift, and not perceiving that its period is yet sufficient; but good memory wherewith nature has endowed us causes everything long past to seem present" (CA 76r a; MacCurdy 62). This invites comparison with another passage in which Leonardo conveyed the feeling of time with special acuteness, translating it into his native language of visual images: "many things which happened many years ago will seem nearly related to the present, and many things that are recent will seem ancient, extending back to the far-off period of our youth. And so it is with the eye, with regard to distant things, which when illumined by the sun seem near to the eye, while many things which are near seem far off" (CA 29v a; MacCurdy 61).

It is this ability to make objects of the most distant past seem "close to the eye," to illuminate them with the light of thought, that distinguishes Leonardo's striking pictures of the earth's history, for example, his lines on the lake which stood on the spot where "we now see the city of Florence flourish" (Leic 9r; MacCurdy 333), or the peaks of the Apennines which "stood up in this sea in the form of islands," and "above the plains of Italy, where flocks of birds are flying

today, fishes were once moving in great shoals" (Leic 10v; MacCurdy 340).

Leonardo pushed back the horizon of time much farther than the negligible 7000 years of biblical chronology: "O time, swift despoiler of created things! How many kings, how many peoples hast thou brought low! How many changes of state and circumstance have followed since the wondrous form of this fish died here in this hollow winding recess?" And, turning to its dead imprint, he continued: "Now, destroyed by Time, patiently it lies within this narrow space and, with its bones dried and bare, it is become an armor and support to the mountain which lies above it" (BM 156r; MacCurdy 1128).

Perhaps it was because Leonardo conceived of time on such a grand scale that he was indifferent to the historical forms of human existence, historical events, historical names, and historical reminiscences. Here one should recall that the verbal sketch of the *Last Supper* does not contain a single name and that the "atmosphere of uniqueness" surrounding it has been built by legend and artistic tradition. Many other examples can be cited to show Leonardo's indifference to the singularities of history as opposed to its sweep. For example, one may note the different manner in which Alberti and Leonardo recounted the same idea. Alberti's instruction to the artist is studded with references to antiquity. "It would be quite absurd to make the hands of Helen or Iphigenia like those of an old woman or a rustic, or to give Nestor a fair breast or a flowing head of hair, or Ganymede a wrinkled forehead or athletic legs, or to paint Milo, the most robust of men, with a fine taper shape. So again in these figures which have a fleshy look, as we say, full of juice, it would be ridiculous to make the body and the hands lean and scraggy."[3]

Leonardo spoke on the same subject in a very abstract and sparing manner, without any of the references to antiquity. "Let the parts of living creatures be in accordance with their type. I say that you should not take the leg of a delicate figure, or the arm, or other limb, and attach it to a figure with a thick chest or neck. And do not mix the limbs of the young with those of the old, nor limbs that are vigorous and muscular with those that are delicate and fine, nor those of males with those of females" (TP 284; McMahon 288).

One might recall further the advice given by Alberti, the humanist, on how to keep the outlines from being too sharp. "The first rule to

TIME

be observed in the outlines is to draw them as thin and fine as possible, so as scarce to be discerned by the eye, as we are told that Apelles used to contend with Protogenes, which should draw the lighter strokes; for indeed the outline is nothing but the tracing of the circumferences, which if they are marked with too strong a line will not seem in the picture to be merely the edge of the surface, but rather so many cracks in it."[4]

Leonardo spoke of this as a mathematician and artist, boldly passing from mathematical determinations to aesthetic judgments. "If the line and also the mathematical point are invisible the outlines of things, also being lines, are invisible, even when they are near at hand. Therefore, painter, do not give contours to objects far from the eye, at a distance where not only those outlines but even the parts of bodies are imperceptible" (TP 694–696; McMahon 860). He uses nature and reason alone to resolve the problem, without recourse to historical example and legend.

It is not just a case of Leonardo being "ahistorical" (we won't call it "antihistorical," because he was simply uninterested in historical details), it was a profound, almost instinctive revulsion against the concept of time, which for Leonardo was primarily a "destroyer of things."

Nature was the same always in all things: "Nature does not change the ordinary kinds [le ordinarie spezie] of things which she creates" (W An B 28v; McMahon 142). It has already been stated that his morphological and functional comparisons which showed the ways to comparative anatomy did not contain a single allusion to genetics, to the concept of evolution, nor does he allude to the actual evolution of the earth. The entire "history" of our planet reduces to a constant change of all those processes, a constant shifting of land and sea, like the oscillations of a pendulum. It could not have been otherwise in Leonardo's time. Let us recall that Engels spoke of the period from the second half of the fifteenth to the middle of the eighteenth centuries as a period characterized by the development of a "peculiar general outlook whose central feature was the concept of *the absolute immutability of nature.*"[5]

Leonardo could have read the following lines in a work by his compatriot Machiavelli: "They say that history is the preceptress of our actions, but most of all of the deeds of princes, that the world was always populated by people subject to the same passions, that there were always subjects and sovereigns."[6] For Machiavelli, history was a

LEONARDO DA VINCI

teacher only because the world was always the same, not because it disclosed the nature of an object in evolution. The ancient Romans were to be imitated because we do not differ from them in essence. Time creates nothing new, it only destroys and carries everything away in its current.

On examining Leonardo's texts, the reader should beware of a possible optical illusion. For example, in reading Leonardo's fragments on fossil shells and fossil fish, the modern reader involuntarily lets his imagination transport him into the prehuman, remote geological epochs, and he recalls the subsequent periods of the earth's history, that is, he begins to regard Leonardo's statements through the prism of later evolutionism. One should not forget that for Leonardo "nature does not change the ordinary kinds of things she creates," and that for him kings, nations, and changes of government were in the same frame of reference as the animals which for us represent quite distinctive past epochs.

Let us examine Leonardo da Vinci's geological reflections more closely and explain in more detail the extent to which his peculiar "feeling of time" is reflected in them.[7]

Undoubtedly Leonardo's hydraulic engineering work focused his attention on geological phenomena. If this work was not the first thing that drew his attention to geology, at least it facilitated his studies considerably. This is indicated, among other things, by the Leicester Codex, which may be dated 1504–1506 and which contains most of his notes on geology. The geological fragments and notes appear among notes on the movement of water in rivers and they alternate with his thoughts on hydrostatics and hydrodynamics.

His interest in various rocks and types of stones was sustained by his activities as an architect, builder, and sculptor: "In the mountains of Parma and Piacenza, multitudes of shells and corals filled with worm holes may be seen still adhering to the rocks. And when I was making the great horse at Milan, a large sack of those which had been found in these parts was brought to my workshop by some peasants, and among them were many which were still in their original condition" (Leic 9v; MacCurdy 337).

The proximity of his notes on geology and hydrodynamics in the Leicester Codex is not the only evidence of a connection between his geological and paleontological observations and his hydraulic engineer-

TIME

ing surveys. Leonardo's thoughts on the earth's past came to him in the same localities as are mentioned in his water projects: Gonfolina, Prato, Pistoia. He often wandered over the section of the Arno between Florence and Empoli, pondering problems of hydraulic engineering and geology. This is the site of "Wolf Mountain" (Montelupo), named for a castle built in 1203. The castle is like a wolf, *lupo,* ready to devour the "goat," Capraia, a settlement on the opposite bank of the Arno. Nearby is Gonfolina with its eroded ravine. The natural aspect of these places was reflected in various ways in the writings and paintings of Leonardo.

Leonardo mentioned Gonfolina (or, as he called it, Golfolina) three times on two pages of the Leicester Codex (8v and 9r). He assumed that the Arno was once dammed by a rock and only later cut itself a path to the sea, which once extended to these localities. Leonardo held that the remains of shells marked the boundaries of the ancient sea: there are always many shells where "rivers flow into the sea."

With the epic calm of a confident narrator, Leonardo sketched a picture of the geological past of these places as if he were beholding it; he saw large lakes at the present sites of Prato, Pistoia, Serravalle, Arezzo, Girone, Perugia, and his native Florence. "Where the valleys have never been covered by the salt waters of the sea, there the shells are never found; as is plainly visible in the great valley of the Arno above Gonfolina—rocks which were once united with Monte Albano in the form of a very high bank. This kept the river dammed up in such a way that before it could empty itself into the sea, which was once at the foot of this rock, it formed two large lakes, the first of which is where we now see the city of Florence flourishing together with Prato and Pistoia; and Monte Albano followed the rest of the bank down to where now stands Serravalle. In the upper part of the Val d'Arno as far as Arezzo a second lake was formed and this emptied its waters into the above-mentioned lake. It was shut in at about where now we see Girone, and it filled all the valley above for a distance of forty miles . . . This lake was joined to that of Perugia" (Leic 9r; MacCurdy 333).

There is an interesting parallel to Leonardo's text in Giovanni Villani's *Chronicle.* Villani (1275–1348), and later Leonardo da Vinci, assumed that the Gonfolina rock had blocked the flow of the Arno, forming lakes in the upper course of the stream, but that the lakes had drained in historic times, after the expedition of Hannibal.[8]

LEONARDO DA VINCI

In the same passage of the Leicester Codex, Leonardo outlined the observations that led him to think that the sea had not extended up the Arno above Gonfolina. The Arno valley is full of alluvium at these points. This soil "is still to be seen in a thick layer at the foot of Prato Magno. Within this soil may be seen deep cuttings of the rivers which have passed there in their descent from the great mountain of Prato Magno; in which cuttings there are no traces visible of any shells or of marine earth."

Leonardo's notes do not always name the region of his geological observations so precisely. On passing from the specific to the general, in order to state a general law (*ragione*), Leonardo sometimes concealed and veiled the initial observation. A passage in the Leicester Codex will serve as an example. He began with a general declaration, "when a river flows out from among mountains," but first he had written "River Vin[ci]" (Leic. 6v; MacCurdy 330).

One cannot help but remember the mountain river which served as the background for the *Monna Lisa*. It was painted so accurately and so true to life that it could have served as an illustration of Leonardo's geological texts; it is immersed in deadly cold greenish-blue twilight which cannot be localized in time and which vies with the Gioconda's smile for elusiveness. This is a "generalized" mountain stream, from the remote, prehuman geological past, without specification as to time and space, without a today or tomorrow.

Leonardo was not the first to contemplate fossil shells. Herodotus also observed them and expressed the opinion that the part of Egypt included between the mountain ranges up the Nile above Memphis was once a gulf of the sea that eventually became filled with river deposits. He pointed out that Egypt extends farther into the sea than the adjacent lands; that "there were shells upon the hills and that salt exuded from the soil to such an extent as even to injure the pyramids"; and finally that the soil of Egypt differs from that of the neighboring countries: in Egypt it is black and crumbly and consists of silt and alluvium, while in Libya it is reddish and sandy, and in Arabia and Syria it inclines to clay and stone.[9]

According to Strabo,[10] Eratosthenes posed the question why large quantities of shells should be found two or three thousand stadia (two or three hundred miles) from the sea, and salt marshes should exist, for example, near the Temple of Ammon and on the road to it,

TIME

a distance of three thousand stadia from the sea. In answer, Eratosthenes cited the opinion of Strato and Xanthus the Lydian. Xanthus held that in the reign of Artaxerxes there was so great a drought that the rivers, lakes, and wells dried up; that he himself had often seen, far from the sea, stones shaped like shells; that he had seen salt marshes in Armenia, Media, and Lower Phrygia, from which he concluded that these plains were once the sea. Strato suspected another reason for the retreat of the sea: the Temple of Ammon now stands on land because part of the sea water drained into the ocean and the sea level dropped. Strato also said that in ancient times Egypt was covered by the sea as far as the bogs about Pelusium, Mount Casium, and Lake Sirbonis, inasmuch as shells are found when wells are dug there, and this indicates that once the country was covered by the sea.

There is no need to go into a detailed examination of the opinions of these ancient authors as to the reasons for the changes in land and sea. I merely wish to point out that this question was touched on long before Leonardo, and that if Leonardo did not know the Herodotus text, he could certainly have known the discussions of Xanthus, Strato, and Eratosthenes cited in Strabo.

Undoubtedly Leonardo knew the passage in Ovid's *Metamorphoses* in which Pythagorus tells of the changes in the face of the earth:*

> I've seen land turn to miles of flood-tossed waters,
> Or land rise up within a restless sea;
> Shells have been found upon a sanded plain,
> With never an ocean or a ship in sight,
> Someone has seen an ancient anchor turn to rust,
> Caught among brushes on a mountain top,
> Stormed by great cataracts, a wide plateau
> Turns to a valley and spring floods have swept
> Far hills into the chambers of the sea.[11]

The mention of an ancient anchor found on a mountain top is highly characteristic of Ovid's conceptions of the times and periods of geological changes, namely, people lived in the most remote times and there was no difference between geological and historical epochs. An entry in Leonardo's notebook has something in common with Ovid's

* Leonardo translated from this same tale of Pythagorus the passage about Helen standing before the mirror.

approach. The note is interspersed with remarks on fossils. He speaks of the remains of a "very large ship" found during the digging of a well: "In Candia, in Lombardy, near to Alessandria della Paglia, while some men were engaged in digging a well for Messer Gualtieri who has a house there, the skeleton of a very large ship was found at a depth of about ten braccia beneath the ground; and as the timber was black and in excellent condition, Messer Gualtieri thought fit to have the mouth of the well enlarged in such a way that the outline of the ship should be uncovered" (Leic 9v; MacCurdy 377).*

Geological and paleontological concepts similar to those of Leonardo da Vinci did not become widely known for a long time. In the sixteenth century Girolamo Fracastoro, Giordano Bruno, and Bernard Palissy held ideas that agreed with Leonardo's in one respect or another, but these were thoroughly forgotten in the seventeenth century. One can see how far ahead of the times Leonardo was when we recollect that in the seventeenth century fossils were often regarded as a "whim of creative nature" or a result of astrological influences. Augusto Scilla, an artist and scholar of Messina (1629-1700), seriously disputed this theory as late as 1670 in his book *La Vana speculazione del senso* (Empty speculation refuted by the senses). In the eighteenth century ponderous tomes were still being published in which the paleontological remains of sea animals were taken as evidence of the universal deluge.[12] Even such a critical mind as Voltaire's considered it "insanity" to see in fossils indications of remote periods of the earth's history. In the 1770's he made this ironic remark in the margins of Buffon's *Histoire Naturelle*: "Leaves from Indian trees in Saint-Chamond and in Germany. Why not from the moon? To the insane asylum, to the insane asylum!"[13]

On observing the erosion of river banks, Leonardo considered the role of water as a basic geological modifier of the earth's face. He regarded water as "nature's carter" [*il vetturale della natura*]" (K 2r; MacCurdy 727), and held that mountains owe their origin to water. Central and northern Italy and France offer particular bits of evidence

* Baratta (*Leonardo da Vinci*, pp. 223-227) pointed out interesting parallels to Leonardo's remarks in Ristoro d'Arezzo, who associated fossil shells with the Deluge; in Ceccho d'Ascoli and his commentator, Niccolò Magnetti, who attempted to examine the process of petrification of rocks with shells embedded in them; and, finally, Boccaccio, who assumed that the shells could have been brought by a violent flood, but had in mind the one reported in Greek myths, not the Biblical deluge.

TIME

of the role of water in modifying the relief, and Leonardo observed these phenomena with special attention.

If he had come to know southern Italy better, he would probably have gone into more detailed studies of the volcanic forces which are treated only fragmentarily in his notes, mostly in pictorial, emotional descriptions, broken off and unfinished; for example, he spoke of Stromboli and Mongibello (Etna), where "pent-up sulphurous flames rend and burst open the mountain fulminating stones and earth mingled together in the issuing flames" (BM 155r; Richter 262).

Leonardo's countryman Leon Battista Alberti wrote very expressively on the erosion of mountains: "And that the hills are actually eaten and washed away, and wasted daily more and more by continual rains, is evident from the caverns and rocks which every day grow more visible, whereas at first they were so covered with earth that we could hardly perceive them. Mount Morello, which is above Florence, in the days of our fathers was all covered with firs, and now is quite wild and naked, occasioned, I suppose, by the washing of the rains."[14]

Leonardo usually based his statements on personal observations. But how did he apply himself to the more general problems that could not be solved by direct observation? He was interested in the Mediterranean basin as a whole, in the tides in its various parts, in the geological past of Egypt, and in many other things. It was inevitable that he should ask questions and employ books, modeling, and reasoning by analogy in seeking answers.

Analogy was an old method, sanctified by tradition. Herodotus resorted to it when he wrote that part of Egypt was once a gulf of the sea: "it resembles, to compare small things with great, the parts about Ilium and Theuthrania, Ephesus, and the Plain of Maeander." He commented that the river Achelous, which "after passing through Acarnania empties itself into the sea opposite the island called Echinades, and has already joined one-half of them to the continent."[15] Leonardo proceeded in a similar manner. In a cursory note he wrote "how within a short time the river Po will cause the Adriatic Sea to dry up in the same way as it has dried up a great part of Lombardy" (Leic 27v; MacCurdy 371). Elsewhere in the Leicester Codex he wrote of the Nile, which he had not seen, comparing it with the Po, which he had seen: "The shores of the sea are constantly moving toward the middle of the sea and displacing it from its original position. The

lowest portion of the Mediterranean will be reserved for the bed and current of the Nile, the largest river that flows into that sea. And with it are grouped all its tributaries, which at first fell into the sea, as may be seen with the Po and its tributaries, which first fell into that sea, which between the Apennines and the German Alps was united to the Adriatic sea" (Leic 10r; J. P. Richter 1063).

One is struck by the bold and free excursions from Italy to northern Africa and Memphis and back to Italy in Leonardo's grandiose picture of the remote geological past, given in sparing, epically austere phrases. "The bosom of the Mediterranean, like a sea, received the principal waters of Africa, Asia, and Europe; for they were turned toward it and came with their waters to the base of the mountains which surrounded it and formed its banks. And the peaks of the Apennines stood up in this sea in the form of islands surrounded by salt water. Nor did Africa, behind its Atlas mountains, as yet reveal the earth of its great plains some three thousand miles in extent; and on the shore of this sea stood Memphis; and above the plains of Italy where flocks of birds are flying today, fishes were once moving in great shoals" (Leic 10v; MacCurdy 340). From the peaks of the Apennines to Africa to the Atlas Mountains to Memphis and again to the plains of Italy. Leonardo's mental gaze soared, as it were, above the whole enormous surface of the Mediterranean Sea and its shores.

What Leonardo da Vinci said of the levels and currents of the seas would seem at first glance to be a mere rehash, especially if one reads the passage in Aristotle's *Meteorology,* where it is stated that the waters of the Sea of Azov flow into the Black Sea, the waters of the Black Sea into the Mediterranean, and the waters of the Mediterranean into the Atlantic Ocean. "The whole of the Mediterranean does actually flow," wrote Aristotle. "The direction of this flow is determined by the depth of the basins and by the number of rivers. The Palus Maeotis [Sea of Azov] flows into the Pontus Euxinus [Black Sea] and the Pontus Euxinus into the Aegean Sea . . . The sea, evidently, gets deeper and deeper toward the Pillars of Hercules [Strait of Gibraltar]. The Pontus Euxinus is deeper than the Palus Maeotis, the Aegean Sea is deeper than the Pontus Euxinus, the Sicilian Sea than the Aegean, the Sardinian and Tyrrhenic being the deepest of all. Outside the Pillars of Hercules . . . the waters lie as in a hollow."[16]

Leonardo wrote: "In the Bosporus, the Black Sea always flows into

TIME

the Aegean, never the Aegean into it. This is because the Caspian Sea, four hundred miles to the east, together with the rivers that flow into it, is always discharging itself through subterranean channels into the Black Sea; and the Don and also the Danube do the same, so that, as a consequence, the waters of the Black Sea are always higher than those of the Aegean" (Leic 31v; MacCurdy 346). The same subject is discussed in another note: "From the straits of Gibraltar to the Don is three thousand five hundred miles, and the difference in level is one mile and one sixth, that is to say, there is a fall of one braccio per mile for all water that moves at a moderate rate of speed. And the Caspian Sea is considerably higher, and none of the mountains of Europe rises a mile above the surface of our seas" (F 50r; MacCurdy 365).

One might think that the distance from the Strait of Gibraltar to the Don was taken from some source, but this was not the case, as evidenced by a later note: "Here it follows that the Sea of Azov, which borders upon the Don, is the highest part of the Mediterranean Sea, and it is three thousand five hundred miles distant from the straits of Gibraltar, as is shown by the navigator's chart, and it has a descent of three thousand five hundred braccia, that is, a mile and a sixth, this sea consequently being higher than any mountain there is in the west" (F 68r and v; MacCurdy 324). Thus, Leonardo not only read Aristotle, or some account of Aristotle, but checked him against a navigator's chart. Even that was not enough. Being interested in tides, Leonardo drew on eye-witness data. We find the following note in the Codex Atlanticus: "Write to Bartolomeo the Turk about the ebb and flow of the Black Sea and ask whether he knows if there is the same ebb and flow in the Hyrcanian or Caspian Sea" (CA 260r a; MacCurdy 363).*

Apparently he based the following notes on such eye-witness reports. "At Bordeaux, which is in Gascony, the sea rises about forty braccia before it ebbs, and the salt waters flood the river for more than a hundred and fifty miles; and the vessels which have been laid up to be caulked are left high and dry on the top of a high hill above where the sea has receded" (Leic 27v; MacCurdy 371). "Near Tunis there is a greater ebb than [elsewhere] in the Mediterranean, namely about two braccia and a half; at Venice the fall is two braccia; in all the other

* Bartolomeo Turco was an Italian sailor nicknamed the Turk because of his knowledge of the eastern seas. Perhaps he was Bartolomeo de li Sonetti, the author of a poetic description of the Aegean islands.

parts of the Mediterranean the fall is little or nothing" (Leic 27v; MacCurdy 371).

Actually, however, Leonardo could only believe his own experience, which, as he knew, "did not deceive." That is why he made a bold attempt at modeling. Deliberating on the movement of water in the Mediterranean Sea, he wrote: "Ask about this experiment in all its demonstrative details." He continued: "Thus, you make a model of the Mediterranean Sea in the form indicated here. In this model let the rivers be commensurate with the size and outlines of the sea. Then, by experimental observation of the streams of water, you will learn what they carry away of things covered and not covered by water. And you will let the waters of the Nile, Don, Po, and other rivers of similar size flow into that sea, which will have its outlet through the straits of Gibraltar. Its bottom should be made of sand, with a level surface. In this way you will soon see whence the water currents take objects and where they deposit them" (CA 84v a).

Thorndike[17] noted with some malignant joy that actually the current at Gibraltar flows in the direction opposite that indicated by Leonardo and, therefore, our great Italian departed from his principle of accurate observation and wrote of something he did not know. In passing this judgment, Thorndike missed completely Leonardo's constant and unyielding effort to reach the truth through all possible sources available to him. Leonardo's misfortune was that of any solitary researcher and, to a considerable extent, it was the lot of all natural scientists of the sixteenth century. Geographical discoveries confronted them with constant surprises. The impossible of yesterday became the reality of today. Exotic wonders erased the boundary between the possible and the impossible. When travelers saw orangutangs, they admitted the possibility of the tale of the ancients about a live satyr that was brought to Rome. Even in the seventeenth century one finds sketches of orangutangs with the legend: "A satyr, called by the local inhabitants orangutang." The empirical data which had grown so fabulously in volume could receive the critical verification it warranted only by collective experimentation, that is, through systematic work by scientific centers (academies), scientific expeditions, and collections and museums and through regular correspondence between scientists of different countries. The sixteenth century, however, inevitably produced the type of scientist who only resorted to books to learn and compare the

evidence of ancient and contemporary authors. The permanent historical significance of Leonardo is that he remained apart from this trend, which was already on the increase during his lifetime. He was more sober, critical, and skeptical than his contemporaries, for example, Giambattista della Porta or Girolamo Cardano, who so typify the sixteenth century. Leonardo did not compare literary sources in order to bring them into agreement or to reconcile them, but took them as a starting point for verification by all possible means. For him, the Aristotelian hypothesis of currents in the Mediterranean basin was just that, a hypothesis, an initial orienting proposition to be verified. If the situation had been different, he would not have made the constant reminders "ask," "find out," "verify," "experiment."

Therefore, we shall not delve deeper into the sources Leonardo used in attempting to resurrect the history of the Mediterranean Sea, for his attitude toward them is clear. We shall limit ourselves to a brief outline of his general views. He held that at one time the Mediterranean Sea "flowed abundantly through the Red Sea," and that these waters "wore away the sides of Mount Sinai" (Leic 31r; MacCurdy 344). The Persian Gulf was once "a vast lake of the Tigris and had its outlet into the Indian Ocean." With time, the mountain that once served as its bank was washed away and its level became the same as that of the Indian Ocean. "And if the Mediterranean had continued to find an outlet through the Gulf of Arabia, it would have produced the same result, that is, it would have caused its level to become the same as that of the Indian Ocean" (Leic 31r; MacCurdy 345).

Why did the Mediterranean Sea stop flowing through the Red Sea? To answer this question, Leonardo again resorted to analogy, offering the same explanation that he had used to account for the formation of the mountain lakes of his own country. "A mountain may have fallen and blocked the mouth of the Red Sea and prevented its outlet to the Mediterranean, and thus overflowing, this sea found its outlet through the passage between the mountains of Gades (Strait of Gibraltar), for in the same way we have seen in our time a mountain fall seven miles and block up a valley and make a lake" (CA 32v b; MacCurdy 319). He continued: "and this was the manner in which most of the mountain lakes formed, for example, Lago di Garda, di Como, di Lugano, and Lago Maggiore." "Having received water through the strait of Gades, the Mediterranean Sea lowered its level somewhat at the

shores of Syria, and considerably in that strait, because before the strait was formed, this sea flowed in a southerly direction and then had to form its flow through the strait of Gades" (CA 32v b).

In another passage Leonardo supplemented his hypothesis on the formation of the Strait of Gibraltar with a hypothesis on the gradual erosion of the adjacent mountains and capped it with a picturesque colophon, the myth of Hercules. "Afterwards Mount Calpe was cut through in the west and separated from Mount Abyla, and this strait formed at the lowest spot in the wide plains which lie between Abyla and the ocean, at the foot of the mountain in the lowland, helped by the hollowing out of one of the valleys by rivers which must have flowed there. Hercules came to open the sea in the west, and then the waters of the sea commenced to flow into the western ocean, and as a consequence of this great fall, the Red Sea remained higher, and therefore the waters have ceased to flow in that direction but have always ever since poured through the straits of Spain" (Leic 31r; Mac-Curdy 344).

According to Leonardo, the Black Sea once stretched as far as Austria and occupied the entire plain through which the Danube now flows. "And the sign of this is shown by the oysters, and cockleshells, and scallops, and bones of great fish which are still found in many places on the high slopes of the said mountains, and the sea was created by the filling up of the spurs of the Adula (Saint Gotthard) range which extend to the east and unite with the spurs of the Taurus range extending to the west." "The waters of the sea drain near Bithynia," and "at the ends of their long course, the spurs of the Adula range are severed from those of the Taurus range, and the Black Sea sank down and laid bare the valley of the Danube . . . and the whole of Asia Minor beyond the Taurus range to the north, and the plain which stretches from the Caucasus to the Black Sea to the west, and the plain of Tanais (the Don) this side of the Rifian (Ural) mountains, that is, at their feet" (Leic 1v; MacCurdy 329).

Thus, Leonardo explained the shifting of the sea primarily by analogy to the processes that occur during the formation and disappearance of mountain lakes. He refers to the collapse of mountains and their erosion, to the formation of Lago di Garda, Lago di Como, Lago di Lugano, and Lago Maggiore in the first instance, and the formation of the Gonfolina ravine in the second: the Arno, flowing to-

TIME

ward the sea, bared broad expanses on which "we now see the city of Florence flourishing together with Prato and Pistoia." But he also considered a slow, secular factor, the uplifting of the land, along with the sudden cataclysms.

The theory of the slow uplifting of the land was expounded in the works of French scholars of the fourteenth century, Jean Buridan and his faithful student Albert of Saxony.[18] It may be summarized briefly as follows. In bodies one must distinguish between the center of magnitude (*centrum magnitudinis*), or the geometric center, and the center of gravity (*centrum gravitatis*). These centers do not coincide in bodies in which the weight is distributed unevenly. Such is the earth: if both its centers coincided, the earth would be a perfect sphere covered with water and it would be in the center of a spherical universe, in the "center of the world." However, at present, that is, in view of the asymmetric distribution of water and land, the center of gravity coincides with the center of the world, but not with the center of magnitude. Neither Buridan nor Albert had yet learned of the existence of America. Therefore, they conceived of the opposite hemisphere of the earth as being completely covered by water.

Buridan wrote:[19] "the center of magnitude of the earth is one thing, and the center of its gravity is another, for the center of gravity is the point at which there is as much weight on the one side as on the other, and it is not in the center of magnitude." "The center of gravity of the earth is the center of the world, and is not the center of its magnitude, in that the earth by its gravity strives toward the center of the world; that is why the earth rises above the water on one side and is completely below the water on the other."*

Our hemisphere—the eastern hemisphere—feels the heat of the sun to a greater extent than does the opposite one. "The idea exists," wrote Buridan, "that the open part of the earth [the part not covered by water] changes by means of the air and the heat of the sun, and that a large amount of air is mixed into it; thus, this earth becomes less dense and lighter, having many pores filled with air or delicate

*Duhem did not know of this text and erroneously saw too great differences between Buridan and Albert. His quotations from Buridan concerning the nature of a point are characteristic of the nominalist point of view, but have no direct bearing on the question under discussion. However Buridan may have interpreted the philosophical nature of the concepts of a point and a center, he continued to use the concepts of "center of magnitude" and "center of gravity," as is evident from the cited passage. See Duhem, *Etudes*, III, 23–34.

LEONARDO DA VINCI

bodies; the part of the earth covered with water cannot be changed as much by the air and the sun and, therefore, remains denser and heavier."[20] Consequently, the surface of the opposite, heavier hemisphere is closer to the center of the world. In the words of Albert of Saxony, the earth is "closer to heaven in the part not covered by water than in the part covered by water."[21]

Loose ground, becoming less dense and lighter because of the sun's action, is washed away by rivers, which carry off the earth particles to a "lower place," that is, to the opposite hemisphere, which is closer to the center of the world. The eastern hemisphere will thus become ever lighter; it should rise steadily with respect to the center of the world, and the opposite hemisphere should gradually draw closer to the center. As Albert wrote: "actually the earth is steadily in motion, for its gravity on one side diminishes more than it does on the other."[22]

In other words, in the eastern hemisphere two factors act in opposite directions. On the one hand there is the gradual erosion of rocks and land in general, the reduction of mountain summits, and on the other there is the slow uplifting of the land because of the transport of earth particles to the opposite hemisphere and the incessant action of the sun's heat. The first factor is weaker than the second. Buridan concludes from this that "with time, the parts that are in the center of the earth will finally emerge onto the surface of the habitable earth, because parts are constantly being removed from it and carried in the opposite direction and thus there will be a continual uplifting of the land."[23]

Albert mentioned another factor not found in the Buridan text, namely, the change in the slope of the ecliptic and, thus, the corresponding changes in the conditions of evaporation of the waters. "I propose that because of the change of apogee of the eccentric of the sun, the part of the earth which is now covered with water was once exposed, and the part which is now exposed was once covered with water. Evidently Aristotle made a clear reference to this in his Book II of Meteorology, although he did not point out that this was caused by a change in the apogee of the sun."[24]

Buridan's work contains an interesting bit of information not in Albert: "This also explains the formation of the highest mountains, for within the earth the parts are very irregular, as miners can tell you: some are stony and hard, others are more delicate and powdery. Inas-

TIME

much as these internal parts would appear to rise to the surface of the earth in the indicated manner, those which are delicate and powdery are again carried to the depths of the sea by the wind, rain, and rivers, while the other, harder and stonier parts cannot separate thus and be washed away, and therefore remain and continually, over very long periods of time (*per longissima tempora*), rise because of the general uplifting of the earth, and thus they may become very high mountains. Even if there were no mountains, they could form such with time."[25] At this point Buridan also wrote of the opposite, or volcanic, theory of the origin of mountains: "Some hold that mountains are created by earthquakes, thanks to dry exhalations (*exhalationes*). However, even if this were true of small mountains, it could hardly be true of relatively high ones and the longest ranges, for it is not clear whence they could take such a large quantity of concealed exhalations capable of lifting such a large quantity of land. And even if such a large mass of land were raised, after the dry exhalations had come out, this land would fall back into the hollow left beneath it."[26]

In the theory of Buridan and Albert the role of the "plutonic" factor was reduced to a minimum. Leonardo did not know Buridan's work and read only that of Albert. Nevertheless, passages must be cited from Buridan's work, first to show that Albert was not original (despite what Duhem says) and secondly to show that Buridan himself did not pretend to be absolutely independent and original. He referred directly to his predecessors: "the idea exists" (*est talis imaginatio*).

There can be no doubt that Leonardo read Albert. This is evident not only from the note on the inside cover of Manuscript F ("Albertus On Heavens and Earth, from Fra Bernardino"), but from notes which, if not literal translations of Albert, are at least replicas of his text. For example, Albert wrote "Omne grave tendit deorsum";[27] and Leonardo states, "Every heavy substance tends to descend" (F 84r; MacCurdy 693). However, it is not true that Albert of Saxony was Leonardo's first inspiration in this respect. It has not been demonstrated that he had read Albert before he received the book from Fra Bernardino; yet the theory developed by Albert was known to Leonardo before 1508–1509. As we have just seen, Albert was not the only one to have evolved such a hypothesis. Notes in Manuscript L (1497–1503) and the Leicester Codex (1504–1506) prove that Leonardo knew of the theory

before 1508–1509. In fact, in the Forster Codex III (1490–1493) one may read a statement of the type Duhem considered to be characteristic of Albert's theory: "The desire of every heavy body is that its center may be the center of the earth" (Forst III 66v; MacCurdy 607).

In Manuscript L, Leonardo wrote: "Thus, the land side of the earth becomes the lighter, the more the soil that is carried away from it" (L 13v). He concluded that the region whence rivers carried away soil to the sea became lighter and more distant from the center of gravity of the earth, which always coincides with the center of the world, or the "common center" (L 17r). He also wrote: "The surface of the watery sphere is always more remote from the center of the world. This comes about by reason of the soil brought by the inundations of turbid rivers" (L 13v; MacCurdy 324). As the soil is carried away from the land side of the earth, the land side becomes lighter, and the other side, where the soil is deposited, becomes heavier (L 13v).

Similar thoughts can be found in the Leicester Codex. "That part of the earth which was lightest remained farthest from the center of the world; that part of the earth became the lightest over which the greatest quantity of water flowed. Therefore, that part became lightest where the greatest number of rivers flow, like the Alps which divide Germany and France from Italy, whence issue the Rhone flowing southward and the Rhine to the north, the Danube or Tanoi toward the northeast, and the Po to the east, with innumerable rivers which join them and which always run turbid with the soil carried by them to the sea" (Leic 10r; J. P. Richter 1063).

Duhem's statement that Leonardo da Vinci was merely a dutiful student of and commentator on Albert of Saxony is clearly false.[28] Leonardo's paleontological observations compelled him to study the theories of his predecessors in more detail and, therefore, more critically. Duhem claims just the opposite, namely, that the paleontological data (of which the Parisian scholar did not even dream) was for Leonardo merely a means of proving his "teacher's" theory.[29]

There can be no disputing Duhem's statement that the theory of slow uplifting of the land was not a prevalent one in Italy at the close of the fifteenth century. If the Italian Averroists in the northern universities did bring it up, it was only for purposes of refutation. The very existence of such polemics is evidence that Albert's book on

TIME

heaven and earth was by no means a natural "source of inspiration" for Leonardo.

Leonardo's modifications of the earlier conceptions are substantial. For example, he spoke of the "center of the world" in the quite conventional meaning of the center of "our world" only, that is, just one of the many worlds. He thought of this "center of the world," or "common center" as he sometimes called it, as the center of a sphere of fire embracing the other elements. The common center was fixed, whereas the center of the earth moved inside this fiery sphere, because when "weight is taken from one side of the earth and transported to the other, where there is not so much weight," the center of the earth becomes farther removed from the common center, and "with the new increase of weight," approaches that center. "Thus, with any change in the weight of the waters above their bottom, the position of the center of the earth also changes with respect to the common center" (CA 153v).

Leonardo's interest in this theory is instructive from the viewpoint of his creative activity as a whole and primarily because here we find a reflection of his basic tendency to examine natural phenomena from the standpoint of mechanics. However primitive the theory of the slow migration of continents might have been, it served as a focal point for deliberations on the infinite horizons of geological time.

I have already spoken of the uninhabited landscapes of the remote past, but I must mention the other clear and masterful pictures Leonardo drew in his letters to the Diodar of Syria, in which he describes those same inundations we discussed in connection with his reflections on mountain lakes and the large seas that cut a path for themselves through rock and lowered the level of the water in various parts of the earth's surface. In his letters to the Diodar he describes these inundations in connection with people, for "nature is always the same" and what once happened repeats itself today. One may regard these letters as a kind of illustration, a *dimostrazione,* of a general text, the same kind of demonstration applied to a specific case as the portrait of Helen complaining before the mirror about time, the ravisher of all things.

The letters about Armenia addressed to the "Diodar of Syria, lieutenant of the Sacred Sultan of Babylon" are preserved in the form of rough drafts in the Codex Atlanticus. The word "Diodar" is

assumed to be a corruption of "defterdar" or "devatdar," the title of a high official at the court of the Egyptian Mameluks. The text of these letters led J. P. Richter to propose that Leonardo da Vinci had traveled to the East. In support of his hypothesis he cited the gaps in our biographical information about Leonardo between 1481 and 1487, during which period he could have journeyed to Cilician Armenia and other parts of Asia Minor. However, Richter's theory is not accepted by most researchers. MacCurdy[30] analyzed the data for and against the journey and concluded that there is only one passage, with an accompanying rough sketch, to support the theory, namely: "When I was at sea [sito di mare] in a position equally distant from a level shore and a mountain, the distance to the shore seemed to me to be much greater than the distance to the mountain" (L 77v; MacCurdy 1127).

Actually, the description of Taurus in Leonardo's letter to the Diodar is a literary fiction, although it is based in part on the reports of travelers or on information drawn from the works of ancient authors. In many details it is reminiscent of another, clearly fantastic letter by Leonardo which begins with these words: "Dear Benedetto Dei, to give you the news from the East, you must know that in the month of June there appeared a giant who came from the Libian desert" (CA 311r a; MacCurdy 1053).* The description of this giant provided Leonardo with a vehicle for contrasting ominous forces with the insignificance and helplessness of "unfortunate man," as in the picture of the flood caused by the bursting of water through the Taurus mountains, which we shall examine later.

The giant "was born on Mount Atlas, and was black, and he fought against Artaxerxes, the Egyptians and Arabs, the Medes and Persians; he lived in the sea upon the whales, the great leviathans, and the ships." Leonardo described the giant's appearance thus:

> The black visage at first sight is most horrible and terrifying to look upon, especially the swollen and bloodshot eyes set beneath the awful lowering eyebrows which cause the sky to be overcast and the earth to tremble. And believe me, there is no man so brave but that, when the fiery eyes were turned upon him, he would not willingly have put

* Benedetto Dei, on behalf of the Florentine merchants Portinari, made a trip through France, Holland, and Switzerland in 1476. A diary of his travels has been preserved. For more about him, see Pisani, *Un Avventuriero del quattrocento.*

on wings in order to escape, for the face of infernal Lucifer would seem angelic by comparison. The nose was turned up in a snout with wide nostrils and sticking out of these were quantities of large bristles, beneath which was the arched mouth, with the thick lips, at whose extremities were hairs like those of cats, and the teeth were yellow.

This monster trampled those on foot and those on horseback and kicked them into the air with his feet.

O wretched folk, for you there avail not the impregnable fortresses, nor the lofty walls of your cities, nor the being together in great numbers, nor your houses or palaces! There remains not any place except perhaps the tiny holes and subterranean caverns where after the manner of crabs and crickets and creatures like these you might find safety and a means of escape. Oh, how many wretched mothers and fathers were deprived of their children! How many unhappy women were deprived of their companions! In truth, my dear Benedetto, I do not believe that since the world was created has there been witnessed such lamentation and wailing of people accompanied by so great terror. In truth, the human species in such a plight has need to envy every other race of creatures; for though the eagle has strength sufficient to subdue the other birds, they yet remain unconquered through the rapidity of their flight, and so the swallows through their speed escape becoming the prey of the falcon, and the dolphins also by their swift flight escape becoming the prey of the whales and of the mighty leviathans, but for us wretched mortals, there avails not any flight, since this monster when advancing slowly far exceeds the speed of the swiftest courser" (CA 96v b; MacCurdy 1054).

Then Leonardo begins and abandons further versions one by one. "When the savage giant fell by reason of the ground being covered over with blood and mire, it seemed as though a mountain had fallen, whereat the country shook as though there were an earthquake, with terror to Pluto in Hell; and from the violence of the shock, he lay prostrate on the level ground as though stunned, until suddenly the people believing that he had been killed by some thunderbolt . . ." This unfinished variant did not please Leonardo and he switched to another ending: "And it seemed as though the whole province shook from his fall." Further, "and Mars fearing for his life fled for refuge under the bed of Jupiter . . ." This motive is also abandoned. Leonardo

returns to the image of the giant falling to the ground: "he began to turn about his great beard, they began to run hither and thither like ants, when the trunk of a fallen oak . . ." Only this theme is developed further.

> Like a swarm of ants they range about hither and thither furiously along an oak felled by the axe of a sturdy peasant, so these are hurrying about over his huge limbs and piercing them with frequent wounds. At this the giant being roused and, perceiving himself to be almost covered by the crowd, uttered a roar which seemed as though it were a terrific peal of thunder, and set his hands on the ground and lifted up his awe-inspiring countenance, and then placing one of his hands upon his head, he perceived it to be covered with men sticking to the hairs after the fashion of tiny creatures which are sometimes harbored there and who, as they clung to the hairs and strove to hide among them, were like sailors in a storm who mount the rigging in order to lower the sail and lessen the force of the wind; and at this point he shook his head and sent the men flying through the air after the manner of hail when it is driven by the fury of the winds, and many of these men were found to be killed by those who fell on them like a tempest" (CA 311r a; MacCurdy 1053).

One who tries to find analogies everywhere in Leonardo of course will call to mind Gulliver and the Lilliputians, but it must be remembered that the "Lilliputians" in Leonardo's letter are real people.

The same themes—a tendency toward hyperbole and the despair of humans before an invincible force—can be found in both variants of the description of the Taurus mountains and the flood in Leonardo's letters to the Diodar. Perhaps the only difference is that in the description of the giant the people were viewed with a detached air, as some kind of "small folk," but in his letters to the Diodar they were treated more humanely, as persons overwhelmed by misfortune. But first let us turn to the description of the Taurus.

From Leonardo's notes it is clear that his pictures of both the Taurus and the flood were to be parts of a larger work, a novel of sorts, with the following plan (CA 145r a; MacCurdy 1132).

The Divisions of the Book.

The preaching and persuasion of faith.
The sudden inundation down to its end.

TIME

The ruin of the city.

The death of the people and their despair.

The pursuit of the preacher and his liberation and benevolence.

Description of the cause of this fall of the mountain.

The havoc that it made.

The avalanches of snow.

The finding of the prophet.

His prophecy.

The inundation of the lower parts of western Armenia.

Their drainage through the gorges of Mount Taurus.

How the new prophet showed that this destruction occurred as he had
foretold.

"*Description of Mount Taurus and of the River Euphrates.* Why the mountain shines at its summit half or a third of the night, and seems a comet after sunset to those who dwell in the west, and before sunrise to those who dwell in the east. Why this comet seems variable in shape, so that at one time it is round, at another long, at another divided into two or three parts, at another united, and sometimes invisible and sometimes becoming visible again" (CA 145r a; MacCurdy 1134).

It is easy to see that the themes that are characteristic of Leonardo's geological deliberations recur in this synopsis: floods caused by rock falls, the rush of water through a gorge. The events which Leonardo etched in the remote uninhabited past—the burst of water through the Gonfolina gorge, the formation of the Strait of Gibraltar—are brought into the present, they are "humanized" to the utmost, involving the fate of people.

The relation between the text and the drawings on various pages is interesting. The first page in which Armenia is mentioned (CA 145r a) is written in three columns and the sketch of the mountain peak follows the text. The second page (CA 145v a) is written in two columns, of which the right one is the plan of the book and the one on the left is the first letter to the Diodar; the sketch was made first in this case. On the third page (CA 145v b) the sketch was also made first, but the text is written more freely and in a bolder hand, across the whole page, and farther down it runs above the sketch.[31]

The letter to the Diodar (CA 145v a; MacCurdy 1133) begins: "The recent unforeseen event that has occurred in these our northern parts

which I am certain will strike terror not only into you but into the whole world shall be revealed to you in its due order, showing first the effect and then the cause." That "event" was the glowing of Mount Taurus, which the inhabitants of Syria took to be the glow of a comet. The "cause" was the mountain itself, through which mountain waters burst. Leonardo undertook to explain the cause of the unusual illumination. He moved on from Syria to Armenia: "Finding myself in this part of Armenia in order to discharge with devotion and care the duties of that office to which you have appointed me, and making a beginning in those parts which seem to me to be most suitable for our purpose, I entered into the city of Calindra which is near to our borders. This city is situated at the foot of that part of the Taurus range which is separated from the Euphrates and looks westward to the peaks of the great Mount Taurus."

There follows a description of the peaks of the Great Taurus visible in the distance. "These peaks are of such a height that they seem to touch the sky, for in the whole world there is no part of the earth that is higher than their summit, and they are always struck by the rays of the sun in the east for four hours before day. And being of exceedingly white stone, this shines brightly and performs the same office for the Armenians of these parts as the beautiful light of the moon would in the midst of the darkness; and by reason of its great height it outstretches the highest level of the clouds for a space of four miles in a straight line. This peak is visible from many places in the west, illuminated by the sun from sunrise through a third part of the night. And it is this which among you in calm weather has formerly been thought to be a comet."

Leonardo attempts to describe the changing features of the distant mountain with an accuracy on a level with his notes on optics. "In the darkness of the night it seems to us to assume various shapes, some-times dividing into two or three parts, sometimes long and sometimes short. This takes place because of the clouds on the horizon situated between part of the mountain and the sun, and intersecting the path of these solar rays; the light of the mountain is broken by clouds at various distances and therefore its brightness is variable in shape" (CA 145v a; MacCurdy 1133, 1134).

On the next page there is a new, more detailed variant of the letter, prefaced by two drafts of the introduction: "I am not justly to

TIME

be accused, O Diodar . . ." "Do not distress yourself, O Diodar . . ." Again he speaks of the causes of "so momentous and startling an occurrence."

"It is this Mount Taurus which, according to many, is said to be the ridge of the Caucasus," writes Leonardo, "but, wishing to be quite clear about this, I set myself to interrogate some of the inhabitants of the shores of the Caspian Sea; they inform me that although their mountains bear the same name, these are of greater height, and they confirm this therefore to be the true Mount Caucasus, since Caucasus in the Sythian tongue means 'supereme height.' And, in fact, nothing is known of the existence either in the east or the west of any mountain of so great a height, and the proof of this is that the inhabitants of those countries which are on the west see the sun's rays illuminating part of its summit for a fourth part of the longest night, and similarly with the countries which are on the east."

Next comes a description of Mount Taurus from nearby, again in hyperbolic fantastic tones, along with specific details of the mountain zones, reminiscent of a passage in the Treatise on Painting. "The shadow of this ridge of the Taurus is so high that in the middle of June when the sun is at the meridian, it reaches to the borders of Sarmatia, which are twelve days' journey, and in mid-December it extends as far as the Hyperborean Mountains, which are a month's journey to the north. And the side that faces the way the wind blows is full of clouds and mists, because the wind which is cleft in twain as it strikes against the rock and closes up again beyond it, carries with it in this way the clouds from all parts and leaves them where it strikes, and it is always full of thunderbolts through the great number of clouds which are gathered there, and this causes the rock to be all fissured and filled with huge debris" (CA 145v b; MacCurdy 1134, 1135).

How reminiscent these words are of the passage in the Treatise on Painting, where the description becomes an instruction: "In many places let rocks be seen hanging over the gorges of high mountains, clothed with thin and pale corrosion, and in some places let them show their true color revealed by the flash of bolts of lightning from the sky, bolts which have been stopped by those rocks and not without revenge in the way of damage" (TP 806; MacMahon 839). One is also reminded inadvertently of the lightning Leonardo saw strike

LEONARDO DA VINCI

"in the rocks of the high Apennines and especially in the rock of La Vernia" (E 1r; MacCurdy 389).

Leonardo draws in even closer to the mountain, ascending the individual peaks, as it were, moving upward from the populous lowlands.

> The mountain at its base is inhabited by a very opulent people; it abounds in most beautiful springs and rivers; it is fertile and teems with everything that is good, and especially in the south. After an ascent of about three miles, you come to where the forests of great firs and pines and beeches and other such trees begin; beyond for a space of another three miles you find meadows and vast pastures, and all the rest as far as the beginning of the peak of Taurus is eternal snow, for this never disappears in any season, and it extends at this height for about fourteen miles in all, counting from the foot of the mountain. Around this peak, at a height of one mile, there are always clouds. Thus, we have fifteen miles of height vertically. As far beyond or thereabouts we find the summit of the peaks of Taurus, and here from about half way upward we commence to find the air grow cold, and there is no breath of wind to be felt and nothing can live there very long. Nothing is brought forth there except some birds of prey, which nest in the deep gorges of the Taurus and descend below the clouds to seek their prey upon the mountain meadows. It is all bare rock from above where the clouds are, and the rock is of a dazzling whiteness, and it is not possible to go to the lofty summit because of the steep and dangerous ascent (CA 145v b; MacCurdy 1135).

In western Europe, Leonardo was the first to climb mountains for scientific purposes. As a painter he was exceptionally sensitive to the beauty of a mountain landscape.[32]

The hyperbolic description of Mount Taurus is supplemented by an equally hyperbolic description of the destructive flood.

> In these past days I have had so many anxieties, so many fears, dangers, and losses, as have also the wretched country folk, that we have come to envy the dead. And certainly I, for my part, cannot imagine that since first the elements by their separation made order out of chaos, they can ever have united their force or rather their frenzy to work such destruction to mankind . . . First, we were assailed and buffeted by the might and fury of the winds, and then followed

the avalanches from the great snow-covered mountains which have choked up all these valleys, and caused a great part of this city to fall in ruins. And, not content with this, the tempest has submerged with a sudden deluge of water all the lower parts of the city; and beyond all this there was added a sudden storm of rain and a furious hurricane, laden with water, sand, mud, and stones all mingled together with roots, branches, and stumps of various trees; and every kind of thing came hurtling through the air and descended upon us, and finally a great fire—which did not seem to be borne by the wind, but as though carried by thirty thousand devils—has burnt up and destroyed all this country and has not yet ceased. And the few of us who remain are left in such a state of dismay and fear that, like those who are half-witted, we scarce dare to hold speech one with another, but giving up even the attempt at work we stay huddled together in the ruins of some of the churches, men and women small and great all mingled together like herds of goats, and but for certain people having helped us with provisions, we should all have died of hunger. Now you can understand the state we are in; and yet all these evils are as nothing by comparison with those which threaten us in the near future" (CA 214v d; MacCurdy 1138).

Let us return to the Buridan-Albert theory of the slow uplifting of the land. Both these philosophers[33] held that the uplifting increased as the mountains were reduced by erosion, and even if the world were to exist forever, these processes would continue "to the benefit of animals and plants."[34] It would be otherwise, they both assumed, if the center of gravity did not differ from the center of magnitude. Then there would not be the slow lifting of the land, and the process would be unilateral. If it is to be assumed, following Aristotle, that the world has always been, by now all the heights would have been leveled. The earth would be covered with water. "The higher parts keep moving in increasing amount from the mountains into the valleys, but nothing or very little moves upward; thus, in infinite time, these mountains *ought to have been* (*deberent*) completely destroyed and have become level with the valleys." The particles of earth carried away by the rivers "do not return from the depths of the sea to the land, and what rises from the sea by evaporation or transformation is merely a fine watery mist and not coarse earth. Hence it is clear that in infinite time the whole ocean depth *ought to have* (*deberet*) filled

LEONARDO DA VINCI

with earth and this uplifting of the land *ought to have* (*deberet*) ceased. Thus, water by nature *ought to have* (*deberet*) surrounded the entire earth and *no* highlands *ought to have* (*nec deberent*) been left exposed."[35] A similar statement can be found in Albert of Saxony:[36] "All that is heavy is drawn downward and cannot remain at a height forever, that is why the entire earth *ought* already *to have become* (*iam esset*) spherical and covered with water everywhere."*

There are scattered notes in Leonardo's works that are very similar to the ones just cited. However, he replaces the subjunctive mood with the indicative for some reason, and he uses the future tense. "Every heavy substance tends to descend, and the lofty things will not retain their height but with time they will all descend, and thus in time the earth will become a sphere and, as a consequence, will be completely covered with water." Then he emphasizes that "the underground channels will remain without movement" (F 84r; MacCurdy 693). "The deep recesses of the ocean bed are everlasting, the summits of the mountains are the contrary; it follows that the earth will become spherical and all covered with water and that it will be uninhabitable" (F 52v; MacCurdy 684).

Was Leonardo speaking from conviction, or did he merely note one of the possibilities which required thoughtful study? Perhaps he did not grasp the meaning of the subjunctive in the source. Whatever the case, it is quite certain that he sorted through various possibilities, experimenting mentally, sketching various pictures of the end of the earth. This type of "eschatological mental experiment" appears in the text sketching another possible end of the world, namely, burning by the sun.

> The watery element remaining pent up within the raised banks of the rivers and the shores of the sea, it will come to pass with the upheaval of the earth that as the encircling air has to bind and circumscribe the complicated structure of the earth, its mass, which was between the water and the fiery element, will be left straitly compassed about and deprived of the necessary supply of water. The rivers will remain without their waters; the fertile earth will put forth no more her budding branches; the fields will be decked no more with waving corn. All the animals will perish, failing to find fresh grass for fodder, and

* I have placed the occurrences of the subjunctive mood in italics.

the ravening lions and wolves and other beasts which live by prey will lack sustenance, and it will come about after many desperate shifts that men will be forced to abandon their life and the human race will cease to be. And in this way the fertile fruitful earth being deserted will be left arid and sterile, and through the pent up moisture of the earth enclosed within its womb and the activity of its nature, it will follow in part its law of growth until having passed through the cold and rarefied air it will be forced to end its course in the element of fire. Then the surface of it will remain burnt to a cinder, and this will be the end of all terrestrial nature" (BM 155v; MacCurdy 74).

But no matter how Leonardo pictured the end of the world, as Gantner aptly pointed out,[37] for him the "end of the world was the physical end, not the divine end, actual destruction, not the judgment of good and evil." One might add that for Leonardo even the initial dissymmetry of the world was not based on theological and teleological motivation, in contrast, for example, to Albert of Saxony, for whom "the unequal distribution of the weight of the earth was established ages ago by God for the benefit of animals and plants" (*et hoc propter difformitatem ab eterno Deus ordinavit pro salute animalium et plantarum*).[38]

In Leonardo's opinion, "movement is the cause of all life" (H 141r; MacCurdy 72). But what did he understand by movement? To answer this question, let us compare Leonardo with Aristotle. For the great Greek scientist, force was the source of movement: a special cause, a special force, was required to keep a body in any state of motion (including steady movement in a straight line). Thus, for Aristotle motion was less natural than rest, and he knew only the first half of the law of inertia: in absence of force, a body is at rest. The Greek atomists admitted the possibility of eternal movement of atoms, but even this concept cannot be compared unreservedly to the later concept of inertia. Emile Meyerson commented that "nowhere, neither among the atomist philosophers nor even in general among the ancient authors, is there a hint of the idea of indefinitely prolonged movement along a straight line as a result of an impulse received, without a constantly acting force. Probably the ancient atomist would have explained the continuous movement of particles by saying that they fall or move because of an internal force inherent in them."[39]

LEONARDO DA VINCI

Even if this statement were not true and if we were to admit that "Democritus was close to the discovery of the law of inertia, inasmuch as he attributed to atoms the capacity for mechanical 'self-propulsion' and assumed that atoms maintain their own motion of themselves, without the aid of external forces,"[40] we still must remember that the ideas of the Greek atomists did not exert and could not have exerted any tangible influence on Leonardo, whose thinking developed in an atmosphere of traditional Aristotelian ideas, but followed a course of critical refutation of them.

Strictly speaking, the law of inertia can only be considered where both rest and steady movement in a straight line are regarded equally as states that do not require a special reason for their preservation, where a reason is sought only for a change in the motion, a change in its direction or velocity. In Newtonian mechanics this cause was force, in contrast with Aristotelian mechanics, where force is the cause of the motion itself, not of its change.

At times it has been held (without sufficient grounds) that the law of inertia is to be found in the theory of impetus and appears in Leonardo's statements about what he called *impeto*. This theory is based on the following line of thought. If, as Aristotle thought, any motion (even steady movement in a straight line) presumes an external force acting directly on the body, then how can a thrown object (mobile), in breaking away from its source, maintain its movement when not moving vertically downward to its "natural place"? Aristotle and some of his followers sought the answer in the properties of the medium: the air surrounding the mobile maintains the initial movement even when the source of this movement is already at rest. It is not difficult to see that this does not solve the problem but averts it, for it does not explain how the air maintains the imparted motion. The theory of impetus was created in the search for an answer. It was first developed in an advanced form by the Alexandrian John Philoponus (sixth century), was subsequently adopted by Eastern science, and later was assimilated and developed by the Parisian nominalists of the fourteenth century (Jean Buridan and Albert of Saxony, Marsilius of Inghen, and so forth).* According to this theory, a mobile impresses

* Some scholars have assumed that the impetus theory first appeared in Latin literature of the Middle Ages, in Peter John Olivi (1248/49–1298), but this is not true. See Maier, *Zwei Grundprobleme,* pp. 142–143.

in itself a certain amount of "motive force," which continues to move it for a certain time until that force is exhausted and spent. Clearly the theory of impetus does not differ in principle from Aristotle's theory; in it, too, some cause, some force, is required to maintain the movement, and without it there is no movement.[41]

Many of Leonardo's statements in which researchers attempt to find an anticipation of the law of inertia can be explained by the theory of impetus, the doctrine that a "motive force" that decreases in proportion to the motion is imparted to a body.[42] For example, Leonardo said: "Every movement tends to maintain itself," but he immediately added words which preclude any hint of the law of inertia: "or rather every moving body continues to move so long as the impression of the force of its mover is retained in it" (VU 13r; MacCurdy 413). The same thing is said in another passage: "Every body will follow its path in a straight line as long as the nature of the motive force that set it in motion persists in it" (CA 109v b; Reynal 209). "Universally all things desire to maintain themselves in their natural state. So moving water strives to maintain the course pursuant to the power which occasions it" (A 60r; MacCurdy 660). He applies his statement "everything naturally desires to remain in its own state" unexpectedly to such a phenomenon as the distribution of folds of cloth, pointing out that cloth "desires to lie flat" (BN 2038 4r; MacCurdy 858).

Leonardo's attacks on the pursuers of perpetual motion should also be interpreted from the viewpoint of the impetus (*impeto*) theory. For example, take the statement: "*Against perpetual motion.* No inanimate object will move of its own accord; consequently, when in motion it will be moved by unequal power, unequal, that is, in its time and velocity, or unequal in weight; and when the impulse of the first motive power ceases, the second will cease abruptly" (A 22v; MacCurdy 518).

The following passage comes closest to the law of inertia: "Every object that is situated on a hard and smooth surface such that its axis is not between portions that are equal in weight will never stop [*mai si fermerà*]. An example can be seen in those who skate, they never stop if [their] parts are at unequal distances from the center" (A 21v). In this passage, as in another which treats of the movement of a spherical body along a surface (CA 246r a), the stress is not placed on the continuation of the action but on the conditions under which it occurs:

LEONARDO DA VINCI

while parts are asymmetric to the axis or center, it must continue and never stop. Of course, in this case Leonardo neglects any action of the surrounding bodies, but does he also depart from the concept of impetus, from the concept of "motive force"? This is not clear because the fragment does not specify whether the motion would continue without the "motive" or "impressed" force. It suffices to recall that even Galileo, in analyzing a quite similar case, speaks of bodies which "have the tendency, in the absence of all chance and external obstacles, to move constantly and steadily once the impulse (*impeto*) has been received."[43] Finally, let us note that Leonardo was not speaking of some general property of bodies, but of the characteristic inherent only in spherical bodies, as did Nicholas of Cusa, who, in his work *De ludo globi* (On playing with a ball), associated constancy of movement with the sphericity (*rotunditas*) of a body. Thus, in Leonardo's mechanics rest is not a special case of motion. On the contrary, things move only when their peace, their "nature," is disturbed. Life and motion are the result of departure from the only natural state, rest. Everything put out of equilibrium strives to return to it, and as long as equilibrium is disturbed, there is life and striving which, in the final analysis, is a striving toward its own destruction. It is no mere chance that Leonardo always spoke in an elevated style about the impossibility of perpetual motion. This was not merely scorn for this widespread charlatanism or for the pursuit of technological fancies. He sensed the philosophical universality of this impossibility. There is no such thing as perpetual motion, but there may be perpetual rest. For Leonardo, even the earth's "history" (and he could be considered the father of this science) was essentially a constant change of all these processes, a constant shifting of land and sea, until a final equilibrium would be attained and everything would be covered with water.

Let us cite one more passage: "Truth alone is the daughter of time" (M 58v; MacCurdy 72). This is taken from Aulus Gellius' *Attic Nights*,[44] but with a slight and characteristic difference. Gellius said simply: "Truth is the daughter of time." For Leonardo it was the only daughter. Everything else was lost in the incessant flow of changing events.

Now let us examine the problems of time from another point of view, from the standpoint of art. The thought of time, the destroyer of all things, that is, the idea of the unconsciousness of natural life, frightened Leonardo. That is why he placed painting at the highest

TIME

level, for "that is more noble which has longer life" (TP 31 b; Mc-Mahon 26). The "marvelous science of painting" preserves alive the "ephemeral beauty of mortals" and creates things which are more permanent than the creations of nature, "which vary continually with time, leading to expected old age" (TP 29; McMahon 39). In this sense, the creation of the painter is "of greater value" than that of "nature, his teacher" (TP 30; McMahon 43). The artist "preserves beauties which time and nature make fugitive" (TP 31 b; McMahon 26).

In what sense should we understand eternity (*eternità*)? Leonardo indicated that it was not just a matter of the material being eternal. The coppersmith's product is more enduring than that of a poet or a painter (TP 19). The sculptor need not fear dampness, flame, fire, or cold, as does the painter, but "this does not make the sculptor more worthy, because this permanence [*permanentia*] comes from the material and not from the artist" (TP 37; McMahon 56). The same applies to the coppersmith's product.

True, Leonardo did not want to yield to the sculptor even on this point. On several occasions he pointed out that "painting, by using enamel colors on copper, can be made much more enduring" (TP 19; McMahon 30), painting "with the aid of enamel becomes eternal" (TP 731). Once, in this connection, he glorified the works of the Della Robbia: "The same kind of permanence can also be found in painting when it is done in enamel on metals, or terracottas, which are fired in a furnace and then polished with various instruments that give a smooth and lustrous surface. These can be seen in several places in France and Italy, and most of all in Florence among the della Robbia family, who have discovered a way to carry out every kind of great work in painting on terracotta covered with glaze. It is true that this sort of painting is subject to knocks and breaks, as is also sculpture in marble, but not to destruction by melting, as are figures in bronze. With regard to durability, it is equal to sculpture and surpasses it with regard to beauty, since in it are combined the two perspectives [natural and artificial], but in sculpture in the round there is no perspective except that found in nature" (TP 37; McMahon 56).

It is quite obvious that an argument based on the durability of material is to no purpose. Leonardo could have recalled his own unsuccessful experiments with paints, the *Battle of Anghiari* and the

Last Supper. If he was not thinking of durability of materials, what did he have in mind? In answering his opponents, Leonardo simply lapsed into their arguments, pointing out that the coppersmith has little "imagination," the sculptor has little "science," and so forth.

Let us turn to what Leonardo wrote of the "sister of painting," music, to analyze this question. We know that he played beautifully on the lyra and that he taught this art to Atalante Migliorotti. Anonimo Fiorentino states that "he was thirty years old when Lorenzo il Magnifico sent him to the Duke of Milan accompanied by Atalante Migliorotti to present him with a lyra, as he was unsurpassed in playing this instrument."[45] Vasari tells us that Leonardo took with him to Milan "that instrument which he had made with his own hands, in great part of silver, in the form of a horse's skull, a thing bizarre and new, in order that the harmony might be of greater volume and more sonorous in tone, with which he surpassed all the musicians who had come together there to play."[46] According to Paolo Giovio, Leonardo sang skillfully to the accompaniment of the lyra.[47] Lomazzo, in his peculiar high-flown, panegyric tones, wrote: "the Florentine Leonardo da Vinci, painter, sculptor, and modeler, the most experienced in all seven of the free arts, a player of such excellence on the lyra that he surpassed all the musicians of his time, a most elegant poet, who left many manuscript books on mathematics and painting."[48] Thus, no one can suspect Leonardo of being amusical or antimusical.

What led him to place music below painting? The fluidity of form, the greater dependence on time, the lesser "durability." The sense of hearing "is less worthy than that of the eye," because "as soon as harmony, which pleases the ear, is born it dies, and its death is as rapid as its birth" (TP 23; McMahon 42). "Therefore music, which is ended as soon as it is born, is less worthy than painting which becomes everlasting [*eterna*] when glazed" (TP 31 b; McMahon 26). "Painting excels and lords it over music, because it does not die immediately after its creation, as does unfortunate music" (TP 29; McMahon 39). "Music has two ills," wrote Leonardo, "the one mortal, the other wasting; the mortal is ever allied with the instant which follows that of the music's utterance, the wasting lies in its repetition, making it seem contemptible and mean" (CA 382v a; MacCurdy 1052).

Music and poetry portray an object in parts, painting shows its parts together, simultaneously (*a un medesimo tempo*). In poetry it is as if

TIME

"we wished to show a face part by part, continually covering up the parts already shown. This would be an exhibition in which forgetfulness would disallow any harmonious proportion to be composed, because the eye would not embrace the parts all at the same time with its visual power" (TP 21; McMahon 40). The poet "does not realize that his words, mentioning the parts of the beauty, are divided by time, one from another. Forgetfulness intervenes and divides the proportion into its elements, but since the poet is unable to name it, he cannot compose its harmonious proportion, which is derived from divine proportion. The poet cannot describe a beauty in words during the time which is taken up by reflection on the beauty in painting" (TP 23; McMahon 42). The poet acts as though "a beautiful face were revealed to him part by part." "But when he does so, you will never be satisfied with its beauty, which alone consists in the divine proportion of those features assembled together. Only at one and the same time [*in un tempo*] do they compose that divine harmony from a commingling of features" (TP 32; McMahon 41).

Leonardo delivered the following rebuke to the poet from the lips of King Mathias Corvinus: "Your work does not content the mind of the hearer or observer as does the proportion of most beautiful features, composing the divine beauties of this face before me, which, shown to me as a whole, at the same time [*in un medesimo tempo*], give me so much pleasure with their divine proportion that I judge there is nothing on earth made by man that could please me more" (TP 27; McMahon 28).

Leonardo did not tire of repeating this contrast between the simultaneous and the sequential, always returning to the comparison with a body viewed in parts. "There is the same difference between the representation of bodily things by the painter and by the poet, as between dismembered and whole bodies. The poet, in describing the beauty or ugliness of a body, will describe it to you part by part and at different times, but the painter will make you see it all at the same time [*in un tempo*]. The poet cannot give you in words the true shape of the parts of which the whole is composed, as can the painter, who places it before you with the same truthfulness that is in nature" (TP 32; McMahon 41).

In music such "examination by parts" has its specific features. In contrast to poetry, music may have simultaneous harmonic consonance.

LEONARDO DA VINCI

In this respect music is closer to painting, and therefore Leonardo called it the "sister of painting" (TP 29). As in painting, "A harmonious proportion results. For example, many different voices joined together at one time [*in un medesimo tempo*] result in a harmonious proportion which so delights the sense of hearing that those who hear it remain stupefied with admiration" (TP 21; McMahon 40). "Music is to be termed the sister of painting, for it is subject to the sense of hearing, a sense second to the eye. It composes harmony with the conjunction of proportioned parts sounded at the same time [*nel medesimo tempo*]. It is obliged to be born and to die in one or a number of tiny intervals of time* that surround the proportion of its parts and create a harmony which is not composed otherwise than is the line which surrounds the forms from which human beauty is derived. But painting excels and lords it over music, because it does not die immediately after its creation, as does unfortunate music" (TP 29; McMahon 39).

"Painting presents its essence in an instant [*in un subito*] to the power of sight. The eye reports with utmost truthfulness the true surfaces and shapes of that which is presented to it. From this arises proportion, called harmony, which with sweet accord pleases the sense of sight just as the proportion of different voices pleases the sense of hearing, which is still less worthy than that of the eye, because as soon as harmony, which pleases the ear, is born it dies, and its death is as rapid as its birth. This cannot happen with the sense of vision, since, if you represent to the eye a human beauty composed of proportioned, beautiful parts, those beauties are not so mortal nor will they disappear so rapidly as music. A painting has great permanence [*lunga permanenza*] and it allows you to see and consider it. It is not reborn as music is, when the playing is repeated" (TP 23; McMahon 42).

Poetry does not possess any of that simultaneous harmony possessed by painting and in part by music. Indeed, "harmony is not born other-

* As a rule, the translators of this passage have not taken into consideration the true meaning of Leonardo's *tempi armonici*. Richter translates them as "harmonic rhythms"; Ludwig, as "einklingende Zeitmasse (oder Accorde)," harmonic measures, or accords; Volynskii, as "akkordy," accords or chords, as does Seidlitz; Guber translates them as "garmonicheskie ritmy," harmonic rhythms. Actually, Leonardo had in mind "musical foot," the "chronos protos" of the ancient music theorists, that is, the smallest unit of calculation. Compare "water . . . will move ¼ braccio per unit time" (in a musical foot, *tempo musicale*) (TA 54r). Or "during every harmonic or, as you may say, musical division of time (*tempo armonico o musicale*), the heart makes three movements, as is contained below, of which tempos an hour contains one thousand and eighty" (W An II 11r; MacCurdy 168). The division of the hour into 1080 parts was commonplace in ancient calendar calculations.

TIME

wise than instantaneously, when the proportions of things become visible or audible." "Do you not see," Leonardo continues, addressing the poet, "that in your science there is no proportion created at any given moment, but that one part is born of another in succession, and the next one is not born until the preceding one dies?" (TP 27; McMahon 28). The same thing happens to the poet as to the musician who sings alone a song composed for four singers singing first the soprano, then the tenor, continuing with the contralto, and finally the bass part. From this performance there results no grace of harmonious proportion contained within the musical feet [*tempi armonici*]" (TP 32; McMahon 41). Within the limits of its harmonic foot, music creates pleasant sounds (*melodie*) from the combination of various voices, but the poet does not command these melodies, owing to their harmonic separation (*discretione armonica*) (TP 32). "Poetry produces no comparable grace, for it has to combine the representation of perfect beauty with the representation of each particular part of which, in painting, the harmony just mentioned is composed. It is as though in music one were made to hear each voice separately at a different time, and from this no accord could be composed" (TP 21; McMahon 40).

I felt it imperative to separate the statements cited above, which are sometimes repetitive, from the passages on the "debate of the arts," for Leonardo's thoughts on simultaneity and succession were interwoven with many others, without a strict system or sequence. Now, having "dissected" and "prepared" the texts, let us go more deeply into their meaning.

When Leonardo spoke of musical harmony as the simultaneous sounding of several tones, he spoke as the child of the new age, or, to be more exact, as its forerunner. The ancients did not think of chords in the sense of simultaneous production of sounds. The main object of ancient harmonics was the question of structure, that is, the laws governing the succession of sounds, not the harmonious or non-harmonious combination of tones.

On one occasion Leonardo also spoke of this type of "harmony," curiously enough in connection with a general discussion of the subject. "Every impression [*impressione*] is preserved for a time in its sensor." "The ear, which indeed, unless it preserved the impression of the notes, could never derive pleasure from hearing a voice alone, for when it passes immediately from the first to the fifth note, the effect is

as though one heard these two notes at the same time, and thus perceived the true harmony which the first makes with the fifth, but if the impression of the first note did not remain in the ear for an appreciable space of time, the fifth, which follows immediately after the first, would seem alone, and one note cannot create any harmony, and consequently any song whatsoever occurring alone would seem to be devoid of charm." The eye creates a similar illusion of continuity ("as if simultaneous") in certain cases. "So, too, the radiance of the sun or other luminous body remains in the eye for some time after it has been seen, as the motion of a single firebrand whirled rapidly in a circle seems one continuous and uniform flame. The fine drops of rain water seem continuous threads descending from their clouds" (CA 360r a; MacCurdy 575).

Leonardo compared the arts from the standpoint of time categories, according to the concepts of duration, simultaneity, instantaneousness, and so forth. Is this aspect as substantial as he thought? We have just noted the possibility of a "pseudo-simultaneity" that is as real as simultaneity. Further, a painting is not instantaneous and, therefore, is a static photograph of reality. One need but remember the movements which Leonardo tried to convey in his paintings of the battle and the flood. Again, Leonardo the naturalist concentrated his attention on processes, not movements. If "the body of every feeding thing continually dies and is continually reborn," how can that art be "most noble" which can engrave only a single moment?

Luporini remarked quite correctly that the frenzied, galloping horseman in the sketch for the *Battle of Anghiari* (W 12340) "is not *instantaneousness,* but something that displays itself in an interval of objective time." He holds that Leonardo depicts time "not as an abstract or subjective *duration,* but as a flow, a succession, and a variation (*decorso, successione e variazione*)."[49]

The answer can only be that for Leonardo the essence of the problem and its solution lie not in simultaneity and succession as such, but in the extent to which the different relations between the parts of the whole are included. Leonardo said that one might compare the techniques of poetry and music as portraying the human face in parts. Harmony is possible in music, that is, some parts, some voices, can be demonstrated together. This is not possible in poetry. Even in music, however, some harmonious combinations are replaced by others, and the relation between the parts is never given all together. Thus, it is

TIME

not a matter of depicting an object simultaneously, but of stretching a whole network of relations between the various elements, of seeing all those relations at once. Poetry and music are engulfed in movement, painting comprehends this movement. The essence lies not in the instantaneous nature of the object depicted, not in fixing the instantaneous, but in capturing simultaneously that which is changing and moving. Therefore, Leonardo's comparisons are far removed from those made later by Gotthold Lessing in his *Laocoön*,[50] namely, "from the eternally changing reality, the artist can take only one moment, and the painter can take that one moment only from one point of view"; "the painter, in his works, where everything is presented simultaneously, can depict only one moment of action and therefore must choose the most fruitful, from which both the preceding and the subsequent will become most comprehensible."

Two passages in the Treatise on Painting are very enlightening in this respect. As we know, Aristotle drew a sharp distinction between mathematics and physics, on the grounds that mathematics abstracts itself from motion. For example, geometry examines bodies only as volumes and not as moving volumes. Therefore, Aristotle relegates motion entirely to the realm of physics.* In speaking of philosophy, with "natural philosophy" in mind, that is, physics in the broad Aristotelian sense of the general study of nature, Leonardo stated that painting is philosophy because it "treats of the motion of bodies in the rapidity of their actions (McMahon 8), and motion is also a subject of philosophy" (TP 9). Therefore, painting, or a painting, treats of motion, although it is not motion itself. It is curious and instructive that the perspectual reduction of objects at various distances from the eye and the laws of aerial perspective were regarded by Leonardo as a kind of "motion," as static data in a painting. "Painting includes only the surface of bodies, and the perspective of painting includes the increase and the decrease [*accrescimento e decrescimento*] of the size and colors of bodies. An object that is moved away from the eye loses as much size and color as it gains distance. Painting is therefore philosophy because philosophy treats of the increase and decrease of motion [*moto aumentativo e diminutivo*]" (TP 9; McMahon 8).

* See Aristotle, *Physics*, 2.2.193b: mathematics "produces abstraction, because figures may be separated mentally from motion"; *Metaphysics*, 1.8.989b: "The objects of mathematics, except those of astronomy, are of the class of things without movement." See also *De motu animalium*, 1.698a: "nothing from mathematics moves."

LEONARDO DA VINCI

*35. Detail from the vaulted ceiling of the Sala d'Asse
in the Castello Sforzesco, Milan*

Painting includes various moments simultaneously and does not snatch one moment from the stream of life. For Leonardo this constitutes the superiority of painting. Painting simultaneously embraces the most complex combination of relations between phenomena. Is this not the very concept of diversity of intertwining relations that Leonardo, "the man of the eye," chose to express in his beloved knotted and winding cords? Vasari says: "He even went so far as to waste his time in drawing knots of cords, made according to an order, so that from one end all the rest might follow the other to fill a round; and one of these is to be seen in the form of an engraving, most difficult and beautiful and in the middle of it are these words, 'Leonardus Vinci Accademia.' "[51] One might also mention the decoration on the ceiling in the Sala d'Asse of the Castello Sforzesco (figure 35).[52] Recently Brion treated these intertwining and "labyrinthal" motives in order to associate them with some sort of "esoteric philosophy,"[53] but his discussions seem to show all too evidently the traces of reading Joyce and therefore are unconvincing. Fumagalli also raised some well-founded objections to this interpretation.[54]

TIME

In summarizing, let us say again that "simultaneity" (*in un tempo, un medesimo tempo, in un subito*) is not a moment of existence snatched from the stream of time, but presumes a "before" and an "after"; it presumes time to be a form of comprehension of animate, flowing life. Life is possible only where there is a "before" and an "after" and a connection between the two. Therefore, time is not only a "destroyer of things," but a prerequisite for their true existence.

7.

HOMO FABER

"Dove la natura finisce di produrre sue spezie, l'omo quivi comincia colle cose naturali di fare, coll'aiutorio d'essa natura, infinite spezie."

"Where nature finishes producing its species, there man begins with natural things to make with the aid of this nature an infinite number of species."
 W An B 13v; MacCurdy 121

IN LEONARDO'S NOTEBOOKS and especially in the Treatise on Painting much space is devoted to a comparison of the arts, *paragone,* or the argument concerning the superiority of one art over another. As we have just discovered, one must learn how to read such notes. If we approach Leonardo's *paragone* in this manner, if we seek in Leonardo the answer to the question of the "superiority" or the "nobility" of one art compared with the others, the fragments give the impression of paradoxes or sophisms. Indeed, Croce referred to Leonardo's arguments in *paragone* as "contrivances and childishness, unworthy of the mind of Leonardo" (*sottigliezze e puerilita, non degna della mente di Leonardo*).[1]

Let us try to prove the point with another example. What is the value of the following comparison between the sculptor and the painter, based on a description of their working conditions? The sculptor works by the sweat of his brow in dust and dirt, while the painter sits at ease before his work in clean attractive clothing. The argument is so picturesque that it should be given in full. "The sculptor pursues his work with greater physical labor than the painter and the painter pursues his work with greater mental labor. This proved to be true, for the sculptor in producing his work does so by the force of his arm, striking the marble or other stone to remove the covering beyond the figure enclosed within it. This is a most mechanical exercise [*esercitio meccanicissimo*] accompanied many times with a great deal of sweat, which combines with dust and turns into mud. The sculptor's face is

HOMO FABER

covered with paste and all powdered with marble dust, so that he looks like a baker, and he is covered with minute chips, so that he looks as though he had been out in the snow. His house is dirty and filled with chips and dust of stones" (TP 36; McMahon 51). The painter is the exact opposite. "For the painter sits at great ease in front of his work, and moves a very light brush, which bears enchanting colors, and he is adorned with such garments as he pleases. His dwelling is full of fine paintings and is clean and often filled with music or the sound of different beautiful works being read, which are often heard with great pleasure, unmixed with the pounding of hammers or other noises" (TP 36; McMahon 51).

Leonardo would seem to have forgotten his own "unskilled" labor with paints and the working conditions in the studios of the master craftsmen. What is more, he appears to have forgotten his own words that "mechanics," practical accomplishment, is the "paradise of the mathematical sciences." According to Leonardo, the imperfection of sculpture is that it is "the most mechanical exercise." Thus, it would appear that he holds to the old comparison between the mechanical and the noble arts: painting is more noble because it is less mechanical. This is all the more strange because he perceived the "mechanical" element, "manual labor," in all the arts, without exception, seeing nothing wrong in it. "If you say that such exact and known sciences are of the mechanical sort, for they cannot achieve their ends except manually [*manualmente*], I shall say the same of all the arts that go through the hands of writers, who are designers of a sort, and design is a part of painting. Astronomy and the other sciences proceed by means of manual activities [*manuali operationi*]." That is why painting, too, "cannot attain perfection without manual participation [*operazione manuale*]." From the painting, "which is in the mind of him who reflects on it" comes the "participation [*perazione*] which is of much more value than the reflection or science just mentioned" (TP 33; McMahon 19).

Much will become clear if we retain our historical perspective and regard Leonardo's notes as a preparation for disputes at court, a kind of verbal tournament. Luporini[2] was quite correct when he remarked that the picture of the painter given in this fragment is the ideal portrayal of a court painter, who differs substantially from the painter of the traditional botteghi.

It should also be mentioned that in an earlier period the scientific

LEONARDO DA VINCI

treatises composed in the nonscholastic tradition aimed at verifying the postulates of science by means of "manual labor" (*opus manuum*) or "manual skill" (*industria manuum*), that is, of technical know-how. For example, the author of the first West European work on the magnet, Peter of Maricourt, wrote in 1269: "the master of this art (making compasses) must know the nature of things, must be conversant with the movements of the heavenly bodies and, further, must occupy himself with manual labor, so that by his labor he may demonstrate remarkable things, for by this diligent effort he will be able to correct an error easily, which he could never have corrected by physics and mathematics alone, without manual labor."[3]

However, the passages devoted to the "debate of the arts" are interesting other than simply as documents on the social conditions of the fifteenth and early sixteenth centuries. If Leonardo's thoughts can be separated from their polemical format and examined independently of the logomachies one will find profound ideas on the nature of the different arts, as well as on art as a whole, without any argument as to the level of their "mechanics" or "nobility."

The main distinction between painting and sculpture is the technical approach and the media requiring special knowledge and skill. It is not at all a matter of "dust" or "fine clothing." Leonardo does not condemn "manual participation" as such, it is the degree of contemplation, the contemplative manual participation that is important.

Sculpture gets its light and shadow from nature itself and does not require theoretical study. Nor does it require study of the theory of coloration and the laws which govern the perception of outlines at great distances ("foreshortening," *perdimenti*). According to Leonardo, sculpture "is not a science, but a most mechanical art [*arte meccanicissima*]," while painting, "by virture of science, shows on a flat surface great stretches of landscape, with distant horizons" (TP 35; McMahon 49). "Painting is a marvelous artifice based on most subtle speculations [*sottilissime speculationi*], of which sculpture is wholly devoid since it involves only brief analysis [*brevissimo discorso*]" (TP 38; McMahon 47). Compared with painting, sculpture "requires little thought" (TP 39; McMahon 48). "Light and shadow together with foreshortening constitute the ultimate excellence in the science of painting" (TP 671; McMahon 840).

Leonardo placed special value on the skill of depicting the transparency of water, seeing in it a special advantage of painting over

sculpture. The painter "shows fish playing between the surface of the water and its bottom; he shows the polished pebbles of various colors lying on the washed sand at the bottom of rivers, surrounded by green plants" (TP 40; McMahon 55). He regarded poetic descriptions of "transparent waters, through which are seen the green depths of their courses, waves that play over meadows and small stones with grass, mingling with playful fish" as the "most noble parts" (TP 20; McMahon 29). In other notes (TP 506, 507) he went into a detailed opticogeometric analysis of such painting, illustrating it with sketches. Eventually this analysis was to fortify his conception that the theory of painting is much more complex than the "scanty" theory of sculpture.

If the task of art consisted merely in naturalistic repetition of reality, there would be no reason to prefer painting to sculpture, which easily creates relief; that is, what Leonardo himself calls the "soul of painting" (TP 124), its "crown" (TP 412), by no means requires "marvelous artifice." Michelangelo had reason for stating, as if in answer to Leonardo: "In my opinion, a painting is the better the nearer it approaches relief, and relief is the poorer, the closer it approaches painting. That is why it usually seems to me that sculpture is a lantern for painting and that the difference between them is like that between the sun and the moon."*

Leonardo valued painting not only for its ability to portray, but because it is one of the highest manifestations of human activity, based on profound knowledge of natural laws and the practical application of that knowledge. Painting is the triumph of that knowledge and artistic mastery. Sculpture gets its light and shadow ready-made from nature, the painter creates light and shadow and aerial perspective on the basis of their laws. The painter understands his subject thoroughly, knows its structure, and that is why he can re-create the object to be depicted. This ability to re-create the object indicates that he has grasped its nature. This is the basis for the proud statements that painting is a "science," that "the divinity which is the science of painting transmutes the painter's mind into a resemblance of the divine mind" (TP 68; McMahon 280). Knowing how to re-create an object in a painting, the artist bears witness to his knowledge of its nature in all its details, as opposed to a sculptor, who need not have such

* Cited in Luporini, *La Mente di Leonardo,* p. 139. Michelangelo's remark was made in 1549 in answer to a question by B. Varchi, who was gathering opinions on the comparative virtues of sculpture and painting.

complete knowledge. The painter controls his subject more than does the sculptor.

Francesco Flora, in a number of lectures, remarked on the dialectic connection between what he aptly calls *homo pictor* (the man who paints and reflects nature) and *homo faber* (the master) or, to put it another way, between the contemplative-theoretical and the practical-technical approaches of Leonardo to reality.[4]

Having learned the natural laws, the painter is able to create objects which do not exist in nature. In Leonardo's words: "It surpasses nature in dealing with things that are simply natural and finite, for the works which our hands do at the command of our eyes are infinite, as the painter shows in his representation of the infinite number of forms of animals, herbs, plants, and places" (TP 28; McMahon 34). Painting is a "free" art, because it "gives heed not only to the works of nature, but to an infinite number of things that nature never created" (TP 27; McMahon 28). Painting embraces "all forms that are and those that are not to be found in nature" (TP 31 b; McMahon 26). Leonardo considered himself correct in saying that "nature is full of infinite causes which were never set forth in experience" (I 18r; Mac-Curdy 72). "Do you not see that if the painter wishes to represent animals, or devils in hell, with what an abundance of discoveries his mind teems?" (TP 15; McMahon 24).

"Nature is concerned only with the production of elementary things, but man from these elementary things produces an infinite number of compounds, although he has no power to create any natural thing" (W An B 28v; MacCurdy 142). Or, even more specifically and succinctly: "Where nature finishes producing its species, there man begins with natural things to make with the aid of this nature an infinite number of species" (W An B 13v; MacCurdy 121).

However, in creating nonexistent forms, the painter continues to be governed by the same laws of light, shadow, and color as he discovered in nature. Leonardo was preoccupied with how to "make an imaginary animal appear natural" (see figure 36) and how to create an image of such an imaginary being, a dragon, from elements of reality. "Take for its head that of a mastiff or setter, for its eyes those of a cat, for its ears those of a porcupine, for its nose that of a greyhound, with the eyebrows of a lion, the temples of an old cock, and the neck of a water tortoise" (BN 2038 29r = TP 421; MacCurdy 891).[5]

The anatomical sketches contain drawings of the legs of strange be-

HOMO FABER

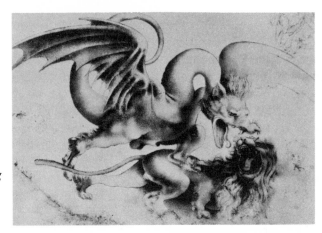

*36. Dragon battling
a lion*

ings (W An V 11r and 14r). Scholars are still trying to guess what real animals the individual parts represent. One thing is sure—viewed as a whole these are the legs of an "imaginary animal" (*animal finto*) in the sense taken by Leonardo in the cited passage: all the elements are real, but the whole is imaginary. As Esche puts it: "Thus far it has been impossible to establish exactly to what living creature the legs belong. They are not at all like a man's. Some of the veins appear to be as in a rabbit's paw; the nails seem to be the product of Leonardo's whim, some have seen in them bear's claws. Perhaps this was one of his jokes and that he proceeded as he had proposed in depicting a monster, advising that the individual parts of various animals be used."[6]

Manuscript H contains abundant material for a "fantastic zoo." For the most part these are excerpts from three works: the anonymous *Fiore di virtù* (Flower of virtue), published in Venice in 1488; *L'Acerba* (from Latin *acervus*, a cluster, heap, abundance), an encyclopedia in verse by Cecco d'Ascoli, published numerous times during the fifteenth and sixteenth centuries;* and Pliny's *Natural History,* that well of wisdom of medieval learning.† Pliny's *Natural History* had been translated into Tuscan by Landino and published in Venice in 1476.[7]

As an example, let us cite two excerpts from Pliny that appear in Manuscript H, concerning the basilisk and a still more fantastic

* Some listings of this encyclopedia bear the title *Liber acerbae aetatis,* indicating the difficulty of the subjects treated.

† Both *Fiore di virtù* and *L'Acerba,* the poem by Cecco d'Ascoli of Bologna, astronomer and contemporary of Dante, are mentioned in the list of books belonging to Leonardo (CA 120r d).

creature, the amphisboena. "*Basilisk.* It is found in the province of Cyrenaica and is not more than twelve fingers long. It has a white spot on its head of the shape of a diadem. It drives away every serpent by its whistling. It resembles a snake but does not move by wriggling, instead it extends itself straight forward from its center. It is said that on one occasion when one of these was killed by a horseman's spear and its venom flowed over the spear, not only the man died but the horse did also. It spoils the corn, not only that which it touches, but that upon which it breathes; it scorches the grass and splits the stones" (H 24r and v; MacCurdy 1089). "*Amphisboena.* This has two heads, one in its usual place, the other at its tail, as though it was not sufficient for it to throw its poison from one place only" (H 25r; MacCurdy 1089).

Of course Leonardo did not believe in the existence of such an animal any more than André de Regni did when he wrote his novel *L'Amphisbène.* In the light of this, it seems odd that Thorndike should take Leonardo's excerpts on aspids, pelicans, and so forth, drawn from medieval bestiaries, as evidence that Leonardo was not only "dependent" on the Middle Ages, but that his science was not based on his own experience.[8] How could Leonardo the scientist take such fairy tales seriously? Surely he wrote them down as possible themes for a future painting or literary work or as material for future plays and masquerades.

This same Manuscript H contains the note: "Rumor should be represented in the shape of a bird, but with the whole figure covered with tongues instead of feathers" (H 22v; MacCurdy 1094). This is the Rumor Bird described by Virgil in the Aeneid:

> Deadly of wing, a huge and terrible monster
> With an eye below each feather in her body,
> A tongue, a mouth, for every eye, and
> Ears double that number.

This strange bird

> . . . in the night she flies
> Above the earth, below the sky, in shadow
> Noisy and shrill; her eyes are never closed

HOMO FABER

In slumber; and by day she perches watching
From tower or battlement, frightening
Great cities.[9]

For all its strangeness, the Rumor Bird in Virgil and Leonardo had "natural" features—it could fly, sit on roofs—but at the same time "was never created by nature." Was not this the way with all of Leonardo's technical inventions, and primarily his plans for flying machines that were like real birds and at the same time not like them?

In creating his artificial bird, Leonardo was governed by the principle of imitating nature, but this did not result in naturalistic imitation, in copying. For example, in his early years, when Leonardo began to concern himself with flying apparatuses, he designed artificial wings which spread when lifted and drew together when lowered, as is the case with a bird. "The feathers spread out one from another in the wings of birds when these wings are raised, and this happens because the wing rises and penetrates the thickness of the air with greater ease when it is perforated than when it is united" (E 46r; MacCurdy 458). However, to convince oneself how much the external appearance of a bird's wing differs from that of a flying machine, one need but glance at the design of the artificial wing, which "when raised is everywhere spread out, but is solid when lowered" (B 73v). The principle is retained, but the details are different. (See figures 37, 38, 39.) The "birds" planned by Leonardo do not exist in nature, just as nature has no Rumor Bird covered with tongues instead of feathers.

Later, in 1505, Leonardo preferred the solid wing of the bat. "Remember that your bird should have no other model than the bat . . . And if you take as your pattern the wings of feathered birds, these are more powerful in structure of bone and sinew because they are penetrable, that is to say, the feathers are separated from one another and the air passes through them. But the bat is aided by its membrane, which binds the whole together and is not penetrated by the air" (VU 15r; MacCurdy 416). In a later note (1508–1509) Leonardo again remarked: "Dissect the bat, study it carefully, and on this model construct the machine" (F 41v; MacCurdy 472). A still later notebook (1510–1516) contains an expressive description of the flight of bats: "Bats when they fly of necessity have their wings covered completely with a membrane, because the creatures of the night on which they feed

LEONARDO DA VINCI

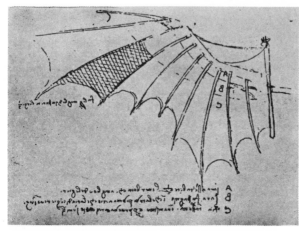

37. Artificial wing

38. Design for a wing

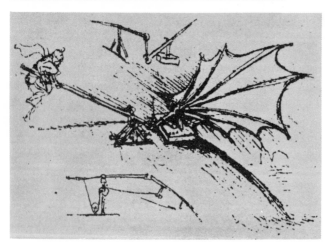

39. Device for testing wings

HOMO FABER

seek to escape by means of confused revolutions and this confusion is enhanced by their various twists and turns. As to the bats, it is necessary sometimes that they follow their prey upside down, sometimes in a slanting position, and so in various different ways, which they could not do without causing their own destruction if their wings were of feathers that let the air pass through them" (G 63v; MacCurdy 475). However, when Leonardo wrote this he understood clearly that any artificial apparatus would be clumsy compared with the tiny bat, gliding through the air and making the most unexpected motions. He had to think not only of the similarities but of the differences. He had to think of such apparatuses as the parachute or the helicopter, which were not at all like animals that fly through the air.

For a time his first stimuli for creating things not in nature were taken from books, from the books of the ancient poets (Virgil's Rumor) as well as those of the contemporary experts on antiquity. We have already mentioned that he read Valturio's remarkable book intently. And, as usual, he not only read it, but developed the thoughts of the author in detail, assimilating them. The historical information of this learned antiquarian and archaeologist inspired Leonardo to many new variants. When reading Valturio he made notes of the following type on the use of asphyxiating smoke by the ancient Germans: "The Germans, in order to asphyxiate a garrison, use the smoke of feathers, sulphur, and realgar, and they make the fumes last seven and eight hours"(B 63v; MacCurdy 830; figure 40). He devised his own methods: "*Deadly smoke*. Take arsenic and mix with sulphur or realgar. Remedy rose water. Venom of toad, that is, a land toad. Slaver of mad dog and decoction of dogwood berries. Tarantula from Taranto. Powder of verdigris or of chalk mixed with poison to throw on ships" (CA 346v a; MacCurdy 845). Or another variant: "If you wish to make a stench, take human excrement and urine, stinking goosefoot, or if you don't have it, cabbage and beets and place them together in a glass jar, seal it tightly, and for a month keep it beneath manure, then throw it where you wish to make a stench, so that the jar will break. You can also take eels and urine and allow them to rot, as above. Also some crabs sealed in a jar and placed in manure. And break the jar where you wish" (B 11r). Having described the asphyxiating dust to be thrown at an enemy vessel, he did not forget what

LEONARDO DA VINCI

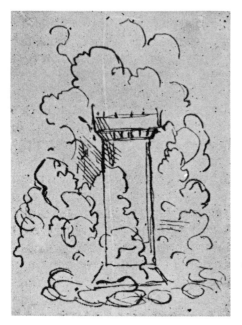

40. Asphyxiating gases

we call the gas mask: "To throw poison in the form of powder upon galleys. Chalk, fine sulfide of arsenic, and powdered verdigris may be thrown among the enemy ships by means of small mangonels. And all those who, as they breathe, inhale the said powder with their breath will become asphyxiated. But take care to have the wind so that it does not blow the powder back upon you, or to have your nose and mouth covered over with a fine cloth dipped in water so that the powder may not enter" (B 69v; MacCurdy 846).

Quintus Curtius, in his history of the campaigns of Alexander the Great, gave the following description of the Scythian chariots in the armies of Darius: "Then came two hundred chariots with scythes, the only refuge of these tribes and, as Darius assumed, would cause great fright among the enemy. Above the pole rose spears with iron tips, on both sides of the yoke there were three swords, between the spokes of the wheels there protruded many sharp barbs, and finally, some scythes were fixed to the rims of the wheels, others turned toward the ground ready to cut everything in the path of the driving horses."[10] Leonardo learned of this description through Valturio[11] and reported it thus:

HOMO FABER

These cars armed with scythes were of various kinds and often did no less injury to friends than they did to enemies, for the captains of the armies thinking by the use of these to throw confusion into the ranks of the enemy created fear and loss among their own men. Against these cars one should employ bowmen, slingers, and hurlers of spears, and throw all manner of darts, spears, stones, and bombs, with beating of drums and shouting; and those acting thus should be dispersed in order that the scythes do not harm them. And by this means you will spread panic among the horses and they will charge at their own side in frenzy, despite the efforts of their drivers, and so cause great obstruction and loss to their own troops. As a protection against these, the Romans were accustomed to scatter iron caltrops, which brought the horses to a standstill and caused them to fall down on the ground from pain, leaving the cars without power of movement (B 1or; MacCurdy 813).

But this was not the end of it. Leonardo's imagination filled out the text with remarkable drawings, which were more than just illustrations of the story of the ancient historian and the commentaries of the learned humanist Valturio. To realize fully the daring and power of the drawings, compare them with the gravure from the printed edition of Valturio's book (figures 41 and 42).

Did Leonardo think, as did Pushkin's niggardly knight, "I know my strength and I am content with this knowledge"? He recalled his own words about painting: "The painter is master of all sorts of people and of all things [*signore d'ogni sorte di gente e di tutte le cose*]. If the painter wishes to see beauties which will make him fall in love with them, he is a lord capable of creating them, and if he wishes to see monstrous things that frighten, or those that are grotesque and laughable, or those that arouse real compassion, he is their lord and their creator" (TP 13; McMahon 35). Does *homo pictor* take precedence over *homo faber* when Leonardo describes the death-dealing chariots, the poisonous fruit, and the asphyxiating gases? (In any event, we have no idea whether Lodovico il Moro or Cesare Borgia actually used these inventions.[12]) Leonardo wrote that alchemists discovered many useful things and for this they deserve "unmeasured praises" and "would deserve them even more if they had not been the inventors of noxious things like poisons" (W An B 28v; MacCurdy 143). However, this did not keep him from writing of means of poisoning fruit.

LEONARDO DA VINCI

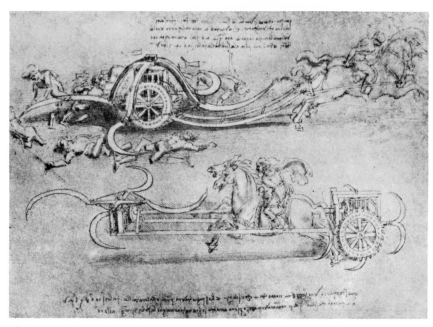

41. Chariot with scythes

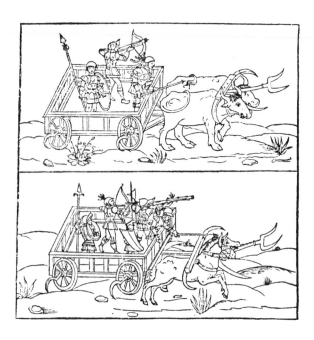

*42. Woodcut from
Valturio's
De re militari*

HOMO FABER

"If you bore an opening in a young tree and drive in it arsenic and realgar sublimed and dissolved in liquor [*aqua arzente*], it will make the fruit poison or dry it up. But this opening must be made larger and go to the heart of the tree and be made during the time the fruit is ripening, and the poisonous water must be forced in with a pump and stopped up with a strong piece of wood. The same may be done when the sap is flowing in the young tree" (CA 12r a).

Homo faber (and perhaps *homo pictor* as well) calmly and cooly entered in his mirror-writing notebooks prescriptions that were to remain unnoticed and unknown. These were proposals for experiments "for himself," that is, not for Alexander Borgia or his son Cesare, who, of course, would not have hesitated to find "useful application" for what Leonardo called *giovamenti* (useful things). Leonardo wrote: "Why do I not describe my method of remaining under water for as long a time as I can remain without food? This I do not publish or divulge on account of the evil nature of men who would practice assassinations at the bottom of the seas, by breaking the ships in their lowest parts and sinking them together with the crews who are in them; and although I will furnish particulars of others, they are not dangerous, for above the surface of the water emerges the mouth of the tube by which they draw in breath, supported upon wine skins or pieces of cork" (Leic 22v; MacCurdy 850). Or, elsewhere: "When besieged by ambitious tyrants I find a means of offence and defence in order to preserve the chief gift of nature, which is liberty; and first I would speak of the position of the walls, and then of how the various peoples can maintain their good and just lords" (BN 2037 10r; Mac-Curdy 839).

In the naive judgment of Vasari, who kept emphasizing the "incompleteness" of Leonardo's work, Leonardo da Vinci "would have made great profit in learning had he not been so capricious and fickle, for he began many things and then gave them up."[13] It should be mentioned that this "incompleteness" of Leonardo's scientific work cannot be explained by his personal qualities and not even by the impediments imposed from the outside; science itself had not grown to the point where it could solve the numerous and complex problems which he posed either generally or specifically.

Leonardo knew the danger of diversity very well. "As a kingdom divided among itself is destroyed, so a mind divided among different

studies is confused and weakened" (BM 180v; Baskin 61). He developed this idea on numerous occasions and in many ways, in the most diverse fields and using the most diverse examples. "If the excessive size of the rivers damages and destroys the sea coasts, then if such rivers cannot be diverted to other places, they should be parted into small streams." He explained his assertion with examples of a bell and a rope: "if I were to split this bell up into tiny bells, it would not be heard at an eighth of a mile even though all the metal in the bells rings at the same time," although the bell could be heard for six miles before. "Similarly, if a rope supports a hundred thousand ounces and you separate it into a hundred thousand strands, each strand of itself will not support one eighth part of an ounce. And so it follows with all the separated powers" (I 111r; MacCurdy 270). "If a bell were to be heard with its sound two miles, and then it were to be melted down and cast again into a number of small bells, certainly if they were all sounded at one time, they would never be heard at as great a distance as when they were all in one bell" (Forst II 32v; MacCurdy 272). In another manuscript he wrote: "if you were to take ten thousand voices of flies all together, they would not carry as far as the voice of a man" (A 23r; MacCurdy 267). Or, finally: "the light of the stars is as powerful as the light of the moon, if it were possible to combine the light of all of them, forming a body much larger than that of the moon, just the same, if there were no moon in our hemisphere, our part of the world would remain dark" (A 3v).

The cast of mind of Leonardo, the experimenter with nature, is shown fully and with remarkable clarity in the fragment which may justly be called his literary self-portrait. With the accuracy of a realistic painter, Leonardo engraved not only his feelings but the expressive pose of a man who is looking searchingly into the darkness of a menacing cavern. "And drawn on by my eager desire, anxious to see a great multitude of varied and strange shapes made by formative nature, having wandered some distance among overhanging rocks, I came to the entrance of a great cavern before which for a time I remained stupefied, having been unaware of its existence, my back bent and my left hand supported on my knee while with my right I made a shade over my lowered and contracted eyebrows."

After this description "from the outside," Leonardo turns to an analysis of his feelings. "And repeatedly bending, first one way and

HOMO FABER

then another, to see whether I could discern anything inside, from this I was prevented by the deep darkness within. And, after remaining there for a time, suddenly there arose within me two emotions, fear and desire—fear of the threatening dark cavern, desire to see whether there might be any marvelous thing therein" (BM 155r; Richter 262).*

Thus, these two feelings are equally close to the soul: fear, reminiscent of Pascal's words "le silence éternel de ces espaces infinis m'effraie" (the eternal silence of these infinite spaces frightens me) and desire (*desiderio*), avid attraction (*bramosa voglia*). Without this avid attraction, without such passion, science dissolves into an isolated empirical triviality. "Just as eating contrary to the inclination is injurious to the health, so study without desire [*voglia*] spoils the memory, and it retains nothing that it takes in" (BN 2038 34r; MacCurdy 72). Leonardo was convinced that: "The acquisition of any knowledge whatever is always useful to the intellect, because it will be able to banish the useless things and retain those which are good. For nothing can be either loved or hated unless it is first known" (CA 226v a; MacCurdy 88).

"Omnivorousness," dissipation of errant curiosity, and harebrained schemes were organically alien to Leonardo. It is true that he was "more of an inventor of machines than a builder of them,"[14] if by builder one means the realizer of a plan and if one considers that most of the plans of Leonardo's machines remained long buried in his manuscripts. I cannot agree, however, that practically no machine invented by Leonardo and none of the more important ones "could have worked even if he had been able to get the money to build them."[15] Models of Leonardo's machines are working in the Museum of Science and Technology in Milan, and at the Polytechnic Museum in Moscow. I recall seeing models in operation during my visit to the town of Vinci on the occasion of the Eighth International Congress of Science Historians in the fall of 1956. These are irrefutable evidence

* One should not seek the source of this profoundly personal fragment about the cavern anywhere but in the inner world of Leonardo. At any rate, only superficial parallels can be drawn. Recently Garin ("Il Problema delle fonti del pensiero di Leonardo," p. 170) noted a parallel for this fragment in Letter no. 57 of Seneca to Lucilius concerning the grotto of Naples, a letter which could have been known to Leonardo in an old Italian translation. Seneca spoke of the darkness of the cavern and of a "certain trepidation" (*ictus animi*), which was not fear but was caused by the "novelty and at the same time the repulsive form of the unknown object" (*insolitae rei novitas simul ac foeditas*). The two "opposite woes" (*incommoda*) about which Seneca wrote did not have anything in common, however, with the two "feelings" of which Leonardo spoke, and therefore the parallel is purely superficial.

LEONARDO DA VINCI

that Leonardo's ideas were vital things, and that they continue to live today.

Leonardo da Vinci's contemporaries and his biographers have played with the consonance of *Vinci* and *vincere* (to be victorious). Luca Pacioli spoke of "Leonardo da Vinci, our Florentine countryman, who deserved his sobriquet more than any other sculptor, modeler, and painter."[16] Fabio Segni, son of Antonio Segni and friend of Leonardo, wrote the following epigram with untranslatable consonance:

> Pinxit Virgilius Neptunum, pinxit Homerus
> Dum maris undisoni per vada fluit equos.
> Mente quidem vates illum conspexit uterque,
> Vincius est oculis; jure vincit eos.*

Are we not correct, indeed obliged, to call Leonardo da Vinci a victor, in the same sense that the hero of an ancient tragedy who struggled against the demands of Fate is called a victor? Leonardo overcame the determinism of his naturalism and mechanics, which condemned reality to an endless cycle, with the concept of *homo faber,* the concept of man as the creator of new implements, of things that are not in nature. This is not some heroic "idealizing," not the contrasting of man to nature and its laws, but creativity based on these very laws and that same nature, for man "is nature's chief instrument (*massimo strumento di natura*)" (W An B 28v). For Leonardo, technical and artistic creativity made the first breach in unyielding nature, which was always the same (and this view of nature was held by natural scientists even in the seventeenth and eighteenth centuries). Dams could be erected to counteract the flooding of rivers, artificial wings could be constructed to lift man into the air. And if the "net which is accustomed to catch fish was seized and carried off by the fury of the fish," as Leonardo related in one of his fables, why could not a different fate await all the other personages of his fables—the unfortunate willows, the grape vines, the lilies—in the new world created by man? If this were so, one would not have to say that human forces are expended in vain and that they drown without a trace in

* "Virgil and Homer depicted Neptune as he drove his horses through the thundering seas. Both these seers showed him to the mind; da Vinci shows him to the eye, and in this surpasses them."

HOMO FABER

the stream of time, the "destroyer of things." On the contrary, one would have to say "wrongfully do men lament the flight of time, accusing it of being too swift, and not perceiving that its period is yet sufficient" (CA 76r a; MacCurdy 62). Then Leonardo's words, which reflect Seneca's thought almost exactly, would be justified (Triv 63r a): "La vita bene spesa longa è," "A life well spent is long."

APPENDIX: THE MANUSCRIPTS

A BRIEF HISTORY

The history of Leonardo da Vinci's manuscripts has been treated many times in the literature.[1] In what follows, I shall give only the most basic information.

As already mentioned, Leonardo willed to his pupil Francesco Melzi all the manuscripts, drawings, and apparatus that he took with him to France. After Melzi's death in 1570 this material passed on to his heirs. To gain an idea of what happened to them between 1570 and 1635, it is best to yield the floor to the Milanese Giovanni Ambrogio Mazzenta, who wrote his memoirs about 1635.[2]

> About fifty years ago, I acquired thirteen books of Leonardo da Vinci's, some written in folio, some in quarto, backwards, in the manner of the Jews, in a good hand, easily readable with the aid of a large mirror. I obtained them by chance, and they came into my hands in the following manner. While I was studying law in Pisa in the home of Aldo Manuzio the Younger, a great bibliophile,[3] there lived in his house one Lelio Gavardi di Ascola, Provost of San Zeno in Pavia, a near relative of Manuzio. This Gavardi, being a teacher of philology, had lived with the Signiori Melzi in Milan, at their villa Vaprio (they should not be confused with the other Melzi, distinguished persons of that city). While there, he found in some old trunks many manuscripts, books, and apparatuses left by Leonardo [to his pupil Francesco Melzi] . . . When this gentleman [Francesco Melzi] died . . . he left this valuable treasure in the villa for his heirs, whose interests and

[1] In addition to the book by Calvi, *I Manoscritti di Leonardo da Vinci,* and the other books cited in the list of manuscripts below, see J. P. Richter, *The Literary Works of Leonardo da Vinci* (II, 393–399); A. Marinoni, "I Manoscritti di Leonardo da Vinci"; G. Séailles, *Léonard de Vinci, l'artiste et le savant;* and A. A. Guber, *Leonardo da Vinchi* (II, 403–422).

[2] Cf. D. L. Grammatica, *Le Memorie su Leonardo da Vinci.* The passage quoted is taken from the Italian text in Richter's *The Literary Works of Leonardo da Vinci* (II, 394–395), from which the comments also derive.

[3] Aldo Manuzio taught law in Pisa in 1587–88.

APPENDIX

occupations were entirely different and who, therefore, neglected them completely and they deteriorated rapidly. That is why it was easy for Lelio Gavardi, who tutored philology in the home of the Melzi, to take as much as he pleased, and he took thirteen books to Florence to give to the Grand Duke Francesco in hope of receiving a high price for them, since that prince loved such works and since Leonardo enjoyed a high reputation in Florence, his native city, where he had lived long and sought employment. About the time Gavardi arrived in Florence, the Grand Duke fell ill and died [October 19, 1587]. That is why Gavardi went to Pisa to Manuzio, where I shamed him concerning his dishonest acquisition; he repented and begged me to go to Milan, after I finished my law studies, and return to the Signiori Melzi what had been taken from them. I carried out my trust, turning over everything to Orazio Melzi, Collegiate Doctor, and head of the house. He was astonished that I had taken this task upon myself and made me a gift of the books, saying that he had many other drawings of the same author, which had been neglected for many years in the attics of the villa. He returned the aforenamed books to me, and later they went to my brothers.[4]

Since my brothers praised them too much and told those who saw the books how simple and easy it had been to obtain them, many began to importune Doctor Melzi and compel him to relinquish drawings, models, sculptures, anatomical studies, together with other precious relics of Leonardo's work. Among these "fishers" was Pompeo of Arezzo, son of Cavaliere Leone. He had been a pupil of Buonarotti's and was now a retainer of the Spanish king Philip II, for whom he executed some bronze pieces for the Escurial. Pompeo promised Doctor Melzi a post, a title, and a place in the Milanese Senate if he, Melzi, would get back the thirteen books and give them to him to give to King Philip, who treasured such curiosities. Melzi hurried to my brother and on bended knees begged him to return the gift. Keeping in mind that he was our colleague in the College of Milan, a person worthy of compassion, respect, and consideration, he returned seven books, but six remained in the house of Mazzenta. One of them was given to that famous gentleman Cardinal Federico[5] and at present is in his Ambrosian Library in a red binding; it treats of shadows and light very philosophically and instructively for artists, and those

[4] In 1590 Giovanni Ambrogio Mazzenta became a monk and gave the manuscripts to his brother Guido.

[5] Federico Borromeo, 1565–1631, Archbishop of Milan, founder of the Ambrosian Library in that city.

APPENDIX

employing perspective and optics.[6] I gave another book to Ambrogio Figini, noble painter of the time, which he left, together with all the rest of the property of his studio, to his heir Ercole Bianchi. At the urgent request of Charles Emmanuel I, Duke of Savoy, I had my brother take the third book to his excellency.[7] When my brother died outside Milan, the remaining books came into the possession, I know not how, of the aforenamed Pompeo of Arezzo, who combined them with others, binding them all into a large book, which he subsequently left to his heir Polidoro Calchi; this latter sold them to Galeazzo Arconati for 300 scudi.[8] This gentleman, a most noble courtier, keeps it in his galleries, which contain thousands of other valuable things; the Duke of Savoy and other princes have asked him for this book many times, but he has always politely refused sums even in excess of 600 scudi.

Now let us trace briefly the fate of the Leonardo manuscripts after 1635, when Mazzenta wrote his memoirs. In 1637 Count Galeazzo Arconati donated the Codex Atlanticus to the Ambrosian Library along with ten of the manuscripts that had been stolen by Gavardi and that had come into the possession of the Count through Leoni.[9] In 1674 Count Orazio Archinti donated another manuscript.[10] Shortly after the manuscripts donated by Galeazzo Arconati appeared in the Ambrosian Library, namely in 1643, the Dominican Luigi Maria Arconati, using as a basis these and some other manuscripts, now lost, compiled the Treatise on the Movement and Measurement of Water for Cardinal Barberini. It was not printed for nearly two centuries. The manuscripts held by the Ambrosian Library were not published either.

The origin of the manuscripts now in England is somewhat more complex and not entirely clear. In addition to the manuscripts sold to Arconati, Pompeo Leoni had others. He left Milan in 1591 and

[6] Manuscript C in the library of the Institut de France in Paris.

[7] The second and third books have been lost.

[8] The so-called Codex Atlanticus in the Ambrosian Library in Milan.

[9] These are the manuscripts now held by the Institut de France (designated A, B, E, F, G, H, I, L, and M) and the so-called Codex Trivulzio (at present in the Castello Sforzesco in Milan). How the Codex Trivulzio disappeared from the Ambrosian Library and Manuscript D (now belonging to the Institut de France) appeared in its place is a mystery. In any event, Giovanni Carlo Trivulzio acquired the first manuscript from private parties in 1750; the second manuscript appears in the Catalogue of the Ambrosian Library for 1790.

[10] This is Manuscript K, also at the Institut de France at present.

APPENDIX

settled in Spain, where he died in 1608. It has been documented that two of the "books" that had belonged to Leoni were in the possession of the Spaniard Don Juan de Espina in 1623–1637, who had intended to give them to the Spanish king. In the seventeenth and eighteenth centuries the Royal Library in Madrid listed two volumes of Leonardo's manuscripts on geometry and mechanics, belonging to the period 1491–1493. How they came to disappear and where they were taken also remains a mystery.[11]

At one time it was assumed that the collection of drawings now in Windsor Castle was one of the "books" that had belonged to Juan de Espina and had been acquired by Lord Arundel in Spain, but this has been refuted by recent research. Lord Arundel came into possession of this collection before 1630 (where and how is not known exactly), whereas the books that had belonged to De Espina were still in Spain as late as 1637.[12] Initially the Windsor collection comprised one album in a leather binding which bore the name Pompeo Leoni.

Lord Arundel acquired a second Leonardo manuscript, which is now in the British Museum (Codex Arundel 263). Arundel died as an emigré in Padua in 1646, having left England in 1641, and the British Museum obtained the manuscript from his heirs in the middle of the seventeenth century.

It is not clear just when the Leoni album became a part of the royal collection, but some Leonardo manuscripts belonging to Charles I are mentioned around 1639, and in 1690 Constantijn Huygens saw the Leoni album in the royal collection.

Late in the seventeenth century, specifically in 1690, the painter Giuseppe Ghezzi (1643–1721) purchased in Rome for a "great sum of gold" a manuscript which he subsequently (between 1713 and 1717) sold to Lord Leicester. This is the so-called Leicester Codex, preserved at Holkham Hall in Norfolk.

The anatomical drawings of the royal collection were not regarded from the standpoint of the history of science until the second half of the eighteenth century. In the early 1760's the librarian Robert Dalton found them in a trunk in Kensington Castle and showed them to Doctor William Gunther, who became entranced with Leonardo's drawings and discussed them in lectures before his students. He under-

[11] They were discovered in the Royal Library in Madrid in 1966. [Translator's note.]
[12] See A. E. Popham, "Leonardo's Drawings at Windsor."

took to publish them, but died in 1783, before he could accomplish this. The first critique of Leonardo's anatomical drawings was published by J. F. Blumenbach in 1788.[13]

At about this same time attention was first turned to Leonardo's works in physics and mathematics. In 1796 Napoleon had the thirteen manuscripts in Milan brought to Paris. In 1797 G. B. Venturi, professor at Modena (1796–1822), reported on the writings in physics and mathematics that are held by the Institut de France in Paris. Venturi marked the twelve manuscripts with the letters A through M. These designations have been widely accepted, but his designation N for the Codex Atlanticus has not been adopted. Venturi laid the foundation for the tradition that Leonardo was the forerunner of later scientists and the prophesier of later discoveries. Here is a highly characteristic example of his judgments:

> One must admit that in his manuscripts one finds some false conclusions, some fruitless speculations; perhaps he himself would have eliminated them in subsequent editing. However, in sand there is gold. In mechanics Da Vinci knew the following in particular: (1) the theory of forces applied at an oblique angle to the handle of a lever; (2) the relative resistance of beams; (3) the laws of friction later formulated by Amontons; (4) the effect of the center of gravity on bodies in motion and bodies at rest; (5) the application of the principle of virtual velocities to certain cases which have been generalized to a higher degree by modern mathematical analysis. In optics he described the camera obscura before Porta; he explained the figure of the sun's image formed during the passage of the rays through a polygonal opening before Maurolico did; he taught us aerial perspective, spoke of the nature of colored shadows, the movement of the pupil, the

[13] For the further history of the study of the anatomical manuscripts, see S. Braunfels-Esche, *Leonardo da Vinci. Das anatomische Werk.* It contains a detailed bibliography (pp. 169–173), to which should be added the more recent literature: G. Favaro, "Leonardo e l'anatomia" (1952); G. Lambertini, "Leonardo anatomico" (1953); M. Senaldi, *L'Anatomia e la fisiologia di Leonardo da Vinci* (1953); E. D. Vitali, "L'Anatomia e la fisiologia" (1954); E. Belt, *Leonardo the Anatomist* (1955); M. Imbert, *Un Anatomiste de la Renaissance, Léonard de Vinci* (1955); D. A. Zhdanov, *Leonardo da Vinchi-anatom* (Leonardo da Vinci, anatomist; (1955); M. A. Tikotin, *Leonardo da Vinchi v istorii anatomii i fiziologii* (Leonardo da Vinci in the history of anatomy and physiology; (1957). Of the earlier works, one must mention J. P. McMurrich's *Leonardo da Vinci, the Anatomist* (1930). Quite recently (1960), S. Braunfels-Esche published a supplement to her bibliography, "Neu Literatur zu Leonardos anatomischem Werk und seinem Studium des Menschen (1952–1958)." A second edition of her book was published in 1961.

APPENDIX

duration of visual impressions, and certain other phenomena connected with the eye, of which there is nothing in Vitellion [Witelo]. Finally, Da Vinci not only noticed all the things of which Castelli spoke a century later concerning the movement of waters, but it seems to me that in this respect he was even superior to the one whom Italy has considered the founder of hydraulics. Consequently, one must place Leonardo first among those who have undertaken the study of the physicomathematical sciences, holding to the proper method. It is a pity that he was unable to promulgate his views in his time; the outstanding people of that time turned to the fine arts, while the rank and file scholars, as previously, bogged down in scholastic or religious disputes, and the genuine interpretation of nature had to wait another century.[14]

In 1815 one of the thirteen manuscripts that had been carried off to France, namely the Codex Atlanticus, was returned to the Ambrosian Library. It is curious that the persons who transported the manuscript and received it thought at first that the mirror writing was Chinese.

In the 1830's Guglielmo Libri (1809–1869) studied the scientific works of Leonardo in the Italian and Parisian manuscripts,[15] but at the same time he plundered them. He removed some of the sheets from the Parisian Manuscript A, comprising the so-called Ashburnham Codex I (or BN 2038), and sheets from Manuscript B, which comprise Ashburnham Codex II (or BN 2037). He sold them to Lord Ashburnham; subsequently they were returned to Paris, to the Bibliothèque Nationale, which in turn gave them to the Institut de France in 1891. Pages were removed from Manuscript B in the same manner, and now constitute the so-called Codex on the Flight of Birds (Il Codice sul volo degli uccelli). This codex was sold first to Count Manzoni, after which it was acquired by T. Sabachnikoff, who gave it to Italy. At present it is in the Royal Library in Turin.

In 1893 Sabachnikoff printed the manuscript on the flight of birds in Paris (with G. Piumati's transcription and the French translation by C. Ravaisson-Mollien). Through his efforts the publication of the Windsor manuscripts was begun in 1898–1901 (the anatomical codices W An A and B).[16] For their part in advancing Leonardo studies,

[14] G.-B. Venturi. *Essai sur les ouvrages physico-mathématiques*, p. 5.

[15] G. Libri, *Histoire des sciences mathématiques en Italie*, III, 10–58, 205–238.

[16] The Leoni album was taken apart and the anatomical folios were grouped in three volumes, two comprising W An A and B, and the third the so-called *Quaderni d'anatomia* (W An I–VI).

APPENDIX

Sabachnikoff, Ravaisson-Mollien, Gustavo Uzielli, and Piumati were named honorary citizens of the town of Vinci. The text of the decree with respect to Sabachnikoff reads:

> The Council, taking into consideration that the illustrious gentleman Theodore Sabachnikoff recently, like a true Maecenas, turned his love of the arts and sciences to the study and publication of unpublished manuscripts of Leonardo da Vinci and brought to a conclusion, to everyone's joy, the publication of the precious *Codex on the Flight of Birds* in a splendid volume, graciously presenting it to our city commune and magnanimously donating this rare pearl to the Royal Library; taking into consideration that the noble decision reached by the generous and renowned gentleman Theodore Sabachnikoff to pledge the publication of other works of Leonardo da Vinci, which have awaited this moment for nearly four centuries, when they will appear before a delighted world to the greater fame of our great countryman; taking into account that this most illustrious gentleman Theodore Sabachnikoff has performed a great service to our commune, the Council decrees that most illustrious Theodore Sabachnikoff be named honorary citizen of the city of Vinci.

In the nineteenth century several previously unknown Da Vinci manuscripts appeared. Such are the three small books or parts of a manuscript purchased in the second half of the century in Vienna by Lord Lytton, from whom J. Forster obtained them. Forster donated these books to the Victoria and Albert Museum; they constitute the so-called Forster Codex.

Individual folios of Da Vinci manuscripts are located at present in Florence, Venice, Oxford, Weimar, New York, and elsewhere.[17]

A CHRONOLOGICAL LIST

All manuscripts marked "Paris" in this list are held by the Institut de France. A diagonal slash mark between years means that the manuscript may be dated approximately within that span of years. A dash between years indicates that the manuscript was written and added to over that span of years.

[17] Several almost unknown folios were recently studied and published by C. Pedretti in his *Studi vinciani,* pp. 203–256.

APPENDIX

Manuscript	Date	Abbreviation
Codex Atlanticus (also called Codice Atlantico). Milan, Ambrosian Library	about 1483–1518	CA
Folios treating of anatomy, the so-called Quaderni d'anatomia V. Royal Library, Windsor	1486–1488 and 1511	W An V
Volume of mixed content, belonging to Count Trivulzio. Milan, Castello Sforzesco	1487/1490	Triv
Quaderni d'anatomia VI. Royal Library, Windsor	1488 and 1511	W An VI
Volume devoted primarily to architecture and warfare. Paris	About 1488/1489	B
Manuscript previously part of Manuscript B. Paris	About 1488/1489	BN 2037 (Ash II)
Notebook. Victoria and Albert Museum	About 1489	Forst I²
Manuscript on anatomy. Royal Library, Windsor	1489–1490 and 1500–1510	W An B
Treatise on light and shadow. Paris	1490	C
Notebook. Victoria and Albert Museum	1490–1493	Forst III
Manuscript previously part of Manuscript A. Paris	1492	BN 2038 (Ash I)
Fragment of a manuscript of mixed content. Paris	1492	A
Quaderni d'anatomia III. Royal Library, Windsor	1482–1494 and 1505–1510	W An III
Notebook in three parts. Paris	1493, 1494 (I); January 1494 (II); March 1494 (III)	H³, H², H¹
Notebook in two parts. Victoria and Albert Museum	1495/1497 (I); 1495 (II)	Forst II², II¹
Notebook in two parts. Paris	1497/1499 (I); 1497 (II)	I², I¹
Notebook. Paris	1497, 1502/1503	L

APPENDIX

Manuscript	Date	Abbreviation
Notebook. Paris	before 1500	M
Quaderni d'anatomia I. Royal Library, Windsor	about 1504–1509	W An I
Collection of treatises and notes. British Museum, Arundel Collection	1504, 1508, after 1516	BM (Arund 263)
Notebook in three parts. Paris	after 1504 (I); after 1504/1509 (II); 1509–1512 (III)	K^1, K^2, K^3
Treatise on stereometry. Victoria and Albert Museum	1505	Forst I^1
Treatise on the flight of birds, previously part of Manuscript B. Turin	1505	VU
Quaderni d'anatomia IV. Royal Library, Windsor	1505–1515	W An IV
Treatise on the eye. Paris	1508	D
Notebook. Paris	1508–1509	F
Manuscript on anatomy. Royal Library, Windsor	about 1510	W An A
Notebook. Paris	about 1510/1516	G
Individual folios. Academy of Arts, Venice	1511 and other years	V
Quaderni d'anatomia II. Royal Library, Windsor	about 1513	W An II
Notebook. Paris	1513 and 1514	E
Folios in Royal Library, Windsor (inventory numbers are given after abbreviation)		W
Treatise on Painting	compiled from the notebooks in the sixteenth century	TP
Treatise on the Movement and Measurement of Water	compiled from the notebooks in the seventeenth century	TA

APPENDIX

This list was compiled on the basis of J. P. Richter's book *The Literary Works of Leonardo da Vinci* (II, 400–401). Richter, in turn, referred to G. Calvi's *I Manoscritti di Leonardo da Vinci*. I derived the exact dating of the anatomical manuscripts from S. Braunfels-Esche's *Leonardo da Vinci. Das anatomische Werk*. A chronological list of folios of the Codex Atlanticus was published recently by C. Pedretti in *Studi vinciani* (pp. 264–289). Pedretti also specified more exactly the chronology of the folios of the British Museum codex (C. Pedretti, "Saggio di una cronologica del fogli del codice Arundel di Leonardo da Vinci").

The manuscripts Forst I[1] and Forst I[2] were bound together (as were the manuscripts Forst II[1] and Forst II[2]; H[1], H[2], and H[3]; I[1] and I[2]; K[1], K[2], and K[3]) and are numbered consecutively. In references to all these manuscripts the superscript has been omitted. For more accurate dating of the fragments, the reader may refer to the following table for the arrangement of the manuscript folios.

Forst I[1]	Folios 1–40
Forst I[2]	Folios 41–54
Forst II[1]	Folios 1–63
Forst II[2]	Folios 64–159
H[1]	Folios 1–48
H[2]	Folios 49–64
H[3]	Folios 65–142
I[1]	Folios 1–48
I[2]	Folios 49–94
K[1]	Folios 1–49
K[2]	Folios 50–80
K[3]	Folios 81–128

BIBLIOGRAPHICAL NOTE

BIBLIOGRAPHIES

The literature on Leonardo da Vinci is immense. The best bibliographic text is the two-volume work by E. Verga, *Bibliografia vinciana* (1931), which covers the field through 1930 and lists more than 2500 titles. Heydenreich's paper "Leonardo-Bibliographie" (1952) and the surveys of the literature published in nos. 14–16 of *Raccolta vinciana* bring the bibliography up through 1952. Material published between 1953 and 1958 is given in no. 18 of *Raccolta vinciana*. The surveys that have appeared in nos. 19 and 20 of *Raccolta vinciana* (1962, 1964) bring the record up to 1964. A classified bibliography containing about 700 items can be found in *Leonardo da Vinci,* New York: Reynal and Company, 1963, pp. 511–518.

BIOGRAPHY

Luca Beltrami's *Documenti e memorie* (1919) continues to be the indispensable biographical source. It covers the period through 1570 (Lomazzo's text). The best work in German is Heinz Lüdecke's *Leonardo da Vinci im Spiegel seiner Zeit* (1952). In Russian, the more important older biographies are printed in Volynskii's *Leonardo da Vinchi* (1909).

Despite its deficiencies, Vasari's biography is an important source, as may be surmised from the numerous quotations from Vasari in the present volume. One of the most obvious defects of Vasari's account is his persistent tendency to state that Leonardo began many things and never finished one of them. The head of the Medusa remained unfinished, as did the head of Christ in the *Last Supper* and the bronze equestrian statue of the Duke of Sforza; according to Vasari even the *Mona Lisa* was unfinished. He tried to explain this personality defect of Leonardo's by stating that his "vast and most excellent mind was hampered through being too full of desire and that his wish ever to seek out excellence upon excellence (*eccelenza sopra eccelenza*) and perfection upon perfection (*perfezione sopra perfezione*) was the reason for it."

The earlier anonymous Florentine author, called Anonimo Fiorentino

BIBLIOGRAPHICAL NOTE

or Anonymus Magliabechianus, gave some colorful details not contained in Vasari's work. His title, Anonymus Magliabechianus, is derived from Antonio Magliabechi (1633–1714), the owner of the manuscript collection containing this biography. The best edition of it is that of Carl Frey (1892). This work is sometimes called the Anonymus Gaddianus, for an owner of the manuscript, Gaddi.

An earlier source is the short biography by Paolo Giovio (Paulus Jovius), which was written shortly after 1527 and was included in three dialogues on famous men and women. The Latin text may be found in Richter's anthology, *The Literary Works of Leonardo da Vinci* (1939; I, xxxii–xxxiii).

EDITIONS OF THE MANUSCRIPTS

The edition of the manuscripts published by Charles Ravaisson-Mollien, *Les Manuscrits de Léonard de Vinci. Manuscrits de la Bibliothèque de l'Institut* (Paris, 1881–1891), comprises six volumes: vol. I (Manuscript A); vol. II (B and D); vol. III (E and K); vol. IV (F and I); vol. V (G, L, and M); vol. VI (H and BN 2037 and 2038, that is, Ashburnham II and I).

The *Reale Commissione Vinciana* began publishing these editions in 1926: vol. I, *I manoscritti ed i disegni di Leonardo da Vinci* (Rome, 1926–1928); vol. II, *Il Codice A nel'Istituto di Francia* (1936); vol. III, *Il Codice A (2171) nell'Istituto di Francia (Complementi)* (1938). This last volume contains the copy of Manuscript A made by Venturi in the late eighteenth century and folios 65–114, which had been stolen by Libri. Libri had sold them to Lord Ashburnham; later the folios reached the Bibliothèque Nationale in Paris, which subsequently gave them to the Institut de France. These folios are known as Ashburnham II or Bibliothèque Nationale (BN) 2038 and Ashburnham 2185. Manuscript B was also published by the Commissione Vinciana in its vol. 5: *Il Codice B (2173) nell'Istituto di Francia* (Rome, 1941). A facsimile edition of Manuscript B with a new transcription was published in France quite recently (1960).

The Trivulzio codex has appeared in two editions: *Il Codice di Leonardo da Vinci nella Biblioteca del principe Trivulzio in Milano,* edited and annotated by L. Beltrami (Milan, 1891), and *Il Codice Trivulziano,* transcribed by N. De Toni (Milan, 1939; without illustrations).

The Codex on the Flight of Birds together with other materials was published by T. Sabachnikoff, with transcription and annotation by G. Piumati, and a translation into French by Ravaisson-Mollien, as *Il Codice sul volo degli uccelli e varie altre materie* (Paris, 1893). This codex had been part of Manuscript B. The missing folios were found later and published in 1926 under the direction of E. Carusi: *I fogli mancanti al Codice di Leo-*

BIBLIOGRAPHICAL NOTE

nardo da Vinci nella Biblioteca Reale di Torino (Rome, 1926). All the folios of this codex in their correct order were published in the Leonardo da Vinci Exhibit edition: *Leonardo da Vinci* (Milan, 1939). I have referred to this new edition with the previously missing folios in the present book.

The Codex Atlanticus was reproduced and published for the Reale Accademia dei Lincei as *Il Codice Atlantico di Leonardo da Vinci nella Biblioteca Ambrosiana di Milano* (Milan, 1894-1904). Individual folios were published earlier as *Saggio delle Opere di Leonardo da Vinci. Tavole tratte dal Codice Atlantico* (Milan, 1872).

The folios A of the manuscripts on anatomy at Windsor Castle were published by T. Sabachnikoff, with transcription and annotation by G. Piumati, and a French translation preceded by a study by M. Duval, as *I manoscritti di Leonardo da Vinci della Reale Biblioteca di Windsor. Dell' anatomia, Fogli A* (Paris, 1898) and *Fogli B* (Turin, 1901).

The Quaderni d'anatomia I-VI (W An I-VI) were published by C. Ove, L. Vangensteen, A. Fonahn, and H. Hopstock, with translations into English and German, in Christiania in 1911-1916.

The Reale Commissione Vinciana published Leonardo's geographic drawings preserved at Windsor Castle as *I disegni geografici conservati nel Castello di Windsor* (Rome, 1941).

One may get a good idea of the Windsor collection as a whole from the catalogue compiled by Kenneth Clark which contains a large number of illustrations: Clark, *A Catalogue of the Drawings of Leonardo da Vinci in the Collection of His Majesty the King at Windsor Castle,* vols. I-II (Cambridge, England, 1935).

The codex in the Library of the Earls of Leicester in Holkham Hall was published by G. Calvi as *Il Codice di Leonardo da Vinci nella Biblioteca di Lord Leicester in Holkham Hall* (Milan, 1909).

The codex of the British Museum was published by the Reale Commissione Vinciana as "Il Codice Arundel 263," in *I manoscritti ed i disegni di Leonardo da Vinci,* vol. 1, pts. 1-3 (Rome, 1926-1928).

The Forster codex was also published by the Reale Commissione Vinciana in its *I manoscritti di Leonardo da Vinci, Serie minore* as *Il Codice Forster,* 5 vols. (Rome, 1930-1934).

COLLECTIONS OF EXCERPTS FROM THE MANUSCRIPTS

Il Trattato del moto e misura dell'acqua, in the series *Raccolta d'autori italiani che trattano del moto delle acque* (Bologna, 1828), X, 270-450; new edition by E. Carusi and A. Favaro in *Istituto di Studi Vinciani, Nuova Serie, Testi Vinciani,* vol. I (Bologna, 1923). A selection of parallel texts

BIBLIOGRAPHICAL NOTE

from Leonardo's notebooks was made by Nando de Toni in *Frammenti Vinciani, 2. Repertorio dei passi Leonardeschi ai quali attinse frate L. M. Arconati per la compilazione del trattato "Del moto e misura dell'acqua,"* bk. 9 (Brescia, 1934).

Trattato della Pittura, text, together with a biography of Leonardo da Vinci by Rafaelle Du Fresne (first, abridged edition; Paris, 1651). The complete edition with a German translation was published as *Das Buch von der Malerei nach dem Codex Vaticanus (Urbinas, 1270),* translated by H. Ludwig (Vienna, 1882). This was part of the *Quellenschriften für Kunstgeschichte,* vols. 15 and 17, and was republished by M. Herzfeld (Jena, 1909). A facsimile of the Codex Urbinas together with an English translation may be found in A. Philip McMahon's *Treatise on Painting,* 2 vols. (Princeton, 1956).

The Treatise on Painting was translated into Russian by A. A. Guber and V. K. Shileiko as *Kniga o zhivopisi* (Moscow, 1934). A detailed bibliography of the manuscripts and printed editions of the Treatise on Painting appears in K. T. Steinitz, *Leonardo da Vinci's Trattato della Pittura* (Copenhagen: Munksgaard, 1958). Her list has been supplemented by her more recent article "Bibliography never ends," in *Raccolta Vinciana,* no. 18 (1960), pp. 97–111. The reader should also refer to T. D. Kamenskaia's article "K voprosu o rukopisi 'Traktata o Zhivopisi' Leonardo da Vinchi i ee illiustratsiiakh v sobranii Ermitazha" (The illustrated manuscript of Leonardo da Vinci's Treatise on Painting in the Hermitage collection), *Leningrad. Ermitazh, Trudy,* 1: 49–59 (1956).

For other, as yet unpublished, compilations in Milan, Naples, and Montpelier, see Carlo Pedretti's article "Copie sconosciute del sècolo XVII," in *Studi vinciani,* pp. 257–263.

WORKS CITED

Agostini, Amedeo. *Le Prospettive e le ombre nelle opere di Leonardo da Vinci.* Pisa: Domus Galileana, 1954.

Albert of Saxony (Albertus de Saxonia). *Quaestiones in Aristotelis libros de caelo et mundo.* Pavia: Antonius Carcanus, 1481.

———— *Acutissime quaestiones super libros de physica auscultatione.* Venice, 1504.

Alberti, Leon Battista. *De re aedificatoria.* Florence: Nicolaus Laurentis, 1485. Translated by James Leoni as *The Architecture of Leon Battista Alberti in Ten Books. Of Painting in Three Books, and of Statuary in One Book.* London: Thomas Edlin, 1726.

Alexander of Aphrodisias (Alexander Aphrodesiensis). "Commentaria in librum De sensu & sensibili" (of Aristotle), in P. Wendland, *Die hellenistisch-romische Kultur in ihren Beziehungen zu Judentum und Christentum.* Tübingen: Mohr, 1912.

Alhazen (Abu Ali al-Hasan). *Opticae thesaurus.* Basel: Johann Riesner, 1572.

Almagià, Roberto. "Leonardo da Vinci geografo e cartografo," in *Atti del Convegno di studi vinciani.* Florence: Olschki, 1953.

Ancona, Paolo d'. *See* Leonardo da Vinci, *La Cène de Léonard de Vinci.*

Anonimo Fiorentino. *Il Codice magliabechiano XVII,* ed. Carl Frey. Berlin: G. Grote'sche Verlagsbuchhandlung, 1892. Cf. *The Anonimo,* ed. G. C. Williamson. London: G. Bell, 1903.

Aristarchus of Samos. *De magnitudinibus et distantius solis et lunae.* Translated by Sir Thomas Little Heath as *Aristarchus of Samos, the Ancient Copernicus. A History of Greek Astronomy to Aristarchus together with Aristarchus's Treatise, On the Sizes and Distances of the Sun and Moon.* Oxford: Clarendon Press, 1913 and 1959.

Aristotle. *The Works of Aristotle,* ed. J. A. Smith, W. D. Ross, et al. Oxford: Clarendon Press, 1928–1931. "Analytica posteriora" in vol. 1; "Physics" in vol. 2; "De anima" in vol. 3; "Meteorology" in vol. 3; "Metaphysics" in vol. 8.

Artelt, W. "Bemerkungen zum Stil der anatomischen Abbildungen des 16. und 17. Jahrhunderts," *Archivo Iberoamericano de Historia de la medicina y antropologia medica,* 8: 393–396 (1956).

WORKS CITED

Babinger, F. "Vier Bauvorschläge Leonardo da Vincis an Sultan Bajezid II (1502/1503). Mit einem Beitrag von L. Heydenreich," *Akademie der Wissenschaften zu Göttingen, Philologisch-historische Klasse, Nachrichten,* no. 1 (1952).

Baratta, Mario. *Leonardo da Vinci ed i problemi della terra.* Turin: Fratelli Bocca, 1903.

Baroni, Constantino. "La Nascita di Leonardo," in *Leonardo da Vinci.* Novara: Istituto Geografico de Agostini, 1940. pp. 7–8.

——— "Tracce pittoriche leonardesche recuperate al Castello Sforzesco di Milani," *Istituto Lombardo di scienze e lettere, Rendiconti, Classe di lettere,* vol. 58 (1955).

Belt, Elmer. "Les Dissections anatomiques de Léonard de Vinci," in *Léonard de Vinci et l'expérience scientifique au XVIe siècle, Colloques Internationaux.* Paris: Presses Universitaires, 1953, pp. 189–224.

——— *Leonardo the Anatomist.* Lawrence, Kansas: University of Kansas Press, 1955.

Beltrami, Luca. *Leonardo da Vinci e la Sala delle Asse nel castello di Milano.* Milan: Allegretti, 1902.

——— *Documenti e memorie riguardanti la vita e le opere di Leonardo da Vinci.* Milan: Fratelli Treves, 1919.

Benedicenti, Alberico. "Leonardo da Vinci e la medicina dei suoi tempi," in *Atti del Convegno di studi vinciani.* Florence: Olschki, 1953, pp. 237–262.

Bernal, John Desmond. *Science in History.* London: Watts, 1954.

Berthé de Besaucèle, Louis. *Les Cartésiens d'Italie.* Paris: A. Picard, 1920.

Bodenheimer, F. S. "Léonard de Vinci, biologiste," in *Léonard de Vinci et l'expérience scientifique au XVIe siècle, Colloques Internationaux.* Paris: Presses Universitaires, 1953, pp. 172–188.

——— "Léonard de Vinci et les insects," *Revue de synthèse,* 77(2): 147–153 (1956).

Bongioanni, F. M. *Leonardo pensatore.* Piacenza: Soc. tip. ed. Porta, 1935.

Boring, Edwin Garrigues. *Sensation and Perception in the History of Experimental Psychology.* New York: D. Appleton-Century Co., 1942.

Borelli, G. A. (I. A. Borellus). *De motu animalium.* Rome: Typographia Angeli Bernabo, 1680–1681.

Bottazzi, Filippo. "Leonardo biologo e anatomica," in *Leonardo da Vinci. Conferenze Fiorentine.* Milan: Fratelli Treves, 1910, pp. 183–223.

Braunfels-Esche, Sigrid. *Leonardo da Vinci. Das anatomische Werk.* Basel: Holbein Verlag, 1954; 2nd ed., Stuttgart, 1961.

——— "Neu Literatur zu Leonardos anatomischem Werk und seinem

WORKS CITED

Studium des Menschen (1952–1958)," *Raccolta vinciana,* no. 18, pp. 222–237 (1960).

Brion, Marcel. *Génie et destinée. Léonard de Vinci.* Paris: Albin Michel, 1952.

——— "Les 'Noeuds' de Léonard de Vinci et leur signification," in *L'Art et la pensée de Léonard de Vinci.* Paris: Etudes d'art, nos. 8–10 (1953–1954), pp. 71–81.

Brizio, Anna Maria. "Delle acque," in *Leonardo. Saggi e ricerche.* Rome: Libreria dello Stato, 1954, pp. 275–289.

Brugnoli, Maria Vittoria. "Documenti, notizie e ipotesi sulla scultura di Leonardo," in *Leonardo. Saggi e ricerche.* Rome: Libreria dello Stato, 1954, pp. 359–390.

Buridan, Jean (Johannes Buridanus). *Quaestiones super libris quattuor de caelo et mundo,* ed. E. A. Moody. Cambridge, Mass.: The Mediaeval Academy of America, 1942.

Calvi, Girolamo. "Il Manoscritto H di Leonardo da Vinci, il 'Fiore di virtù' e 'L' acerba' di Cecco d'Ascoli," *Archivio storico Lombardo,* 25: 73–116 (1898).

——— *I Manoscritti di Leonardo da Vinci.* Pubblicazoni dell'Istituto Vinciano in Roma, 6. Bologna: N. Zanichelli, 1925.

Cardano, Girolamo. *De subtilitate rerum.* Basel: per Sebastianum Henricpetri, 1582.

——— *De vita propria liber.* Translated by J. Stoner as *The Book of My Life.* New York: E. P. Dutton, 1930.

Cassirer, Ernst. *Individuum und Kosmos in der Philosophie der Renaissance.* Leipzig: B. G. Teubner, 1927. Translated by M. Domandi as *The Individual and the Cosmos in Renaissance Philosophy.* New York: Harper and Row, 1964.

Castelfranco, Giorgio. "Sul pensiero geologico e il paesaggio di Leonardo," in *Leonardo. Saggi e ricerche.* Rome: Libreria dello Stato, 1954, pp. 470–476.

Castelli, Benedetto. *Della misura dell'acque correnti.* Rome: per Francesco Caualli, 1639.

Cecco d'Ascoli (Francesco degli Stabili). *L'Acerba.* Venice: Bernardinus Rizzus, 1487.

Cellini, Benvenuto. *Autobiography.* New York: P. F. Collier and Son, The Harvard Classics, vol. 24, 1910.

——— "Della architettura," in *I Trattati dell'oreficeria e della scultura,* ed. Carlo Milanesi. Florence: Le Monnier, 1857; Milan, 1927.

Chastel, André. *Léonard de Vinci par lui-même.* Paris: Nagel, 1952. Trans-

WORKS CITED

lated by E. Callmann as *The Genius of Leonardo da Vinci: Leonardo da Vinci on Art and the Artist.* New York: Orion Press, 1961.

—— "Léonard et la culture," in *Léonard de Vinci et l'expérience scientifique au XVIe siècle, Colloques Internationaux.* Paris: Presses Universitaires, 1953, pp. 251–263.

—— *Marsile Ficin et l'art.* Geneva: E. Droz, 1954.

Cianchi, Renzo. *Vinci Leonardo e la sua famiglia. Con appendice di documenti inediti.* Milan: Museo della scienze e della tecnica, publ. no. 10, 1952.

Cicero. *De finibus bonorum et malorum libri v.* London: Heineman, 1931.

Cisotti, Umberto. "The Mathematics of Leonardo," in *Leonardo da Vinci.* New York: Reynal and Company, 1963, pp. 201–204.

Clark, Kenneth. *A Catalogue of the Drawings of Leonardo da Vinci in the Collection of His Majesty the King at Windsor Castle.* Cambridge, Eng., 1935. 2 vols.

Condillac, Etienne Bonnot de. *Traité des sensations.* Amsterdam, 1749. Translated by G. Carr as *Condillac's Treatise on Sensations.* Los Angeles: University of California Press, 1930.

Corsi, Giovanni. *Vita Marsilii Ficini,* chap. 8. Text cited in R. Marcel. *Marsile Ficin, 1433–1499.* Paris: Les Belles Lettres, 1958.

Croce, Benedetto. "Leonardo filosofo" (1906), in *Leonardo da Vinci. Conferenze Fiorentine.* Milan: Fratelli Treves, 1910, pp. 227–256.

Crombie, Alastair C. *Robert Grosseteste and the Origins of Experimental Science, 1110–1700.* Oxford: Clarendon Press, 1953.

Curtius, Rufus Quintus. *Historia Aleksandri Magni.* Amsterdam: Blaviana, 1684. Translated by J. C. Rolfe as *Quintus Curtius (History of Alexander).* Cambridge, Mass.: Harvard University Press, The Loeb Classical Library, 1946. 2 vols.

Degenhart, Bernhard. "Unbekannte Zeichnungen Francescos di Giorgio," *Zeitschrift für Kunstgeschichte,* 8(3/4): 117–150 (1939).

Dezarrois, André. "La Vie française de Léonard," in *L'Art et la pensée de Léonard de Vinci.* Paris: Etudes d'art, nos. 8–10 (1953–1954), pp. 223–238.

Dibner, Bern. *Leonardo da Vinci, Military Engineer.* New York: The Brundy Library, 1946.

Diderot, Denis. "Lettres sur les aveugles a l'usage de ceux qui voient," in his *Opera,* vol. 2. Paris: Desray, 1798, pp. 177–266.

—— "Lettres sur les sourds et muets a l'usage de ceux qui entendent et parlent," in his *Opera,* vol. 2. Paris: Desray, 1798, p. 280.

Dolce, Lodovico. *Dialogo della pittura.* Venice: Gabriel Giolito de'Ferrari, 1557.

WORKS CITED

Dugas, René. "Léonard de Vinci dans l'histoire de la mécanique," in *Léonard de Vinci et l'expérience scientifique au XVIe siècle, Colloques Internationaux.* Paris: Presses Universitaires, 1953, pp. 89–114.

Duhem, Pierre. *Etudes sur Léonard de Vinci.* Paris: A. Hermann, 1906–1913. 3 vols. Reprinted, Paris: De Nobele, 1955.

Duval, M., and A. Bical. *L'Anatomie des maîtres.* Paris, 1890. Translated by F. E. Fenton as *Artistic Anatomy.* London: Cassell and Co., 1891.

Efimov, A. V. *Iz istorii velikikh russkikh geograficheskikh otkrytii v Severnom Ledovitom i Tikhom okeanakh* (History of Great Russian geographic discoveries in the Arctic and Pacific oceans). Moscow: Gosgeografizdat, 1950.

Engels, Friedrich. *Dialectics of Nature.* New York: International Publishers, 1940.

Favaro, Giuseppe. *Leonardo da Vinci, i medici e la medicina.* Rome: S. Maglione & C. Strini, 1923.

——— "Leonardo da Vinci e l'anatomia," *Scientia,* no. 6, pp. 170–175 (1952).

Ficino, Marsilio (M. Ficinus). *Opera.* Paris, 1641.

Flora, Francesco. *Leonardo.* Milan: Mondadori, 1952.

——— "Umanesimo di Leonardo," in *Atti del Convegno di studi vinciani.* Florence: Olschki, 1953, pp. 4–25.

Francastel, Pierre. "La Perspective de Léonard de Vinci et l'expérience scientifique au XVIe siècle," in *Léonard de Vinci et l'expérience scientifique au XVIe siècle, Colloques Internationaux.* Paris: Presses Universitaires, 1953, pp. 61–72.

Fumagalli, Giuseppina. *Leonardo prosatore; scelta di scritti vinciani.* Milan: Albrighi, Segati and Co., 1915.

——— *Leonardo "omo sanza lettere,"* 6th enl. ed. Florence: Sansoni, 1952.

——— "Bellezza e utilità; appunti di estetica vinciana," in *Atti del Convegno di studi vinciani.* Florence: Olschki, 1953, pp. 125–142.

——— "Leonardo: ieri e oggi," *Leonardo. Saggi e ricerche.* Rome: Libreria dello Stato, 1954, pp. 391–414.

——— *Leonardo ieri e oggi.* Pisa: Nistri-Lischi, 1959.

Galen. *De usu partium corporis humani.* Paris: ex officina Simonis Colinaei, 1528.

Galilei, Galileo. *Dialogo sopra i due massimi sistemi del mondo.* Translated by S. Drake as *Dialogues Concerning the Two Chief World Systems: Ptolomaic and Copernican.* Berkeley, California: University of California Press, 1953.

——— "Discorsi e dimostrazioni matematiche intorno a due nuove scienze, giornata 4," in his *Opere,* vol. 8. Florence: Edizione nazionale, 1898.

WORKS CITED

Translated by Henry Crew and Alfonso de Salvio as *Dialogues Concerning Two New Sciences*. New York: McGraw-Hill, 1963.

Gantner, Joseph. *Leonardos Visionen von der Sintflut und vom Untergang der Welt*. Bern: Francke, 1958.

Garin, Eugenio. "La Cultura fiorentina nell'età di Leonardo," *Belfagor*, 7(3): 272–289 (1952).

——— "La Filosofia di Leonardo," *Scientia*, 6: 293–298 (1952). French translation of same, pp. 157–162.

——— "Il Problema delle fonti del pensiero di Leonardo," in *Atti del Convegno di studi vinciani*. Florence: Olschki, 1953, pp. 157–172.

Gavrilova, S. A. "Karty Leonardo da Vinchi" (Leonardo da Vinci's maps), *Voprosy geografii*, no. 34, pp. 161–162 (1954).

G. C. "Gli studi di Ladislao Reti sulla chimica di Leonardo," in *Leonardo. Saggi e ricerche*. Rome: Libreria dello Stato, 1954, pp. 47–56.

Gellius, Aulus. *Noctes atticae*. Translated by J. C. Rolfe as *The Attic Nights of Aulus Gellius*. Cambridge, Mass.: Harvard University Press, 1948–1954, 3 vols.

Geymüller, H. de. "Ecclesiastical Architecture," in J. P. Richter, *The Literary Works of Leonardo da Vinci*. London: Oxford University Press, 1939, II, 28–29.

Ghiberti, Lorenzo. *Commentarii*. Naples: R. Ricciardi, 1947.

Giacomelli, Raffaele. *Gli scritti di Leonardo da Vinci sul volo*. Rome: G. Bardi, 1936.

——— "Leonardo da Vinci aerodinamico, aerologo, aerotecnico ed osservatore del volo degli uccelli," in *Atti del Convegno di studi vinciani*. Florence: Olschki, 1953, pp. 353–373.

——— "La Scienza dei venti di Leonardo da Vinci," in *Atti del Convegno di studi vinciani*. Florence: Olschki, 1953, pp. 377–400.

Gianotti, Agostino. *Geografia e geologia negli scritti di Leonardo da Vinci*. Milan: Museo Nazionale della scienze e della tecnica, publ. no. 6, 1953.

Gille, Bertrand. "Léonard de Vinci et la technique de son temps," in *Léonard de Vinci et l'expérience scientifique au XVIe siècle, Colloques Internationaux*. Paris: Presses Universitaires, 1953, pp. 141–149.

Giovio, Paolo. "The Life of Leonardo," in J. P. Richter, *The Literary Works of Leonardo da Vinci*. London: Oxford University Press, 1939, I, xxxii.

Goethe, Johann Wolfgang von. *Sämtliche Werke*. Munich: G. Müller, 1909–1931. 45 vols. Vols. 31–45 were published in Berlin, im Propyläen Verlag.

Gordon, L. S. "Estestvennoistoricheskie vozzreniia Vol'tera (po materialam

WORKS CITED

ego biblioteki)" (Voltaire's views on natural history, according to the material in his library), *Akademiia Nauk SSSR. Institut Istorii Estestvoznaniia, Trudy,* no. 3, p. 411 (1949).

Gortani, Michele. "La Geologia di Leonardo da Vinci," *Scientia,* 87: 197–208 (1952).

Grabmann, Martin. *Die Geschichte der scholastischen Methode.* Vol. 1, Berlin: Akademie-Verlag, 1956.

Grammatica, D. Luigi. *Le Memorie su Leonardo da Vinci di Don Ambrogio Mazzenta.* Milan: Alfieri e Lacroix, 1919.

Griffiths, J. G. "Leonardo and the Latin Poets," *Classica et Mediaevalia,* 16(1/2): 270–272 (1955).

Grigor'ian, A. T., and V. F. Kotov. "O nekotorykh voprosakh istorii antichnoi mekhaniki" (Some questions on the history of ancient mechanics), *Istoriko-Matematicheskie Issledovaniia,* no. 10, pp. 670–765 (1957).

Grothe, Hermann. *Leonardo da Vinci als Ingenieur und Philosoph.* Berlin: Nicolaische Verlagsbuchhandlung, 1874.

Guber, A. A. "Rukopisi Leonardo" (Leonardo's manuscripts), in *Leonardo da Vinchi. Izbrannye proizvedeniia* (ed. Guber, et al.). Moscow: Izd-vo Akademii Nauk SSSR, 1935. vol. 2, pp. 403–422.

Guber, A. A., and V. K. Shileiko, trans. *Kniga o zhivopisi* (Treatise on painting). Moscow, 1934.

Guber, A. A., A. K. Dzhivelogova, V. P. Zubov, et al., trans. *Leonardo da Vinchi. Izbrannye proizvedeniia* (Leonardo da Vinci. Selected works). Moscow: Izd-vo Akademii Nauk SSSR, 1935. 2 vols.

Guilelmus de Conchis (Guillaume de Conches). "Philosophia mundi," in J. P. Migne, *Patrologia latina,* vol. 172, col. 85.

Gukovskii, M. A. *Mekhanika Leonardo da Vinchi* (Leonardo's Mechanics). Moscow: Izd-vo Akademii Nauk SSSR, 1947.

—— *Leonardo da Vinchi. Tvorcheskaia biografiia* (Leonardo da Vinci. A Critical Biography). Leningrad: Iskusstvo, 1958.

—— "Piat' let posle iubileia (Iz zarubezhnoi literatury o Leonardo da Vinci za 1952–1957 gg.)" (Five years after the jubilee; from foreign literature on Leonardo da Vinci, 1952–1957), *Vestnik Istorii Mirovoi Kul'tury,* no. 2, pp. 99–113, 1958.

—— *Madonna Litta. Kartina Leonardo da Vinchi v Ermitazhe* (Madonna Litta, a Leonardo da Vinci Painting in the Hermitage). Leningrad: Iskusstvo, 1959.

Haas, E. "Antike Lichttheorien," *Archiv für Geschichte der Philosophie,* 20: 355–356 (1907).

WORKS CITED

Hero of Alexandria (Heronis Alexandrini). *Heronis Alexandrini Geometricorum et stereometricorum reliquiae,* ed. F. Hultsch. Berlin: Weidmann, 1864.

Herodotus. *The History of Herodotus,* translated by G. Rawlinson. New York: Tudor Publishing Company, 1928.

Herzfeld, Marie. *Leonardo da Vinci. Der Denker, Forscher und Poet.* Leipzig: E. Diederichs, 1904; 4th rev. ed., Jena, 1926.

Heydenreich, L. H. *Die Sakralbau-Studien Leonardo da Vinci. Leonardo da Vinci als Architekt.* Leipzig: Vogel, 1929.

—— *Leonardo da Vinci.* Berlin: Rembrandt-Verlag, 1944; Basel: Holbein-Verlag, 1952. Authorized translation from the German, *Leonardo da Vinci.* London: Allen and Unwin, 1954.

—— "Quellenstudien zu Leonardos Malereitraktat," *Kunstchronik,* 4(10): 255–258 (1951).

—— "Leonardo-Bibliographie (1940–1952)," *Zeitschrift für Kungstgeschichte,* 15(2): 195–200 (1952).

Holl, M. "Eine dem Leonardo da Vinci zugeschriebene Skelettzeichnung in den Uffizien zu Florenz," *Archiv für die Geschichte der Medizin,* 7: 323–334 (1914).

Hooykaas, R. "La Théorie corpusculaire de Léonard de Vinci," in *Léonard de Vinci et l'expérience scientifique au XVIe siècle, Colloques Internationaux.* Paris: Presses Universitaires, 1953, pp. 163–169.

Horace. *The Odes and Epodes,* with an English translation by C. E. Bennett. Loeb Classical Library, Cambridge, Mass.: Harvard University Press, 1934.

Imbert, Marc. *Un Anatomiste de la Renaissance, Léonard de Vinci.* Lyon, 1955.

Isidore of Seville (Isidorus Hispalensis). "Etymologiae," in J. P. Migne, *Patrologia latina,* vol. 82, col. 473.

Ivanov, N. "Remarques sur Marsile Ficin et l'art de la Renaissance," *Revue d'esthétique,* 1(4): 381–391 (1948).

Johnson, Martin. "Pourquoi Léonard de Vinci cherchait-il les manuscrits scientifiques d'Archimède et comment les trouva t-il?" in *Léonard de Vinci et l'expérience scientifique au XVIe siècle, Colloques Internationaux.* Paris: Presses Universitaires, 1953, pp. 23–29.

Kamenskaia, T. D. "K voprosu o rukopisi 'Traktata o zhivopisi' Leonardo da Vinchi i ee illiustratsiiakh v sobranii Ermitazha" (Concerning the Leonardo da Vinci manuscript "Treatise on Painting" and its illustrations in the Hermitage collections), *Leningrad. Ermitazh, Trudy,* 1: 49–59 (1956).

WORKS CITED

Kant, Immanuel. "Metaphysische Anfangsgründe der Naturwissenschaft," in his *Sämmtliche Werke*, vol. 8. Leipzig: L. Voss, 1838.

Keele, K. D. *Leonardo da Vinci on the Movement of the Heart and Blood*. London: Harvey and Blythe, 1952.

Klibansky, Raymond. "Copernic et Nicolas de Cues," in *Léonard de Vinci et l'expérience scientifique au XVIe siècle, Colloques Internationaux*. Paris: Presses Universitaires, 1953, pp. 225–235.

Knögel, Elsmarie. "Schriftquellen zur Kunstgeschichte der Merowinger-zeit," *Jahrbuch des Vereins von Altertumsfreunden im Rheinlande*, no. 140/141, pp. 1–258 (1936).

Knorr, G. W., and J. E. I. Walch. *Lapides, ex celeberrimorum virorum sententia diluvii universalis testes*, vol. 1 of *Sammlung von Merkwürdig-keiten der Natur und Alterthümern des Erdbodens*. Nürnberg: A. Bieling, 1755.

Koyré, Alexandre. "Rapport final," in *Léonard de Vinci et l'expérience scientifique au XVIe siècle, Colloques Internationaux*. Paris: Presses Universitaires, 1953, pp. 237–246.

Kretschmer, K., H. Lautensach, et al. *Allgemeine Geographie. I. Teil. Physikalische Geographie*. Potsdam: Akademische Verlagsgesellschaft Athenaion, 1933.

Lagrange, J. L. *Mécanique analytique*, 4th ed. Paris: Gauthier-Villars, 1888–1889. 2 vols.

Lambertini, Gastone. "Leonardo anatomico," in *Atti del Convegno di studi vinciani*. Florence, Olschki, 1953, pp. 289–309.

Latini, Brunetto. *Li Livres dou trésor*. Paris: Ministère de l'Instruction Publique, 1863.

Lazarev, V. N. *Leonardo da Vinchi* (in Russian). Moscow: Akademiia Nauk SSSR, Institut Istorii Iskusstva, 1952.

———— *Ukazatel' osnovnoi literatury o Leonardo da Vinchi* (Index of basic literature on Leonardo da Vinci). Moscow: Akademiia Nauk, Funda-mental'naia Biblioteka Obshchestvennykh Nauk, 1952.

Leonardo da Vinci. New York: Reynal and Co., 1963. A compendium, illustrated, with classified bibliography, pp. 511–518.

Leonardo da Vinci. *Les Carnets de Léonard de Vinci*, introduction, classifica-tion and notes by E. MacCurdy, translations from English and Italian by L. Servicen, preface by P. Valéry. Paris: Gallimard, 1942; 2nd ed., 1951. 2 vols.

———— *La Cène de Léonard de Vinci*, text by Paolo d'Ancona. Milan: A. Pizzi, 1955.

———— "Il Codice Arundel 263," in *I Manoscritti ed i disegni di Leonardo*

WORKS CITED

da Vinci. Rome: Reale Commissione Vinciana, vol. 1, pts. 1–3, 1926–1928.

———— *Il Codice A nell'Istituto di Francia.* Rome: Reale Commissione Vinciana, vol. 2, 1936.

———— *Il Codice A (2171) nell'Istituto de Francia (Complementi).* Rome: Reale Commissione Vinciana, vol. 3, 1938.

———— *Il Codice Atlantico di Leonardo da Vinci nella Biblioteca Ambrosiana di Milano,* reproduced and published for the Reale Accademia dei Lincei by G. Piumati. Milan: U. Hoepli, 1894–1904.

———— *Il Codice B (2173) nell'Istituto di Francia.* Rome: Reale Commissione Vinciana, 1941.

———— *Il Codice di Leonardo da Vinci nella Biblioteca del principe Trivulzio in Milano,* transcribed and annotated by L. Beltrami. Milan: Pagnoni, 1891.

———— *Il Codice di Leonardo da Vinci nella Biblioteca di Lord Leicester in Holkham Hall,* published by G. Calvi. Milan: Cogliati, 1909.

———— *Il Codice Forster.* Rome: Reale Commissione Vinciana (I Manoscritti di Leonardo da Vinci. Serie minore), 1930–1934. 5 vols.

———— *Il Codice sul volo degli uccelli e varie altre materie,* published by Theodore Sabachnikoff, transcription and notation by G. Piumati, French translation by G. Ravaisson-Mollien. Paris: Rouveyre, 1893.

———— *Il Codice Trivulziano* transcribed by N. de Toni. Milan, 1939 (without illustrations).

———— *I Disegni geografici conservati nel Castello di Windsor.* Rome: Reale Commissione Vinciana, 1941.

———— *I fogli mancanti al Codice di Leonardo da Vinci sul volo degli uccelli,* edited by E. Carusi. Rome: Danesi, 1926.

———— *I Libri del volo,* edited by A. Uccelli with the collaboration of C. Zammattio. Milan: U. Hoepli, 1952.

———— *I Libri di meccanica* in the reconstruction ordered by A. Uccelli. Milan: U. Hoepli, 1940.

———— *I Manoscritti di Leonardo da Vinci della Reale Biblioteca di Windsor. Dell'Anatomia, Fogli A,* published by T. Sabachnikoff, transcribed and annotated by G. Piumati, with French translation, preceded by a study by M. Duval. Paris: Rouveyre, 1898. *Fogli B.* Turin: Roux and Viarengo, 1901.

———— *I Manoscritti ed i disegni di Leonardo da Vinci.* Rome: Reale Commissione Vinciana, vol. 1, 1926–1928.

———— *Les Manuscrits de Leonard de Vinci.* Manuscripts in the Institut de France, ed. Charles Ravaisson-Mollien. Paris: Quantin, 1881–1891. 6 vols.

WORKS CITED

—— *Quaderni d'anatomia I–VI,* published by C. Ove, L. Vangensteen, A. Fonahn, and H. Hopstock, with English and German translations. Christiania: J. Dybwad, 1911–1916.

—— *Saggio delle Opere di Leonardo da Vinci, Tavole tratte dal Codice Atlantico.* Milan, 1872.

—— *Scritti,* with a preface by L. Beltrami. Milan: Istituto editoriale italiano, 1913.

—— *Scritti scelti,* edited by Anna Maria Brizio. Turin: Unione Tipografico-editrice torinese, 1952.

—— *Trattato della pittura* of Leonardo da Vinci recently brought to light, with the Life of this same author written by Rafaelle du Fresne. Paris: Apresso Giacomo Langlois, 1651. This is the first incomplete edition of the Treatise on Painting.

—— *Il Trattato del moto e misura dell'acqua.* Bologna, 1828. In the series *Raccolta d'autori italiani che trattano del moto delle acque,* X, 270–450. New edition by E. Carusi and A. Favaro. Bologna: N. Zanichelli, 1923.

—— *Tutti gli scritti,* edited by A. Marinoni, *Scritti letterari.* Milan: Rizzoli, 1952.

Lessing, Gotthold Ephraim. *Laokoon, oder über die Grenzen zwischen der Malerei und Poesie.* Leipzig: Velhagen and Klasing, 1922. Translated by E. C. Beasley as *Laocoön; an Essay on the Limits of Painting and Poetry.* London: Longman, Brown, Green, and Longman, 1853.

Libri, Guillaume. *Histoire des sciences mathématiques en Italie.* Paris: Renouard, 1838–1841. 4 vols.

Lilley, Sam. "Leonardo da Vinci and the Experimental Method," in *Atti del Convegno di studi vinciani.* Florence: Olschki, 1953, pp. 401–420.

Lomazzo, Giovanni Paolo. *Trattato dell'arte della pittura.* Milan: P. G. Pontio, 1584.

—— *Idea del tempio della pittura.* Milan: P. G. Pontio, 1590; 2nd ed., Bologna, 1785.

Lombardini, E. "Dell'origine e del progresso della scienza idraulica nel milanese e altri parti d'Italia," *Istituto Lombardo di scienze e lettere,* ser. 2, vol. 13 (1862). Published separately, Milan: Saldini, 1872.

Lomonosov, M. V. "Rassuzhdenie o tverdosti i zhidkosti tel" (1760) (Discussion of solids and fluids), in *Polnoe sobranie sochinenii* (Complete collected works), vol. 3. Moscow: Izd-vo Akademii Nauk SSSR, 1952.

Lorenzo, Giuseppe de. *Leonardo da Vinci e la geologia.* Bologna: N. Zanichelli, 1920.

Ludwig, Heinrich, trans. *Das Buch von der Malerei nach dem Codex Vaticanus (Urbinas, 1270).* Vienna, 1882; reprinted, Jena: M. Herzfeld, 1909.

WORKS CITED

Lücke, Theodor. *Leonardo da Vinci. Tagebücher und Aufzeichnungen.* Leipzig: P. List Verlag, 1940; 2nd ed., Zurich, 1952; Munich: P. List, 1956.

Lüdecke, Heinz. *Leonardo da Vinci im Spiegel seiner Zeit.* Berlin: Rütten und Loening, 1952; 2nd ed., 1953.

Luporini, Cesare. *La Mente di Leonardo.* Florence: Sansoni, 1953.

Macchi, Vladimiro. *Leonardo da Vinci. Eine Auswahl aus seinen Schriften.* Berlin: Deutscher Verlag der Wissenschaften, 1954. (Italian text.)

MacCurdy, Edward. "Leonardo and Ovid," *Burlington Magazine,* 46(4): 204 (1925).

———— *The Mind of Leonardo da Vinci.* New York: Dodd Mead and Co., 1928.

———— *The Notebooks of Leonardo da Vinci.* New York: George Braziller, 1958.

Machiavelli, Niccolò. "Del modo di trattare i popoli dell Val di Chiana ribellati" (1502), in *Opere di Niccolò Machiavelli,* vol. 2. Florence, 1813.

———— *The Prince.* New York: P. F. Collier and Son, The Harvard Classics, vol. 36, 1910.

McMahon, A. Philip. *Treatise on Painting.* Princeton, N.J.: Princeton University Press, 1956. 2 vols.

McMurrich, J. P. *Leonardo da Vinci, the Anatomist (1452–1519).* Baltimore: Williams and Wilkins Co., 1930.

Maier, Anneliese. *Zwei Grundprobleme der scholastischen Naturphilosophie: Das Problem der intensiven Grösse. Die Impetustheorie.* 2nd ed. Rome: Edizioni di storia e letteratura, 1951.

Maltese, Corrado. "Il Pensiero architettonico e urbanistico di Leonardo," in *Leonardo. Saggi e ricerche.* Rome: Libreria dello Stato, 1954, pp. 331–358.

Marcel, Raymond. *Marsile Ficin, 1433–1499.* Paris: Les Belles Lettres, 1958.

Marcolongo, Roberto. *La Meccanica di Leonardo da Vinci.* Naples: Stabilimento industrie editoriali meridionali, 1932.

———— *Memorie sulla geometria e sulla meccanica di Leonardo da Vinci.* Naples: Stabilimento industrie editoriali meridionali, 1937.

Marinoni, Augusto. *Gli appunti grammaticali e lessicali di Leonardo da Vinci.* Milan: Castello Sforzesco, 1944–1952. 2 vols.

———— "Per una nuova edizione di tutti gli scritti di Leonardo," in *Atti del Convegno di studi vinciani.* Florence: Olschki, 1953, pp. 95–114.

———— *I Rebus di Leonardo da Vinci; raccolti e interpretati con un saggio su "Una virtù spirituale."* Florence: Olschki, 1954.

———— "I Manoscritti di Leonardo da Vinci e le loro edizioni," in *Leonardo. Saggi e ricerche.* Rome: Libreria dello Stato, 1954, pp. 229–274.

WORKS CITED

—— "Rebus," *Raccolta vinciana,* no. 18 (1960), pp. 117–128.

Meyerson, Emile. *Identité et realité.* Paris: F. Alcan, 1908. Translated by K. Loewenberg as *Identity and Reality.* New York: Dover, 1962.

Michel, Paul-Henri. *Un Ideal humain au XVe siècle. La pensée de L. B. Alberti.* Paris: Les Belles Lettres, 1930.

Migne, Jacques Paul. *Patrologiae cursus completus.* Latin series, one and two. Paris, 1844–1864. 221 vols. (Referred to by Zubov as *Patrologia latina.*)

Mikhailov, B. P. *Leonardo da Vinchi, arkhitektor* (Leonardo da Vinci, Architect). Moscow: Gosizdat Lit. po Stroitel'stvu i Arkhitekture, 1952.

Möller, Emil. "Der Geburtstag des Lionardo da Vinci," in *Jahrbuch der preussischen Kunstsammlungen.* Berlin, 1939, pp. 71–75.

Natucci, Alpinolo. "Leonardo geometra," *Archimede,* 4: 209–213 (1952).

Nicholas of Cusa. "De docta ignorantia," in *Opera omnia,* vol. 1, ed. E. Hoffmann and R. Klibansky. Leipzig: Felix Meiner, 1932.

Nicodemi, Giorgio. "Initiation aux recherches sur les activités de Léonard de Vinci en France," in *L'Art et la pensée de Léonard de Vinci.* Paris: Etudes d'art, nos. 8–10 (1953–1954), pp. 271–284.

Nordenskiöld, A. E. *Facsimile-Atlas to the Early History of Cartography,* translated from Swedish by J. A. Ekelöf and C. R. Markham. Stockholm: P. A. Norstedt, 1889.

Olschki, Leonardo. *Geschichte der neusprachlichen wissenschaftlichen Literatur.* Heidelberg: Winter, 1919.

O'Malley, C. D., and J. B. de C. M. Saunders. *Leonardo da Vinci on the Human Body.* New York: Schuman, 1952.

Orbeli, R. A. "Al'pinizm Leonardo da Vinchi" (Leonardo da Vinci's alpinism), in *Issledovaniia i Izyskaniia.* Moscow, 1947, pp. 193–195.

Ovid. *Metamorphoses,* with an English translation by F. J. Miller. Loeb Classical Library, Cambridge, Mass.: Harvard University Press, 1960.

Pacioli, Luca. *De divina proportione.* Venice: Paginus Paganinus, 1509.

—— *Summa de arithmetica, geometria. Proportioni et proportionalita.* Venice: Paginus Paganinus, 1523.

Panofsky, Erwin. "Die Perspektive als 'symbolische Form'," in *Vorträge der Bibliothek Warburg, 1924–1925.* Leipzig: Teubner, 1927, pp. 258–330.

Peckham, John. *Perspectiva communis d. Johannis archiepiscopi Cantuarensis.* Milan, ca. 1480.

Pedretti, Carlo. "Indagine con gli 'infrarossi' in una pagina di Leonardo," in *Sapere,* 1956, pp. 244–247.

—— *Studi vinciani.* Geneva: E. Droz, 1957.

—— "Saggio di una cronologica del fogli del codice Arundel di Leonardo da Vinci," *Bibliothèque d'humanisme et Renaissance, Travaux et documents,* 22: 172–177 (1960).

WORKS CITED

Péladan, Josephine. *Textes choisis de Léonard de Vinci.* Paris: Mercure de France, 1908.

Peter of Maricourt. "Letter on the magnet," Russian translation by V. P. Zubov in *Akademiia Nauk SSSR. Institut Istorii Estestvoznaniia i Tekhniki, Trudy,* no. 22, p. 302 (1959).

Piero della Francesca (Franceschi, Pietro di Benedetto dei). *De prospectiva pingendi,* ed. C. Winterberg. Strassburg: J. H. E. Heitz, 1899. 2 vols. critical edition, edited by G. Nicco Fasola. Florence: Sansoni, 1942.

Pisani, Maria. *Un Avventuriero del quattrocento; la vita e le opere di Benedetto Dei.* Genoa: Societá anonima de F. Perrella, 1923.

Plato. "Phaedo," translated by B. Jowett in *The Dialogues of Plato,* 3rd ed., London: Oxford University Press, 1892.

————— "Thaetetus," translated by B. Jowett in *The Dialogues of Plato,* 3rd ed., London: Oxford University Press, 1892.

Popham, A. E. "Leonardo's Drawings at Windsor," in *Atti del Convegno di studi vinciani.* Florence: Olschki, 1953, pp. 77–91.

————— "The Dragon-Fight," in *Leonardo. Saggi e ricerche.* Rome: Libreria dello Stato, 1954, pp. 221–227.

Psellus, Michael. *De daemonibus,* 1503.

Raccolta vinciana. Milan: Commune di Milano, Castello Sforzesco, fasc. 1–20, 1905–1964.

Rapin, René. *Lettre d'un philosophe à un cartésien de ses amis.* Paris, 1683.

Reti, Ladislao. "Le Arti chimiche di Leonardo da Vinci," *Chimica e l'industria,* 34(11): 655–667 (1952) and 34(12): 721–743 (1952).

————— "Leonardo da Vinci's Experiments on Combustion," *Journal of Chemical Education,* 29(12): 590–596 (1952).

Richter, Irma A. *Paragone: A Comparison of the Arts.* London: Oxford University Press, 1949.

Richter, J. P. *The Literary Works of Leonardo da Vinci,* 2nd ed., London: Oxford University Press, 1939. 2 vols.

Ristoro d'Arezzo. *Della compositione del mondo.* Milan: G. Daelli e comp., 1864.

Ronchi, Vasco. "Leonardo e l'ottica," in *Leonardo. Saggi e ricerche.* Rome: Libreria dello Stato, 1954, pp. 159–186.

Saint Augustine. *De vera religione.* Turin: G. B. Parovia, 1932.

Saitta, Giuseppe. *Marsilio Ficino e la filosofia dell'umanesimo.* Florence: F. le Monnier, 1943.

Salutati, Coluccio. *De nobilitate legum et medicinae,* edited by Eugenio Garin. Florence: Vallecchi, 1947.

Santillana, Giorgio de. "Léonard et ceux qu'il n'a pas lus," in *Léonard de Vinci et l'expérience scientifique au XVIe siècle. Colloques Internationaux.* Paris: Presses Universitaires, 1953, pp. 343–359.

WORKS CITED

Sarton, George. "Léonard de Vinci, ingénieur et savant," in *Léonard de Vinci et l'expérience scientifique au XVIe siècle. Colloques Internationaux.* Paris: Presses Universitaires, 1953, pp. 11–22.

Sartoris, Alberto. *Léonard, architecte.* Paris: A. Tallone, 1952.

Savonarola, G. *Opus perutile de divisione, ordine ac utilitate omnium scientiarum.* Venice, 1534.

———— *Compendium totius philosophiae tam naturalis quam moralis.* Venice, 1542.

———— *Triompho della croce.* Venice, 1547.

Schlosser, J. Magnino (Julius, Ritter von Schlosser). *La Letteratura artistica.* Florence: Nuova Italia, 1956.

Scilla, Agostino. *La Vana speculazione dal senso.* Naples, 1670.

Séailles, Gabriel. *Léonard de Vinci, l'artiste et le savant.* Paris: Perrin, 1892.

Seidlitz, Woldemar von. *Leonardo da Vinci. Malerbuch.* Berlin: Bard, 1910 and 1919.

Senaldi, Mario. *L'Anatomia e la fisiologia di Leonardo da Vinci.* Milan: Mostra della scienza e della tecnica, 1953.

Sergescu, Pierre. "Léonard de Vinci et les mathématiques," in *Léonard de Vinci et l'expérience scientifique du XVIe siècle, Colloques Internationaux.* Paris: Presses Universitaires, 1953, pp. 73–88.

Severi, Francesco. "Leonardo e la matematica," *Scientia,* 88: 41–44 (1953).

Solmi, Edmondo. *Frammenti letterari e filosofici di Leonardo da Vinci.* Florence, 1899.

———— "Le Fonti dei manoscritti di Leonardo da Vinci," *Giornale storico della letteratura italiana,* supplement no. 10–11, 1908.

———— "Nuovi contributi alle fonti dei manoscritti di Leonardo da Vinci," *Giornale storico della letteratura italiana,* no. 58, pp. 297–357 (1911).

———— *Scritti vinciani,* papers collected by Arrigo Solmi. Florence: "La Voce," 1924.

Somenzi, Vittorio. "Leonardo ed i principi della dinamica," in *Leonardo. Saggi e ricerche.* Rome: Libreria dello Stato, 1954, pp. 145–157.

———— "Riconstruzioni delle macchine per il volo," in *Leonardo. Saggi e ricerche.* Rome: Libreria dello Statto, 1954, pp. 52–66.

Speziali, P. "Léonard de Vinci et la 'Divina proportione' de Luca Pacioli," *Bibliothèque d'humanisme et de Renaissance, Travaux et documents,* 15: 295–305 (1953).

Steinitz, K. T. "A Reconstruction of Leonardo da Vinci's Revolving Stage," *Art Quarterly,* no. 4 (1949), pp. 325–338.

———— *Leonardo da Vinci's Trattato della Pittura.* Copenhagen: Munksgaard, 1958.

———— "Bibliography Never Ends," *Raccolta vinciana,* no. 18, pp. 97–111 (1960).

WORKS CITED

Strabo. *The Geography of Strabo* with an English translation by Horace Leonard Jones. New York: G. P. Putnams' Sons, 1917.

Suesanus, Agostino Nifo de. *De intellectu.* Venice, 1503, 1527, 1554.

Sumtsov, N. F. *Leonardo da Vinchi.* Kharkov: "Pechatnoe Delo," 1900.

Taylor, F. Sherwood. "Léonard de Vinci et la chimie de son temps," in *Léonard de Vinci et l'expérience scientifique au XVIe siècle, Colloques Internationaux.* Paris: Presses Universitaires, 1953, pp. 151–162.

Tertullian (Quintus Septimus Florens Tertullianus). "Apologeticus adversus gentes," in J. P. Migne, *Patrologia latina,* vol. 1, col. 510–511.

Thorndike, Lynn. *A History of Magic and Experimental Science,* vol. 5, New York: Macmillan, 1941.

Tikotin, M. A. *Leonardo da Vinchi v istorii i fiziologii* (Leonardo da Vinci in the history of anatomy and physiology). Leningrad: Medgiz, 1957.

Timpanaro, Sebastiano. "Leonardo e gli spiriti," in *Scritti di storia e critica della scienza.* Florence, 1952, pp. 86–90.

Toni, Giovanni-Battista de. *Frammenti vinciani,* 1–4, with unedited documents. Padua: Seminario, 1900.

Toni, Nando de. "L'Idraulica di Leonardo da Vinci," *Frammenti Vinciani,* nos. 2–9. Brescia: Morcelliana, 1935.

Uzielli, Gustavo. "Leonardo da Vinci e le Alpi," *Bolletino del Club Alpino Italiano,* 23(56): 81–156 (1890).

Valéry, Paul. "Note et digression" (1919) and "Léonard et les philosophes" (1929), in his *Les divers essais sur Léonard de Vinci.* Paris: Editions de la Nouvelle Revue Française, 1938, pp. 13–57, 119–166.

Valla, Giorgio. *De expetendis et fugiendis rebus opus.* Venice, 1501.

Valturio, Roberto. *De re militari libri.* Paris, 1535.

Vasari, Giorgio. *Vita de'più eccellenti architetti, pittori, e scultori italiani.* Florence, 1550. Translated by Gaston DuC. DeVere as *Lives of the Most Eminent Painters, Sculptors, and Architects.* New York: The Modern Library, 1959. "Leonardo da Vinci," pp. 190–208. This translation is used in the present text.

—— *Vita di Leonardo da Vinci,* edited by G. Poggi. Florence: L. Pampaloni, 1919.

—— *The Life of Leonardo da Vinci,* ed. L. Goldschneider. London: Phaidon Press, 1945.

Veitbrekht, I. *Istoriia estestvoznaniia v Rossii* (History of natural science in Russia). Moscow: Izd-vo Akademii Nauk SSSR, 1957–1962.

Venturi, Adolfo. *Leonardo da Vinci e la sua scuola.* Novara: Istituto geografico de Agostino, 1942. (Zubov cites the French edition, *Léonard de Vinci et son école,* Paris, 1948.)

Venturi, Giovanni-Battista. *Essai sur les ouvrages physico-mathématiques de*

WORKS CITED

Léonard de Vinci avec les fragments tirés de ses manuscrits. Paris: Chez Duprat, 1797.

Verga, Ettore. *Bibliografia vinciana, 1493–1930.* Bologna: N. Zanichelli, 1931. 2 vols.

Villari, Pasquale. *Niccolò Machiavelli e suoi tempi.* Florence: 1877–1882. 3 vols. Translated by Linda Villari as *The Life and Times of Niccolo Machiavelli.* London: T. F. Unwin, 1898.

——— *La Storia di G. Savonarola e de'suoi tempi.* Florence: 1887. 2 vols. Translated by Linda Villari as *Life and Times of Girolamo Savonarola.* New York: Scribner and Welford, 1888. 2 vols.

Virgil. *The Aeneid of Virgil,* translated by Rolfe Humphries. New York: Charles Scribner and Sons, 1951.

Vitali, E. D. "L'Anatomia e la fisiologia," in *Leonardo. Saggi e ricerche.* Rome: Libreria dello Stato, 1954, pp. 115–143.

Vitruvius Pollio. *De architectura.* Rome: G. Herolt, 1486. 10 vols. Translated by J. Gwilt as *The Architecture of Marcus Vitruvius Pollio in Ten Books.* London: Lockwood, 1874.

Volynskii, A. L. *Leonardo da Vinchi.* Saint Petersburg, 1901; 2nd ed., Kiev, 1909.

Walker, Daniel P. *Spiritual and Demonic Magic from Ficino to Campanella.* London: Warburg Institute, University of London, 1958.

Walser, E. *Poggius Florentinus. Leben und Werke.* Leipzig: B. G. Teubner, 1914.

Weyl, Richard. "Die geologischen Studien Leonardo da Vincis und ihre Stellung in der Geschichte der Geologie," *Philosophia naturalis,* 1(2): 243–284 (1950).

Witelo. *Perspectiva.* Basel: Johann Riesner, 1572.

Wittgens, Fernanda. "Il Restauro in corso del 'Cenacolo' di Leonardo," in *Atti del Convegno di studi vinciani.* Florence: Olschki, 1953, pp. 39–52.

——— "Restauro del Cenacolo," in *Leonardo. Saggi i ricerche.* Rome: Libreria dello Stato, 1954, pp. 1–13.

Zhdanov, D. A. *Leonardo da Vinchi-anatom* (Leonardo da Vinci, anatomist). Leningrad: Medizdat, Leningradskoe Otdelenie, 1955.

Zubov, V. P. "Kontseptsii Diuema v svete noveishikh issledovannii po istorii estestvoznaniia" (Duhem's concepts in light of the most recent research on the history of natural science), in *Soveshchanie po Istorii Estestvoznaniia, 1946, Trudy.* Moscow: Izd-vo Akademii Nauk SSSR, 1948, p. 99.

——— "Leonardo da Vinchi i rabota Vitelo 'Perspektiva'," *Akademiia Nauk SSSR. Institut Istorii Estestvoznaniia i Tekhniki, Trudy,* 1954, pp. 219–248.

WORKS CITED

———— (ed., trans.) *Leonardo da Vinchi. Izbrannye estestvennonauchnye proizvedeniia* (Leonardo da Vinci. Selected works in natural science). Moscow, 1955.

———— "Fizicheskie idei Renessansa" (Renaissance ideas on physics), in *Ocherki razvitiia osnovnykh fizicheskikh idei* (Outlines of the development of basic ideas of physics). Moscow: Izd-vo Akademii Nauk SSSR, 1959, pp. 129–155.

———— "Léon-Battista Alberti et Léonard de Vinci," *Raccolta vinciana,* no. 18 (1960), pp. 1–14.

———— "Quelques aspects de la théorie des propotions esthétiques de L.-B. Alberti," *Bibliothèque d'humanisme et Renaissance, Travaux et documents,* 22: 54–61 (1960).

NOTES

CHAPTER I. BIOGRAPHY

1. Möller, "Der Geburtstag des Lionardo da Vinci"; see also Baroni, "La Nascita di Leonardo," p. 7.

2. Anonimo Fiorentino, *Il Codice magliabechiano.*

3. Beltrami, *Documenti e memorie,* p. 161.

4. One of the most noteworthy works of recent times on the childhood of Leonardo and on his family is that of the librarian of the Biblioteca Leonardiana, Renzo Cianchi, *Vinci Leonardo e la sua famiglia.*

5. Vasari, *Lives,* p. 52.

6. Ghiberti, *Commentarii,* bk. 2, chap. 22.

7. Concerning Pollaiuolo's anatomical sketches, which are among the first authentic models of the human anatomy, see Degenhart, "Unbekannte Zeichnungen Francescos di Giorgio."

8. Vasari, *Lives,* p. 191.

9. Corsi, *Vita Marsilii Ficini,* chap. 8. The text of this may be found in Marcel's *Marsile Ficin,* p. 683.

10. Marcel, *Marsile Ficin,* pp. 354–355.

11. Ficino, *Opera,* II, 103.

12. *Ibid.,* I, 924, "Letter to Filippo Valori, 25 March 1488."

13. *Ibid.,* I, 74–414, "Theologia platonica sive de immortalitate animorum."

14. Marcel, *Marsile Ficin,* p. 430.

15. *Ibid.,* p. 593.

16. Vasari, *Lives,* p. 190.

17. Beltrami, *Documenti e memorie,* p. 163.

18. Ficino, *Opera,* I, 969, "Letter of 13 September 1492." See also Chastel's book *Marsile Ficin et l'art,* p. 61 (additional references to the literature on p. 63).

19. Luporini, *La Mente di Leonardo,* pp. 190–191.

20. Savonarola, *Opus perutile,* fol. 2r–2v and 4v.

21. Fumagalli, *Leonardo ieri e oggi* (1959), p. 186.

22. Beltrami, *Documenti e memorie,* pp. 8–9.

23. Vasari, *Lives,* p. 146.

24. Gellius, *Noctes atticae,* 13.17.

25. Fumagalli, "Leonardo e Poliziano" in *Leonardo ieri e oggi,* p. 98.

26. Bongioanni, *Leonardo pensatore.*

27. Gukovskii, *Leonardo da Vinci,* p. 60; see also his *Madonna Litta,* pp. 47–49.

28. *De re militari.*

29. The sketches have been analyzed by Geymüller and Heydenreich. See Geymüller, "Ecclesiastical Architecture," and Heydenreich, *Leonardo da Vinci,* pp. 143–160. See also Sartoris, *Léonard, architecte;* Maltese, "Il Pensiero architettonico e urbanistico di Leonardo"; and Mikhailov, *Leonardo da Vinchi, arkhitektor.*

30. Detailed information can be found in Lombardini, "Dell'origine e del progresso della scienza idraulica."

31. Regarding Leonardo's hydraulic engineering works of the first Milan period, see E. Solmi, *Scritti vinciani,* pp. 75–96, 111–136.

32. *Perspectiva communis d. Johannis archiepiscopi Cantuarensis.*

33. Probably *De ponderibus* by Jordanus Nemorarius. [Translator's note.]

34. *De divina proportione* was printed in Venice in 1509. The text of this edition was reprinted with commentaries and a German translation by K. Winterberg. All citations in the present book are from the Winterberg edition. For further information on Leonardo's relation to this work, see Speziali, "Léonard de Vinci et la 'Divina proportione' de Luca Pacioli."

35. Pacioli, *De divina proportione,* p. 144.

36. Pedretti, "Il 'De viribus quantitatis' di Luca Pacioli," *Studi vinciani,* pp. 43–53.

37. Lomazzo, *Trattato dell'arte della pittura,* I.I.9 (*benche la pittura sia rovinata tutta*); the remarks on the sketches of the *Last Supper* and the *Battle of Anghiari* appear in his work *Idea del tempio della pittura,* p. 43.

38. For information on the restoration of the *Last Supper* after World War II, see the reports of Wittgens (formerly curator of the Brera Gallery), "Il Restauro in corso del 'Cenacolo' di Leonardo" and "Restauro del Cenacolo." See also d'Ancona, *La Cène de Léonard de Vinci.*

39. Brugnoli, "Documenti, notizie e ipotesi"; concerning the Sforza statue, see pp. 364–373.

40. Pacioli, *De divina proportione,* p. 33.

41. Varari, *Lives,* p. 200.

42. Beltrami, *Documenti e memorie,* p. 166. English translation in Richter, *Literary Works,* I, xxxii.

43. Savonarola, *Opus perutile,* fol. 15v–16r.

44. *Ibid.,* fol. 21v.

45. Villari, *Life and Times of Girolamo Savonarola,* II, 143.

46. Beltrami, *Documenti e memorie,* p. 66.

47. Pedretti, "Rilievi sconosciuti," *Studi vinciani,* pp. 217–221.

48. Babinger, "Vier Bauvorschläge."

49. For details on this project and the works carried out, with excerpts from the documents, see Villari, *The Life and Times of Niccolo Machiavelli.*

50. Beltrami, *Documenti e memorie,* p. 162.

51. Vasari, *Lives,* p. 205.

52. Beltrami, *Documenti e memorie,* p. 166; Richter, *Literary Works,* I, xxxii.

53. Beltrami, *Documenti e memorie,* p. 163.

54. Cellini, *Autobiography,* bk. I, chap. 12, p. 24.

55. Cianchi, *Vinci Leonardo,* pp. 49, 76, 79, 80.

56. Vasari, *Lives,* pp. 200–201.

57. See De Toni, *Frammenti vinciani,* and Bottazzi, "Leonardo biologo e anatomico."

58. Vasari, *Lives,* p. 201.

59. *Ibid.,* p. 207.

60. *Ibid.,* p. 206.

61. *Ibid.,* p. 195.

62. *Ibid.,* p. 206.

63. See E. Solmi, "Leonardo da Vinci ed i lavori di prosciugamento," *Scritti vinciani,* pp. 299–336.

64. Vasari, *Lives,* p. 203.

65. Venturi, *Léonard de Vinci et son école,* p. 25.

66. Beltrami, *Documenti e memorie,* pp. 212–213.

67. Pedretti, "Storia della Gioconda," *Studi vinciani,* pp. 132–141.

68. Beltrami, *Documenti e memorie,* p. 182.

69. Many facts about the final period of Leonardo's life can be found in the collection of papers *L'Art et la pensée de Léonard de Vinci,* published as the communications of the Congrès International du Val de Loire held in 1952 (the five hundredth anniversary of Leonardo's birth). See in particular the papers by Dezarrois (pp. 83–115) and Nicodemi (pp. 271–284).

70. Cellini, "Della architettura," p. 264.

71. Braunfels-Esche, *Leonardo da Vinci,* pp. 52, 62.

72. Beltrami, *Documenti e memorie,* p. 149.

73. Richter, *Literary Works,* II, 389.

CHAPTER 2. WRITINGS

1. See, for example, the opinions expressed by Sarton and Bodenheimer at the Jubilee Colloquium held in Paris in 1952 (Sarton, "Léonard de Vinci, ingénieur et savant," p. 20; and Bodenheimer, "Léonard de Vinci, biologiste," p. 187.

2. Dugas, "Léonard de Vinci dans l'histoire de la mécanique," pp. 92, 98.

3. Koyré, "Rapport final," pp. 237, 239, 238.

4. Santillana, "Léonard et ceux qu'il n'a pas lus," pp. 46–47.

5. Koyré, "Rapport final," p. 239. Bodenheimer, who also participated in the colloquium, concurred in this stress on the oral tradition; "Léonard de Vinci, biologiste," p. 187.

6. An extensive comparison of the fragments can be found in Baratta, *Leonardo da Vinci,* pp. 272–273.

7. Cf. Johnson, "Pourquoi Léonard de Vinci cherchait-il les manuscrits."

8. The exaggerations of Solmi and Duhem have been treated in a paper by Garin, "Il Problema delle fonti del pensiero di Leonardo." Many of Solmi's papers have been collected by his brother Arrigo and published in a readily available work entitled *Scritti vinciani.* However, this collection does not include Solmi's special historical sketches devoted to the Leonardo manuscripts (E. Solmi, "Le

Fonti dei manoscritti di Leonardo da Vinci" and "Nuovi contributi alle fonti dei manoscritti di Leonardo da Vinci").

9. Alberti, *Of Painting, Of Architecture, and Of Statuary.*

10. Alberti, *Of Painting,* bk. 1, p. 6.

11. *Ibid.,* bk. 2, p. 19.

12. *Ibid.,* bk. 2, p. 13.

13. *Ibid.,* bk. 2, p. 11.

14. Alberti, *Of Architecture,* bk. 5, chap. 2.

15. *Ibid.,* bk. 8, p. 62.

16. For more details on Leonardo and Alberti, see my "Léon-Battista Alberti et Léonard de Vinci."

17. Marinoni undertook an analysis and deciphering of the rebuses in his *I Rebus di Leonardo da Vinci* and "Rebus."

18. Marcolongo, *La Meccanica di Leonardo da Vinci,* p. 4.

19. See Pedretti, *Studi vinciani,* pp. 79–87; comments on it can be found in Fumagalli, *Leonardo ieri e oggi,* pp. 255–276. Pedretti's first report on this research appeared in *Sapere* in 1956.

20. I took the comments on *bellezza* and *ornamenti* from Fumagalli, *Leonardo ieri e oggi,* pp. 69–75. She expressed these same ideas earlier in a lecture delivered at the congress on Leonardo studies held in 1952.

21. Marinoni, *Gli appunti grammaticali,* which is summarized in his "Per una nuova edizione."

22. Fumagalli (*Leonardo ieri e oggi,* pp. 79–89) attempted a literary analysis of Leonardo's passages on the flight of birds.

23. Leonardo's texts and drawings pertaining to the heart have been analyzed by Keele, *Leonardo da Vinci on the Movement of the Heart and Blood.*

24. Many interesting details on the technique of the anatomical drawings can be found in Braunfels-Esche, *Leonardo da Vinci. Das anatomische Werk,* to which I refer the reader for further information.

25. An interesting discussion of this subject can be found in Artelt, "Bemerkungen zum Stil der anatomischen Abbildungen des 16. und 17. Jahrhunderts."

26. For an informative comparison of the anatomical drawings of various masters (Leonardo, Raphael, Michelangelo, and others), see Duval and Bical, *L'Anatomie des maîtres* (translated by F. E. Fenton as *Artistic Anatomy*).

27. See Grabmann, *Die Geschichte der scholastischen Methode,* I, 173.

28. Pedretti, "L'Arte della stampa in Leonardo da Vinci," *Studi vinciani,* pp. 109–117.

29. Beltrami, *Documenti e memorie,* p. 149.

30. Cardano, *De subtilitate,* bk. 17, p. 809, Basel edition.

31. Vasari, *Lives,* p. 201.

32. Lomazzo, *Idea del tempio della pittura,* p. 15.

33. See Brizio, "Delle acque," for the dating of many notes pertaining to water, especially the earlier ones.

34. Garin, "La filosofia di Leonardo."

35. Aristotle, *De anima,* 2.7.418b.

CHAPTER 3. SCIENCE

1. Valéry, "Note et digression," p. 54.
2. Vasari, *Lives*, p. 193.
3. *Ibid.*, p. 207.
4. Machiavelli, *The Prince*, p. 40.
5. Villari, *Life and Times of Girolamo Savonarola*, I, 94–95.
6. Salutati, *De nobilitate legum et medicinae*, cited by Cassirer, *Individuum und Kosmos*, pp. 150, 162. For details see Walser, *Poggius Florentinus*, pp. 250–258.
7. Savonarola, *Opus perutile*, fol. 6v–7r.
8. Marcel, *Marsile Ficin*, p. 288.
9. Villari, *Life and Times*, vol. I.
10. Cardano, *Book of My Life*, chap. 43, pp. 208–209.
11. Savonarola, *Compendium totius philosophiae*, 1.17 and 28, fol. 4r and 5r.
12. Savonarola, preface to *Triompho della croce*, cited in Villari, *Life and Times*, I, 105–106.
13. Aristotle, *De anima*, 3.8.432a (*Kai dia touto oute me aisthanomenos methen outhen an mathoi oude zuneie*).
14. Savonarola, *Triompho della croce*, fol. 4v, cited in Villari, *Life and Times*, I, 106.
15. Ficino, *Opera*, I, 974, "Letter to M. Uranius."
16. Aristotle, *Analytica posteriora*, 1.13.78a–79a.
17. More details can be found in Crombie, *Robert Grosseteste*.
18. Galileo, *Dialogo sopra i due massimi sistemi*.
19. Galileo, "Discorsi e dimostrazioni," VIII, 296. [This is from Zubov's translation of the Italian original. Translator.]
20. Lilley, "Leonardo da Vinci and the Experimental Method," p. 401.
21. Beltrami, *Documenti e memorie*, p. 204; English translation in Richter, *Literary Works*, I, 29; Lomazzo, *Trattato dell'arte della pittura*. 1.2.1, pp. 106–107.
22. On this subject see the comments of Castelfranco, "Sul pensiero geologico."
23. Giacomelli, *Gli scritti di Leonardo da Vinci*, pp. 186, 248.
24. Vasari, *Lives*, p. 193.
25. Vitruvius, *The Architecture of Marcus Vitruvius*, 10.16.5.
26. Galileo, *Dialogues*, pp. 2, 125, 126, 4, 125.
27. *Ibid.*, p. 126.
28. Alberti, *Of Painting*, bk. 1, p. 7.
29. Olschki, *Geschichte der neusprachlichen wissenschaftlichen Literatur*, vol. I.
30. *Ibid.* The italics are mine.
31. Ristoro D'Arezzo, *Della composizione del mondo*, bk. 1, chap. 20, p. 41. See also Baratta, *Leonardo da Vinci ed i problemi della terra*, p. 78.

CHAPTER 4. THE EYE, SOVEREIGN OF THE SENSES

1. Aristotle, *Metaphysics*, 1.1.980a.
2. Savonarola, *Compendium totius*, 1.1.2r.

3. Pacioli, *Divina proportione,* p. 35.

4. Alberti, *Of Architecture,* bk. 2, pp. 19–20.

5. Cited in Michel, *Un Idéal humain,* p. 181.

6. Cicero, *De finibus bonorum,* 5.29.87; Gellius, *Noctes atticae,* 10.17; Tertullianus, *Apologeticus,* 46, in Migne, *Patrologia latina,* vol. I, cols. 510–511.

7. Plato, *Phaedo,* 65b–67d.

8. Ivanov, "Remarques sur Marsile Ficin," in which reference is made to Saitta's *Marsilio Ficino,* p. 313.

9. Chastel, "Léonard et la culture," p. 258.

10. Ficino, *Opera,* II, 291, "In Convivium Platonis de amore."

11. *Opera,* I, 374–376.

12. *Ibid.,* I, 999–1009.

13. *Ibid.,* I, 797–798.

14. *Ibid.,* I, 989–999. Cf. Marcel, *Marsile Ficin,* pp. 434, 454, 526–527.

15. Plato, *Phaedo,* 176b.

16. Villari, *La Storia di G. Savonarola,* I, 532–533.

17. Saint Augustine, *De vera religione,* 39-MPL. 34.165.

18. Condillac, *Traité des sensations.*

19. *Ibid.,* pt. 1, chap. 2, para. 1, vol. I, p. 160.

20. *Ibid.,* para. 2, vol. I, p. 108.

21. Diderot, "Lettres sur les aveugles."

22. Diderot, "Lettres sur les sourds."

23. Condillac, *Traité des sensations,* pt. 3, chap. 3, para. 2, vol. II, pp. 29–30; para. 26, vol. II, p. 70.

24. Aristotle, *De anima,* 2.6.418a; 3.1.425a.

25. Witelo, *Perspectiva,* 3.51; cf. Alhazen, *Opticae thesaurus,* 2.64.

26. Pacioli, *De divina proportione,* pp. 40–41.

27. Hero of Alexandria, *Geometricorum,* pp. 250–251.

28. See the interesting study by Panofsky, "Die Perspektive als 'symbolische Form'."

29. Alberti, *Of Painting,* bk. 1, p. 2.

30. Schlosser Magnino, *La Letteratura artistica,* p. 140.

31. Piero della Francesca, *De prospectiva pingendi.*

32. Boring, *Sensation and Perception,* p. 283.

33. Many interesting ideas on the theory of Leonardo's perspective can be found in Francastel, "La Perspective de Léonard de Vinci."

34. For more details see my "Leonardo da Vinchi i rabota Vitelo 'Perspektiva'."

35. See *Aristarchus of Samos, the Ancient Copernicus.*

36. Cf. Francastel, "La Perspective de Léonard de Vinci."

37. Guillaume de Conches, *Philosophia mundi,* 4.1, in the edition published under the name Honorius of Autun, in Migne, *Patrologia latina, vol.* CLXXII, col. 85.

38. Latini, *Li Livres dou trésor,* 1.1.3.105.

39. Nicholas of Cusa, "De docta ignorantia," bk. 2, chap. 12, in *Opera omnia,* I, 105.

40. *Ibid.*

41. Duhem, *Etudes sur Léonard de Vinci,* II, 153.
42. Klibansky, "Copernic et Nicolas de Cues," p. 227.
43. Santillana, "Léonard et ceux qu'il n'a pas lus," p. 49.
44. Garin, "Il Problema delle fonti"; and "La Cultura fiorentina," p. 288.
45. This work, *Quaestiones de caelo et mundo,* was published several times: Pavia, 1481; Venice, 1492, 1497, 1520.
46. Duhem, *Etudes,* II, 22–27; vol. III.
47. Buridan, *Quaestiones,* 1.2.19, pp. 212–217.
48. Albert of Saxony, *Quaestiones,* 1.2.22.
49. Buridan, *Quaestiones,* 1.2.19, p. 215.
50. Albert of Saxony, *Quaestiones,* 1.2.24.
51. Duhem, *Etudes,* I, 27–29.
52. Baratta, *Leonardo da Vinci,* pp. 268–269.
53. Ristoro d'Arezzo, *Della composizione del mondo,* 1.8.19, pp. 294–295.
54. See also Pacioli (*Divina proportione,* p. 41) concerning the pleasure brought by painting to reasoning and unreasoning beings.
55. Knögel, "Schriftquellen zur Kunstgeschichte."
56. Dolce, *Dialogo della pittura.*
57. Alberti, *Of Painting,* bk. 2, p. 13.
58. Alberti, *Of Architecture,* bk. 8, p. 60.
59. Lomazzo, *Trattato dell'arte della pittura,* 1.2.1, p. 107.
60. Goethe, "Erste Bekanntschaft mit Schiller" (1794), *Sämtliche Werke,* XXX, 448.
61. "Zur Metamorphose der Pflanzen," *ibid.,* p. 502.
62. "Farbenlehre. Didaktischer Teil," *ibid.,* XXI, 189.
63. *Ibid.,* XXI, 57–58.
64. *Ibid.,* XXI, p. 58.
65. "Zur Farbenlehre. Geschichtliches," *ibid.,* XXX, 499.
66. Cassirer, *The Individual and the Cosmos,* p. 157.
67. Luporini, *La Mente di Leonardo,* pp. 153–154.
68. For an analysis of this allegory, see Pedretti, *Studi vinciani,* pp. 54–61, who took the fragments from Lomazzo's descriptions.
69. Gukovskii, *Leonardo da Vinci,* pp. 85–86.
70. Machiavelli, *The Prince,* chap. 28, p. 60.

CHAPTER 5. THE PARADISE OF THE MATHEMATICAL SCIENCES

1. Koyré, "Rapport final," p. 242.
2. Other examples can be found in Leonardo da Vinci, *I Libri di meccanica* (1940 edition, pp. 465–467).
3. Pacioli, *De divina proportione,* p. 33.
4. Kant, "Metaphysische Anfangsgründe" (1786), p. 444.
5. Pacioli, *De divina proportione,* p. 34.
6. Aristotle, *Metaphysics,* 13.3.1078a.

7. Pacioli, *Summa de arithmetica,* fol. 187r and 187v.

8. The texts on traveler problems were reproduced by Libri (*Histoire des sciences mathématiques,* III, 286–294), who noted their interest from a purely mathematical standpoint.

9. Santillana, "Léonard et ceux qu'il n'a pas lus," p. 44.

10. Pacioli, *De divina proportione,* pp. 37–39.

11. E. Solmi, "Leonardo e Macchiavelli," *Scritti vinciani,* p. 207.

12. For more details, see Cisotti, "The Mathematics of Leonardo." [Translator's note.]

13. For information on Leonardo as a mathematician, see Marcolongo, *Memorie sulla geometria e sulla meccanica;* Sergescu, "Léonard de Vinci et les mathématiques"; Severi, "Leonardo e la matematica"; and Natucci, "Leonardo geometra."

14. Richter, *Literary Works,* vol. I, pp. 245–258, paras. 308–349.

15. I have attempted to demonstrate this with respect to Alberti; see my "Quelques aspects."

16. *The Architecture of Marcus Vitruvius,* 5.1.3.

17. Pacioli, *De divina proportione,* p. 162.

18. Lagrange, *Mécanique analytique,* p. xiii.

19. Holl, "Eine dem Leonardo da Vinci zugeschriebene Skelettzeichnung."

20. Valéry, "Léonard et les philosophes," p. 151.

21. Cf. Berthé de Besaucèle, *Les Cartésiens d'Italie,* who also mentions (p. 53) Borelli's student, Lorenzo Bellini (1643–1704), who carried the postulates of his teacher to extremes.

22. In particular, the works of the Petersburg Academician I. Veitbrekht (1702–1747); see *Istoriia estestvoznaniia v Rossii* (History of natural science in Russia), I, 454.

23. For more details, see Giacomelli, *Gli scritti di Leonardo da Vinci.*

24. Lomonosov, "Rassuzhdenie," p. 387.

25. Rapin, *Lettre d'un philosophe,* p. 127.

26. An analysis of the various meanings of *spirito* and *anima* in the works of Leonardo da Vinci can be found in Luporini, *La Mente di Leonardo,* pp. 53–106. Without knowing of Luporini's book I attempted the same thing in *Leonardo da Vinchi,* p. 941.

27. Isidore of Seville, *Etymologiae,* 13.2.1; Migne, *Patrologia latina,* vol. 82, col. 473.

28. Giacomelli, *Gli scritti di Leonardo,* p. 357.

29. Recently Reti made a careful study of Leonardo's texts in chemistry; see "Le Arti chimiche di Leonardo da Vinci" and "Leonardo da Vinci's Experiments on Combustion." For a general survey see G. C., "Gli studi di Ladislao Reti."

30. For example, Grothe, *Leonardo da Vinci als Ingenieur und Philosoph.* Among Russian writers, Sumstov, *Leonardo da Vinchi,* p. 129, held that "Leonardo was close to the discovery of oxygen."

31. Reti, "Le Arti chimiche," p. 727.

32. Taylor, "Léonard de Vinci et la chimie."

33. Concerning Leonardo's attitude toward medicine, see Favaro, *Leonardo da Vinci, i medici e la medicina,* and Benedicenti, "Leonardo da Vinci e la medicina."

34. In Benedicenti, "Leonardo da Vinci e la medicina," p. 245.
35. Lazarev, *Leonardo da Vinchi,* pp. 98–99.
36. Flora, "Umanesimo di Leonardo," p. 7.
37. Vasari, *Lives,* p. 208.
38. Horace, *Odes,* 2.10.9–12.
39. Luporini, *La Mente di Leonardo,* p. 27.
40. Machiavelli, *The Prince,* chap. 14, p. 50.

CHAPTER 6. TIME

1. *Metamorphoses,* XV, 232–236, Loeb translation, cited in MacCurdy, *Notebooks.* p. 62. [Translator's note.]
2. See Calvi, *I Manoscritti,* and MacCurdy, "Leonardo and Ovid." MacCurdy also made note of the three-part composition in his *Notebooks,* first published in 1906, and many others followed him. Comments on this may be found in Griffiths, "Leonardo and the Latin Poets."
3. Alberti, *Of Painting,* bk. 2, p. 7.
4. *Ibid.,* p. 14.
5. Engels, *Dialectics of Nature.*
6. Machiavelli, *Del modo di trattare i popoli* (1502).
7. Concerning Leonardo as a geologist, see Baratta, *Leonardo da Vinci ed i problemi della terra;* de Lorenzo, *Leonardo da Vinci e la geologia;* Weyl, "Die geologischen Studien Leonardo da Vincis"; Gortani, "La Geologia di Leonardo da Vinci"; and Gianotti, *Geografia e geologia.*
8. For the quotation, see Baratta, *Leonardo da Vinci ed i problemi della terra,* p. 306.
9. *The History of Herodotus,* II. 10–12, p. 84.
10. Strabo, *Geography,* I. 3–4, pp. 179–189.
11. Ovid, *Metamorphoses,* XV(262–267), pp. 430–431.
12. Cf. Knorr and Walch, *Lapides diluvii universalis testes.*
13. Gordon, "Estestvennoistoricheskie vozzreniia Vol'tera" (Voltaire's views on natural history), p. 411.
14. Alberti, *Of Architecture,* bk. 3, p. 41.
15. *The History of Herodotus,* II. 10.
16. Aristotle, *Meteorology,* 2.1.354a.
17. Thorndike, *History of Magic,* vol. 5, p. 21.
18. Buridan, *Quaestiones,* 1.2.7, pp. 158–160; Albert of Saxony, *Quaestiones,* 1.2.25 and 28, and *Acutissime quaestiones,* 1.2.10.
19. Buridan, *Quaestiones,* p. 159.
20. *Ibid.,* p. 159.
21. Albert of Saxony, *Quaestiones,* 1.2.28.
22. Albert of Saxony, *Acutissime quaestiones,* 1.2.10.
23. Buridan, *Quaestiones,* p. 160.
24. Albert of Saxony, *Acutissime quaestiones,* 1.2.10.
25. Buridan, *Quaestiones,* p. 160.

26. *Ibid.,* p. 160.

27. Albert of Saxony, *Quaestiones,* 1.2.28.

28. Duhem, "Albert de Saxe et Léonard de Vinci," in *Etudes,* I, 1–50; and "Léonard de Vinci et les origines de la géologie," in *Etudes,* II, 281–357.

29. Duhem, "Albert de Saxe et Léonard de Vinci," pp. 39, 50.

30. MacCurdy, *The Mind of Leonardo da Vinci,* pp. 248–249.

31. See Gantner, *Leonardos Visionen,* pp. 125–129.

32. See the interesting article by Uzielli, "Leonardo da Vinci e le Alpi," and the Russian paper by Orbeli, "Al'pinizm Leonardo da Vinci."

33. Buridan, *Quaestiones,* 1.2.7, pp. 154–160; Albert of Saxony, *Quaestiones,* 1.2.28.

34. Buridan, *Quaestiones,* p. 159; Albert of Saxony, *Quaestiones,* 1.2.28.

35. Buridan, *Quaestiones,* p. 154.

36. Albert of Saxony, *Quaestiones,* 1.2.28.

37. Gantner, *Leonardos Visionen,* p. 197.

38. *Quaestiones,* 1.2.28.

39. Meyerson, *Identité et réalité,* p. 95.

40. Grigor'ian and Kotov, "O nekotorykh voprosakh istorii antichnoi mekhaniki" (Some questions on the history of ancient mechanics), p. 692.

41. For more details on the history of this idea, see my "Fizicheskie idei Renessansa," pp. 126–128, 152–153.

42. References to the literature on this subject can be found in Somenzi, "Leonardo ed i principi della dinamica"; Gukovskii, *Mekhanika Leonardo da Vinchi,* p. 495; and Luporini, *La Mente di Leonardo,* pp. 107–116.

43. Galileo, *Dialogues.*

44. Gellius, *Noctes atticae,* 12.11.2.

45. Beltrami, *Documenti e memorie,* p. 9; cited in Richter, *Literary Works,* I, 70.

46. Vasari, *Lives,* p. 197.

47. Beltrami, *Documenti e memorie,* p. 166.

48. Lomazzo, *Idea del tempio,* chap. 9, p. 37.

49. For further details see Luporini, *La Mente di Leonardo,* pp. 120–122.

50. Lessing, *Laocoön.*

51. Vasari, *Lives,* p. 192.

52. For details, see Beltrami, *Leonardo da Vinci,* and Baroni, "Tracce pittoriche leonardesche."

53. Brion, "Les 'Noeuds' de Léonard de Vinci," and *Génie et destinée. Léonard de Vinci,* pp. 183–214.

54. Fumagalli, "Leonardo: ieri e oggi"; see also her book of the same title, pp. 9–62.

CHAPTER 7. HOMO FABER

1. Croce, "Leonardo filosofo."

2. Luporini, *La Mente di Leonardo,* pp. 135–139.

3. Peter of Maricourt, "Letter on the magnet."

4. Flora, "Umanesimo di Leonardo," p. 7; *Leonardo,* p. 145.

5. Popham compared this text with Leonardo's rough drafts in "The Dragon-fight."

6. Braunfels-Esche, *Leonardo da Vinci* (1954 ed.), p. 34.

7. The sources of Manuscript H were first examined in detail by Calvi; see his "Il Manoscritto H."

8. Thorndike, *History of Magic,* V, 20.

9. Virgil, *The Aeneid,* IV. 181–187, p. 98.

10. Curtius, *Historia,* 4.9.

11. Valturio, *De re militari,* pp. 230–231.

12. For a comprehensive review of Leonardo's military inventions, see Dibner, *Leonardo da Vinci, Military Engineer.*

13. Vasari, *Lives,* p. 193.

14. Koyré, "Rapport final," p. 242.

15. Bernal, *Science in History.*

16. Pacioli, *De divina proportione,* p. 33.

INDEX

INDEX

INDEX

INDEX

INDEX

INDEX

INDEX

INDEX